WILD
MINDS

Also by Reid Mitenbuler

Bourbon Empire:
The Past and Future of America's Whiskey

WILD
MINDS

THE ARTISTS AND RIVALRIES THAT INSPIRED THE GOLDEN AGE OF ANIMATION

REID MITENBULER

Atlantic Monthly Press
New York

FIRST EDITION

Published simultaneously in Canada
Printed in Canada

This book is set in 11-pt. ITC NEW Baskerville by Alpha Design & Composition.

First Grove Atlantic hardcover edition: December 2020

Library of Congress Cataloging-in-Publication data is available for this title.

ISBN 978-0-8021-2938-3
eISBN 978-0-8021-4705-9

Atlantic Monthly Press
an imprint of Grove Atlantic
154 West 14th Street
New York, NY 10011

Distributed by Publishers Group West

groveatlantic.com

20 21 22 23 10 9 8 7 6 5 4 3 2 1

To Lauren

What's truer than the truth? The story.

—Jewish proverb

Contents

Author's Note

Since many of the animated cartoons discussed in this book are short, usually less than ten minutes in length, I invite you to watch them as you read this text. Before the digital age, copies of these cartoons were difficult to find, but now it's much easier. If you choose to access these films online, however, a necessary word of caution: quality can vary depending on the source, and some versions have been edited into something far different from what their creators intended. As goes for anything you find on the Internet, be cautious.

Prologue

"Make Us Another"

Otto Messmer was eager—for fame, for riches, for his big break. At night he could look into the sky above West Hoboken, New Jersey, and see the glow from Manhattan's lights—barely two miles east, and yet a world away. He was a struggling young newspaper cartoonist, only twenty-three years old, on the verge of joining that more dazzling world across the Hudson River.

This was in 1915, when the newspaper business was still healthy, at the peak of its clout and reach. Talented artists working within its system were rewarded handsomely. At the *New York Journal*, a star cartoonist like Winsor McCay made more than $50,000 a year in syndication—a sum that afforded him multiple homes, chauffeur-driven sedans, and the kind of bold wardrobe choices you don't often find in the closets of people with less eccentric careers. It was a grand lifestyle, and one just starting to come within Messmer's grasp. His work was occasionally published in the *New York World* and sometimes featured in *Punch, Life*, and *Judge*—the most prestigious humor magazines of the day. But there was a problem: these sporadic freelance appearances didn't yet provide a stable living. Dry spells could mean washing his laundry in a bucket of cold water, or having to order the smellier cuts of meat from the butcher. Success seemed close, but he still needed a steady job.

One day, in search of additional work, Messmer packed a portfolio of drawings under his arm and headed to Fort Lee, New Jersey, several miles to the north. In the earliest years of the movie business, before people realized that Hollywood had better light and cheaper taxes, Fort Lee was a leading center of the film industry. Visitors there might catch a glimpse of glamorous stars like Lionel Barrymore posing for photographers, the wind dancing in his hair; or perhaps

D. W. Griffith standing next to his camera, shouting into a bullhorn. Messmer hoped to show his portfolio of drawings to the studios and get a job painting background sets for the movies.

Messmer presented his work at Universal, then just an upstart studio. Among his sample drawings was a flipbook featuring a short cartoon about the war then happening in Europe. At this point, animation was still very new; some argued that it could blossom into a great art form, while others said it would never be more than a novelty—the debate was still up in the air. A few movie studios, including Universal, thought animated cartoons had entertainment potential, that they could be used as a kind of hors d'oeuvre before main features. When Messmer presented his little flipbook, the hiring man paused. "Look, don't you know they're starting animation?" he asked. "You look like you could fit in that."

Messmer was excited, but also worried. He had included the flipbook only to make his portfolio look thicker. He had no real understanding of how animation was done on a larger scale, nor did he know whom to ask. It was still a new and mysterious craft; the few people doing it guarded their methods as secrets, the same as magicians with their tricks. Messmer told the hiring man he was interested but admitted he had no idea what he was doing.

The hiring man just shrugged. "Go ahead and see what you can do."

Messmer figured out the basics and made a one-minute test cartoon, entitled *Motor Mat*, about a reckless driver who fixes a flat tire by blowing a smoke ring with his cigar and using it as a spare. To Messmer's mind, this was what cartoons should be: wild and fantastic, immune to the logic of physics or reality. Animation could magically bring to life worlds and ideas that live action couldn't.

When other Universal executives saw the cartoon, they gave Messmer a humble space where he could work on his ideas. It wasn't even a proper office, just a rickety desk wedged into an open area between two film sets. Since movies were still silent in those days, the space was noisy from directors on different projects shouting over each other, competing to be heard. Amid this ruckus Messmer set to work drawing, trying to keep his pen from being jostled by crew members squeezing by. A few feet from his desk sat a caged lion, which the studio staff

explained was used for jungle pictures and kept starved so he would "emote" more. Messmer, whose work often involved metaphors, no doubt wondered if this was some sort of omen.

Universal fired Messmer shortly after hiring him—not because he wasn't talented, but because it was easier to just buy animated cartoons from outside studios that specialized in them. Messmer thus began floating among jobs at the handful of new animation studios trying to figure out the craft and become profitable.

Before any of his animation gigs was able to take off, Messmer was drafted to fight in World War I. He headed to Europe in 1917, dressed in his green wool Army uniform, keeping a diary of experiences that he no doubt hoped to some day use in his art. The diary's early pages— full of beautifully looping penmanship and clever doodles—described a pleasant ocean voyage to France and then a march through a lush countryside of green hills and thatched-roof cottages. As the journey progressed, however, the diary's tone darkened. Messmer began noticing artillery hidden among the wildflowers. He could hear the roar of battle off in the distance, and whiff the dry, sulfury smell of the guns. Once he joined the fighting, his penmanship grew thick and clumsy with descriptions of the war's horrors: a friend's pink brains splattered in the mud, the dying gasps of men's last words. Atrocities were all around, but he sometimes found relief in the little things, like the moments when buried artifacts from medieval French cities would suddenly appear in the trenches, surfacing in the mud like lost treasure floating up from the seafloor. It was a moment like this that perhaps inspired Messmer to jot in his diary a possible scenario for some future cartoon: "Fearless Freddy. Digs for gold; digs up all kinds of things from the earth."

By the time Messmer returned home, in 1919, animation had grown as an industry. It was beginning to offer a viable way to make a living, although some thought it was still just a novelty. Cartoons hadn't yet ignited the public's imagination, and no cartoon character had captured people's attention in the same way as real-life celebrities like Charlie Chaplin or Mary Pickford.

Messmer resumed work in an animation studio run by Pat Sullivan, a convicted felon who had recently been released from prison. Sullivan was a rotten boss but allowed Messmer to work for other

studios on his own time, so long as Sullivan made money from any deals. In this way, Messmer one day ended up at Famous Players–Lasky, the studio later known as Paramount, pitching an idea to an executive named John King.

King leaned back in his chair as Messmer loaded the projector with a cartoon titled *Feline Follies*, featuring a black cat that would eventually be named Felix. Translated from Latin, the name loosely meant "good luck," an ironic way to name a black cat.

The film began with Felix being kicked out onto the street by his owner because he had failed to protect the house from mice. Distressed and worried about his fate, Felix wanders to the home of his girlfriend, Miss Kitty White, and begs her for a place to stay. It's not a request Miss Kitty White seems excited about as she introduces him to a litter of neglected kittens and tells him he's the father. Facing down this vision of a life shackled to domestic drudgery, Felix responds by rushing off to the local gasworks, putting a hose in his mouth, and committing suicide.

Once the cartoon finished, the end of the film reel flapped loudly in the projector. Messmer leaned over to switch it off and then glanced at King to get his reaction. It's easy to imagine a film executive from a later generation becoming uncomfortable with the film's subject mater, but this was a younger America, when people had higher tolerance, and perhaps even a taste, for this kind of darker material. Back then, the movie industry still existed on the untamed fringe of society and had a higher risk tolerance. King could not have predicted that Felix would soon become one of the most recognizable icons in the world, or that animation would ever become anything more than just a novelty. When he finally stopped laughing at the cartoon, he turned to Messmer with a demand: "Make us another."

The origin story of Felix the Cat will be a surprising revelation to most. This and other early cartoon characters were often subversive and decidedly adult—not qualities usually associated with animation now. Many people today assume that cartoons have always primarily been children's entertainment. However, this reputation—that there

is something inherently juvenile about animation—is relatively new. It began in the 1950s, when the studios stopped making animated shorts for theatrical release, and cartoons moved to television. The natural habitat of cartoons was no longer in dark movie theaters, where profits were generated by admission tickets; it was now in living rooms, on television, where squeamish corporate advertisers had influence over what was presented. Those advertisers were also starting to notice how the postwar baby boom had created an enormous new audience of young people, and that their parents had plenty of disposable income. Once these new factors were understood, animation changed almost overnight. Before, it was something created by artists who saw themselves in the sophisticated mold of artists like Charlie Chaplin or Buster Keaton. After, it became a way to sell sugary breakfast cereal to kids. While recent history has seen a revival of some cartoons that echo the older sensibilities—glimpsed in the occasional feature, or in television shows like *The Simpsons, South Park,* or *BoJack Horseman*—the art form still carries a reputation from when it was disrupted.

This book is about animation's origins and rise, the first fifty years, wild decades spanning the early twentieth century to the 1960s. The cartoons created then were often little hand grenades of social and political satire: bawdy yet clever, thoughtful even if they were rude. Some Betty Boop cartoons contained brief glimpses of nudity. Popeye cartoons were often loaded with sly messages about the injustices of unchecked capitalism. The teaming of animators with jazz musicians like Cab Calloway was, in the 1920s and '30s, just as subversive as hip-hop would be in the 1980s and '90s. The old Warner Bros. cartoons— Bugs Bunny, Daffy Duck, and more—occasionally offered some of the most perceptive social commentary of their era. Much of this color was censored when these old cartoons were repackaged for new formats and audiences, particularly television and young children. Much of their original spirit was reimagined, if not forgotten.

The people who made classic cartoons offer a treasure trove of colorful backstories. These wild minds occupied the same zip codes as stand-up comics like Lenny Bruce, Joan Rivers, Richard Pryor, or Dave Chappelle in years to come. Like much great art, their work could be controversial—much of it upsets the sensibilities of later

generations fancying themselves as sensitive and enlightened. Understood in the proper context, however, classic cartoons reveal much about the past, its people, and American culture. During its first half-century, animation was an important part of culture wars about free speech, censorship, the appropriate boundaries of humor, and the influence of art and media on society. During World War II, it played a large role in propaganda and popular culture. Later on, it would demonstrate how the medium affects the message.

This book is a narrative history of the personalities behind animation's first half-century, when the art was experimental, subversive, spooky, sometimes dangerous, and often hilarious. This is the tale of an older age and a younger nation, collapsed to the scale of a curious industry: the promise and ambition; fortunes made and lost; a rise and then the fall. It is also about art and how creative people work, how their art was shaped by its time, and how that art affected the future.

WILD
MINDS

Chapter 1

"Slumberland"

In 1911, newspaper cartoonist Winsor McCay confidently declared himself to be "the first man in the world to make animated cartoons." Perhaps he made his claim because he was unaware of the others, or maybe he just meant that he was the first to do it *his* way. Ultimately, it didn't matter. Once the words were uttered, controversy erupted and other cartoonists came forward, indignantly declaring their own right to the title. In truth, McCay wasn't technically the first—multiple people had come up with similar concepts around the same time—but he was the most famous and admired of all the contenders. Thus, to him went the credit and the glory.

Ever since McCay was a boy, people spoke of him the way they spoke of legends. His family claimed he drew his first picture before he said his first word, while people from his hometown shared similar apocryphal stories about his unique artistic gifts. The effect of these stories was to provide a sense of clarity about the vast scope of his talent, and to imbue Winsor with a sense of destiny.

McCay was already famous when he created his first animated cartoon in 1911. By that time, he had revolutionized the newspaper comic strip into something resembling movie storyboards of the future: the illusion of motion, creative perspective, people frozen in action poses. His strips were filled with epic stories, capturing the public's imagination and making Winsor one of the most widely recognized newspaper cartoonists in the country.

Despite these achievements, McCay was restless, wanting to expand his art further. He was drawn to the new technology behind motion pictures—then a burgeoning art form—and couldn't stop talking to his newspaper colleagues about the movies' potential. Soon

he began dreaming of making his comic strips move in a similar way. He would animate only a handful of cartoons during his lifetime, but they were wildly influential, inspiring many other cartoonists—early greats such as Max Fleischer, Otto Messmer, and Walt Disney—to do something similar.

His influence was profound, but Winsor McCay's impact on animation was all but forgotten by the time of his death, in 1934. Some two decades later, his name would fade from public memory, even though many of his protégés, such as Walt Disney, would become famous. Disney was generous about celebrating those who had inspired him, however, and decided to produce, in 1955, a short television segment about McCay. Before it aired, Disney invited McCay's son, Robert, himself now gray at the temples, to come visit his studio in Burbank, California. After a private tour of the grounds, full of sunshine and swaying palms, the two men eventually found themselves standing in Disney's office, gazing out the window. Warm and casual, Walt gave credit where it was due. "Bob," he said, sweeping his hand across the gorgeous view of his empire, "all this should have been your father's."

Winsor McCay earned his first money from art in the late 1880s, by drawing portraits of people at Sackett & Wiggins's Wonderland, a dime museum located in Detroit, Michigan. He lived in nearby Ypsilanti and was attending classes at Cleary's Business College, where his parents had sent him to learn practical skills such as typewriting, shorthand, and simple accounting. But Winsor bristled at the prospect of a life involving practical skills and played hooky so he could go draw portraits instead. He dropped out of school shortly thereafter.

Decades later, memories of Wonderland would resurface in McCay's animation. The museum was a warren of velvet curtains, red brick, and flickering gas lamps. Dwarfs and bearded ladies roamed the hallways while tattooed men announced upcoming shows: *Professor Matthew's Circus of Performing Goats!* or *Billy Wells! The man with the iron skull who allows stone and boards to be broken on his head!* Wonderland taught Winsor a practical lesson he would use later in his career: always please your audience. "A great many women and girls had me draw their pictures, and even at that age I was wise enough to make

all of them beautiful whether they were entitled to it or not," Winsor said. "I used to leave that place with my pockets bulging with money."

Young and restless, McCay left Ypsilanti and, after a short stint in Chicago, landed in Cincinnati in 1891. Those who knew him said this was where he found his true voice as an artist—his "heart was always with the Queen City," his son Robert recalled. The town still possessed some of its glory from the old riverboat days, picturesque yet gritty, an optimistic place that also had an interesting dark side: party bosses, rigged elections, poker games ending with an angry gambler flipping the table over.

In Cincinnati, McCay once again found himself working in a shabby dime museum, Kohl & Middleton's. His office was a dingy room on the top floor, where he could look down and see pickpockets lurking around the ticket window. It was there that he designed posters for the museum's various shows—"Transient and Permanent Curiosities without number," read one that also boasted "Freaks, fun and frolic from foreign lands for fictions fancy." The shows often featured performers like the midget Jennie Quigley, whose alias was "the Scottish Queen"; or Anna Mills, known by most as "the girl with the prodigious feet." The poster for "Wild Man of Afghanistan," another popular attraction, billed its star, rather long-windedly, as "a good-natured and harmless colored giant who pushed a handcart down in the West End. But when chained up and eating raw meat, and growling maniacally, he was a fearsome-looking object and drove sleep away from the cots of many boys and grown-ups, too."

McCay left the dime museum in 1896, after Charles J. Christie, editor of Cincinnati's *Commercial Tribune*, noticed his work. Using the punchy language of an emphatic newspaper editor, Christie made McCay an offer to come work for him: "The same money you're getting at the dime museum and I'll make a newspaperman out of you. The best god-damned newspaper cartoonist in the country, that's what I'll make of you!"

"Where can I hang my coat?" McCay replied.

Many great artists had started their careers working for newspapers. Winslow Homer, William Glackens, and John French Sloan had all

once done stints as "artist-reporters," drawing depictions of recent news events. The pictures were reasonably accurate, but like all great artists, these men knew that stretching the facts here and there could sometimes illustrate a larger truth. It was a lesson that was also understood by the first generation of animators, many of whom had also started their careers working for newspapers, drawing cartoons and comic strips while honing their senses of humor and satire.

While at the *Tribune*, McCay began submitting cartoons to the leading humor magazines of his day: *Life*, *Puck*, and *Judge*, where his art broadened into sharper commentary. When the United States began fighting in the Philippines in 1899, he published a cartoon of a pistol-packing Uncle Sam in a carnival game, flinging doll-size U.S. soldiers at a Filipino's head and asking, "Is the Game Worth the Candle?" The cartoon was exquisitely drawn, as were all his drawings, and editors at other publications took note. *Life*, *Puck*, and *Judge* were the magazines they read to find new talent.

In 1900, Winsor took a job with the *Cincinnati Enquirer*, rival to the *Tribune*, after it offered him a higher salary. His work there took on a new dimension, more surreal and full of playful fancy. In 1903, he began publishing a comic strip entitled *The Tales of the Jungle Imps by Felix Fiddle*, a spoof of both Charles Darwin and Rudyard Kipling. In each installment, various jungle animals sought relief from the torment they constantly endured at the hands of three seminaked black children known as the Imps. After consulting with Dr. Monk and his team of wise monkeys, the animals would then be endowed with some new physical feature they could use to defeat their aggressors. Each episode's plot was hinted at in its title—"How the Alligator Got His Big Mouth" or "How the Quillypig Got His Quills." Even though the strip's title mentioned a character named Felix Fiddle, he rarely had much to do with anything, making appearances as a bearded old man who just stands off to the side watching all the action while clutching a cane and briefcase.

In 1903, McCay received a letter from the *New York Herald*, which was interested in hiring him. It was a big move, off to a much larger city and market. "What do you think I ought to do?" he asked his boss at the *Enquirer*.

"Wire 'em and tell 'em if they'll send you a check for traveling expenses you'll take their offer," his boss said. With that, McCay and his family took a train east, the small towns drifting by their window until the skyscrapers of New York eventually appeared on the horizon.

In the era before television and radio, newspapers were the main form of mass communication, and their cartoon sections were especially popular. Because a well-liked cartoon could help greatly increase a paper's circulation, top newspaper cartoonists found themselves part of a well-paid media elite—Winsor McCay's starting salary at the *New York Herald* was $60 a week at a time when the average American made $9. Newspaper moguls of the day—including William Randolph Hearst, Joseph Pulitzer, and James Gordon Bennett Jr.—regularly launched bidding wars for good cartoonists, driving their salaries into the stratosphere. By the time Hearst hired McCay away from Bennett's *Herald*, in 1911, Winsor was making $50,000 a year—a princely sum. He could afford chauffeured cars, multiple homes with dark wood paneling, and custom suits in brave colors like white and fawn.

The same year that McCay started at the *New York Herald*, he made his first animated cartoon—not because he needed extra money, but because he was seeking an artistic challenge. It all began one day while McCay was sitting at his desk, listening to his colleagues joke about how prolific an artist he was. It was a reputation Winsor was proud of; he liked telling people about how he had once received a box of chalk for his fifth birthday and used it to leave drawings all over his hometown like some sort of doodling Johnny Appleseed. "I drew on fences, blackboards in school, old scraps of paper, slates, sides of barns," he recalled. "I just couldn't stop." The habit lasted into his adult years, and now his colleagues were teasing him for it. As McCay liked to tell the story, this is when his good friend George McManus, creator of the comic strip *Bringing Up Father* (also known as *Jiggs and Maggie*), challenged Winsor to churn out several thousand drawings, photograph them quickly in sequence, and then show the result in theaters as a moving picture.

McCay accepted the challenge and decided to animate characters from his own popular comic strip, *Little Nemo in Slumberland,* which he had created for his former employer but still held the rights to. The strip had first appeared in 1905, six years after Sigmund Freud published *The Interpretation of Dreams,* which had helped launch a popular obsession with the psychology of the subconscious. Once people read the book, they couldn't stop talking about their dreams and the notion that ideas and feelings might exist in a realm somewhere between magic and reality. McCay explored similar territory in his comic strip, playing with the familiar tropes of dreamscapes: falling through space, drowning, moving slowly while everything else around you moves quickly. Each week, his characters floated around outer space on milkweed seeds, on beds that acted as flying carpets, or in ivory coaches pulled by cream-colored rabbits. These fantasies were always rudely interrupted by reality—falling off the flying bed and waking up in a real bed, or being jolted awake by a voice telling you it was all just a dream. Adults enjoyed *Little Nemo in Slumberland* because it helped them reconnect to their childhood minds; for youngsters, it was a bridge to their blossoming adult minds. The strip was so popular it was adapted for the stage in 1908, costing more than any other production of its era—nearly $300,000—and featured the biggest names known in theater. The production was a critical success and popular with audiences, but made little profit because of its extravagant cost.

Little Nemo in Slumberland was a highly personal cartoon for McCay. He claimed the title character was based on his young son, Robert, even though the name Nemo in Latin technically means "no one." The character also demonstrated qualities Winsor had as a boy growing up in Spring Lake, Michigan, a logging town where literacy didn't extend much past *McGuffey's Third Reader,* and most people hadn't understood McCay's dream of drawing as a career. It was a place where someone like Winsor—small, pale, destined to go bald early—inevitably adopted introverted hobbies like drawing. Just as young Winsor had done, Little Nemo attempted to escape the real world by hiding in his dreams.

The tools McCay used to animate his cartoon were simple: stacks of rice paper, a bottle of Higgins India ink, a stack of Gillott #290

pens, and some art gum. Puffing his way through endless cigarettes, a machine belching out exhaust, he set to the task of producing 4,000 drawings, all a little different from each other. In one, he would establish a pose; in the next, he would move it ever so slightly. Flipping through the drawings quickly gave the suggestion of movement. Each drawing was assigned a serial number and was given marks to keep it in register with the other drawings. Then the drawings were photographed, with the marks kept in careful position to ensure the final image didn't vibrate on the screen.

McCay was known for drawing so efficiently, his colleagues joked, that he could draw a picture in a single line without ever raising his hand from the paper. As he worked, a cigarette always dangled from his lips, the thin plumes of smoke pooling underneath his wide-brimmed hats.

Fifteen years earlier, McCay had seen his first movie while working at the dime museum in Cincinnati. That film had been part of

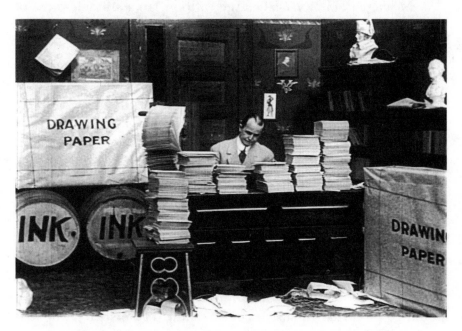

Winsor McCay re-creating the laborious process he used
to produce his *Little Nemo* cartoon, circa 1911.

Thomas Edison's Vitascope project, when cinema was still very much a novelty. The premise was simple—just a train moving toward the camera—but it frightened those who had never seen a moving film before. During the showing one man stood up, screaming his head off, while another man fainted and crumpled to the ground. In subsequent years, people became comfortable with seeing photographs move on-screen, but they still had never seen drawings like McCay's move in a similar way.

On April 12, 1911, McCay showed his animated cartoon at New York's Colonial Theatre, a vaudeville house that seated nearly 1,300 people. The spectators sat mesmerized, asking each other excitedly if it was all some sort of trick using special photography as they watched characters—Impy, Nemo, and Dr. Flip—float in space, no wires visible, as Nemo appeared out of fragments of stray lines that had coalesced to form him. When the cartoon reached its end, just a few minutes after it started, a green dragon named Bosco lumbered into the frame holding a chair in his mouth to carry all the characters away.

Moving Picture World called the cartoon "an admirable piece of work," and claimed that it "should be popular everywhere." What the magazine didn't know, because animation was still brand-new, was that McCay's film had set a very high bar. Only people looking back, from many years in the future, could appreciate just how high that bar was. In the 1960s, an animator named Bob Kurtz would call McCay's work "Seventy or eighty years ahead of its time—as if he had really been born in 2025, acquired a complete knowledge of animation, then took a time capsule back to 1911 and faked it." In 1985, Chuck Jones, who helped create many of the iconic Warner Bros. cartoon characters, would say, "It is as though the first creature to emerge from the primeval slime was Albert Einstein; and the second was an amoeba, because after McCay's animation, it took his followers nearly twenty years to figure out how he did it."

After finishing his first cartoon, McCay began dreaming of animation's vast potential and championing it as a new art form. Perhaps it would even replace great styles of art that had come before, he told anyone who would listen. "Take, for instance, that wonderful painting which everyone is familiar with, entitled *The Angelus*," he announced to a crowd of fans one day, referring to a popular oil painting by the

French master Jean-François Millet, of two peasants standing in a field solemnly praying over a meager harvest of potatoes. "There will be a time when people will gaze at it and ask why the objects remain rigid and stiff. They will demand action. And to meet this demand the artists of that time will look to motion picture people for help and the artists, working hand in hand with science, will evolve a new school of art that will revolutionize the entire field."

Chapter 2

"Fantasmagorie"

Winsor McCay didn't come up with his ideas in a vacuum, and they weren't the result of a sudden epiphany. For centuries, people had been fascinated with the idea of animation, of making drawings appear to move. McCay's achievements were just the next breakthrough in a long series.

In prehistoric times, people probably waved flickering torches in front of cave drawings to make them appear to move. By the time of China's Tang dynasty (618–907), shadow puppets—cut from buffalo hide and moved around behind a screen—were a common way to tell popular stories of the day. Centuries later, shadow puppets became popular in Europe as well. By this point, people were using mathematics coupled with new lens technologies to study light and motion. In 1645, the Jesuit scholar Athanasius Kircher published *Ars Magna Lucis et Umbrae* (The Great Art of Light and Shadow). In the last chapter, he mentioned a lantern containing a candle and a curved mirror that, if manipulated in the right way, could make cutout shapes appear to move. This wasn't technically animation, but it was exciting—so exciting, in fact, that some called it witchcraft. Kircher, who had always wanted to be a missionary and didn't appreciate the witchcraft accusations, reassured everyone by using his device to show Bible scenes. Once everyone was calmed down, the path was then clear for other entrepreneurs to use Kircher's techniques for something more important: making money.

A Dutchman named Pieter van Musschenbroek quickly improved upon Kircher's lantern by fitting it with a disc containing sequential images that, when turned, made the images appear to move in a more sophisticated manner. Then, a Frenchman, Abbé Guyot, compiled

this and the growing number of other animation techniques in his book *Rational Recreations in Which the Principles of Numbers and Natural Philosophy Are Clearly and Copiously Elucidated, by a Series of Easy, Entertaining, Interesting Experiments.* Insofar as lantern showmen could remember the title, this was the book they couldn't stop talking about. "Magical theater" shows took off like a dance craze.

One lantern showman stood out from all the others, a Frenchman named Étienne-Gaspard Robert of Liège. In the 1790s he developed a spooky show, "Fantasmagorie," which quickly grew famous. By 1794, at the height of the French Revolution, his crowds were so big that he had to move his show to the ruins of a large old monastery in Paris. Audiences filed into the darkened crypts, dim candlelight reflecting off piles of neatly stacked bones, to gaze at flickering portraits of fallen heroes from the recent fighting. A grand finale featured the Grim Reaper floating through the air, reminding everyone of "the fate that awaits us all."

In 1824, Peter Mark Roget, who would later become famous for his thesaurus, published *The Persistence of Vision with Regard to Moving Objects.* It described how the human eye will blend a series of sequential images into motion if the images are shown fast enough. Two years later, John Ayrton Paris built on this idea by inventing a toy called a "thaumatrope," consisting of a string threaded through a disc with a different image on each side—say a bird on one side and a cage on the other. When spun, the images seemed to combine, making it appear that, in this example, the bird was in the cage. A dispute then arose over who invented the thaumatrope—the contenders included Paris himself, Charles Babbage, Dr. William Fitton, Sir John Herschel, and Dr. William Wollaston—but the argument faded as thaumatropes were replaced by Fantoscopes. These featured a greater number of discs and shutterlike slits allowing for more sophisticated movement.

In 1834, the Englishman William Horner invented what he called the "daedalum," or Wheel of the Devil, which didn't become popular until the 1860s, after it was renamed the "zoetrope," or Wheel of Life, which sounded more pleasant. The zoetrope was a hollow drum with slits on the sides where paper was fed in. Images were printed on the paper, and when the drum was turned, the images appeared to move.

By 1868, flipbooks were popular. These contained sequential images that appeared to move when the pages were flipped quickly. They were given as gifts and promotions, like one that was entitled "Turkish Trophies" and given out with cigarettes; the cover billed it as an instruction manual for deep-breathing exercises, but the naughty images inside showed pornography instead.

In 1877, the Frenchman Charles-Émile Reynaud invented the *praxinoscope*, a device similar to the zoetrope except that it used mirrors instead of slits on the side of a moving drum. In practice, it worked much like the old lantern shows. Reynaud called his lantern plays *pantomimes lumineuses* and enjoyed subject matter depicting the wild and surreal, such as one show portraying a black boy juggling his own head. These shows were quite popular, seen by an estimated 500,000 people between 1892 and 1900.

By the dawn of the twentieth century, many artists were experimenting with new cameras that recorded motion. Thomas Edison was experimenting with what he called a "mutoscope," a mechanical

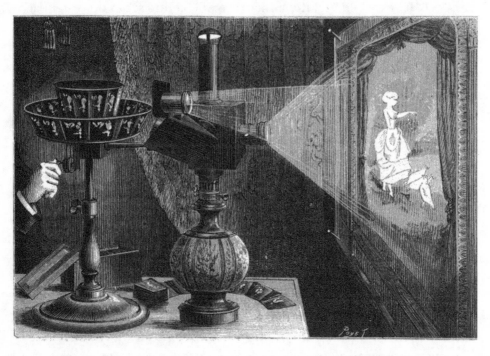

The praxinoscope was an early technology used to animate images.

flipbook where sequential photographs were attached to a ring out-fitted with a crank (Winsor McCay used a mutoscope to check the movement of his *Little Nemo in Slumberland* cartoon). Edison was also experimenting with the "kinetograph," a kind of motion picture peep show that viewers could watch through a small pane of glass.

Eventually, some of the old ideas were combined with the new motion picture technology. In 1906, an American cartoonist named James Stuart Blackton created a short film entitled *Humorous Phases of Funny Faces*. His process was simple: he drew some faces on a black-board with chalk, photographed them, changed them slightly, pho-tographed them again, and so on. When the film played, the faces appeared to come alive; in the film, the face of a woman blows smoke into the face of a man. Most film historians consider this to actu-ally be the first animated cartoon. Winsor McCay knew James Stuart Blackton, and he almost certainly saw Blackton's film, although he never mentioned it.

The next year, Blackton made another film, *The Haunted Hotel*. Best described as a "trick film," it used stop-motion photography to make random household objects appear to move on their own—a teapot pouring itself, a knife floating across a room to cut a loaf of bread. The film eventually made its way to France, where it was seen by Émile Cohl, a cartoonist who had once worked as a magician in Paris. After seeing Blackton's film, but before McCay would make *Little Nemo*, Cohl decided that he also wanted to make animated cartoons.

Émile Cohl got upset whenever he heard someone give Winsor McCay credit for inventing animation. Muttering under his breath, his bushy mustache twitching, he would rush over to correct the offender. If the claim ever appeared in a newspaper, he'd quickly dash off a strongly worded letter to the editor. Such false claims often came from Amer-ica, prompting Cohl to joke that "American ingenuity" was just a euphemism for stealing other people's work.

Throughout his career, Cohl had problems with people stealing credit from him. But once, in 1907, it worked to his advantage. He was walking down a street in Paris when he spotted a poster for a movie that stole its concept from one of his comic strips. Cohl figured that

the film company, Gaumont, now probably owed him money, or at least some kind of credit. He stormed into the studio and demanded to speak with the person in charge. When he left, he had somehow managed to finagle a new career directing movies—it was a new industry then, and barriers to entry were low.

Cinema intrigued Cohl; this new art form had so many possibilities. He particularly admired film director Georges Méliès, whose films—*The Vanishing Lady, The Cave of the Demons,* and *A Trip to the Moon,* among others—were all known for their elaborate special effects and imaginative sequences. As a former magician, Cohl no doubt wondered how Méliès had accomplished his visual effects. After seeing Blackton's *The Haunted Hotel,* he studied a copy of the film frame by frame, figuring out exactly how it worked.

When Cohl decided to make his first animated film, in 1908, he was fifty-one years old and a veteran political cartoonist. He had much life experience. For his cartoon, he drew inspiration from his involvement in the Incoherents, a short-lived French art movement started by his friend Jules Lévy in 1882. Sporting a mustache resembling the wings of a condor in flight, Lévy was given to immodest pronouncements, per his era's fashion of avant-garde manifestos. When he announced his art movement, a predecessor of dadaism, he declared that "gaity is properly French, so let's be French." To him, this meant the embrace of absurdist satire, dreams, and practical jokes. The Incoherents' first exhibit, in 1883, was billed as "an exhibition of drawings by people who do not know how to draw." It featured paintings like *Negroes Fight in a Tunnel,* which was nothing but a black canvas, and short films like "A cardinal eating lobster and tomatoes by the Red Sea," which was nothing but a red screen. Cohl wanted to give his first animated cartoon a sensibility similar to these exhibitions: insanity as its own aesthetic.

Cohl's animated film consisted of seven hundred separate drawings in India ink on white rice paper, traced and retraced over a light box. Although the film would be projected at a rate of sixteen frames per second, Cohl cut his work in half by making only eight drawings for each second, then photographing each twice, helping to slow down the action and improve the fluidity of motion. When the film was developed, he asked that it be printed in negative to create a white-on-black effect. The final film was barely two minutes long

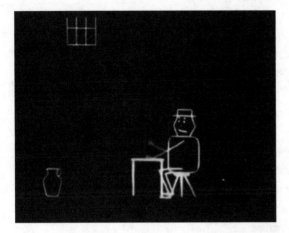

A still from Émile Cohl's animated *Un Drame Chez les Fantoches*, 1908.

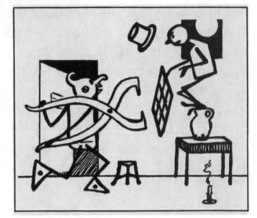

Un Drame, 1908. Drawing by Émile Cohl representing the surreal nature of his early animated films.

and featured what were essentially stick figures. The action, however, was highly imaginative, calling to mind a stoned dream about the circus. The Incoherents would have been proud. The stick figures drift through an alternative dimension before becoming trapped in a bottle that suddenly transforms into a flower. Stepping out onto the stem of the flower, they soon found it turning into an elephant's trunk. Cohl called his cartoon *Fantasmagorie*, borrowing the name from what lantern showman Étienne-Gaspard Robert of Liège had presented to audiences in 1794.

Fantasmagorie was shown in France but didn't appear widely in the United States. Few Americans saw it, and none of America's early

animators ever cited it as an inspiration. Instead, they typically refer-
enced Winsor McCay's work, a habit that Cohl would later haughtily
point to as evidence of American "provincialism."

In 1912, one year after McCay premiered *Little Nemo in Slumber-
land*, Émile Cohl moved to America to begin making movies, includ-
ing animated cartoons. Stepping off the boat onto Ellis Island, he was
promptly met by a customs agent who asked him to shave his mustache
for "sanitary reasons." Cohl hesitated because his mustache—long and
swoopy and twisted at the ends—had symbolic value. He had worn it
for decades in honor of André Gill, a famous caricaturist who taught
Cohl the art of political cartooning. Gill had once used a cartoon
to lampoon the incompetence of Napoleon III, an act that got him
briefly thrown into jail but also made him a legend among French
cartoonists. Without the mustache, Cohl resembled a plain-looking
shopkeeper, or perhaps a jeweler—the kind of "practical" jobs his
father had once pressured him to take, before Gill taught him about
cartooning.

Cohl shaved the mustached but started growing it back imme-
diately thereafter. Then he made his way to Fort Lee, New Jersey,
where he started a job working for the American outpost of France's
Éclair Studio.

Before Hollywood became the undisputed capital of America's movie
industry, many big studios were located in and around Fort Lee, New
Jersey, just across the Hudson River from Manhattan. Almost all of
Hollywood's first generation of moguls—Adolph Zukor of Paramount,
Samuel Goldwyn of MGM, and William Fox of the Fox Film Corpora-
tion, among others—had grown up in New York. Fort Lee offered
ample studio space and easy access to shooting locations. Because of
the area's early role as a film center, it also became the center of the
animation industry, which would linger there long after the live-action
studios moved to California.

One of Émile Cohl's first assignments for Éclair was directing The
Newlyweds, an animated series based on a popular American comic
strip by George McManus, the cartoonist who first challenged Win-
sor McCay to make his animated cartoon *Little Nemo in Slumberland*.

The studio wanted it as a regularly recurring series and Cohl did all the work himself. Because drawing the images by hand took a long time, he devised a shortcut using stop-motion photography and cut-out figures similar to paper dolls. This was an enormous timesaver but resulted in a rudimentary appearance and jerky motion. In the end, the shoddy quality didn't particularly matter because theaters wanted the cartoons mainly for novelty effect, to play as a short amusement before their main features. Advertisements for Cohl's cartoons brought to mind flyers for a magician's set. "The Newlyweds are not real people dressed up to imitate the famous McManus cartoons, but *are drawings that move!*" an Éclair poster read. Newspaper stories covering the new series mark the first time anyone used the term "animated cartoons."

None of the newspapers ever gave Cohl credit—the name of George McManus, as creator of the comic strip, was far more marketable. Émile's name was recognizable in France, but rarely surfaced in American papers; when it did, it was often misspelled as "Emil."

In 1912, Cohl saw Winsor McCay's second cartoon, *The Story of a Mosquito,* during a show at New York's Hammerstein Ballroom. In his diary, he raved about it. The cartoon was spooky but also enchanting and fun, like the ideas the Incoherents used to come up with. It featured a mosquito named Steve that occasionally descends on a sleeping man to drink his blood, Steve's abdomen filling like a water balloon before finally bursting. In many ways, it captured the same playful sense that Cohl was going for, except that it was much more elaborate and better drawn. McCay had spent months producing the cartoon and the result was gorgeous. Cohl called him "the most skillful and most graceful draftsman of the United States."

In 1914, Cohl saw *Gertie the Dinosaur,* McCay's third film, at the Hammerstein Ballroom. It was the kind of masterpiece that can change an artist's perspective. Nobody knew it yet, but *Gertie* is the film that would inspire many young cartoonists to try animation. (Walt Disney spoke of his first time seeing *Gertie* the same way priests talk of finding God.) The film was only a few minutes long but had taken McCay nearly two years to make in his free time away from his day job drawing for the newspaper. Every part of *Gertie* was painstakingly precise. McCay had timed his breaths with a stopwatch in order to

capture the motions of Gertie's heavy breathing, and no matter what Gertie was doing—throwing rocks at a mastodon, munching on trees, performing a dance number—her movements were perfect. The cartoon had little plot, but what made it significant was that Gertie showed personality: petulance, docility, humor, anger. Winsor had been able to capture these emotions with the subtlest of gestures—a crinkle around her eyes, a slight change to her smile. This was the film that would cement his reputation and make him the patron saint of animation.

Ever the showman, McCay started showing *Gertie* as part of a vaudeville act. As the cartoon played, Winsor stood to the side of the stage and shouted "commands" at his character. He wore long coat-tails and cracked a bullwhip, like a lion tamer, playfully telling the crowd that Gertie was "The only dinosaur in captivity!" For a sequence featuring Gertie eating apples, McCay would toss real apples up and behind the screen. The show was clever and drew large, paying crowds, prompting Cohl to later write, a bit huffily, "It was lucrative for McCay who never left the theater without stopping by the cashier to be laden with a few banknotes on the way out."

Émile Cohl's frustration grew over the years. In the 1930s, long after he had moved back to France, reporters would occasionally visit but find him irritable. Sitting in his humble quarters—a dingy spare bedroom in his brother's house—the reporters would ask him about his political cartoons, but Cohl would always change the topic to animation. He was annoyed that the French press called animation *le mouvement Américain*, ignoring the contributions that the French, and by French he mainly meant himself, had also made. He told one reporter from *Pour Vous* that the French didn't promote themselves as well as the Americans did, and this also bothered him.

Poor promotional skills might be one reason Cohl was forgotten, but another (much more likely) reason was that almost all the cartoons he animated in America were destroyed. A fire roared through the Éclair studios in Fort Lee a day after he set sail back to France, in 1914. Film stock back then was highly flammable, much more so than today, and the studio flared up like a Roman candle. Only one of Cohl's Newlyweds cartoons survived, and few other prints ever

surfaced later. Nobody was thus able to see his legacy, which survived mainly by word of mouth.

During his later years, Cohl told another story of his time in America, this one verging on conspiracy. He said two strangers had visited him while he was living in New Jersey—one talkative, the other silent. They demanded to know how animated cartoons were made, but refused to reveal what they intended to do with the information. It remains unclear exactly what Cohl told them. Perhaps not coincidentally, a similar visit was made to Winsor McCay around the same time, according to John Fitzsimmons, McCay's assistant during the time he made *Gertie*. He said that a man had showed up on McCay's doorstep asking to learn his methods; McCay, eager to promote animation in the way that a missionary is eager to spread the word, gladly showed him. But this visitor had motives different from McCay's. The blossoming industry had attracted the attention of men who were more interested in profit than art.

Chapter 3

"The Artist's Dream"

"Winsor, you've done it! You've created a new art!" George McManus told Winsor McCay after seeing *Gertie the Dinosaur*. What McManus should have then added was, "Now, go patent it!"

"Had I taken out patents I would have strangled a new art in its infancy," McCay later explained. Animation's business potential didn't interest him as much as its artistic possibilities. It also helped that McCay wasn't particularly worried about money; he earned roughly $50,000 a year drawing for Hearst's newspaper, augmenting his salary with earnings from his vaudeville act. Others, however, were more intrigued by animation's commercial prospects. Among them was the man who darkened the doorway of McCay's studio seeking to learn his methods: John Randolph Bray was another newspaper cartoonist, but, on the day of his visit, he posed as a reporter writing an article about animation. It was a disingenuous introduction, designed to conceal his motives, but McCay never appeared to become suspicious—in fact, he was quite the opposite. "Wishing to aid the writer in every way possible," according to John Fitzsimmons, "McCay showed the young man every detail of the process he had developed."

Bray then spent the next eighteen months making his own cartoon: *The Artist's Dream*, a crowd-pleaser about a clever dog that reaches a plate of sausages on top of a dresser by using the drawers as steps, then eats so many sausages that he explodes. Simple but effective, Bray's cartoon was released in 1913, after which he immediately sold the rights to the French film company Pathé, which had an office in Fort Lee, down the street from where Émile Cohl worked at Éclair. (Bray briefly worked for Pathé, and is likely one of the men who darkened Cohl's doorway as well, although he never admitted it.) "I was

paid two thousand dollars for that first cartoon," Bray later remembered about *The Artist's Dream.* "Not much money to have earned in eighteen months of terribly hard labor! But that didn't worry me, for I had worked out a process which made animated cartoons mechanically and *commercially* possible."

"I thought there was good money in it," he told an interviewer, explaining his motives. But before animation could generate significant revenue, the processes behind it would need to be reimagined. What McCay had treated as an artisanal endeavor—slow and labor-intensive—Bray saw as a process that needed to become more efficient. He wanted to speed up production and make animated cartoons on a larger scale. America was at the beginning of a new age of mass media, led by cinema and radio, and Bray predicted that cartoons could be similarly lucrative if he could find a way to release them on a regular schedule. His second film, *Colonel Heeza Liar in Africa,* a spoof of former president Teddy Roosevelt's globetrotting exploits, was the

Still from John Randolph Bray's *The Artist's Dream* (1913).

first in a series meant to regularly appear in theaters, not as a one-off or as part of a vaudeville act, the way McCay had released his films.

Shortly thereafter, Bray started Bray Productions. Working with an employee, Earl Hurd, he began testing new methods to make animation more efficient. One of the first problems the men addressed was how to combine moving characters with static backgrounds. McCay had simply ignored this problem, drawing everything—both moving and stationary parts—in every single frame, a redundant and time-consuming process. Bray's solution was to print multiple copies of the background and then draw his characters onto them, scraping away parts of the background that didn't need to be in the picture. This saved the animator from having to draw the entire background anew for each frame, so it was an enormous timesaver. It also helped make the picture look more consistent, avoiding the little errors and "vibrations" introduced by constantly having to retrace stationary images. Within a year of this advance, Earl Hurd then pioneered the use of "cels," transparent sheets on which moving parts of the action were drawn. These cels would be a mainstay of animation for decades to come. Placed over the backgrounds, which now needed to be printed only once, the clear sheets eliminated problems with screen flicker that had previously been caused by photographing the translucent tracing paper. Because they could be washed and reused, they also helped save money. Other new efficiencies used by Bray included the use of "cycles," recycled drawings such as the leg movements in a stride, that were used multiple times in the same cartoon. Together, these and other breakthroughs revolutionized the technical aspects of animation, increasing efficiency while lowering costs.

Bray was bringing to animation the same mindset that Andrew Carnegie had brought to steelmaking, or that John D. Rockefeller had brought to oil production. Within a few years, animators would nickname him "the Henry Ford of animation," a reputation he helped cultivate by appearing in magazine profiles dressed not as an eccentric artist, but as a shrewd mogul: a high collar riding halfway up his neck, every hair on his head nailed neatly into place. During interviews, he avoided speaking in the romantic style of Winsor McCay, and instead adopted the motivational style of language that captains of industry used to promote the American dream. "If you have faith in

your dream, and faith that *you* can make it a reality, don't be afraid to take a chance!" he told one magazine.

Bray modeled himself on moguls who didn't just change industries, but owned them, building great monopolies and crushing their competitors. He saw animation as a frontier where the landgrab was only just starting. Soon he began patenting his processes, hoping to make a fortune by charging his competitors fees. Once his patents were registered, he then began suing. In 1914, Winsor McCay himself received in the mail a "citation of infringement," claiming that he "would be required to pay royalties on all future productions of animated cartoons to the holder of the patent rights."

McCay was furious. "He felt he was high-jacked and double-crossed," according to his friend Isadore Klein, who would later become a cartoonist for the *New Yorker*. Bray responded carefully, never admitting that he had learned anything from McCay. "I didn't know Winsor McCay was doing anything," he told an interviewer in 1974, when he was ninety-four years old. "I just got the idea that I wanted to make animated cartoons for the movies. Winsor McCay never thought of that."

Fortunately for McCay, Bray's original patent, filed in February 1914, was rejected by the patent examiner. He had seen McCay's *Little Nemo in Slumberland* and declared Bray's process too similar. Both used cross marks to register stationary drawings, both had an assistant trace the nonmoving elements, and both had recycled drawings in order to use fewer of them. Bray's lawyer, Clair W. Fairbank, counterargued that Bray's process was actually quite different. He highlighted Bray's various refinements, such as his method of printing multiple backgrounds, whereas McCay had simply retraced the background art for every frame. After six months of arguing, pressing his case and wearing down the bureaucrats, Fairbank eventually got the patent granted, along with several more patents, including one for the use of cels. Now, with the paperwork settled and in place, Bray resumed his legal assault.

What was perhaps most insulting to McCay was Bray's tone during their fight. Bray was condescending, sneering that McCay's cartoons were nothing more than "an interesting curiosity exhibited and lectured about," as if they carried little more than academic value.

Then he made a bold accusation, claiming that McCay's inefficient methods had "caused the commercial failure of all attempts to secure animated cartoons prior to my invention." He was basically saying that animation was something he had to rescue from McCay, and McCay fumed over the misrepresentation. He certainly wasn't against Bray's genuine improvements; he actually encouraged them, since they promoted animation as an art form. What offended him was the prospect of having to pay Bray royalties, as well as Bray's insinuation that McCay was somehow degrading animation. Bray had even gone so far as to call his legal offensive a way to "uphold the dignity of the animated cartoon."

To McCay, this condescending language was a way to obscure Bray's true goal of establishing a monopoly. Bray was contributing useful new methods to animation but wasn't necessarily using them for purposes that Winsor respected. Some of Bray's cartoons were clever, but others felt like novelties built around cheap gags made to get quick laughs. Bray valued quantity over quality.

McCay avoided the lawsuit after his lawyers argued that *Little Nemo in Slumberland* was shown in theaters years before Bray filed for his patents. This protected him from further lawsuits but didn't protect other animators. When McCay learned that Bray was planning to sue others, he didn't protest, but instead responded contradictory to his professed goal of championing animation for its own sake. He secretly worked out a deal whereby he would get a cut of any settlements. The arrangement was kept quiet; historians wouldn't know about it for decades, until letters from Bray's attorney were discovered in McCay's private papers. Even so, McCay's cut would never amount to much. In 1932, the year Bray's patents ran out, it was a mere $65.71—"McCay won a moral victory but about eighteen cents in cash," Isadore Klein joked.

Bray would have a successful career in animation but would never rule over the entire industry the way he once envisioned. Other competitors had carved out their own niches before he could establish dominance. One of them, Raoul Barré, had opened his own full-time studio in the Bronx in 1914, around the same time Bray opened his. Independent of Bray, Barré and his partner Bill Nolan had pioneered their own distinctive advancements, including a clever way to keep

stacks of drawings in register by using pegs to hold them in place, thus helping animators trace their drawings more easily. They also began using special desks equipped with both this peg system and panes of glass that could be illuminated from below.

Animation was quickly becoming a competitive field, full of new ideas. The new methods pioneered by men like Bray and Barré now allowed small crews of three or four animators to make a short cartoon in less than a month, compared with the eighteen months it took Bray to make *The Artist's Dream*. Their upstart studios were able to release a regular stream of material to theaters, so long as they kept creating ideas. For his part, McCay continued down his own path, tackling ambitious material that he released only sporadically. Newcomers to the industry respected him for his artistry, but considered Bray's and Barré's model the best way to make a living. They knew that, if animation were to survive and become more than a novelty, it would need to be profitable. The industry was still in its infancy but beginning to attract more and more talent.

Chapter 4

"The Camera Fiend"

One evening in 1914, Waldemar Kaempffert, editor of *Popular Science* magazine, took his wife to the movies. Before the main feature started, one of John Bray's cartoons from the Colonel Heeza Liar series flickered up on the screen. Kaempffert's wife responded by slumping down in her seat and groaning, "Oh, how I hate these things."

The next morning at work, Kaempffert was complaining about how Bray's cartoon had almost ruined his date night with Mrs. Kaempffert. Listening from the doorway was the magazine's young art editor, Max Fleischer. Kaempffert explained that the cartoon's concept wasn't bad, but the execution was poor—the picture was wobbly and the movement jerky. He thought Fleischer might be able to do better. "Max, you're a bright young man," he said. "You're an artist, you understand mechanics, and machinery, and photography, and you've got a scientific mind. Surely you can come up with some idea, some way to make animated cartoons look better, smoother, and more lifelike."

Fleischer came from a long family line of people who enjoyed tackling such challenges. His father, a tailor by trade, was a constant tinkerer who had invented the detachable-faced brass buttons that allowed police officers to shine them without smudging their uniforms with polish; his brother Joe had built a wireless radio that allowed him to hear about the *Titanic* sinking before it was in the news; and his brother Charlie had invented the penny arcade claw-digger machine. Max likewise understood machines and instruments, loved touching them, loved the smell and language of workshops and labs. At thirty-one years old, he had spent the previous decade working, in one form or another, on all the different aspects that composed animation:

drawing, photography, mechanics. In a previous stint as a cartoonist at the *Brooklyn Daily Eagle*, he had even created a comic strip, *E. K. Sposher, the Camera Fiend*, specifically about photography. Now, animation offered Fleischer a chance to combine his two great loves: art and engineering. "To me, machinery was an art also," he would later write. "I still see great art in machinery."

Fleischer took up Kaempffert's challenge by designing a machine consisting of a projector and a glass drawing board with a camera dangling above it. The idea was to film an action scene—a person dancing, for example—and then project the images onto the glass drawing board, where a person could then trace them. The timing of the camera would hopefully help smooth the motion. He called his device a "rotoscope."

Fleischer's younger brother Dave was excited when he heard about the idea. Both had seen Winsor McCay's *Gertie the Dinosaur*

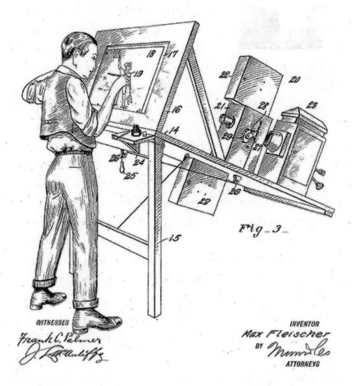

Illustration from Max Fleischer's rotoscope patent application.

earlier that year and left the theater enchanted. The film inspired
Dave to begin taking whatever paper was at hand—notebooks, phone
books, etc.—and create flipbooks. His favorite subjects were scenes to
accompany popular songs of the day, creating a kind of precursor to
music videos. Earlier that year, Dave had taken a film-editing job for
Pathé in Fort Lee, in the hope of starting a career in film. "Dave was
fascinated by it," Max recalled about his rotoscope idea. "He couldn't
sleep anymore."

The brothers got to work building their rotoscope, enlisting the
help of the three other Fleischer brothers, Charlie, Joe, and Lou.
Because of their day jobs, they worked in Max's living room until the
small hours of the morning, often around four o'clock, trying not to
wake Max's wife, Essie, sleeping in the next room. Essie, "a five foot
three firecracker with a constantly smoking short fuse and a slightly
broken nose that was never properly set," as her son Richard would
later describe her, had a vicious temper that Max and his brothers
didn't want to upset. But besides her temper she was otherwise sup-
portive. When Max told her he had spent all their savings, about $100,
on his rotoscope idea, she didn't blow up as the brothers expected;
instead, she went off to the bedroom and came back with $150 she
had saved on her own—she had a heavy gambling habit and was cur-
rently in the black. Handing the money over to Max, she told him,
"This is for your crazy idea."

Once the rotoscope was finished, Max Fleischer got hold of
a Charlie Chaplin film. The brothers spent eight months tracing
every move of the star's jaunty waddle, feeling their way through
the process, not always fully aware of other animators' advance-
ments—it was a learning time for all. Again, they worked in Max's
living room late into the night, bleary-eyed when the morning sun
peeked through the curtains. Once they finished rotoscoping and
tracing, the final cartoon was three minutes long. The brothers were
pleased with the result.

Fleischer tried showing the cartoon to film distributors but could
get meetings with only two. Once the first one saw it, he looked at
Max and asked, "That's very nice. What are you going to do with it?"

"I don't know," Fleischer answered. "I just thought it was some-
thing, that's all."

"Could you make one of these a week?"

Fleischer laughed at the question—this had taken him nearly a year. He could probably do it faster the second time, but not much faster.

"My dear fellow," the distributor advised. "Go home and make something practical. If you had something we could offer for sale every week, or every month, you'd have something."

Fleischer's second appointment was with J. A. Berst, an executive at Pathé who admired the quality of the brothers' animation but didn't want to buy it—what if Chaplin sued? Fleischer was crestfallen, berating himself for not thinking of the legal angle. But Brest was encouraging nonetheless. He invited Fleischer to return once he had something original. After Max shared this news with Dave, Dave came up with an idea.

Max and Dave Fleischer were a good pairing, but not without their differences. Max dressed impeccably, his suits neatly tailored and his Chaplinesque dab of a mustache always precisely manicured. Dave was sloppier, his hair wild and his shirttails sometimes untucked—he had only a nodding acquaintance with decorum. Max's courtship with Essie was relatively formal, while Dave had proposed to his wife, Ida Sharnow, on Halloween night by handing her a bag of candy with a ring at the bottom.

When Max presented the challenge of creating an original character, Dave recalled his days working as a clown on the Coney Island boardwalk. This was when Coney Island was a rough place of conmen and pickpockets, of lipstick-smeared prostitutes calling down to men from the fire escapes. Dave's job didn't necessarily involve normal clown activities, such as making balloon animals, so much as it meant playing questionable pranks on people. One favorite prank involved shocking unsuspecting passersby with a weakly charged electric whip— "They'd scream every time and they'd run like hell, and that was my job," Dave later recalled. Sometimes he used the whip to scare women into jumping over holes that had fans strategically hidden under them, then watch as gusts of air blew the ladies' dresses up. As soon as Max told him his problem of needing an original character, Dave

dragged his old clown suit out of
the closet. The simple design—a
baggy suit with three side buttons
and a pointy hat, all in clean black
and white—would show up well on
film and be easy to animate.

The other Fleischer brothers
were again enlisted to help make a
cartoon of the new character. They
climbed up to Max's roof, rigged
up a white sheet as a background,
and filmed a minute's worth of
Dave dancing around in the suit.
Then they spent roughly a month
tracing the images using the roto-
scope, followed by five months of
inking and photographing the
separate images.

J. A. Berst at Pathé was pleased
when he saw the final cartoon. He
immediately agreed to give them
space in his Fort Lee studio, as well
as build them three more roto-
scopes. The brothers were excited,
but within a few days Berst voiced

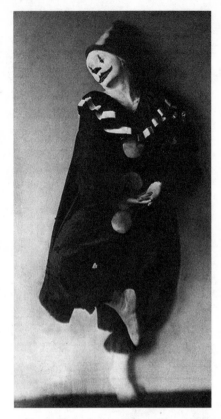

Dave Fleischer as "The Clown,"
which would later inspire the
Fleischers' character Koko.

second thoughts. Like many others, he wasn't convinced that animated
cartoons would ever be more than just a novelty. Growing increasingly
skeptical, he pressed Max to explain how his cartoons would fit in with
the studio's newsreels, comedies, and serials.

Fleischer tried to reassure him by pitching an idea he thought
was a surefire success. Instead of featuring a clown, they would instead
feature Teddy Roosevelt, much as John Bray had done with his Colonel
Heeza Liar series. Fleischer's version, however, had a twist: he wanted
to add the plot from "Chanticleer and the Fox," a story from Geoffrey
Chaucer's *Canterbury Tales* about a proud rooster who believed the sun
rose and set based on his crowing. After hearing the pitch, Berst agreed.

Dave sat dumbfounded when Max later explained everything to him. What was wrong with the clown? Max's plan to involve a Chaucer story illuminated a difference between the brothers' sensibilities. Max sometimes wanted to go highbrow when Dave wanted to keep their material simple. Nor did Dave see how the *Canterbury Tales* angle connected with Teddy Roosevelt and the Colonel Heeza Liar series—it seemed disjointed. But Max persisted, telling Dave that he had already discussed it with Berst, and that Berst was comfortable with doing a political satire. Besides, Max continued, adding the rooster storyline might be a good way to flatter studio owner Charles Pathé, who had adopted a rooster as the studio's mascot. Max didn't think a funny rooster could miss.

After Dave finally agreed to Max's vision, the brothers got to work—filming the action, then rotoscoping and animating it. Dave played the rooster and Joe played Teddy Roosevelt, running around the set whipping a lasso over his head until he finally caught the bird, tied it up, and began pumping angry rounds of hot lead into its feathery body. The moment Charles Pathé saw this truly bizarre cartoon—this adaptation of Chaucer ending with the murder of his studio mascot by a crazed Teddy Roosevelt—the Fleischer brothers were fired.

That evening, the brothers glumly rode the slow ferry from Fort Lee back to Brooklyn, sitting apart as if they were strangers. The boat was nearly empty and mostly quiet, save for the engine's low growl and the light slap of waves against its hull. Joe was first to break the silence. "That would happen to us!" he joked, trying to lighten the mood. His laughter spread to Dave, who looked over at Max, hoping to cheer him up.

"What the hell are you two laughing at?" Max snapped back, livid over how his idea had cratered.

After the unfortunate rooster incident, Max Fleischer hit the pavement, calling on any film studio willing to meet him. He visited waiting room after waiting room, carrying under his arm the clown cartoon that had helped get him the first animation job with Pathé. Most of

the meetings ended with "No thanks," a polite handshake, and the click of a door behind his back.

Fleischer eventually found himself in the most intimidating studio of all: Famous Players–Lasky, which was then in the process of integrating forces with Paramount Pictures Corporation. He stood in the cavernous waiting room, all marble and mahogany, of studio president Adolph Zukor, a man who communicated primarily through stares and frowns and was nicknamed "Creepy," a reference to the way an Indian warrior might "creep" up behind you and slit your throat. Zukor had originally arrived in America penniless from

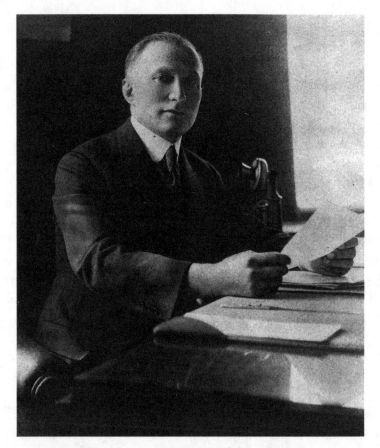

Film mogul Adolph Zukor, who would rule over
Paramount Pictures with an iron fist,
deciding the fate of many animators.

Hungary in 1891, then built a company worth nearly $50 million before the movies even had sound. Waiting in Zukor's intimidating lobby, Fleischer nervously shifted his weight from leg to leg. He didn't have an appointment and was hoping to cold-pitch Zukor as he stepped out of his door.

But when the door opened, a surprising figure emerged: John Bray.

"What are you doing here, Max?" Bray asked, surprised to see him. The two men knew each other from working together more than a decade earlier, as newspaper cartoonists for the *Brooklyn Daily Eagle*. They hadn't kept in touch but had always been on friendly terms.

"Waiting to show Paramount a sample cartoon I've produced," Fleischer answered.

"I've got an exclusive contract to handle shorts for Paramount," Bray told him. "Why not come down to my studio and let me see it."

This was a lucky break, for Bray was far more receptive than Zukor would have been. He thought the film was funny and well animated, not to mention he was interested in Fleischer's rotoscope technology. He asked Fleischer to come work for him and Max agreed, starting as a production manager and animator on, ironically, the Colonel Heeza Liar series. Fleischer's brothers didn't join him—that would come later—but he finally had a foothold in the budding animation industry.

Chapter 5

"Cherubs That Actually Fly"

Two years after the release in 1914, of *Gertie the Dinosaur*, Winsor McCay found himself going through a professional rough patch. The relationship with his boss, newspaper magnate William Randolph Hearst, was strained. Hearst thought McCay was spending too much time on animation and not enough on his comic strips. Winsor hadn't come cheap, and Hearst didn't think his work was as good as it used to be.

As one of the most ruthless moguls in a ruthless field, Hearst was not a man to tangle with. He had started in the newspaper business in 1887, at the age of twenty-three, when his millionaire father gave him control of the *San Francisco Examiner* after winning the paper in a high-stakes poker game. Hearst's entry into the business was random —a rich kid inheriting a plaything—but he quickly developed a taste for it, shrewdly buying up competitors until he was the most powerful media baron in the nation. At the peak of his career, nearly a fifth of the U.S. population would subscribe to his newspapers. Politically ambitious, he twice won a seat in Congress and unsuccessfully ran for president in 1904, using his media empire to cudgel his political enemies. Not surprisingly, he demanded devout loyalty from anyone working for him.

Much of McCay's time away from the office was spent on the road, where he showed *Gertie* in vaudeville theaters. It was a tough circuit; most performers spent years bouncing from one dingy theater to another, clawing their way up its ranks. But Winsor had shot straight to the top, from the start playing some of the most prestigious houses in New York: Proctor's Fifth Avenue, the Alhambra, B. F. Keith's

Palace, and the Victoria, perhaps the most prestigious theater in the nation. "No one, however good an act, [is] important enough to play the Victoria unless he [has] a tremendous reputation," theater owner Willie Hammerstein boasted. McCay shared bills with W. C. Fields, Will Rogers, and Harry Houdini—the top names in show business. "His act is one of the most interesting and novel seen in vaudeville in some time," the *New York Telegraph* said.

The situation between McCay and Hearst boiled to a head one night while McCay was away performing his animated *Gertie* routine. Hearst was back at the office and had an editorial question about a cartoon that McCay had drawn for his star columnist, Arthur Brisbane. When Hearst asked where McCay was, the staff told him he was performing his vaudeville show at the Victoria. Handling the matter personally, Hearst phoned the theater and his call was answered by a stagehand.

Winsor "can't come now. He's busy," the stagehand said abruptly before hanging up, unaware of who the caller was.

Hearst's reaction was swift. The next morning, one of his papers, the *Morning Telegraph*, announced: "Hearst to Stop Vaudeville Engagements of Cartoonists." Theater mogul Willie Hammerstein also discovered that advertisements for his vaudeville acts were banned from appearing in Hearst's papers.

McCay returned to the paper, he was called into the office of Brisbane, who was not only Hearst's top columnist, but also his chief editor and advisor. "Mr. McCay, you're a serious artist, not a comic cartoonist," Brisbane said, referring to Winsor's highly regarded work drawing political cartoons. He wanted McCay to give up the distractions and focus on drawing "serious cartoon-pictures around my editorials."

This was devastating news. Not only would it mean less time for Winsor to pursue animation; Brisbane was an angry blowhard and a horrible boss, a man who snooped through the trashcans of his subordinates looking for signs of disloyalty. A predecessor of overheated cable news pundits, his was an anger that was translated into a yearly salary of $260,000 through a hysterical style of spouting "half-baked theories" and "half-remembered fact and fiction," according to one of his biographers. Winsor's art, on the other hand, was whimsical and dreamlike, almost the exact opposite of Brisbane's angry diatribes,

which carried the tone of a man trying to win an argument by shouting louder than everybody else in the room. By assigning McCay to Brisbane's desk, Hearst was clipping his wings.

William Randolph Hearst didn't initially see the profit in animation, and thus didn't pay it much mind. But he always appreciated the value in illustrated cartoons, which had helped him build his media empire. He understood that, in a nation of immigrants who couldn't always read English, cartoons often had more influence than articles, and therefore more power. This had long been understood by politicians like Tammany Hall chieftain William "Boss" Tweed, who once said, "I don't care what the papers write about me. My constituents can't read. But, damn it, they can see the pictures." (Ironically, when Tweed escaped jail in 1876, he was arrested by an official who recognized him from the caricatures in *Harper's Weekly,* drawn by Thomas Nast.)

When Hearst entered the newspaper business, one of his earliest hires was a teenage cartoonist named James Swinnerton, known as Jimmy to some and Swinny to others. Swinny had previously worked at a racetrack, but joined Hearst's *San Francisco Examiner* in 1892 after realizing that he preferred drawing to gambling. After spreading upcoming comic strips on the floor of Hearst's office, Swinny would then watch as Hearst walked among them, enthusiastically scribbling notes in the margins. After Swinny's hiring, Hearst continued acquiring top talent, often by poaching it away from his competitors. In 1898, Hearst hired Richard Outcault, one of the first cartoonists to use speech balloons, from his rival and fellow newspaper magnate Joseph Pulitzer. Done in order to acquire Outcault's popular "Yellow Kid" character, the acquisition inspired the term "yellow journalism," describing the newspaper industry's breathless competition for market share, sensationalism, and profit. Hearst then rubbed Pulitzer's nose in his victory by printing "eight pages of iridescent polychromous effulgence that makes the rainbow look like a lead pipe. That's the sort of a Colored Comic Weekly people want—and—THEY SHALL HAVE IT!"

As moguls battled over their talents, newspaper artists were well aware of their bargaining power. Sometimes, they used their cartoons

A bidding war between Joseph
Pulitzer and William R. Hearst
to acquire *The Yellow Kid* comic
strip character would inspire the
term "yellow journalism," referring
to the industry's breathless pursuit
of sensationalism.

to send subtle messages to their employers. In 1911, while still working
for James Gordon Bennett's *Herald*, Winsor McCay had been frustrated
over his pay and what he considered a lack of creative freedom, so
he slipped a secret message to Bennett into one of his *Little Nemo
in Slumberland* strips. "Now we can do and go wherever we please!"
Nemo squeals as he tours different American cities in an airship. Soon
thereafter, McCay signed his contract with Hearst.

A year after curtailing Winsor's vaudeville appearances, Hearst
began to change his low opinion of animation. John Bray's and Raoul
Barré's fledgling studios had begun releasing regular series of ani-
mated cartoons, some based on newspaper comics, and Hearst realized
how animation could boost the popularity of his own strips, which
included Krazy Kat, Happy Hooligan, and the Katzenjammer Kids.
In 1915, Hearst started his own animation studio, International Film
Service (IFS), and hired one of Barré's animators, Gregory La Cava,
to run it. The cartoons weren't particularly well drawn and the studio
ultimately lost money, but this didn't matter to Hearst so long as they

increased the popularity of his newspaper comics and helped sell papers. Losses were written off as an advertising expense. The studio was shuttered a few years later, after Hearst decided it was no longer worth the effort.

McCay never worked for IFS. A cartoonist of his skills was far more valuable at the newspaper. Nor would he have wanted to work there; the work primarily consisted of simple line drawings and gag humor, and wasn't up to McCay's level. Instead, he continued toiling away on artwork for Arthur Brisbane's ghastly columns. But his thoughts remained on animation and dreaming up his next big project.

Winsor McCay opened his morning newspaper on May 7, 1915, to read that a German U-boat had torpedoed the British ocean liner *Lusitania.* The ship sank to the bottom of the Atlantic in eighteen minutes, its four giant smokestacks hissing and sputtering as they slipped underneath the sea. No pictures of the tragic sinking existed; there were images only of the aftermath: bloated bodies, tangled in seaweed, washing up on the shores of Ireland, many of them children.

For days, talk of the sinking filled New York, rattling the windows of cafés and diners. Americans wondered when they would get involved in the war. Speculation filled the newspapers but was noticeably absent from one man's papers: those of William Randolph Hearst, a staunch isolationist. This bothered McCay, who thought the German aggression needed to be confronted. The only country Hearst did support attacking was Mexico, but this was probably only because Pancho Villa had once looted Hearst's vacation house in Chihuahua, and Hearst likely wanted revenge. Hearst certainly didn't want to enter a war to assist the British, whom his papers still sometimes referred to as "redcoats." Two days after the *Lusitania* sank, Arthur Brisbane argued that the ship "was properly a spoil of war, subject to attack and destruction under the accepted rules of civilized warfare."

McCay was still working for Brisbane, providing illustrations for his off-kilter rants. The drudgery was wearing on him, making his work flabby and less lively. He often disagreed with Brisbane and particularly disagreed with him about the *Lusitania.*

Despite his being in the rotten position of having to work for an unpleasant boss, Winsor's situation was slowly improving. Hearst had loosened his moratorium on cartoonists holding side jobs, allowing McCay to take *Gertie the Dinosaur* back on the vaudeville circuit, although with some restriction on how much he could travel. Back in the saddle, he began thinking about new animation projects to tackle, his thoughts constantly returning to the sinking of the *Lusitania*. Since no photographs had captured the dramatic moment, a cartoon of it might help people better realize war's human cost.

In July 1916, McCay was in Detroit showing his cartoons at vaudeville theaters when he announced his next project. "Imagine how effective would be cherubs that actually fly and Bonheur horses that gallop and Whistler rivers that flow!" he told a gaggle of reporters, reminding them of animation's grand possibilities. Whenever he talked about the new art form, he liked referencing fine art, the kind of art done on canvas with oil paint. He then reminded the reporters of the ways animation was evolving, thanks to many innovations introduced by men like John Bray and Raoul Barré. McCay explained that he would be using some of those innovations in his next project. "I am now working on a film which will show the sinking of the *Lusitania*," he announced. Then he added a dramatic flourish: "The film will revolutionize cartoon movies."

McCay needed two years to make *The Sinking of the Lusitania.* He had help from his assistant, John Fitzsimmons, and another friend, William Apthorp Adams, who was a descendant of John Adams and one of Winsor's cartoonist pals from his Cincinnati days. Because of McCay's newspaper duties, the men could only work part-time and the task quickly became daunting. It required approximately 25,000 separate drawings even though the film was only a little over ten minutes long. To get the atmospheric effects he wanted, McCay experimented with elaborate shading techniques and ink washes to capture the complicated movements of drifting smoke and churning water. Each frame was its own little painting.

"Winsor McCay's Blood Stirring Pen Picture—the World's Only Record of the Crime that Shocked Humanity!" the movie poster read

A signed cel from Winsor McCay's *The Sinking of the Lusitania* (1918).

when the film debuted in July 1918. Other animators were awed by how the ink washes had given it an impressionistic effect, while fine cross-hatching and intentional splatters added to its impact by providing the feel of a newsreel documentary. On-screen, the *Lusitania* glided silently across the black water under a silver crescent of moonlight; the breathtaking visuals, alternating shots of close-ups and pans, done at varying speeds, were far more advanced than the camera work of much live-action cinema being done then. After taking the audience underwater to glimpse fish darting away from the bubbly wake of the German torpedoes, McCay ended with images of the passengers' heads bobbing on the waves. For the finale, a mother slips beneath the water, struggling to push her infant to the surface.

The Sinking of the Lusitania was instantly deemed a masterpiece, although it didn't have the full cultural impact McCay had wanted. He originally envisioned it as a call to arms, inspiring Americans to

join the war in Europe, but millions of American soldiers were already fighting in France by the time the cartoon finally debuted. Thus, *The Sinking of the Lusitania* served more as a memorial, solemn and brooding, rather than as a battle cry. It also set a high-water mark for other animators to reach; its movie poster boasted that it was "the picture that will *never* have a competitor!"

Chapter 6

"This Place Is Full
of Sharks"

In 1914, William Marriner, a notoriously volatile cartoonist working for the McClure newspaper syndicate, committed suicide by lighting his house on fire and refusing to leave. As a result, the fate of Marriner's comic strip, *Sambo and His Funny Noises*, was uncertain. Originally based on a book by Helen Bannerman, *The Story of Little Black Sambo*, the strip was an unfortunate example of the era's casual racism— its main character exists mainly to mock African-American dialects ("Dere ain't no room on dis earth fo' dem white boys an' me!")—but was nevertheless quite popular. As Marriner's affairs were sorted out, the strip was taken over by his former assistant, Patrick Sullivan, who immediately began seeking ways to boost its popularity. Intrigued by the potential of animation, he decided to adapt it into a cartoon.

But first he would need to learn how to animate. Knocking on the doors of New York's few fledgling animation studios, he began asking for a job.

Australian by birth and twenty-nine years old, Sullivan had few qualities recommending him to an employer, although his résumé was no doubt interesting. It included a position he described as "gentleman in waiting and special valet to a boat load of mules," referring to a job as a deckhand on a commercial ship traveling back and forth between London and America. Once he had grown tired of the job, he jumped ship into New York Harbor and swam to shore, which is how he had ended up in the United States. Work as a boxer soon followed, leading to a cauliflower ear and a flat nose from too many "left wings to the button," he liked to joke.

After tiring of boxing, he then took up work as a cartoonist, which he had some experience doing back home in Australia. He was not an impressive cartoonist, however; the earliest known example of his work, published in 1907 in *The Gadfly*, an Australian weekly, was sloppy. But it did give a hint of Sullivan's character. Standing on the deck of a ship, a nervous woman warily eyes a pipe-smoking seaman. "Any fear of drowning?" she asks.

"No," he replies, "This place is full of sharks."

Regardless of his poor artistic skills, Sullivan had an easy charm and magnetic charisma. People couldn't help leaning in when he told colorful stories about his boxing days and adventures sailing the seas on merchant ships—impressive tales that convinced the McClure Newspaper Syndicate to give him a chance and hire him as an assistant. This same charisma is what later convinced Raoul Barré to give Sullivan a chance as an animator, although Barré drove a harder bargain and insisted on paying him $5 less per week than he had made at McClure's.

Barré's studio in the Bronx was located in the Fordham Arcade building, near the last stop on the old Third Avenue elevated line. Inside, the windows were painted in a grimy shade of green that cast an eerie glow on the animators' faces. This kept the room dark, so the artists could better see the drawings on their light tables, which were arranged in long rows, as in a factory. The other animators at Barré's studio all remembered Sullivan as a poor student who always showed up late and hungover, the alcohol vapors rising from his rumpled clothes like morning fog cooking off a pond. Animators generally weren't known for their sobriety, so for them to have commented on Sullivan's drinking habits suggests a pretty serious problem. Nor did his work impress Barré, who fired him after nine months.

Nine months had been enough time for Sullivan to learn the basics, however. By the middle of 1915, he started his own studio at 125 West 42nd Street, located between Times Square and Bryant Park, and quickly charmed his way into contracts with the Efanem and Edison film companies, two early studios that would eventually go defunct. The latter was owned by Thomas Edison, who was then trying to patent equipment used in the film industry and create a monopoly (like Bray's, his efforts to do so would fail). Edison had contracted a

cartoon series at Barré's studio called the Animated Grouch Chasers, which Sullivan had worked on. Once Sullivan started his own studio, he was able to negotiate his own deal to provide Edison with cartoon advertisements and entertainment shorts. He also adapted the *Sambo* comic strip into a cartoon, although he changed the main character's name to Sammy Johnsin to avoid paying royalties to Marriner's heirs.

Of all the lessons Sullivan learned while working for Barré, perhaps the most important was that of delegation. Animation really wasn't difficult if talented people were hired to do the work. Sullivan's most important hire, made in early 1916, was a young artist named Otto Messmer. The two men were total opposites. Sullivan was raffish while Messmer was quiet and demure. Sullivan had traveled the world, while Messmer, who was twenty-four, still lived with his parents in New Jersey. When they first met, Messmer had just been fired from Universal, where he had attempted to start an animation unit but failed, and was glad to get the job.

Otto Messmer's background was typical of many young men entering animation during the earliest decades of the industry. After graduating from high school in 1907, he enrolled in night classes at the Thomas School of Art in Manhattan, "where they taught you to draw more 'straight'" rather than cartoony, he recalled. Next came a job illustrating fashion catalogues for a company called the Acme Agency. "But I didn't like that," he remembered. "I kept thinking about cartoons." By 1910 he had sold a few cartoons to *Life*, building a portfolio he could use to get a steadier job. His brief stint at Universal came several years later. Messmer had seen all of Winsor McCay's films, along with Émile Cohl's Newlyweds series, and had figured out most of the basics on his own. His father helped him build a special desk with a backlit glass panel and a wooden frame that would register drawings, similar to Raoul Barré's peg system.

Sullivan taught Messmer the techniques he had learned from Barré. "He taught me a lot of things about timing, [and] so forth," Messmer remembered about one of his earliest assignments producing a dozen *Charlie Chaplin* cartoons. A movie producer had suggested featuring Chaplin as a cartoon character, an idea that Chaplin loved. "So Chaplin sent at least thirty or forty photographs of himself in different [poses] . . . He was delighted, cause this helped the propagation

of his pictures, ya see?" Messmer studied the pictures in the same way a religious scholar pores over the Talmud, absorbing every lesson possible. "We used a lot of that kind of action in Felix," he later said of the Chaplin films.

After teaching Messmer the basics, Sullivan mostly left him alone. "I did it all practically by myself," Messmer said. His mind was wild, good at dreaming up gags and clever scenarios that defied reality. He wasn't a fan of devices like Max Fleischer's rotoscope, which required filming one's subjects in live action—"Why animate something that you can see in real life?" he asked. To Messmer, a cartoon was something that described the impossible. It was most effective when it ignored reality.

The United States entered World War I, and Messmer was drafted right as he was getting his footing at Sullivan's studio. As a corporal in the Army Signal Corps, he would see the worst horrors the war offered. Once, chatting with a buddy while scanning the smoky horizon for enemy troops, Messmer turned around to investigate why his friend had gone silent, discovering him slumped over with a bullet through his head. Another time, someone in his unit shot a German sniper who hadn't yet died when the American troops reached him. Messmer, who spoke German, comforted him during his final moments, as the sniper showed the Americans pictures of his family. Just before he closed his eyes forever, he offered the Americans his last cigarettes, which otherwise wouldn't get smoked. All these experiences made a deep and lasting impression on Messmer. He would rarely ever speak of the war, but glimpses of it would surface in his art once he returned to America.

While Messmer was off fighting the war, Patrick Sullivan was in New York fighting a serious lawsuit. It started one day in April 1917, after Sullivan and another animator, Ernest Smythe, began flirting with two young girls they had spotted in a rented apartment opposite the studio, whistling and catcalling to them from across the courtyard. Dark-haired Alice McCleary and her blond friend Gladys Bowen were fourteen and fifteen, respectively, and had run away from home five days earlier. They were seeking an adventure in the city. The animators

convinced the girls to meet them in a nearby bar and, once everyone was settled, ordered a round of crème de menthes. The girls sipped their bright green drinks and explained they wanted to be actresses. When Sullivan heard this, he turned on his charm and announced that he and Smythe were already in show business, as animators. Basking in the glow of the men's celebrity, the girls agreed to go out again the next night. By the third night, Sullivan had convinced Alice to go out alone, just the two of them.

A week later, police showed up at the studio and arrested the animators. Smythe was charged with "abduction," a charge eventually lowered to "impairing morals," while Sullivan was charged with statutory rape. During the trial that followed, animator George Clardy testified that Sullivan had shown up the morning after his outing with Alice, bragging that "he had screwed the dark one."

"He told me that if I didn't undress he'd undress me," Alice told the courtroom during the trial. "After he had intercourse with me the first time I bled," she continued. "He got me a drink of water. Then he had intercourse with me again later on. Then he had intercourse with me again . . ." The next morning, Sullivan told her "that he had made a regular girl of me," she quietly continued. The trial uncovered other details revealing that the encounter wasn't consensual, not to mention that Alice was underage. After seeking help, Alice learned that she had also contracted a venereal disease, almost certainly from Sullivan.

Sullivan's wife, Marjorie, asked the judge for leniency in a letter written on studio stationery and decorated with images of Sammy Johnsin. Sullivan's lawyer argued for the same on the grounds of his client's budding career as an animator. Persuaded by this argument, the judge sentenced Sullivan to two years in prison instead of the maximum ten, calling him "a man of very considerable ability." Within days, Sullivan was sent to Sing Sing Prison, a gray clutch of stone buildings on the bank of the Hudson River thirty miles upstream from New York City. Serving only nine months of his sentence, Sullivan appeared to spend more time corresponding with his lawyer than he did with Marjorie, decorating his letters with doodles of Sammy Johnsin living prison life. In one, Sammy wears a striped uniform while busting rocks in the prison yard with a sledgehammer. "Golly

ids is a skinch!" Sammy says in his pidgin English. "Think ob de poor goop dats gotter dig dese hyah rocks outer de quarry fo' me—an all ah gotter do is smash em!!"

Sullivan's studio disbanded while he was away but reopened when he was released from prison. On July 6, 1918, when the *Motion Picture News* announced Sullivan's return to "Cartoon Making," it didn't mention where he had been in the interim, nor would any of the many articles that would come afterward. When Messmer returned from France eleven months later, he found the studio barely survivng. Needing a job, he went back to work for his boss, and their relationship returned to its former pattern: Sullivan drumming up new business while Messmer handled the creative work. They started making the Chaplin cartoons again, as well as short parodies of travelogue films, which had become popular in theaters.

By 1919, the studio was so busy it sometimes had to turn away job offers. That year, Earl Hurd, who worked for John Bray and had helped come up with cel technology, approached the studio to ask if it had any extra material to sell. He was putting together a package of films for Paramount and was short some cartoons.

Sullivan almost said no but hesitated because Messmer wanted to pitch something new. "If you want to do it on the side, you can do any little thing to satisfy them," Sullivan told him. He then stressed that this wouldn't be freelance work for which Messmer would be paid separately; Sullivan would still enjoy profits and credit on work Messmer did in his spare time. Messmer agreed.

Messmer tackled the side job on nights and weekends. His first task was coming up with a new character; he settled on an all-black cat because that design required less time to draw. Using one block of color saved him "making a lot of outlines, and solid black moves better," he recalled. His sample cartoon, called *Feline Follies,* featured the cat—which would soon be named Felix—committing suicide in order to avoid the drudgery of domestic life after he knocks up his girlfriend, Miss Kitty White. It pushed the envelope and might have been in poor taste, but Paramount executive John King, who couldn't stop laughing, loved it anyway. This is when King told Messmer to "make us another."

* * *

Felix's rise to fame was meteoric, a big bang moment. The name Felix was used for the first time in the character's third film, *The Adventures of Felix*, released in December 1919, a date that sat on the edge of a new decade and big changes. The war was over and the world was ready to move on, to tip into the Jazz Age.

Success like Felix's can't be engineered; timing and luck gathered in a perfect storm. But one factor in Felix's success was crucial: he was the first recurring cartoon character with a distinct personality, a thinking character and not a mindless action figure. He communicated directly with the audience, winking at them from the screen, holding up a finger as if to say, "Watch this" before launching into some caper. These mannerisms echoed Messmer's as he waltzed through the

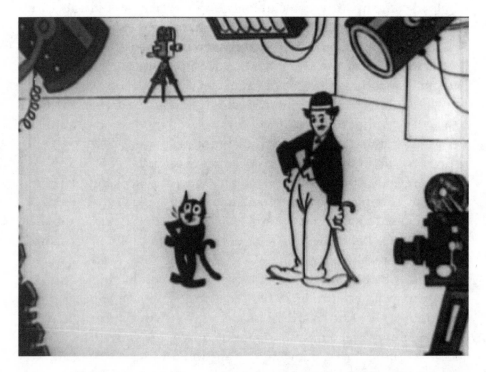

Felix stars alongside an animated version of Charlie Chaplin
in *Felix in Hollywood* (1923).

studio, pantomiming Felix's movements for his staff: clenching his fists straight down when he was frustrated; pondering a question by pacing back and forth, hands behind his back; and the famous "eureka" gesture, slapping his fist into his palm when he had a revelation.

During Felix's early years, Messmer sometimes drew from his war experience for storylines. Just before shipping out to France, he had married Anne Mason, who remained his wife for fifty-nine years. Some of Messmer's friends, however, had returned home to discover that their girlfriends had left them. In *Felix Turns the Tide*, Felix likewise returns home from war to discover that his girlfriend has had kittens with another cat. But before Felix can get mad, he sees how she nags this other cat, which is saddled with a litter of needy, whining kittens. Suddenly, Felix is relieved, shrugging it off while laughing to a friend, "Gosh! I had a narrow escape!"

Nor did Messmer's war-themed cartoons shy away from showing violent death. Mountains of limp bodies, x's for eyes, pile up on the battlefield in *Felix Turns the Tide*, released in 1922, which featured Felix joining the Army after rats declare war on cats. In later years, after the movie industry imposed censorship rules on itself, audiences would no longer see images so graphic. A cartoon character might fall off a cliff, have an anvil crush its skull, or be blown up by dynamite, but viewers would never see it actually die. There was a window of time during Felix's earliest years, however, when Messmer showed death graphically.

Felix's on-screen movements—full of unexpected changes, improvisation, and metamorphic riffs—resonated with the decade's new jazz sounds. His look, angular and pointy, moved away from art nouveau, the curvilinear and fluid motion of Winsor McCay, toward the fragmented cubism of postwar modernism. Felix's rising popularity, however, soon demanded adjustments to his appearance. Animators needed a look that allowed them to draw him faster, so they could meet increased demand for more cartoons. Animator Bill Nolan, a former Hearst employee, helped Messmer develop a look that was more round than angular, helping smooth Felix's on-screen motion and making him easier to draw. Rather than diminish Felix's popularity, the changes seemed to boost it. One psychologist thought the rounder head, accentuated by a smaller body, triggered the audience's

innate affection for babies. Messmer himself put this analysis in terms of psychology, saying, "Felix represented a child's mind . . . and that's why I think it took hold. He'd wonder where the wind came from, or how far away is a star? How deep is the ocean? Things like that . . . then, with some gag, he would solve the problem."

Pundits of the Roaring Twenties excitedly declared Felix the icon of their era. "He becomes the impossible," Marcel Brion of the Académie Française wrote in 1928. "Nothing is more familiar to him than the extraordinary, and when he is not surrounded by the fantastic, he creates it." The literary world was also enthusiastic. Aldous Huxley wrote in *Vanity Fair* that European filmmakers should study Felix cartoons—this would help improve their humor, he said, and guide them to be less pretentious. George Bernard Shaw gave particularly high praise, seeing the same potential in cartoons—as a high art—that Winsor McCay saw. "If Michelangelo were now alive," he said, "I have not the slightest doubt that he would have his letter box filled with proposals from the great film firms to concentrate his powers to the delineation of Felix the Cat instead of the Sistine Chapel."

Chapter 7

"How to Fire a Lewis Machine Gun"

In the years after World War I, Max Fleischer found working for John Bray frustrating. Max was still one of Bray's best employees, but Bray's interests had shifted. He was no longer interested in making the kind of comedies that inspired Max; he was now focused on training and industrial films.

During the war, Bray saw the contracts going to defense contractors and smelled a lucrative new opportunity. The military would need training films, and animation offered a way to illustrate certain concepts much better than live action could. After meeting with Army officials at West Point, Bray procured a contract to make the films they needed, many of which would rely on Fleischer's rotoscoping process. When the Army then tried to draft Fleischer, Bray asked, "How can I make films when you draft all my men?"

Bray had a fair point, so the Army agreed to an arrangement. Fleischer was relieved of regular service and sent to "Fire School" at Fort Sill, Oklahoma, where he would supervise the production of training films made there. A dusty scrubland surrounded by even dustier scrubland, Fort Sill was a far cry from New York, but Fleischer didn't seem to mind. Clad in a custom-tailored wardrobe of drab olives and muted browns so he would appear at least somewhat Army-like, he directed films with titles like *How to Operate a Stokes Mortar, How to Fire the Lewis Machine Gun, Submarine Mine Laying*, and *How to Read a Contour Map*. After the war ended, Fleischer returned to New York and convinced Bray to hire his brother Dave, who had been stationed in Washington, D.C., making training films for the medical corps. Able

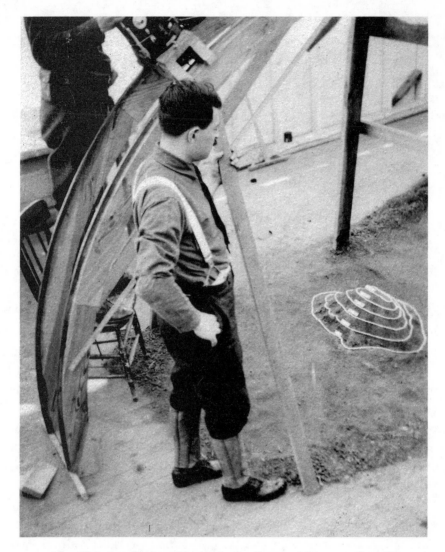

Max Fleischer filming *How to Read a Contour Map*, one of many
military training films he made during World War I.

once again to focus on comedic cartoons, the brothers revived Dave's
old clown character and began working up a new series, Out of the
Inkwell (although the character would go nameless for several years,
by 1924 he would regularly be referred to as Koko, or sometimes
Ko-Ko). A mix of live action and animation, each installment of the
series began with Max sitting at a drawing table, bringing Koko to life

and then setting him off on a series of misadventures in the city. The series was released on a bimonthly schedule starting in 1919.

Although not as popular as Felix—a difficult feat to match—Koko quickly became one of his few notable competitors. Like Felix, he possessed a unique personality, much more than just a simple cartoon automaton performing simple gags and stunts. His films possessed a reflexive nature not seen in other cartoons; he was always aware that he was living as a cartoon, made of pen and ink. This concept, reflecting his creators' sly self-awareness, thrilled audiences. The clown was "a living example of what can be accomplished by hard work and concentration," according to *Moving Picture World*. The *New York Times* was also impressed, proclaiming that "Mr. Fleischer's work, by its wit of conception and skill of execution, makes the general run of animated cartoons seem dull and crude." Fleischer was pleased by the attention but was nagged by a question raised by another *Times* reviewer: "Why doesn't Mr. Fleischer do more?"

Max did want, very badly in fact, to do more. He tried to convince Bray that, even though Koko was already a star, he could be

Model sheet used by animators to standardize the appearance, posture, and gestures of Koko the Clown.

so much bigger—some theaters had even started advertising him
on their marquees, which almost never happened for the opening
shorts; it was meant only for main features. But Bray wasn't inter-
ested. His success with military training films had convinced him that
educational material was the future of animation. Such films might
not have been as sexy as entertainment films, but they did offer steady
and dependable revenue from government and corporate contracts.
This was important to Bray because he was by now having financial
difficulties. His expansion plans had included a production and
distribution contract with the Goldwyn Company, a contract worth
roughly $1.5 million, which required that he release more than 150
reels of film a year, a number he had trouble reaching. By 1921, he
faced numerous legal threats for contractual breaches related to
nonperformance and lack of delivery. He would ultimately survive
his precarious financial predicament, but not by producing the kind
of films that interested the Fleischers. By 1928, he would shutter his
entertainment division in order to focus on military films, which he
would make well into the Cold War. He would also become the auto
industry's biggest provider of training films.

Bray's new priorities prompted the Fleischers to leave and start
their own studio in 1921. Named Out of the Inkwell Films, Inc., it had
humble beginnings, operating out of a dingy basement apartment
at 129 East 45th Street, just beneath the groaning floorboards of an
old brothel.

How Max Fleischer got the financing to start his own studio was never
quite clear. Judging by the colorful stories passed around about the
family's gambling habits, this murkiness might have been intentional.
Not only was Essie Fleischer a regular at the racetrack, she liked orga-
nizing poker games, where she smoked cigars and pipes alongside the
men and ordered her scotch "neat—no water, no soda, no ice, just
scotch," according to her son. From what were probably gambling
winnings, she had given Max the money he needed to finish designing
his rotoscope, and perhaps a similar arrangement was in play with the
new studio. Perhaps not coincidentally, Dave Fleischer won $50,000

gambling on horses just before the Fleischers left Bray. Whatever the case, the Fleischers were never particularly clear about their financing.

One of Max Fleischer's children later speculated that some money might have come from a distributor named Margaret Winkler. A scrappy immigrant from Hungary, Winkler got her start in the film industry in 1912, at the age of seventeen, working as a secretary for Harry Warner of Warner Bros. When Warner decided to shed the studio's cartoon distribution deals in the early 1920s—he was not yet convinced that cartoons had staying power—he gave them to Winkler. Not only did he admire her competence, but her bicoastal contacts—made during the years when Warner Bros. was expanding its business into California—were an important qualification for a good distributor. Soon she had worked her way into a deal distributing the Felix cartoons, the most popular series on the market. Signing a distribution agreement for the increasingly popular Fleischer cartoons, which the brothers were trying to distribute themselves, was likewise a shrewd business move.

The arrangement with Winkler was also useful for Max Fleischer. Good distribution could make or break a film's success, and a skilled distributor like Winkler was crucial. The job meant navigating a complex set of rules known as the "states rights method," a corrupt and murky system that guided how films were distributed. Under this system, film prints were first sold to brokers, who then distributed them to theaters in a given territory, oftentimes underreporting their numbers and skimming from the percentage owed to the producer. In other cases, brokers sometimes made illegal copies of a film, distributed those, and pocketed the full take. A successful distributor like Winkler had to be part accountant, part bouncer. Her colleagues noted that most of her success was because of her "quick mind," though others added that her "short temper" also proved handy.

Winkler was also one of the few women in the industry with any real power or influence. Because she knew that some people were wary of doing business with a woman, she used the initials "M. J.," in "M. J. Winkler Productions," as a way of hiding her gender (The "J." in her initials had been made up since she didn't actually have a middle name.) "How did you do it?" a newspaper reporter once asked

Winkler in 1923. "Are people surprised to find out that M. J. Winkler Productions is owned by a woman?"

Winkler would smile politely at such questions, well aware of the obstacles impeding women in her line of work. "I think the industry is full of wonderful possibilities for an ambitious woman," she said. "And there is no reason why she shouldn't be able to conduct business as well as the men." Some men were threatened when they first met her, she explained, "but they got over it."

As the Out of the Inkwell series grew in popularity, the Fleischers upgraded their studio in 1923. The space beneath the funky old brothel was exchanged for the spacious sixth floor of 1600 Broadway, an impressive tower of elegantly curved brick archways located near the bright lights of Times Square. The staff numbered nearly two dozen now, and included the important addition of Richard "Dick" Huemer, an animator who had previously worked for Raoul Barré. Huemer helped redesign Koko and conceptualize for him a pet dog named Fitz, a sidekick whose main role seemed to be getting Koko into trouble.

As the studio grew, Max and Dave settled into a division of labor. Even though Max's name was bigger than Dave's in the credits, the studio's cartoons reflected Dave's personality equally. Max handled a fair amount of creative work, but also most of the back-office administration: phone calls, payroll, meetings organized around lunch. Dave's responsibilities were almost entirely creative: directing cartoons, initiating story ideas, dreaming up gags. His informal directorial style usually started with a general idea upon which the staff would riff—he avoided storyboards and most other forms of organized structure. Individual animators were free to add pretty much any idea, so long as it got laughs. In this way, what the films lacked in gloss they usually made up for in energy. The studio animators also reduced their use of the rotoscope, preferring instead to let their imagination steer the action.

In 1923, shortly after moving into his new studio, Max Fleischer decided to take animation in a new direction. This didn't mean drastic changes to the Out of the Inkwell series, which had settled into a nice groove; it meant exploring ideas that weren't strictly comedy.

Ever since Albert Einstein published his general theory of relativity in 1915, Fleischer had been fascinated by it. The theory had revolutionized how scientists thought about space and time, but very few laypeople understood it. It was just the sort of puzzle Fleischer had once worked on as art editor of *Popular Science* magazine, and he thought animation might help explain the concept.

He started by enlisting the help of Professor Garrett P. Serviss, a science writer for the *New York American* whose mind "worked at the speed of light," Fleischer liked to joke. Soon after the two men began working together, however, they clashed over how best to translate Einstein's complex ideas. Serviss was a literal-minded scientist, uncomfortable with making the leaps of faith that good storytelling often requires. Fleischer was sympathetic, but also knew that audiences become confused by too many details. After Fleischer suggested using a title card that read, "When you see the stars twinkle," Serviss pounded his fists on the table in angry disagreement, arguing that stars don't actually twinkle, and that such effects are actually just an illusion.

Fleischer pleaded with Serviss to see things like a storyteller. "Poets make pictures," Max explained. "They paint with words, but give you a mental picture nonetheless, and since the world has poets and people like poetry, in my opinion it is correct to say that the stars 'twinkle' as I think they do."

Serviss rose from his seat and continued pounding the desk. "I will not go any further, nor will I permit the use of my name in connection with a gross misrepresentation of scientific fact!" he roared. "It's too bad that after sixty years of scientific writing for the public, here comes Max Fleischer trying to tell me what is right or wrong to say."

Fleischer gave Serviss a few days to cool off, then tried again. People can reread confusing sections of articles, he calmly explained, but they have a harder time rewatching films. "We must tell our audience these facts in a language they understand the first time," he said. Serviss finally relented but refused to watch the "stars twinkle" segment whenever it came up on the screen. "It amused me," Fleischer remembered. "But Professor Serviss was a true scientist."

When Albert Einstein saw the film, titled *The Einstein Theory of Relativity*, he was impressed enough to write Fleischer a fan letter.

Other reviewers were equally positive, lauding the film for staying as simple as possible. "They have wisely confined themselves almost entirely to the more popular aspects of this complicated theory and have not attempted to delve deeply into the sections regarding the fourth dimension and the bending of light rays which Einstein himself is quoted as saying can only be clearly comprehended by about a dozen persons," a writer from *Moving Picture World* wrote. Another reviewer was more succinct, writing that Fleischer was "either a man of super-intelligence or just plain crazy."

Despite the positive reviews, the film flopped. Fleischer thus learned a valuable lesson about audiences: they generally want to be entertained rather than educated, to see a clown fall down an open manhole rather than learn about Einstein's theories regarding space and time. Fleischer would later joke about the film's commercial failure. "There were supposed to be only three people who understood Einstein's theory," he said. "Now there are four."

Two years after *The Einstein Theory of Relativity*, Fleischer was ready to try making another similarly ambitious cartoon. This time, he wanted to tackle the theory of evolution. The papers of the day were full of stories about the Scopes "Monkey Trial," in which John Scopes, a substitute high school teacher in Tennessee, was accused of violating state laws forbidding the teaching of human evolution in state-funded schools. The case attracted some of the most famous legal names in the country, with three-time presidential candidate William Jennings Bryan arguing for the prosecution, and famed defense attorney Clarence Darrow speaking for Scopes. Fleischer figured the controversy would drive interest in his cartoon, a combination of animation and live action that chronicled Earth's creation and the advancement of life, progressing from single-celled organisms into dinosaurs, lower mammals, and eventually humans.

When the film debuted, more people showed up to protest than to buy a ticket. During the premier at New York's American Museum of Natural History, fistfights erupted in the lobby as angry mobs pushed over display cases, scattering shards of glass across the marble floor. Failing to gain wide release after that, the film failed financially. "The picture made an attempt to merely illustrate Darwin's theory and not to teach the theory," Fleischer would later explain defensively.

Throughout the rest of his career, Fleischer would continue to occasionally dabble with similar conceptual material. But he would also remember what kind of cartoons paid the bills. In 1924, the studio began releasing Song Car-Tunes, a series that used an animated bouncing ball over song lyrics to lead audiences in theater sing-alongs. It was a smash hit.

The Fleischers weren't the only ones to leave Bray's studio for more creative endeavors. And though they were the most well known of the Bray alumni, they weren't the most financially successful. That honor would go to Paul Terry, whose unique path would lead somewhere very different. Many considered his cartoons some of the worst ever, although he made a fortune from them.

In person, Terry was charming and witty, describing himself as "a dreamer, more or less." Around 1904, he dropped out of high school and got a job working with the cartoonists at the *San Francisco Chronicle*. He later headed east after landing a cartoonist job with the *New York Press*. After seeing Winsor McCay present a screening of *Gertie the Dinosaur*, he decided to become an animator.

Two formative experiences guided him. The first came in 1915 as he tried to sell a cartoon to famed film mogul Lewis J. Selznick, who watched Terry's film, paused for a second, then offered him a dollar a foot for the finished product.

"Mr. Selznick," Terry answered, "the film I used cost me more than a dollar a foot."

"Well," Selznick replied, "I could pay you more for it if you hadn't put those pictures on it!"

The second experience came after a distributor told Terry that he used his cartoons to clear people out of their seats after the feature. Terry wasn't even sure if the distributor knew that he was the creator.

From that point on, Terry thought of cartoons strictly as a commodity, not an art. The business became, to him, entirely about cool logic, math, and figuring out the business angles. During his stint working for John Bray, he improved his ability to draw quickly and efficiently, two important skills. He left in 1917 after selling a cartoon with his original character, Farmer Al Falfa, to the Edison company.

After World War I—he animated training films for combat surgeons—
he struck out on his own. Then, in 1920, Terry received a call from a
young actor-turned-writer named Howard Estabrook, who pitched him
the idea of a cartoon series based on Aesop's fables. Terry had never
heard of Aesop or his fables, but he was intrigued when Estabrook
said it might be profitable.

Terry also liked how the fables featured animals. In many ways,
animals made better characters than humans, as Felix's rising popu-
larity was starting to prove. "When you do something with an animal,
it's unconscious satire, and it seemed to be more sympathetic," one
of Terry's colleagues would recall. People who act like animals get
shunned, but animals that act like people can become immortal.
Animal characters also reduced the possibility of offending audi-
ences through ethnic stereotyping, thereby helping them gain wider
national appeal, as well as avoid the New York in-jokes commonly
found in most other cartoons of the time. Anthropomorphized ani-
mals could still be offensive, but started on relatively safer ground, thus
helping boost their reputation with distributors and theater owners.

Terry organized his studio the way a factory owner might lay out
his plant, with about twenty cartoonists working at desks lined up in
rows. Like Bray, he divided the labor into specific tasks, as in an assem-
bly line, to create a hierarchy of labor that was by then becoming an
industry standard. The best artists drew only "extreme" poses—that
is, poses that anchored the major points of movement in a character's
action. A second tier of artists, known as "in-betweeners," would then
trace in all the drawings between the extremes. These in-between draw-
ings were considered easier to draw, since more tracing was involved,
and thus freed up the better artists to focus on harder tasks where their
skills were most needed. Finally, a bottom tier of assistants completed
the inking, a more menial task that involved filling in the outlines
drawn by the others. When labor was delegated this way, animation
could be done more quickly and efficiently.

Terry treated every aspect of a cartoon like a variable in an equa-
tion. "He kept a file of A gags, B gags, and C gags," animator Art Bab-
bitt remembered. "The A gags would get a hilarious laugh, the B gags
would get a friendly response, and the C gags were not so successful."
Terry mixed and matched the components like a dealer shuffling a

deck of cards. Drawings were recycled from other cartoons, while shortcomings were often hidden by speeding scenes up or making them more violent.

"It didn't matter what the hell the story was," Babbitt said. The plots featured characters like "Lucky Duck" or "Rufus Rooster," and were often just random series of non sequiturs. They rarely made sense, and the "lessons" at the end of each fable rarely had anything to do with the story. "A man who cannot remember phone numbers has no business getting married," read one. "He who plays the other fellows game is sure to lose," read another, which also highlighted the studio's loose control of grammar.

"We take any idea that sounds like a laugh," Terry told the *New York Times* about his business strategy. Babbitt put it another way: "What we were doing was just crud . . . Terry didn't care—he was out for the bucks." Terry, whose studio would remain one of the most profitable in the business well into the 1950s, would freely admit this as well. Another animator remembered applying for a job with him and being told, "We do shit here, compared to the rest of the business, but it makes me a lot of money. If you don't like to do shit, don't ask for a job."

Chapter 8

"Being Famous
Is Hard Work"

By 1925, Felix the Cat was by far the most popular cartoon character in the world, his name and likeness as widely recognized as Charlie Chaplin's or Buster Keaton's. In fact, Chaplin regularly praised him, and Keaton parodied him in the classic *Go West*. Director Federico Fellini, then just a young boy in Italy, would later recall fondly that Felix was his first sweet taste of American culture.

In the fall of that year, Pat Sullivan and his wife, Marjorie, embarked on a five-month promotional tour around the globe, visiting England, France, the Mediterranean, Africa, China, and Australia. They began by sailing from New York to Southampton, England, aboard the luxury ocean liner HMS *Majestic*, the crown jewel of the glamorous White Star fleet, a wedding cake of a ship full of dazzling ballrooms and glass-ceilinged swimming pools. In Southampton, the couple was greeted by a crowd of reporters waiting at the bottom of the gangway; flashbulbs popped as the photographers jostled for the best angles. Off to the side, a jazz band played "Felix Kept On Walking," one of the biggest radio hits of the year (*"He's won picture fame, Felix is his name . . ."*). Felix was so popular in England that the Prince of Wales made him the British polo team's official mascot. Queen Mary, who had received a stuffed Felix doll at the Great Empire Exposition at Wembley, an event celebrating England's global prominence, made a show of presenting it to her husband, King George.

Felix's extraordinary popularity sparked a merchandising bonanza, prompting one trade journal to write that Felix had more "publicity producing angles than a centipede has legs." Men wore

Felix tiepins and women wore Felix brooches. Smoke shops sold Felix cigars and automakers sold Felix radiator caps. Infants smelling of Felix baby oil napped under Felix blankets. Felix Crystal Radio sets, the cat's tail serving as the tuner and his whiskers as the crystal, played "Felix the Cat," another megahit akin to "Felix Kept On Walking." The merchandising rights alone earned Pat Sullivan $100,000 per year.

When the Sullivans reached the bottom of the gangway, reporters' questions exploded around them. Mostly the reporters wanted to know how Felix came to be. Without ever once mentioning Otto Messmer, Sullivan spun yarns about himself, stories with the kind of rags-to-riches angle he knew would make good copy. "It seems a dream to look back now on my early struggles as a cartoonist," he told one reporter. "I am one more case of a poor boy who made good abroad." Sometimes, Sullivan brought up the character he actually did create, Sammy Johnsin, and would tie him to Felix. "Two, three years ago I was drawing a little nigger—Sammy Johnsin—for the films, and was trying to figure out something fresh . . ."

Depending on his audience, Sullivan sometimes gave credit for Felix to his wife, Marjorie. "You must blame it on my wife," he said rather disingenuously. "She runs out of the room whenever the cat's mentioned now, but she started the thing." In this version of the story, Sullivan would explain that Marjorie came "bursting into the studio carrying in her arms the most washed out, pop-eyed, half starved ragamuffin of a cat that ever lived in a New York back street. I looked at the thing for a minute . . . 'Well,' I said, 'what's the joke?'"

"An idea!" Marjorie replied. "Everybody's drawing men. Why not do an animal feature?"

"That was how Felix began," Sullivan told the reporters.

In another interview, this one with the *Sunday Express,* a London paper, Sullivan used a metaphor to illustrate just how much the creative process had taken out of him. "An old German guy called Frankenstein once started something he could not finish. Well, I just feel like that about Felix," he explained. "Frankenstein, you will remember, created a machine man that could do everything a real man could do. Except that a real man only works eight hours a day and this Frankenstein monster could work twenty-four hours to the day. All the Frankenstein creation lacked was a soul. Try as he would,

old man Frankenstein could not give his creation a soul. So in the end the clockwork man got sore, boomeranged on his boss, and strangled him."

This version of the story was surprising, even alarming, to some. Was Sullivan saying that the pressure of creating Felix would kill him?

Sullivan assured them it wouldn't. "I don't exactly fear at the moment that Felix will get a death grip on my windpipe; but he's coming perilously near getting a stranglehold on my personality."

"Then why such a burden?" the reporter asked.

"Being famous is hard work," Sullivan replied.

While Pat Sullivan was out doing the "hard work" of "being famous," Otto Messmer was back at the studio, doing the actual hard work of writing and directing the Felix cartoons. Sullivan never mentioned Messmer in the press, allowing the illusion that he himself alone was Felix's creator. Not until the 1960s would film historians commonly know otherwise, after interviewing other animators from the era who all spoke about Messmer's role. In 1974, one interviewer sat down with Messmer himself, now old and gray, and asked about Sullivan's taking credit for his work, as well as reaping all the financial rewards. Had Messmer ever heard "the tale Sullivan told about his wife bringing in the stray cat"? the interviewer asked.

"Oh, that was publicity," Messmer quietly answered.

"He told it all over the world."

"I know. He had to have something."

"Did you design the first Felix the Cat?"

"Oh yes, yes . . ."

"Why did Pat Sullivan get credit for it?"

"It belongs to the firm . . . he was the head of the studio."

Sullivan was indeed head of the studio, but Felix had originally been created for Paramount, so how did Sullivan end up receiving all the profits for the character?

Hal Walker, an animator who worked for Sullivan, said that his boss told the story "once and only once." After that, it became a colorful tale the animators passed among themselves. In the spring of 1920, just as Felix was starting to get popular, Paramount boss Adolph

Zukor had apparently decided to do away with the packaged bundle of films—known in the industry as a "magazine," consisting of shorts, features, newsreels, and cartoons—that the Felix series was part of. This was before Felix's popularity had skyrocketed; Zukor, not thinking the cartoon was profitable enough, wanted to shave the expense.

When Sullivan heard the news, he realized he didn't own the rights himself. Upset and out-of-his-mind drunk, he barged into Zukor's office screaming that he had been robbed of his livelihood. Then he climbed onto Zukor's desk, unzipped his pants, and began urinating as Zukor watched the yellow puddle spread across his papers.

According to Sullivan, Zukor, one of the most intimidating men in the film industry, picked up his phone and told his attorney to hand over the rights. The story would be impossible to believe if Sullivan hadn't actually somehow come away with the rights. Perhaps Zukor, a man with bigger fish to fry, just wanted the maniac out of his life. Sullivan then tried to make a quick buck by selling the series to Warner Bros., but Harry Warner, who was little interested in cartoons, encouraged Margaret Winkler to take it on as part of her new distribution business. This was a lucky break, paving the way to a much bigger fortune than Sullivan ever anticipated.

The animators working in Sullivan's studio remembered their boss barely ever being there. When he did show up, he was almost always drunk. According to Shamus Culhane, Sullivan was "the most consistent man in the business—consistent in that he was never sober." Culhane's most vivid memory of Sullivan was of someone who would stumble through the doorway, toss a bag of dirty laundry to the nearest animator, and fire him on the spot if he didn't take it to the cleaners fast enough. Messmer would then write the animator a severance check, send him home, and quietly welcome him back the next morning, after a night of hard drinking had washed the memory from Sullivan's brain.

In the meantime, Messmer kept the studio running. During Sullivan's long absences, he would forge his boss's name on the studio's checks, memos, and other paperwork. In addition to writing and directing most of the films, he also drew the weekly Felix comic strips, signing Sullivan's name to those as well. This earned his boss

an extra $80,000 per year on top of the nearly $8,000 he made per film, plus the $100,000 he made on merchandising. In comparison, Al Eugster, an animator who started working at the studio on April Fools' Day, 1925, started off at ten dollars per week, nine dollars less than he previously made at the American Radiator Company. He didn't care about the pay gap, though, because "it was something I wanted to do," he said. There was a priceless thrill in helping to create an iconic character then dominating popular culture. "At last, here was the symbol of our generation scrambling to realize its wild dreams in absurdities," M. Paule wrote of Felix in *Hollywood Life* in January 1927. "There was the airplane, the submarine and the Charleston. Felix of the form plastic could manipulate that war dance as no living human with two legs. In sum here was in Felix the Cat the Delphic oracle and a world horoscope rolled all into one."

Chapter 9

"I Love Beans"

Felix attracted countless copycats. His success created a giant slip-stream these imitations maneuvered their way into, trying to see how far they could get—most were barely discernible from the original. John Bray's Thomas Cat, created in 1920, could have been mistaken for Felix in a police lineup. Paul Terry, who was in animation only for the money, introduced a cat that not only looked similar, but was actually called Felix until the threat of legal action convinced him to change the name to Henry Cat. But the most exasperating imitator of all was a cat named Julius. It first appeared by that name in 1925, created by a young upstart animator struggling to get noticed.

Walter Elias Disney first arrived in California in August 1923. Only twenty-two years old, he tried to look older by sporting a mustache, a wispy over-the-lip number that begged others to take him seriously. He arrived by train from Kansas City, a skinny kid in a borrowed suit hoping to break into Hollywood. Tucked away in his luggage was a small handful of films he had made back home, a series entitled Alice's Wonderland, a mix of live action and animation, that was loosely based on Lewis Carroll's book *Alice's Adventures in Wonderland*. He hoped to sell the series in a format featuring Alice in various settings: *Alice's Day at Sea, Alice Hunting in Africa, Alice's Spooky Adventure, Alice's Wild West Show*, and so on. It was in these films that Disney occasionally cast Julius, the Felix knockoff, which appealed to distributors wanting to capitalize on Felix's success, but not enough for them to sign a contract with him.

Disney's first two months in Los Angeles were filled with rejection. Nobody was interested in this unknown kid's pitches. His contacts suggested he might have better luck in New York, where most of the

animation studios were located and where distributors might be more receptive. But there was no money to travel east, so Disney was stuck in California, continuing to knock on doors.

In October he finally caught a lucky break and signed a distribution deal with Margaret Winkler. She lived in New York, but Disney, covering his bases, had started corresponding with her from afar. He had caught her at the perfect time, when she was desperate for new talent amid troubles with her star clients. Max Fleischer was threatening to begin distributing his Out of the Inkwell shorts on his own, while Pat Sullivan was likewise threatening to take Felix elsewhere for more money. Winkler badly needed to diversify her portfolio to hedge against the potential losses and hoped Disney's films might help her avoid disaster.

Once the contracts were signed, Disney set to work scraping up money to start a studio. Partnering with his brother Roy, who had come to California to recover from tuberculosis, he received a small loan from his uncle, enough to rent a small office and studio space. Then he convinced the family of Virginia Davis, the young girl from the live-action portions of the *Alice* shorts, to move from Kansas City to California. Her father, a traveling salesman who already spent a lot of time on the road; and her mother, a stagestruck housewife obsessed with her daughter's potential stardom, were an easy sell. Once they arrived, Disney took Virginia around town and filmed her live-action sequences himself, using mainly public spaces and occasionally ducking the police because he lacked the proper filming permits. He also drew most of the films' animated sequences himself, delivering the first new installment of the series, *Alice's Day at Sea*, to Winkler by December.

Winkler was disappointed when she saw it. The film wasn't particularly funny and the work felt rushed. She demanded he do it over, explaining that she knew what audiences wanted. "Inject as much humor as you possibly can," she told him, suggesting he make it more like *Felix the Cat* and *Out of the Inkwell.* But even though she was critical, she was also encouraging, hoping to cultivate this young upstart she had taken a gamble on: an unknown kid with few contacts, no money, and no real studio. Plus, he was trying to make animated cartoons in California, a continent away from where they were usually made,

in New York. Many had already asked Disney the same question: why had he come here and not gone there?

If the stars had aligned a little differently, Walt Disney might have been born in California. In the nineteenth century, both of his grandfathers, Kepple Disney and Charles Call, had set out for California in search of gold, departing in wagon trains for the frontier. But the trip was hard, and along the way they both got sidetracked, putting down roots in the Midwest instead. Thus, in 1901, Walt was born in Chicago, a town he remembered as noisy and dirty, penetrated by the dark breathing of factories and slaughterhouses.

When Walt Disney was four, his family left dirty Chicago for Marceline, Missouri. It was a postcard town: Zircher's Jewelry Store, with an impressive freestanding clock on its corner; Hott's Tavern, run by the cheerful Judge Hott; and Ripley Square, full of handsome gazebos where bands played during the warm summers. The beautiful farmhouse they lived in was fronted by a carpet of green grass and shaded by swaying willows that whispered in the breeze. Disney's memories of Marceline were always pleasant: his Aunt Maggie giving him his first drawing tablet and pencils; or his neighbor, Doc Sherwood, paying him a nickel to sketch his horse. That moment—receiving money from Sherwood to draw—was, up to that point, "the highlight of Walt's life," according to Roy Disney.

Unfortunately, Walt's father was not a good farmer. Elias Disney had interesting notions about agriculture, including the idea that using fertilizer was like "giving whiskey to a man—he felt better for a little while, but then he was worse off than before." After the farm inevitably failed—when Walt was ten—the family moved to Kansas City, into a house that was cramped, lacked plumbing, and was close enough to the street for the Disneys to hear drunks rustling by in the night. By now, Elias had decided that Walt was old enough to work. No more playing and drawing, his first love; now he had a paper route with 650 customers. His childhood was over. He creaked awake before dawn to deliver the morning *Kansas City Times*, and stumbled home in the dark after delivering the evening *Star*.

When giving interviews later in life, Disney would sometimes use the examples of Marceline and Kansas City as a way to compare the extremes of American life—country versus city, one an ideal to strive for, the other a thing to avoid. It was a philosophy often echoed in his cartoons. Marceline was bucolic, peaceful, and full of friendly neighbors. Kansas City was the opposite: noisy, crass, filled with hustlers. Walt's sister Ruth and his brother Roy would both claim their upbringing wasn't nearly as hardscrabble as Walt described, but that was part of Disney's genius: reimagining the past and shaping it to fit the aspirational myths that people want to believe.

During Disney's freshman year in high school, the family moved from Kansas City back to Chicago after Elias invested in O-Zell, a promising (he hoped) jelly and fruit juice company. It was yet another city Walt didn't particularly care for. He enrolled in a new school, but his teachers there remembered him as "seldom more than lukewarm about the funny business of the three Rs." He preferred doodling in his textbooks instead, converting them into flipbooks to entertain his classmates. "Walter Disney, one of the newcomers, has displayed unusual artistic talent, and has become *Voice* cartoonist," the *McKinley Voice*, the high school newspaper, announced shortly thereafter. When America entered World War I, his cartoons took a sudden political bent. One, a drawing of a wounded doughboy, featured the caption "Your summer vacation. WORK or FIGHT. Will you be doing either?" Disney was too young to fight, but he wanted adventure, so he dropped out of school and joined the Red Cross, which had a younger age limit than the Army.

Just seventeen, Disney remarkably found himself driving a Red Cross ambulance in France, soon after the war ended. He also moonlighted as his unit's painter, drawing sketches for the chow hall menu, designs for the tent flaps, and caricatures of the troops. Teaming up with a young man from Georgia, nicknamed "the Cracker," he started an artistic side hustle of salvaging German helmets from the dump, scuffing them up in the mud, shooting them to make an "authentic" bullet hole, and selling them to replacement troops who didn't know better.

Disney returned home in 1919 and informed his family that he was going to be an artist. "This nonsense of drawing pictures!" Elias

shouted when he heard the news. How could Walt reject the good job Elias had gotten for him at O-Zell that paid $25 a week!? Elias was upset but also saw that Walt was an adult now, tall and broad across the shoulders, his hands rough from his time in France. He had also started smoking, the beginning of a lifetime habit that he now used to perfect his impersonation of Charlie Chaplin's famous kick-a-cigarette-behind-his-back move. Walt had been obsessed with Chaplin ever since high school, dissecting all his moves and performing them for friends. He loved acting as much as drawing, performing in school plays and local competitions. "[I] liked the applause, liked the cash prizes that were being handed to us, liked the weird smells and weirder sights behind the scenes," he later recalled. When finally faced with the choice of drawing or acting, however, he got practical and chose drawing because "it seemed easier to get a job as an artist."

"I went for it," Disney said about his decision to move back to Kansas City. Roy was living there, and Walt managed to get a job for a printing company designing catalogue and letterhead art for publications like the *Restaurant News* and the *United Leather Workers' Journal*. He drew comics on the side, but no money came from them, only yellow rejection slips from magazines like *Life* and *Judge*. Thinking wishfully, he made "cuts" of his unpublished comics on the blank margins of his customers' printing plates, later pressing them onto blank newspaper stock and surrounding them with news stories, pretending they had been published. His coworkers, as a rule, respected his work but didn't admire it—by Disney's own admission, he was never a great artist, just an adequate one. His coworkers did, however, admire his work ethic. "He had the drive and ambition of ten million men," one secretary remembered. During breaks, the other artists played poker, gently making fun of Disney, who chose instead to huddle in the corner, hunched over a pad of paper so he could practice his autograph.

That fall, in 1919, Disney told a federal census-taker that he was a "commercial artist." As the census-taker walked away, Walt reconsidered his answer and waved him back, correcting his response to "cartoonist."

Disney was laid off from the printing shop after the holiday rush but quickly got another job at the Kansas City Slide Company, located in a pale-brick building lined with tall windows that provided good

Walt Disney's business card from 1921.

light for the artists. They drew advertisements to play in movie theaters before the main attractions. Disney wrote to an old Red Cross friend to say he was now drawing "cartoons for the moving pictures—advertiser films . . . and the work is interesting." Soon he convinced his boss to let him write and shoot his own ads, rather than work with the copy department, and to lend him an old camera that was otherwise collecting dust on a shelf.

Disney's interest in animation quickly swelled into an obsession, consuming his nights and weekends. His parents had moved back to Kansas City after O-Zell failed to pan out, and he converted the shabby garage behind their house into a makeshift studio. He worked there at night, after a full day at the Slide Company, with Roy dropping by for late visits. Roy recalled later how the studio window was always the last on the street to go dark, with Walt inside, "puttering away . . . experimenting, trying this and that."

Disney learned the basics of animation by picking the brain of a former Slide Company artist called "Scarfoot" McCrory, who had left Kansas City to work at a New York animation studio but

frequently returned for visits. He also began studying a book by Edwin Lutz entitled *Animated Cartoons: How They Are Made, Their Origin and Development*; the work was a gateway read for many budding animators. Its advice included making films that satirized "topics of the hour," prompting Disney and a handful of friends to make a series of shorts spoofing Kansas City's potholes, local news, and slow streetcar service. They called them "Laugh-O-Grams," and the local Newman Theater liked them well enough to place an order. For about an hour after the sale, Walt was ecstatic, "walking on air," until he suddenly realized the price he had quoted the theater didn't include profit—his greatest gifts didn't involve finance, a deficiency that Roy would later help remedy. Still, the attention he got from the Laugh-O-Grams was worth it. "I got to be a little celebrity in the thing," he remembered.

In the summer of 1920, the Slide Company changed its name to the Kansas City Film Ad Company and began shifting its business from slides to movies. This was lucky for Disney, who now had access to more equipment that would help him pursue animation in his free time. He recruited a "staff"—mainly friends—for his own upstart studio, telling them that he could pay them only "in experience." They didn't seem to mind, though—"It was more fun than pay," his friend Walt Pfeiffer charitably remembered. Profits, once they came, were razor-thin—exhibitors weren't willing to pay much for material they considered little more than a way to kill time before the main attraction. Disney slept in his office on a few thin rolls of canvas and some moth-eaten old cushions. He couldn't afford to heat the beans he lived on, prying them cold from the can. This didn't bother him, however—"I love beans," he said, keeping a positive attitude. (Even after he was a success, he often continued eating cold beans from a can for lunch, munching away on them while sitting in his spacious office.)

Disney eventually decided to leave the Film Ad Company and start his own outfit, called the Laugh-O-Gram Studio. The tiny staff focused its efforts on gag cartoons similar to Paul Terry's spoofs of Aesop's fables, as well as inventive adaptations of other stories such as Lewis Carroll's *Alice's Adventures in Wonderland*. This is how he came to make the sample films he would later take to California. But Disney's

talent and drive notwithstanding, his cartoons failed to find a market and his studio was forced into bankruptcy—he still couldn't match the quality of New York animation. It was time to admit the drawbacks of being in Kansas City. "Our ideas were great, but we were in the wrong area. Kansas City wasn't the place for this kind of work," animator Rudy Ising recalled.

Refusing to quit, Disney decided to start anew and began evaluating new locations. All the great animators worked in New York, but Walt had reservations about moving there. The animation industry was there only because it always had been, close to the newspapers and art schools that provided talent. But the movie business, which it was a part of, had clearly migrated to California; there was year-round good light and a disdain for unions, allowing the studios to get away with paying lower wages. It seemed to Disney that it might make better sense to move west. He was torn, but California had one factor that tipped the balance in its favor: Walt's older brother Roy was recuperating from tuberculosis there, thus ensuring that Walt would have a place to stay. Roy also had business acumen and would prove a valuable partner.

When Walt announced his decision to his family, he was dressed in black-and-white-checked trousers, a mismatched checkered jacket, a gabardine raincoat, and an old brown cardigan—a look suggesting that he'd slipped into a clown's closet and dressed in the dark. He didn't own a suit of his own, and those close to Disney always remembered him as an eccentric dresser. His brother Herbert's mother-in-law looked him up and down as he announced his news, then slipped out of the room and returned with an outgrown suit of her son's. She also had three bags of meals for him to eat on the train; she hoped the food would help him regain some of the weight he had lost while struggling to start his studio. Disney was driven to the train depot by another Kansas City acquaintance, his name lost to time. The man's family would later joke about how his main boast in life was telling everybody in Kansas City, "I took Walt Disney to the station when he went to Hollywood."

Several months after starting his studio in Los Angeles, Walt Disney hired an inker named Lillian Bounds. She was not particularly

enamored of show business, nor would she ever be. Around her, Walt would stay grounded; she was a source of valuable, non-Hollywood perspective. He was shy toward her at first, politely giving her rides home from work, but he clearly liked her, and she him. In 1925, the two were married. When they returned from their honeymoon, they were in a glow, and their wave of good fortune continued. It had been more than a year since Disney had started making Alice shorts for Margaret Winkler—a long, shaky beginning—but he'd finally found a groove, earning positive reviews from the trade papers. "Here is a clever cartoon novelty . . . and should lend an acceptable variety to your program," *Film Daily* advised theater owners looking for material. Walt and Roy's growing success made them feel comfortable about putting down a $400 deposit on an office building located on Hyperion Avenue near Griffith Park. The new studio was the size of a small supermarket, a spacious upgrade compared with the two cramped rooms they had previously been using.

Still, a few positive trade reviews notwithstanding, the Alice shorts were not a knockout hit. Throughout 1926 they rarely made more than $300 profit per installment, and sometimes even lost money. The series' success had plateaued, putting the studio in a shaky financial position. This was clear to Charles Mintz, a film producer who had married Margaret Winkler in 1924 and took over her business once she was pregnant. Mintz began pushing Disney to create a character that looked "more like Felix," prompting a shift to focus on Julius as much as Alice. But Disney was never comfortable with what felt like plagiarism, telling his staff, "You'd better watch that stuff, fellows, you're going to run into copyright problems." Nor was Julius ever particularly popular—there were just too many Felix knockoffs on the market, none nearly as good as the original. Disney's work was also hamstrung by the brutal production schedule demanded by his contract with Mintz: one new cartoon every two weeks, a breakneck pace that valued quantity over quality. There simply wasn't enough time to allow for proper creativity, and this lack bothered Disney. After four years in Los Angeles, he was hitting a ceiling and burning out. As he said later, "I was ambitious and wanted to make better pictures."

By 1927, Disney was not only searching for new characters and ideas; he was searching for new staff. Upon hearing that Otto

Messmer, not Pat Sullivan, was actually the creative force behind Felix, he tried to hire him away. Because Sullivan was taking all the money anyway, Disney probably figured he could get a steal. "He begged and pleaded," Messmer remembered. "It was pressure!" But Disney's offer came with a catch that Messmer wasn't ready for: move to California. Messmer turned him down, recalling, "My home, family, and roots were in New York." It was an attitude shared by many animators, native New Yorkers who thought of animation as a homegrown industry.

The surplus of Felix clones indicated that any new breakout stars would need to be original. This was clear to Carl Laemmle, head of Universal, who spread the word that his studio wanted to reenter animation after a ten-year absence—he, like many, had been skeptical of animation, but he was starting to come around. He wanted his new cartoon star to be an animal, although he couldn't say exactly what kind of animal. Mintz had heard of Laemmle's desire for new material and took the prospect to Disney. But all he could tell Disney about Universal was that "they seem to think that there are too many cats on the market."

Disney began brainstorming with an employee, Ub Iwerks, with whom he had worked in Kansas City and whom he later convinced to move to California. Then they started designing a rabbit with long ears and, for some reason, a monocle. Universal liked the initial design but wanted some adjustments, starting with losing that monocle—the result was basically a character resembling Felix with rabbit ears. Disney knew better than to just copy Felix's look, however; he knew the cat's success was due to a unique personality—all the gags and everything else were just an extension of that. "I want the characters to *be* somebody," he explained. "I don't want them just to be a drawing." Happy with the result after seeing it, Universal signed an agreement with Mintz for twenty-six shorts, which the Walt Disney Studio would make, receiving an advance of $2,250 for each cartoon.

"I am the LUCKY rabbit," a promotional poster read when Disney and Iwerk's new character, Oswald the Lucky Rabbit, debuted in 1927. Universal was confident the "Krazy Kartoon Knockout" would "set the industry on its rabbit ears," it announced in an advertisement. As Oswald began flickering up on screens across the nation, reviewers

tended to agree. *Motion Picture News* called the series "clearly drawn, well-executed, brimful of action and fairly abounding in humorous situations." *Film Daily* mused that it was "funny how cartoon artists never hit on a rabbit before," as if the animators had discovered a new element in the Periodic Table. Not only was the character novel, it had charm and personality lacking in so many of its competitors. In the contest to oust Felix from his throne, the paper declared that "Oswald looks like a real contender."

Walt Disney developed Oswald's personality by closely studying films of comedians whose gags were extensions of their personalities: Laurel and Hardy, Charlie Chaplin, Harold Lloyd, and Buster Keaton, among others. He also observed the actor Douglas Fairbanks, a master of expressing personality purely through movement. These lessons, alongside creative camera effects, angles, and editing, made the Oswald shorts stand out from the competition.

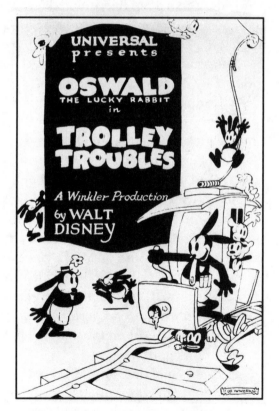

The Oswald series was successful enough to improve the studio's financial footing. Walt's salary was only $100 a week and Roy's $65, but yearly profits beyond that were $8,935, split sixty-forty between them—solidly middle-class incomes, although nothing

Movie poster for an early *Oswald* cartoon, released shortly after Walt Disney struck a fortunate business arrangement with distributor Margaret Winkler.

extravagant. By the end of the year, the number of staff increased to twenty-two, a large portion of it new inkers and painters.

Before the Oswald series was even a year old, however, Disney fell out with Charles Mintz. Located far away in New York, Mintz had little insight into exactly how the studio was run. He questioned how it was operated without knowing the full details. Since cartoon studios were organized like factories, he extended that comparison, forgetting they made art, not widgets. To him, Disney was just another cog in the machine, one that drew a higher-than-average salary and was always haggling with Mintz for more money and control. He was a headache.

Looking to raise his take and rid himself of this problem child, Mintz devised a plan: he would take over. He sent his brother-in-law, George Winkler, to California to begin quietly hiring away Disney's animators. Once they were all hired, so went the plan, the Disney brothers would be cut loose, in a quick and silent coup. What Mintz didn't fully realize was that Disney was actually a visionary, not just a factory foreman watching over a bunch of workers drawing pictures of a rabbit. He injected the enterprise with its spirit; his ideas and input were a crucial part of Oswald's success.

Disney caught wind of Mintz's plan just before a scheduled trip to New York to meet with him about other business matters. Although he was not convinced that Mintz would do something so low, he nonetheless prepared a countermove. Arriving in New York, he began visiting other studios, Oswald prints under his arm, and soliciting for competing bids to put pressure on Mintz. Another studio's acquisition of the rights from Universal would threaten Mintz's distribution agreement.

It was a smart plan but didn't get any takers. Before brusquely waving Disney off, Fred Quimby at Metro-Goldwyn-Mayer told him that "cartoons [were] on the wane." Thus, Disney was unable to gain any additional leverage.

Disney's meeting with Mintz was awkward and strained. Mintz fidgeted and talked to him like a subcontractor. As Disney watched him, seeing how evasive and awkward he was, he gradually became convinced that the rumors were true. Wandering out of the office, he promptly wired an ominous message to Roy: BREAK WITH CHARLIE LOOMING. Anxious to prevent staff from leaving, he then ordered Roy

to meet with their attorneys and draw up "ironclad" agreements: ALL CONTRACTS WITH ME PERSONALLY . . . MAKE THEM SIGN OR KNOW REASON BEFORE ALLOWING THEM TO LEAVE.

Roy wired back, reporting that most of the staff refused to sign; they considered the papers little more than loyalty oaths. From this, Walt immediately knew two things: that higher corporate powers had made him expendable at his own company, and that he had just been betrayed. Mintz had reached his employees before he himself was able to. Two days later, Disney tried to negotiate with Mintz, but hit a wall. Mintz held the upper hand. He offered Disney a slight pay raise and control of daily operations at the studio, but only as an employee, not as the owner. This was his move to squeeze out a slightly bigger take, an age-old dance between Hollywood creatives and executives. Disney realized he had no recourse, especially since he didn't own the rights to the Oswald character. He left the meeting furious.

"He was like a raging lion on the train coming home," Lillian Disney recalled. She had accompanied him to New York because Walt wanted the trip to be a second honeymoon. But the episode with Mintz soured the mood. "All he could say, over and over, was that he'd never work for anyone again as long as he lived," Lillian said. "He'd be his own boss." She spent her time on the train watching the drab winter landscape drone past her window, listening to Walt sputter and curse about how Mintz had cheated him, and how his treasonous staff had left him. Once his anger finally calmed—somewhere deep into the Midwest, Lillian couldn't remember exactly where—Walt began planning his next steps. He would start a new studio. In the lore, as Walt would later tell it, he began doodling on a napkin and spitballing ideas, conjuring up a new strategy—and a new character—to revive his career.

Chapter 10

"Bad Luck!"

In May 1927, aviator Charles Lindbergh accomplished the first transatlantic flight. It was one of the most widely covered news stories in the world, and Lindbergh became one of the most recognized names in history. Although he regularly took his pet kitten, Patsy, on test flights, he chose not to take her across the Atlantic, explaining, "It's too dangerous a journey to risk the cat's life." It was widely rumored, though never proved, that he took a stuffed Felix doll instead—the cat's name, after all, roughly translated to "lucky" in Latin.

Five months after Lindbergh's transatlantic flight, aviatrix Ruth Elder, the "Miss America of Aviation," attempted to become the first woman to do the same. For good luck, she likewise carried a stuffed Felix doll, along with a Bible—a curious pairing. After she ignored advice not to fly over the North Atlantic in cold weather, Elder's plane, *American Girl*, splashed into the ocean shortly after takeoff. She was rescued but the Felix doll wasn't. Pat Sullivan, always a publicity hound, seized the opportunity for a press stunt by sending her a telegram: AM ALL RIGHT. SWAM ASHORE. WILL SEE YOU SOON—FELIX.

When Elder arrived back home, she posed for the papers with a new Felix doll that had just arrived in the mail from Sullivan. Grinning for the cameras, she said, "Luck saved me."

Felix's popularity appeared indestructible. When reporters asked Sullivan if he ever planned to fiddle with Felix's magic formula, he dismissed them with a wave of his hand. "Why change?" he asked. Otto Messmer remembered the time period as being caught in what felt like a permanent glow. "Felix was goin' so good," he recalled. "It seemed like he would go on forever."

* * *

In the fall of 1927, right around the time of Ruth Elder's unfortunate flight, about thirty animators met in New York at Roth's, a swanky hotel and restaurant bedecked with dark wood paneling, polished marble floors, and burnished brass fixtures. The gathering was meant to celebrate all they had achieved in their art. A marginal novelty when it first began, animation was now a regular part of the cinema experience. The animators were proud, laughing and drinking their bootleg liquor together, the air milky with cigar smoke. Max Fleischer hosted, shouting through the din to announce the evening's guest of honor. "[Winsor] McCay created the miracle of animation," he said, gesturing toward their esteemed colleague, "and another miracle was getting all the animators into one big friendly gathering."

Almost a decade earlier, McCay had released *The Sinking of the Lusitania*. By 1921, he had made three more short cartoons—*The Centaurs, Flip's Circus*, and *Gertie on Tour*—that were never shown commercially and would survive only in fragments. He had also released three films adapted from *Dreams of the Rarebit Fiend*, another of his comic strips. Like *Little Nemo in Slumberland*, it dealt with the complex psychology of dreams. In this trio of films, *Bug Vaudeville* was about dancing bugs; *The Pet* was about a creature, similar to King Kong, who terrorizes a city; and *The Flying House* was about a man who attaches wings to his house so he can fly away to escape his debts. All three were visually breathtaking and imaginative, but none was particularly popular; they played mainly to niche audiences on sporadic schedules. They were also time-consuming to make. When William Randolph Hearst learned how committed his star cartoonist remained to animation, he again stepped in to limit how much effort McCay devoted to it. McCay was once more forced to concentrate his attention on his newspaper career, forgoing animation.

McCay's reputation as an animator quickly faded from the public mind, but he was still a hero among his fellow animators, who considered him a standard-bearer and a true artist. They buzzed with excitement whenever rumors surfaced that he was thinking of making another animated film. The projects, heard about only in bits and pieces, were always ambitious. *The Barnyard Band* was to involve McCay conducting, in person, a cartoon orchestra made up of animals. Another idea involved an animated history of World War I, for

which he started doing concept drawings but which he ultimately abandoned. His most epic idea, however, was an animated history of the world according to the Bible; he planned on collaborating with his friend George Randolph Chester but abandoned the idea when Chester died unexpectedly.

McCay, who was always comfortable holding a microphone or standing on a stage, continued giving speeches advocating for animation. He was still convinced, wholeheartedly, that it was an art form worthy of galleries and museums. This attitude put him somewhat at odds with some of the animators present at Roth's that night, notably Paul Terry. Terry's low-rent style and sensibility had taken hold of a segment of the industry—it was trending, a later generation would say—and this bothered McCay. Earlier that fall, he had complained to a radio audience, "Since I originated animated drawings the art has deteriorated . . . I hope and dream the time will come when serious artists will make marvelous pictures." Then he mused about what Michelangelo might have done "had he known this art."

Despite McCay's speeches and occasional public utterances, his fellow animators seemed largely unaware of his criticism. In person, he was mostly cheerful and easygoing. Perhaps this is why the cartoon they chose to play that night, partly in honor of him, was so tone-deaf.

The animators had all come together to make a special cartoon for the evening, titled *Eveready Harton in Buried Treasure*, the title a reference to erections and sexual intercourse. Which studio started the film is not known, but once it animated a short section, it passed that on to the next studio, which animated another short section and passed the film on again, creating a kind of animated chain letter. This was never meant for public consumption, and in fact was so dirty that no lab in New York would process the film, for fear of violating decency laws; apparently it had to be developed in Cuba, where the law was more lax. It was so notorious, and its showing at Roth's so hush-hush, that many animators and historians, over time, began to doubt that it had ever actually existed. Only a few scattered copies would survive until the Internet age caused it to be widely disseminated.

Once the cartoon started rolling, it was immediately clear that no topic was out of bounds, no matter how tasteless or crude. There were glistening erections, fully detailed labia, mounds of pubic hair, endless ethnic jokes. Eveready Harton, the main character, has a penis so big he needs a unicycle to support it as he runs around trying to have sex with both people and animals, opening a Pandora's box of gags involving venereal disease, bestiality, any and all types of sexuality. No fold, flap of skin, or bodily secretion went hidden.

"The laughter almost blew the top off the hotel where they were screening it," one animator remembered. It provided a glimpse of what many animators of the era—mostly young men—thought was truly funny when left entirely to themselves. It was the equivalent of the filthy jokes stand-up comics tell to one another in the dressing room after their sets, trying to one-up each other.

Later in the evening, Max Fleischer motioned for McCay to come to the front of the room and give a speech. Winsor made his way through the crowd, unsmiling. The room quieted down once he reached the front, then the situation turned awkward as he started a dry lecture about the technical aspects of animation. Everyone there already knew the details of what he was talking about and became distracted; the room was soon lost, filling rapidly with the sound of scattered side conversations. Sensing that he had lost control, McCay regained everyone's attention by abruptly changing the topic to what he really wanted to discuss: the current state of animation. "Animation should be an art," he scolded the room, his voice cold. "That is how I conceived it. But as I see what you fellows have done with it, is making it into a trade. Not an art, but a trade. Bad luck!"

The night, which was supposed to be jovial, turned sour, as Izzy Klein recalled. The way McCay's speech had ended—"Bad luck!"—didn't even make complete sense. It sounded like a bad omen, or even a curse. But there was an uncomfortable grain of truth in McCay's words. For all the inventiveness, imagination, and achievements of a handful of artists—McCay, the Fleischers, Otto Messmer, and now Walt Disney—the industry was slipping into a lull. In many ways, much of McCay's work from a decade earlier was still the high-water mark of the industry. Animation hadn't evolved at the same rate live action

had during the same period. Many animation studios, particularly the ones operating in Paul Terry's wake, were becoming overly reliant on the same formulas and patterns, based on the same repetitive gags. Theater owners were beginning to grow weary. The only major studios still bothering with cartoons at that moment were Paramount and Universal. If animation were going to blossom into something bigger, as McCay hoped, the industry would need something new to shake it up.

Chapter 11

"Giddyap!"

Long before Winsor McCay's speech at Roth's, Max Fleischer had been working on a novel way to improve cartoons. Starting in the early 1920s, he had tinkered with ways to give them better sound, synchronized with the action on-screen. It was a long, difficult process, involving one early experiment that had ended in disaster.

Dr. Hugo Riesenfeld, conductor at the Rialto Theater, a luxurious movie palace on Broadway, had hired Fleischer to animate a cartoon conductor that would direct his live orchestra from the screen. As Max set up for a rehearsal, he was startled by the sudden sight of an Apache Indian, tomahawk in hand, bearing down on him atop a white horse galloping at full speed. But the horse never got to him—it was on a treadmill, a setup devised by Riesenfeld to create a live soundtrack of a horse galloping for a later showing of *The Vanishing American,* a silent western featuring the lantern-jawed Richard Dix.

Fleischer watched as his young son, Richard, napping in the front row, was jolted awake by the noise. The horse was aimed right at him, and Fleischer realized that the treadmill setup was disaster waiting to happen. "You can't do that!" he shouted at the director. "What would happen if, when the horse is going full gallop, the treadmill jammed? That horse would come flying off that treadmill right into the orchestra pit and probably into the audience too."

Fleischer offered a solution: Position the horse sideways, which was safer and would allow the audience to see all its legs in motion. "All we have to do is turn the treadmill sideways, put the horse and rider on it, and say, 'Giddyap!'" he explained.

The horse was shifted and brought again to a full gallop.

Then the treadmill jammed. The horse launched into the stage wings, hooves clattering, and smashed into a wall, breaking its neck; the rider jumped off right before the crash, sustaining only minor injuries. This was a story Fleischer liked to tell later, as a way to illustrate why movies needed to get the sound question figured out.

Riesenfeld was also drawn to the challenge of matching sound and film, and hired Fleischer as a creative technical consultant, introducing him to his friend Dr. Lee de Forest, a sound engineer.

Bushy-eyebrowed, with a push-broom mustache, Lee de Forest was something of a throwback, a man from that age of inventors who spent their time in laboratories crammed full of interesting gear. He held 216 patents, including one for the thermionic triode detector, an electric current amplifier that helped usher in the age of broadcast radio. Like Fleischer, de Forest had also been struggling with the many challenges of sound synchronization. If inconsistent hand-cranked cameras didn't ruin the timing, then projectionists cutting damaged frames out of film reels did. Many notable engineers had failed to solve these problems, including Thomas Edison, who in 1913 invented the Kinetophone, a device composed of a phonograph placed near a screen and connected to the projector by wires running under the floor. His attempt was a failure—rats constantly chewed through the wires, and the sound was almost always scratchy, prompting annoyed audiences to boo. Defeated, Edison eventually began arguing that synchronized sound wasn't desirable. "Americans require a restful quiet in the moving picture theater," he reasoned. "For them talking from the lips of the figures on the screen destroys the illusion."

Unlike Edison, de Forest wasn't willing to give up so easily. All he needed was money, but American investors were wary. They feared de Forest was running a stock manipulation scheme, a crime he was narrowly acquitted of earlier in his career. He also had a string of bankruptcies to his name, and a history of getting swindled by his business partners. With his prospects of working in the United States thus limited, de Forest found financial backing in Berlin instead, working on his "Phonofilm" idea there. In Germany he made progress, solving many of the synchronization problems by imprinting the sound recordings directly onto the film instead of playing them separately. Returning to America in 1923, he began screening examples of what

Phonofilm could do: a film of Calvin Coolidge giving a speech about the evil of taxes; another of singer Eddie Cantor warbling a song about "Georgie Porgie", and a third showing performer DeWolf Hopper onstage reciting "Casey at the Bat."

Fleischer was sold once he saw de Forest's demos. Using his introduction from Riesenfeld, he enlisted the engineer's help on an idea he was working up: the Song Car-Tunes series, in which audiences sang along to a ball bouncing across lyrics projected onto the screen. Their first film together was 1924's *My Old Kentucky Home*, which was technically the first sound cartoon.

Even though *My Old Kentucky Home* was released in 1924, by 1927 the industry still hadn't converted from silents to sound. Fleischer had been an exception, an early adopter of new technologies. But other industry leaders were wary. They worried that sound threatened their preexisting business models, criticizing it in the same way that high priests once called the printing press a passing fad. They ignored the potential and saw only the drawbacks, such as the hissy sound or the way actors' voices garbled each other out.

Those fearful of sound had various and differing reasons. Theater owners dreaded the expense of wiring cinemas for sound. Filmmakers resisted the extra hours of preparation sound required before a shoot. Actors worried it would drain spontaneity and life from their performances—Chaplin's *Modern Times*, portraying machinery as a confusing tangle of gears, was in part a statement on this. Critics likewise had their reservations, worrying that sound would drag cinema, a unique art form, into an unholy alliance with theater. Musicians were also scared: cinemas were one of their biggest employers, hiring them to fill the orchestra pits and play during silent features.

The biggest opponents of sound, however, were the studio moguls. They already fretted about the new radio technology, fearful of families abandoning movies to stay home at night and listen to prizefights and concerts instead. To neutralize what they saw as a growing threat, they had even launched a stealth propaganda campaign against "the dangers of radio," publishing alarming editorials about how radios "poisoned the air," causing hearing loss and starting

house fires. Their initial fear of "talkies" was similar; they worried that foreign audiences wouldn't accept movies where only English was spoken. "Who the hell wants to hear the actors talk?" grumbled Harry Warner of Warner Bros.

Harry Warner's fears quickly evaporated, however, once he realized how much money he could save by firing the thousands of musicians hired to play in his theaters. After that realization finally set in, sound was suddenly the future! In 1925, Warner Bros. met with Western Electric, where engineers were using de Forest's triode detector to develop a public-address system that could also work for movies. The new system they created for Warner Bros., a system called "Vitaphone," was announced in 1926.

The rest of the industry remained skeptical, and the other studios began organizing to fight what they called the "Warner Vitaphone Peril." But their opposition soon crumbled after *Variety*, an important trade paper, called Vitaphone an impending revolution. The other moguls also no doubt noticed Warner Bros. stock soar from $8 to $65 per share in late 1926, another enticement to jump aboard the train. In a flash, every studio was suddenly advertising new sound systems: Movietone! Cinematophone! Cameraphone! Synchroscope! Phonofilm!

In October 1928, Warner Bros. released *The Jazz Singer*, widely credited as the first "talkie." Audiences paid as much as $10 a ticket to watch Al Jolson in blackface, his arms outstretched and hands wagging, crooning, "You ain't heard nothing yet!"

There was no looking back. Eighteen months after *The Jazz Singer* debuted, a mere three of the seventeen movie theaters on Broadway were still showing only silent films. With the industry disrupted, the old fears no longer mattered. But, despite Max Fleischer's advocacy for sound, there was still one area of cinema where it had not yet flourished: cartoons. Since the images were drawn by hand, they were more difficult to synch than live action. Nor did audiences seem particularly eager for sound cartoons. Something about them just didn't seem natural. "Drawings are not vocal," animator Wilfred Jackson said. "Why should a *voice* come out of a cartoon character?"

Chapter 12

"That's Money
over the Barrelhead"

When Walt Disney saw *The Jazz Singer*, he wasn't scared of how it might disrupt the industry, he was thrilled—and also, no doubt, curious about how it might help his career. Like Max Fleischer, he did not resist but embraced new technology. Sound offered him the perfect opportunity for reestablishing himself after his falling-out with Charles Mintz and loss of Oswald. He just had to create a new character he could use it with.

When Disney returned to Los Angeles from New York, still smarting from his encounter with Mintz, the atmosphere in the studio was tense. Only three of his top staff had remained loyal to him, including Ub Iwerks. The others had agreed to continue working for Mintz, who had set up an agreement to make cartoons, including Oswald, for Universal. Disney was still obligated to make three more Oswald cartoons under his old contract, but once those were finished, his staff would transfer to Mintz's new studio; Disney and his loyalists would be left on their own.

Disney immediately began hiring replacement staff and working up a new plan. Not knowing whom to trust among Mintz's people, he and his remaining loyal staff began creating their new character in secret. Iwerks erected big black curtains around his desk and always kept a pile of random drawings handy, throwing them over his sketches when others walked by. The men also worked in Disney's garage, curtains drawn tight against the windows, where the atmosphere was more relaxed but still secret. This new character, which their livelihood depended on, soon became an obsession.

The exact origins of Mickey Mouse are murky—Disney knew that a good creation myth works best when left a little slippery. He was a performer first, never letting dry facts or details get in the way of a good story. Over the years, he would tell several different versions of Mickey's origins, each of which would be clarified and challenged by his colleagues and family members, all of whom inevitably had their own versions.

The most popular version has Disney creating Mickey during that angry train ride from New York to Los Angeles, while fuming over his fight with Mintz. Disney claimed he spent the long hours sketching a variety of characters onto cocktail napkins, then holding them up for Lillian's opinion. She paused when he held up a mouse named Mortimer. It was good, but a little "too sissy," she said—a name you might associate with a soap salesman or an undertaker's apprentice, not a cartoon character. Walt took a second to think and then suggested Mickey, a good Irish name, as well as an outsider's name that carried a kind of plucky appeal. "It sounded better than Mortimer," Lillian said, "and that's how Mickey was born."

At other times, depending on his mood, Disney put Mickey's origins in Kansas City. Sometimes he said the inspiration came when a mouse scurried by a park bench he was sitting on. At other times he said it came after he heard a mouse in the Laugh-O-Gram office. In yet another version, he said the idea came while he was working for the Film Ad Company, after he made pets of the mice he found munching on lunch scraps in his wastebasket—these mice he trained to eat from his fingers so he could sketch them in different poses. In still another version, always told with great emotion, he spoke of having to set one of these beloved pet mice loose. "When I looked back," Disney said, choking up, "he was still sitting there in the field watching me with a sad, disappointed look in his eyes."

Ub Iwerks, Disney's chief collaborator, typically laughed off these stories as "highly exaggerated publicity material." Iwerks was also from Kansas City and had worked with Disney since the very beginning. The two were a good pairing, and even looked a little bit like each other, except that Iwerks's hair domed up as if he had combed it with an electrical cord. He was the superb technical draftsman that Disney wasn't,

while Walt had the qualities—the storytelling gene, the showmanship, the gift for self-promotion—that the stoic Iwerks lacked.

As Iwerks remembered it, Disney didn't return from New York bursting with confidence, strutting into the studio waving a cocktail napkin with a picture of Mickey on it. Instead, he wandered through the door depressed. According to Iwerks and several others, he, Walt, and Roy began meeting daily to brainstorm new ideas, sitting in the office, huddled away from the Mintz loyalists. Their research consisted of flipping through magazines and hoping an idea would grab them. After settling on a mouse, Walt took the first stab at designing it, but it didn't look very good—long and skinny, more like a rat than a mouse. Then Iwerks took a turn, redesigning Disney's idea into something rounder and cuter, which also happened to be easier to animate. If they were "to push out 700 feet of film every two weeks," Disney recalled, "we couldn't have a character who was tough to draw." The circular ears could be drawn the same every time, saving animators the effort of adjusting for perspective required with more elongated shapes. Iwerks also gave Mickey four fingers instead of five, a modification that saved the animators even more time. Years later, after the Disney studio blossomed into a corporate empire, the four fingers would become an entertainment industry joke. "You realize now when you work for Disney why the mouse has only four fingers," said one comedian. "Because he can't pick up a check."

Mickey first appeared in *Plane Crazy*, a silent cartoon spoofing Charles Lindbergh's transatlantic flight. Disney said he dreamed up the story during the fateful train ride from New York, while Iwerks said it originated during the spitball sessions among him, Roy, and Walt. However it came about, they all described production the same way: they worked in secret, hiding from the Mintz loyalists. Iwerks, a staggeringly productive artist, did most of the drawing himself, churning out 700 drawings a day. This first portrayal of Mickey was far different from how people would later remember him: in *Plane Crazy* he is chauvinistic and sexually aggressive, pawing at his girlfriend, Minnie, who flees his advances by jumping from the airplane and using her bloomers as a parachute. Mickey responds by laughing and throwing a horseshoe after her—a horseshoe she had given him as a gift, for good luck.

Once it was finished, Disney began shopping *Plane Crazy* around to distributors, announcing that he intended to "make the name of 'Mickey Mouse' as well known as any cartoon in the market." But the distributors weren't interested. Nor were they interested in *The Gallopin' Gaucho*, another silent Mickey cartoon made on the heels of *Plane Crazy*. Not only were cartoons "on the wane," as an executive from MGM put it, so were silents. Disney was planning for his third Mickey cartoon to have sound, however; he knew that this would be the future. He had even reprinted his business cards to read, "Sound Cartoons."

While working on his first sound cartoon, Disney occasionally slipped out of the studio to go watch other animators' efforts to do the same. But he was rarely impressed. MY GOSH—TERRIBLE—A LOT OF RACKET AND NOTHING ELSE. I WAS TERRIBLY DISAPPOINTED, he cabled to Roy after catching a sneak preview of *Dinner Time*, Paul Terry's first synchronized sound cartoon. BUT HONESTLY—IT WAS NOTHING BUT ONE OF THE ROTTENEST FABLES I BELIEVE THAT I EVER SAW, he continued, unable to hold back. THE TALKING PART DOES NOT MEAN A THING. IT DOESN'T EVEN MATCH. WE SURE HAVE NOTHING TO WORRY ABOUT FROM THESE QUARTERS.

His next Mickey cartoon, the third one, spoofed Buster Keaton's film *Steamboat Bill, Jr.*, and was called *Steamboat Willie*. Once the cartoon was animated, the soundtrack was recorded in New York during a troublesome recording session that lasted almost two months in summer 1928. The first musician to arrive, a bass player, had a bottle of moonshine tucked away in his instrument case and played so heavy that he kept blowing vacuum tubes in the recording equipment. There were also problems with the orchestra conductor; Carl Edouarde, a showy, artistic type who wore his hair long and fancied himself a maestro, kept bickering with Disney, saying that such "comedy music" was beneath him. Then there was the difficulty of playing the sounds so they synched to the preexisting images; this required the careful use of metronomes and bar sheets to match the timing of the measures and beats with the action. (Animators would quickly learn that recording the soundtrack first, then drawing the action accordingly,

was easier.) Disney spent the entire time so preoccupied with getting everything right that he forgot to eat, losing ten pounds.

Disney was pleased with the finished results, but he and Roy had one final problem: they didn't have a distributor. Walt traveled all over New York screening the film but was constantly rejected, told by potential distributors they would be in touch if interested, which meant they probably weren't. Finally, in a stroke of luck, Harry Reichenbach, manager of New York's Colony Theatre, attended one screening and was impressed by what he saw. After hearing Disney fret about the lack of distributor interest, he offered to host the film for two weeks. If it got a good reception, then perhaps distributors would be more interested. Lacking a better option, Walt agreed.

Steamboat Willie debuted at the Colony on November 18, 1928, alongside a feature film entitled *Gang War*, about a saxophone player whose love for a dancer named Flowers traps him in the middle of a gang confrontation. Walt sat in the back of the dark theater nervously watching the audience, which he knew was really there just to see *Gang War*. After the crowd was in place, the lights dimmed and *Steamboat Willie* started rolling. Then the darkness slowly began filling with chuckles, which soon snowballed into laughs, and then into knee-slapping guffaws. Disney's anxiety melted into relief, then ecstasy when he later saw the reviews in the papers. "Not the first animated cartoon to be synchronized with sound effects," *Variety* said, "but the first to attract favorable attention. This one represents a high order of cartoon ingenuity, cleverly combined with sound effects. The union brought laughs galore. Giggles came so fast at the Colony they were stumbling over each other."

Before the two-week run ended at the Colony, Disney got phone calls from many of the distributors who had recently rejected him. Now they wanted the film but were still stingy over what they would pay for it; many in the film industry remained unconvinced of cartoons' staying power. Disney eventually signed a deal with Pat Powers, a businessman whose company, in addition to selling Walt the sound recording system used for *Steamboat Willie*, also distributed films.

Shortly thereafter, in 1929, Disney began releasing the Silly Symphony series, whimsical cartoon shorts set to sound. With a few exceptions, they were one-off cartoons that didn't feature recurring

characters. The first, and still one of the most famous, was *The Skeleton Dance*, a spooky, trippy portrayal of skeletons dancing in a graveyard. Ub Iwerks animated most of it in approximately six weeks. Its relative lack of plot and of gags turned out to be to its benefit, focusing the audience's attention instead on the film's moody and breathtaking atmospherics. It would prove to be one of the most captivating films of Disney's entire career, although many theater owners initially hesitated to show it because they thought it too gruesome. It was a clear demonstration of Disney's dedication to craft and high production values, employing visuals usually seen only in live-action films—the use of shadows, creative camera angles—and proved a watershed moment. Disney was fast proving himself an industry leader, filling the creative void Winsor McCay had complained about during the dinner at Roth's. Other animators began speaking of Disney as a genuine genius, with a knack for wringing every last drop of creativity from his collaborators with his out-of-nowhere inspiration. Many wanted to quit the studios they were working for and move to California to join Disney.

After a year of distributing his films through Powers's company, Disney felt he was not receiving a fair share of profits, so he set out to find a new distributor. Thus, in 1929 he found himself showing his films to MGM studio head Louis Mayer, a grizzled mogul who wore double-breasted suits, stabbed the air with his cigar when he talked, and was full of strong opinions. Two of Mayer's directors, George Hill and Victor Fleming, the latter of whom would go on to direct *The Wizard of Oz* and *Gone with the Wind*, had seen Disney's work and enthusiastically encouraged their boss to take a look. The first film they showed him was a Silly Symphony set in a garden, featuring flowers and plants swaying in time to music.

"Ridiculous!" Mayer growled, reaching over and punching a button on the projector, bringing the film to a lurching stop. "Women and men dance together. Boys and girls dance together. Maybe in boarding schools girls dance with girls . . . but flowers? Bah!" He moved toward the door, glaring at Disney. "I should be interrupted from a conference for such trash?"

Fleming steered Mayer back toward his seat and urged him to watch another, this one featuring Mickey Mouse. "That's money over the barrelhead," Fleming confidently assured him.

Mayer roared even louder when the next cartoon started. "Goddamn it! Stop that film!" he shouted, belching cigar smoke. "All over this country pregnant women go into our theaters to see our pictures and to rest themselves before their dear little babies are born. And what do we show them on the screen? Every woman is scared of a mouse, admit it . . . and here you think they're going to laugh at a mouse on the screen that's ten feet high." When his tirade was over, Mayer stomped out of the room, slamming the door behind him.

Rejected by MGM, Disney next visited Columbia, meeting there with Frank Capra, a young Sicilian immigrant who had quickly worked his way up from writing gags for Mack Sennett to become the studio's star director. Capra was unenthusiastic about taking the meeting, remembering Walt as a "scrawny, non-descript, hungry-looking young

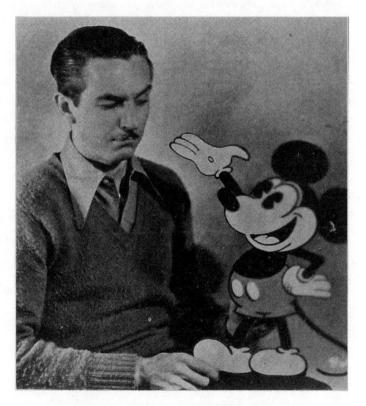

Walt Disney posing with Mickey Mouse
for a magazine profile in October 1931.

man, wearing two days' growth of beard and a slouch cap." But once he saw Disney's cartoons, he was impressed enough to urge his boss, studio head Harry Cohn, to also watch. Cohn's studio was relatively small compared with powerhouses like Paramount, making him willing to take risks others weren't, in hopes of standing out. Impressed with Disney's work, Cohn signed him to a distribution deal.

As soon as the ink was dry, Columbia began promoting its new star. A full-page ad in *Film Daily* called Mickey "The Most Popular Character in Screendom." The advertising soon become a self-fulfilling prophecy, as Mickey's success shot into the stratosphere as fast as Felix's had a decade earlier. From the beginning, people recognized and theorized about Mickey's unique connection to audiences. Dr. A. A. Brill, the first translator of Freud into English, told *Photoplay* that Mickey "narcotized" adults by returning them to a childhood where "everything could still be attained through fantasy." Another analysis claimed that Mickey's round design suggested a kind of impregnability that made him a "perfect expression of what he symbolizes—survival." The *Saturday Review of Literature* suggested that Mickey tapped into the id of a jittery new machine age: "The jerky rhythm of his movements, the constant collisions, explosions, and projections, are symbolic of nervous modern man living in a whirl of mechanical forces." *Progress Today* even granted Mickey a kind of religious status, calling him "St. Francis of the Silver Screen."

Disney had a once-in-a-lifetime phenomenon on his hands but didn't get swept up in all the analysis. He seemed to intuitively understand that academic noodling would kill the magic, so he kept his answers simple and plain. When no less a writer than Aldous Huxley asked him to elaborate on Mickey's theoretical underpinnings, he threw up his hands and shrugged. "We just make a Mickey, and then the profs come along and tell us what we got."

Chapter 13

"It Became the Rage"

The advent of sound films, or "talkies" as some called them, sent shock waves through the entertainment industry. Some careers, like Walt Disney's, were advanced by sound, while others were ruined. Clara Bow, adored as Hollywood's "It Girl," lost favor with audiences once they heard her squawky Brooklyn accent. Reginald Denny, loved for his American heartland appeal, was finished when audiences heard his dashing accent and realized he was actually British.

Similar disruptions happened to cartoons in the wake of *Steamboat Willie*. Now every cartoon studio wanted to convert to sound. "It became the rage," wrote one producer. "Everybody was talking about it and raving about the funny action this mouse character did." As silent cartoon stars were sent packing, Paramount, which was now a partner in Max Fleischer's studio, told Fleischer to start looking for characters to replace Koko.

None of this boded well for Felix either. Even so, Patrick Sullivan insisted to reporters that Felix would never change. He said the same thing to his staff. "You don't change when you're making money." What Sullivan didn't realize was that cultural shifts would change the context around his character, suddenly deflating Felix's popularity. Nor did he know, because nobody knew this yet, that the era Felix symbolized—the Jazz Age, wild, surreal, lawless, and a touch sinister—was about to become the Great Depression, a time when audiences would yearn for something more cheerful, optimistic, and plucky.

By the time Pat Sullivan finally ordered his studio to convert Felix the Cat into a sound cartoon, it was already too late, nearly two years after *The Jazz Singer*. The switchover was announced in a *Film Daily* ad featuring Felix mimicking Al Jolson's words, "You ain't heard nothin'

yet!" But the new cartoons seemed to reject sound the same way a body rejects a blood infusion of the wrong type. Felix's voice was a grating whine and the films were done cheaply, postsynchronized and rushed, resulting in mismatched skips and delays. "Felix was doomed because he was a silent pantomime character," animator Hal Walker recalled. "Disney put us out of business with his sound."

Walker and other staff were fired and replaced by cheap free-lancers. Walker, who had been "eating, breathing, sleeping Felix the Cat," said the firing "was like the world came to an end." During a trip to New York, Walt Disney again surfaced at Sullivan's studio, like a shark slipping over the edge of a reef, to attempt to hire away his talent. Otto Messmer turned down the offer, but when animator Burt Gillett heard of Disney's presence, he timed his exit from work that day so he would run into Disney outside. Gillett, who had worked for Raoul Barré, Hearst's IFS, and Max Fleischer, practically knocked Walt over as he thrust his hand out and declared, "I'm your man!"

After their short, sputtering flameout, the Felix cartoons were stopped in 1931, although brief attempts were made to periodically revive them over the coming decades. Even so, the character still required work from Otto Messmer. He continued to draw the Felix Sunday comic strip and would eventually draw a Felix comic book. Sullivan still continued to earn most of the profits and paid Messmer his small portion by check, although the checks became harder to cash because alcoholism had made Sullivan's signature nearly illegible. By the time Sullivan died, in 1932, alcohol and syphilis had so chewed up his brain that he no longer recognized Messmer when he walked into the room.

The final months of Sullivan's life were filled with speculation about the death of his wife, Marjorie, who was rumored to have been sleeping with the couple's chauffeur. Pat Sullivan apparently confronted them about it in their seventh-floor luxury apartment in the Forest Hotel, and, moments after the chauffeur stormed away in a huff, Marjorie tumbled out of the window. Her impact knocked over a nearby pedestrian, who became so startled he broke into a run and had to be chased down by policemen trying to determine what happened.

Was it suicide, murder, or an accident? Hal Walker faulted Sullivan. "Pat was an alcoholic and a sex maniac" who had "used Marjorie for purposes of influencing other men," he later said, adding that Sullivan had used his Felix money to finance a madam and open a brothel. This was surely humiliating for Marjorie, who contracted syphilis from her husband; it marred her body with scars and forced her to appear in public wrapped in scarves.

Even though Marjorie Sullivan's life was sad, many didn't accept the suicide theory. "She had everything," her niece argued. Otto Messmer likewise thought that, despite her unfortunate domestic situation, she didn't seem prone to killing herself. The facts and details became garbled as people attempted to unravel them. In her obituary, the *New York Times* said the whole incident was an accident, reporting that she had merely wanted to go shopping, plummeting to her death after leaning too far out the window while trying "to attract the attention of her chauffeur."

Just as sound disrupted the movie industry, another new disruptive technology began emerging, although its full effect wouldn't be felt for another two decades. One summer day in 1928, a group of technicians stood in RCA's mid-Manhattan studio erecting a twelve-inch papier-mâché Felix doll on a phonograph turntable. They switched on the turntable and the doll began slowly turning, bathed in hot lights, as the technicians made adjustments. As they fiddled, another group of technicians in Kansas City, more than a thousand miles away, flipped another switch and watched a tiny two-inch screen spark alive. A grainy image emerged, as if filmed through venetian blinds, of the rotating Felix doll.

People had not yet settled on a name for this new technology, by turns describing it as "distant electric vision," "radio with pictures," and "radiovision." The name that would eventually stick, however, was used by Philo T. Farnsworth, an inventor who had provided the important breakthrough of using cathode-ray tubes and electron beams for the new technology. His efforts were so secret that he had waited until his wedding night to even tell his new bride about them. "Pemmie," he

said, grabbing her by the shoulders, his eyes wild. "I have to tell you. There is another woman in my life—and her name is Television."

Born in 1906, Philo T. Farnsworth was described by one biographer as looking "the way an inventor of that era is supposed to look: slight and gaunt, with bright-blue exhausted eyes, and a mane of brown hair swept back from his forehead." Bouncing between fits of exuberance and depression, he had been a boy genius, good at math and science, declaring by the age of six his intent to follow in the footsteps of Thomas Edison and Alexander Graham Bell. As a boy, while tilling his parents' potato field in Idaho, the fourteen-year-old Farnsworth had seen the neat rows of dirt in front of him and had the sudden epiphany that a picture could be sent through the airwaves the same way: broken down into transmittable lines and then reassembled wherever the transmission ended. At nineteen, he dropped out of college and moved to California, securing enough financing to establish a small laboratory where he could work on his ideas.

The concept of television had existed since at least the 1870s, much of it based on the same idea Farnsworth had in his parents' potato field: that images could be broken down into individual lines, then transmitted and reassembled. Over the next several decades, scores of engineers tried but failed to come up with a workable solution to achieve this goal. Then, in 1908, a British engineer named A. A. Campbell Swinton suggested it might make most sense to scan the images electronically, using a cathode ray. Almost two decades later, Philo Farnsworth was the first to discover how to actually do it. His image dissector was a vacuum tube fitted with a lens and a photoelectric plate next to the lens to convert the light emitted by images into electricity. An image was broken down into separate lines, scanned by an "anode finger," transmitted over the airwaves, and then reassembled back into the original image and onto a screen. Farnsworth spent 1927 developing a working prototype.

Several months before the Felix broadcast at RCA, Farnsworth met with the group of investors sponsoring his research. "Here's something a banker will understand," he told them, turning on his prototype screen to display an image of a dollar sign that was being filmed, several feet away, by his makeshift television camera. Upon seeing it, the investors laughed and slapped their knees. Right then,

they decided to stop calling the project "Jonah," an inside joke about how it had been swallowing all their cash.

Exactly how the project would make them money was another matter. The technology still needed more research and development —nobody could say for certain how much. As of then, the screen was tiny and the image poor—"shadow spaghetti," the *Baltimore Sun* sniffed. And what it would be used for was far from clear. *Scientific American* speculated that it could be used to prevent crime. AT&T saw potential in "visual telephones." Others wondered if it had some business use, like a primordial fax machine. Still more thought it might have military applications.

Only a few considered its entertainment potential; at this point, the crude technology was clearly no competition for film or radio. But one of the positive few was Winsor McCay, who wondered how this emerging new technology might benefit cartoons. He would die in 1934, never learning the answer, but several months before his death he appeared on the radio to discuss his thoughts about the matter. "The industry now in the laboratory—television—offers new hope," he began. "Larger than the stage and the screen together, it will be forced to develop its own talent—forced to breed a race of showmen. It will take time, of course, but it will come. American ingenuity, American enterprise, American creativeness will achieve it . . . Television will discover new lands for the animated cartoonist to explore, new problems for him to solve, new things for him to create. I envision the day when 100,000 men and women will be turning out animated comic strips to be televised over the networks under the sponsorship of breakfast foods' manufacturers for the entertainment of the nation's youngsters."

McCay's words were eerily prescient, but it would be many years before more than a few Americans would begin discussing television. First, the technology needed its kinks worked out. Besides McCay, no other animators commented on television or its potential at that point. They were all still trying to adapt to sound.

When Paramount told Max Fleischer to create a new character for the sound age, replacing Koko the Clown, the job fell to Dick Huemer, the animator who helped redesign Koko in 1923 and had also

helped design Fitz, Koko's canine sidekick. His new character would
be a dog similar to Fitz, but with a little more swagger and a rounder
face, similar to Mickey Mouse. The character he helped dream up was
named Bimbo, after Max Fleischer's pet Brussels griffon. Although
that word would eventually come to describe a zany woman, during
Fleischer's era it was more typically used as slang for a man who gets
into lots of fights.

On March 29, 1930, Bimbo made his debut in the fourth cartoon
of the Fleischers' new Talkartoons series, entitled *Hot Dog*. His first
line of dialogue—"AAAAAHHHHHH!!!!"—is in response to getting
punched in the head by a woman trying to escape his lecherous grasp.
Just prior, she had been roller-skating down the street, enormous

Recording session for a cartoon
at a Paramount recording studio, circa 1932.

bosom jiggling, as Bimbo scooped her into his car. A police officer responds to the ensuing commotion and hauls Bimbo to court not because he was assaulting a woman, but because he was speeding.

"Well yer honor, ya see it was this way . . ." Bimbo tells the judge, trying to explain himself. Words failing him, he whips out a banjo and starts strumming Eddie Peabody's *St. Louis Blues*. As the song roars through the courtroom, the judge's face softens, the jury sways back and forth, and a blindfolded Lady Justice begins shaking her hips. The court stenographer bangs away at her typewriter like a pianist, arms swinging up and down, recording Bimbo's scat lyrics: "doo-ey a do do e-ya doodle e doo doo ey a doo!" As the room hits peak frenzy, Bimbo flips his banjo on its end and begins riding it like a unicycle, tipping his hat to the jury as he rides out the door, shouting, "That's all!"

Within a year, the Fleischers released nearly a dozen more Talkartoons, many starring Bimbo. Most featured popular songs similar to Peabody's *St. Louis Blues*, which Paramount held the rights to. With the advent of sound, film studios suddenly realized the value of using cartoons to promote their vast music catalogues, creating what a later generation of marketing gurus would call "synergy." This addition of contemporary music gave the cartoons wider appeal than they had ever had. Only two studios—Universal and Paramount—had been bothering with cartoon distribution at the time of McCay's dinner at Roth's in 1927, but sound had renewed interest among the others. "When the motion picture was in its pre-sound days, the whole animated cartoon industry might have been purchased for a mere $250,000," *Popular Mechanics* wrote in July 1931. "But with the aid of sound the hand-made movies achieved a huge popularity. They appeal alike to the Chinese coolie and the Alaskan Indian."

Within a year, it was obvious that Bimbo's success would not match Mickey's. The reasons were many, starting with Bimbo's general obnoxiousness and inconsistent appearance. The freewheeling spontaneity of Fleischer Studios meant that Bimbo rarely looked the same from film to film. In some cartoons he was black, in others white. Sometimes he wore a hat, sometimes he didn't. Also, his voice was unpleasant, a guttural sort of bark bringing to mind a bulldog choking on sandpaper; it was provided by Billy Murray, an old vaudeville singer who had built his career during an era of primitive microphones that

forced him to develop a shouty and grating singing style. (His career would fade when better microphone technology enabled the era of Bing Crosby–like crooners.)

Eager to boost Bimbo's popularity, Dave Fleischer began brainstorming new ideas. Wandering over to the desk of an artist named Grim Natwick, he posed a question. "Mickey Mouse has Minnie," he said. "Do you think Bimbo needs a girlfriend?"

Natwick was one of the best artists in the studio, with skills well suited to an assignment like this. After studying at the Chicago Art Institute and New York's National Academy of Design, he had spent several years studying the works of Gustav Klimt and Egon Schiele in Europe, gaining a reputation for being particularly good at drawing the female form. With an intense stare and a dense thicket of swept-back hair, he resembled the German expressionists he had studied with in Vienna. Leggy and broad-shouldered, he had also been a track champion in Wisconsin, an experience he claimed gave him an intuitive sense of movement, thus making him a better animator. Getting realistic female characters to move in believable ways was one of the top challenges then faced by animators.

For inspiration, Dave Fleischer handed Natwick a photo ripped from a magazine.

"She was wearing spit-curls I remember, she had a kind of round face, and so I started creating a little dog character," Natwick recalled. "But as I got into it, I couldn't resist making a cute little chorus girl . . . a little burlesque." Natwick's initial design, resembling a cross between a dog and a woman, looked almost primordial: it had the bust and hips of a human, the jowls of a bulldog, and the ears of a French poodle, drawn to resemble hoop earrings.

Still without a name, the new character debuted as a nightclub singer in August 1930, in a film entitled *Dizzy Dishes*. Held together by little more than a few garter belts and some hairspray, she crooned a hit song from the Paramount catalogue—"And if I want to make whoopee"—while fanning her skirt up for Bimbo. In the background, a caricature of Mickey Mouse ogles her, the Fleischers' sly nod to their competition.

During the character's second appearance, in *Barnacle Bill*, she was still nameless as she finds herself seduced by Bimbo, here playing a

sailor on port call, who serenades her on the street and then stomps up to her room while singing, "I'll spin you yarns and tell you lies . . . I'll drink your wine and eat your pie . . . I'll kiss your cheek and black your eye." The curtains are drawn and the camera cuts away to alley cats gossiping about what the two might be doing up there. Back in the bedroom, the dog-woman asks Bimbo if he wants to get married. Horrified at the prospect of being chained down, he jumps out the window and into the harbor, where he begins dancing with two buxom mermaids.

It was soon apparent to Natwick that the character's appearance —that funky hybrid between a dog and a woman—didn't quite work. His response was to make her more humanlike with sexier curves, but Dave Fleischer wasn't convinced once he saw it. "I like the face," he began, "but Bimbo is a dog. Shouldn't she have a dog's body?"

Betty Boop model sheet, circa 1931. Note the doglike ears
used as she transitioned from being Bimbo's canine-like companion
into a fully human woman.

Natwick grabbed a new pencil and drew the new character's face with a fully canine body. Then he pointed back to his other sketch. "What do you want? A dog's body or a pretty girl's?"

"You're right, Grim."

Several months later, the character briefly appeared topless in *Mysterious Mose*, and she appeared again in April 1931 in *The Bum Bandit*, both times still nameless. A month later, when *Silly Scandals* debuted, she surfaced again, singing on a stage. This time, she appeared more humanlike, and also had a name, shouted out by another character in the crowd: "Betty!"

Betty Boop's popularity quickly grew into a whirlwind of success that her creators never would have imagined. Soon, she was starting to rival Mickey. Then, in 1932, she sparked a scandal that threatened to ruin the studio.

Chapter 14

"I Have Become a Ghost"

The Manhattan courtroom was noisy. An excited crowd of spectators drowned out the sound of the gavel trying to keep order. The Betty Boop trial had dragged out from days into weeks during the spring of 1934. Max Fleischer sat at the defendant's table, across from the only man who seemed to want to be there less than he did: New York Supreme Court Justice Edward McGoldrick.

Throughout the trial, McGoldrick watched the newspaper hacks turn his courtroom into a circus. They just couldn't take a trial about cartoons seriously. When the court stenographer interrupted the lawyers to ask how to properly transcribe Betty Boop's lyrics, they burst into rude laughter. Was it "Boop-boop-a-doop," she asked, or just "Boop" followed by "doo-doo-doo?"

The lawyers couldn't agree, bombarding each other with renditions of their own interpretations. It was an important matter to clarify, since the lyrics were at the heart of the trial. Witnesses were then called to perform, but that only made things more awkward. When one of them suggested that the proper interpretation might actually be "Boo-doo-da-doop," a new round of heated disagreement erupted.

McGoldrick hushed the courtroom with his gavel, then ordered the stray "boops" struck from the record. Order restored. Nevertheless, the next day's papers had a field day with the proceedings. One described the analysis of Betty's singing as "Boop-Boop-a-Doopery," as though this were some esoteric field of linguistics. Another headline called the fiasco the "'Boops' Heard Round the World."

The plaintiff in the trial was Helen Kane, a singer who claimed that Betty Boop was based on her, and that Max Fleischer had stolen the idea. Originally from New York, Kane had traveled east from

Hollywood for the trial. She wanted $250,000. If she won, Fleischer Studios would be ruined.

Throughout the trial, Fleischer stole glances at Kane across the courtroom. On the day of the "Boop-Boop-a-Doopery" debate, she wore, sticking out of a red hat, a long feather that jabbed her lawyer in the face whenever he leaned in to whisper something. Her own rise in showbiz had been as meteoric as Betty Boop's. She became a star in the early 1920s after performing with the Marx Brothers at age fifteen. She was soon making $8,000 per week, a Hollywood starlet lounging in the backs of limos as they zoomed through the studio gates. As a singer, she was paid as much as $5,000 to sing just a few bars at society galas. She called her chirpy, childlike style "baby vamp." To hear her courtroom testimony and see her face—with hair like Betty's, parted down the middle, flanked by spit curls—made it clear she had a strong case. Plus, she had popularized the "boop-boop-a-doop" line before Betty Boop was ever created

In the courtroom, Kane's attorney questioned her. "How do you interpolate your boops in your songs?" he asked.

"It's hard to say," Kane explained. "It's a form of rhythm I created. There's a bar of music and at the end there's a stop."

"Were you ever known as the boop girl?"

"Sometimes, I was introduced as just 'Boop.'"

Career wise, Kane was in a vulnerable position. She had recently fallen off a hot streak—six films in just two years, alongside big stars like William Powell and Buddy Rogers. But job offers had suddenly started drying up, and now her personal life was a struggle as well. In the two years since she launched the lawsuit, she had divorced one husband, married another, and lost much of her fortune on a bad investment in a dress company. Then her second husband abandoned her, igniting a nervous breakdown. Kane checked into a sanatorium far outside Los Angeles, wandering amid the cactus, waiting for her comeback. Perhaps worst of all—at least by showbiz standards—she had gained weight, enough to scare movie producers into looking over her shoulder for the next girl they could cast. *Time* magazine showed her no mercy, describing her in the courtroom as "fatter but still talking with the voice of an indignant doll."

Her accusation bothered Fleischer. He would wander around his studio talking about it, questioning her motives, trying to figure out her angle. It was easy to resent her. Here he was, a rising mogul, and there she was, just another shooting star fading out over Hollywood's desert sky.

Kane's lawyer, Samuel Weltz, rose from the plaintiff's table and began questioning Fleischer, asking where he got his inspiration for Betty. Fleischer was the studio head, but, like other animation studio heads, he took disproportionate credit for creating characters that were often dreamed up by others. Weltz treated him as if he were the sole creator, and Fleischer played along, just as Walt Disney or Patrick Sullivan probably would have done in similar circumstances, in order to serve his role as promoter.

Fleischer admitted that he had seen Kane perform in 1928, the year she first began using "boop-boop-a-doop." According to Kane, the phrase was just some playful gibberish she tacked onto the end of her song "That's My Weakness Now." It had reached No. 5 on the charts, part of the 1920s soundtrack moving a dancing sea of flapper cloches and straw boaters. Though admitting he saw Kane perform, Fleischer insisted Betty Boop was nevertheless a figment of his imagination.

Weltz didn't buy this, drilling Fleischer with more questions. "Aren't you influenced by the people you meet in life when you create a cartoon character?"

"Not exactly," Fleischer answered carefully.

"Is the hairdress of Betty Boop one of the figments of your imagination?"

"Yes."

Weltz's questions took a hard edge. "When you saw Miss Kane in 1928, did you look at her nonchalantly or studiously?"

Fleischer's lawyer objected, dragging the trial out further. Justice McGoldrick sat in his chair, probably wondering how somebody like himself, a man who had so carefully navigated Tammany Hall politics, could now be sitting here listening to this. He sustained the motion. This was lucky for Fleischer, who was taking liberties with his testimony.

* * *

Tracing the exact origins of most cartoon characters is a difficult task. Many are created collaboratively, in a process that can resemble a chain reaction: an artist tosses out an idea and others riff on it, like jazz musicians improvising a tune. Credit became more important in a case like Betty Boop's; once the character became famous, a lot of money was suddenly at stake, and artists would begin telling stories that colored the facts with their own ambition and motives.

During his courtroom testimony, Fleischer didn't take full credit for Betty, but did say her "mature" figure and "rolling eyes" were his idea, even though they were actually Grim Natwick's. Nor did he mention the magazine photo that Dave Fleischer handed to Natwick as inspiration. Years later, Natwick would recall that the photo was of Helen Kane, who was then under contract with Paramount. Natwick also recalled Dave telling him they had found another singer who could do a perfect impression of Kane.

By the time of the court case, Grim Natwick had left the Fleischer studio and gone to work for Walt Disney. Disney obsessively watched his competitors' work, scouting their talent so he could poach it. During his interview with Natwick, he admired one scene in particular—of Betty climbing onto a train—and commented specifically on the ways Betty's body had moved and her dress had fluttered. These small details helped reveal her character, which impressed Disney, who thought that strong character was the secret of good animation. "Until a character becomes a personality, it cannot be believed," Walt wrote in the *Disney Handbook*, a studio reference guide. "Without personality, the character may do funny or interesting things, but unless people are able to identify themselves with the character, its actions seem unreal." Disney's commitment to such details captured Natwick's respect, luring him away. It also captured critical respect, another enticement to animators of Natwick's caliber. In June 1932, Gilbert Seldes, esteemed critic from the *New Republic*, wrote that Disney's Silly Symphony series was the "perfection of the movies," proving that cartoons had "reached the point toward which the photographed and dramatic moving picture should be tending, in which, as in the silent pictures, everything possible is expressed in movement and the sound is used for support and clarification and for contrast."

In a roundabout way, Disney was at least partially responsible for Betty Boop's popularity. As the Fleischer animators watched Disney's success pass theirs, they responded by implementing his lessons in their own work. Betty Boop became the studio's marquee star because of her complex personality—the way she flirted coquettishly and used a sense of mystery to establish control over others. In *Betty Boop's Crazy Inventions*, she's an inventor changing the future. In *Betty Boop for President*, she wins the White House backed by crowds cheering, "We want Betty!" Reminiscent of the Jazz Age more than the Great Depression, Betty offered an escape back to a happier era, but without sentimental or sappy nostalgia. She was of the past, but also of the future. Just what everyone had been waiting for, she set a new tone. Whereas the waifish, flat-chested look of flappers had been fashionable during the 1920s, the 1930s embraced zaftig curves like Betty's. Two years after her debut, the Formfit bra company introduced the "Boneless Duo-Sette," which "beautifully accents the uplift bust." The April 1932 issue of *Vogue* announced, "Spring styles say CURVES!" Betty surfed the cultural waves of the 1930s the way Felix had surfed those of the 1920s.

Betty had widespread popularity, but her appeal was also very specific: she was for outsiders. The Fleischer artists designed her for people living in the kinds of neighborhoods they themselves had mostly grown up in: Lower East Side tenements where laundry dried on fire escapes, cross-pollinated by the old Baltic smells drifting up from the delis and smoke shops. The Lower East Side, along with Brooklyn, was home to a diaspora of Yiddish-speaking Jews who had been forced from Europe. In America, they were caught between two worlds, a predicament the Fleischer cartoons acknowledged through a language of codes, inside jokes, and sly winks. A diner customer who bellows for pork in *Dizzy Dishes* finds Bimbo hurling at his face a ham that is labeled with the markings of Kashruth, Jewish dietary law. The same Hebrew lettering flashes briefly, almost subliminally, atop an ambulance in *Betty Boop's Big Boss*, and explodes out of the thermometer Koko the Clown uses to take his temperature in *I'll Be Glad When You're Dead, You Rascal You*. These were jokes about the trade-offs involved in abandoning one culture for another. In *Betty Boop's Bamboo Isle*, the Fleischer Studio framed this theme as a

question of identity. Betty is cast as a brown-skinned Samoan princess who falls in love with Bimbo, who is cast as an American sailor lost at sea. Once he washes ashore, he begins serenading her with a ukulele—an unsubtle way to cram a song from Paramount's music catalogue onto the soundtrack.

"Don't be scared," she tells him as the natives approach, angry and clutching spears. Fearing he'll be killed as an outsider, Bimbo disguises himself by darkening his face with mud and sticking a bone in his hair.

"*Shalom aleichem*," one of the natives shouts, using the universal greeting of Jews in the diaspora. They recognize Bimbo as one of their own. Then, instead of killing him, they make him king, treating him to a life lounging on a throne beneath a canopy of palms, enjoying paradise. After a rainstorm rinses the mud from Bimbo's face, however, his true identity is exposed, and the natives reject him as suddenly as they had accepted him. Bimbo and Betty are chased into the night, sending a clear message to audiences: they'll eventually discover your disguise, and then come after you.

This was a favorite theme of Fleischer cartoons. After Bimbo falls through a manhole cover in *Bimbo's Initiation*, he finds himself in a sewer that is a grotesque funhouse of mirrors and hidden doors. On the street above, a caricature of Mickey Mouse runs up and clasps a padlock on the manhole cover, sealing him into his fate. After his eyes adjust to the dark, he finds members of a cult waiting for him underground, carrying planks studded with nails, chanting, "Wanna be a member? Wanna be a member?"

"No!" Bimbo cries, but the initiation rites begin anyway: lashings, stabbings, spankings. He finally escapes by jumping through a door, but only to find himself in a room worse than the one before. So he jumps through another door, and then another, successively finding himself in increasingly worse places. In one, a swinging blade decapitates his shadow, while reflections in the mirrors take on lives of their own. Just as it seems that there are no more metaphors to exhaust, Bimbo finds himself trapped under a canopy of spikes held aloft by a rope that's slowly being burned away by a candle. Playing in the background is the cheerful fiddle music of "Turkey in the Straw," a favorite tune of Americans who immigrated to the United States a

generation or two before the Fleischers. The message of the music is clear: they don't want the newcomers there. Bimbo again escapes to find that one of the cult members, after removing her mask, is actually Betty.

"Wanna be a member? Wanna be a member?" she sings, seductively rubbing her hands up and down her body. The carefree Americana soundtrack has faded into a wisp of minor-key clarinet, calling to mind the memory of sounds once heard wafting over the cobblestone streets of places like Minsk.

"Yes!" Bimbo shouts as the cult members rip away their masks to reveal they all look like Betty. As the cartoon ends, Bimbo pulls Betty in for a dance. A smile spreads across his face, and they begin spanking each other.

During the "Boop-Boop-a-Doopery" trial, a group of young women who had all voiced Betty Boop in her cartoons were called to testify. The roster included Margie Hines; Kate Wright; Bonnie Poe; and Ann Rothschild, whose stage name, Ann Little, came from the fact that she was four feet ten inches tall and weighed only seventy-six pounds. Since 1931, however, Mae Questel had mainly provided the voice, earning the job after winning a Helen Kane impersonation contest in 1930. Her prize included $150, an autographed picture of Helen Kane (signed "To another Helen Kane"), and a four-day show at the RKO Fordham Theatre. This resulted in her getting booked at other shows along the East Coast, one of which Fleischer saw before hiring her. During the trial, Kane at one point allegedly approached Fleischer and offered to drop the case if he would fire Questel and hire her instead. Why have an impersonator if you can have the real thing? But Fleischer refused.

By providing testimony from several women who had performed as Betty, the defense argued that no single individual owned her identity. The defense also asked how one could realistically copyright words that were essentially gibberish. Little Ann Little took the stand and told the court that "boop-oop-a-doop" had started out as "ba-da in-de-do" and then evolved into "bo do-de-o-do" before morphing into its final form. She described the process the way a scientist might

Actress Mae Questel provided voices for
the Fleischer characters Betty Boop and Olive Oyl.

explain how a lump of coal becomes a diamond. Every time, she
squeaked out her own renditions.

Once she was finished, Kane's attorney asked if she spoke that
way all the time.

"Yes indeedy!" she chirped.

The defense argued that gibberish singing had a history long
before Kane. Alfred Evans, who worked for the singer Rudy Vallee,
testified that he heard Edith Griffith sing similar sounds during a
performance in Nebraska as far back as 1927. French singer Felix
Mayol's song "Bou Dou Ba Da Boum," from 1913, was also used as
evidence. Revisiting the case many years later, even Kane's husband
(she would eventually remarry) would make a case for the defense,
referencing *Much Ado About Nothing* and saying that booping probably
"goes back to Shakespeare with hey-nonny-nonny."

Kane was eventually called to the stand herself. Her lawyer asked her to remove her hat and coat and then began arranging her curls across her face, getting them to look just like Betty's. Then he handed McGoldrick a stack of sheet music featuring photos of his client.

"Of course, I shall consider only the pictures," McGoldrick began, "but I suppose counsel will have no objection if I try the music on the piano." As it turns out, McGoldrick was quite a piano player, eager to show off his skills. He also clearly took pity on Kane, adding that he would have no problem considering just the pictures because they were obviously the prettiest part of the sheets.

"Thank you," Kane murmured.

On April 23 and 24, 1934, McGoldrick retired to a screening room to watch films of Betty Boop and Helen Kane. During breaks, the lawyers continued making their arguments. The defense claimed that, among sixty-six songs featured in forty-six Betty Boop cartoons, Kane had previously performed only four. The defense lawyers also made their case in more secretive ways, removing a direct reference to Kane from a screening of *Stopping the Show* before McGoldrick had a chance to see it.

The case tipped decidedly in Fleischer's favor on May 2, after his defense team showed the courtroom a film of a black nightclub singer named Esther Jones, who went by the stage name Baby Esther. She had sung "boop-oop-a-doop" before Kane had. When Lou Walton, Jones's theater manager, was called to testify, he claimed that Kane and her manager had seen Jones perform just a few weeks before Kane began using the phrase herself. "Baby Esther made funny expressions and interpolated meaningless sounds at the end of each bar of music in her songs," Walton explained.

"What sounds did she interpolate?" defense attorney Louis Phillips demanded, wanting to know exact details.

"Boo-Boo-Boo," Walton replied.

"What other sounds?"

"Doo-Doo-Doo."

"Any others?"

"Yes, Wha-Da-Da-Da."

When the gavel fell, the Esther Jones evidence sealed the case in Fleischer's favor. McGoldrick ruled that Kane failed to prove that

the defendants had wrongfully used her singing technique. Clearly, others had been using it before her, although nobody bothered to ask if Jones, the African-American singer, might have a viable case herself. With the verdict, Kane sat crestfallen, and for years afterward she would insist that the Betty Boop cartoons were "a deliberate caricature of me." As the crowd drifted out of the courtroom, a reporter went over to Kane and captured her parting quote. She spoke of how people in Hollywood once regularly "greeted me as Betty Boop." But now, her legacy diminished by the trial, "I have become a ghost."

Chapter 15

"The Formula"

One fall day in 1933, a group of priests associated with the National Legion of Decency gathered in protest outside the window of the Fleischer Studio in Times Square, angry about another film playing nearby. They waved signs through the air as if these were torches and pitchforks, picketing the new Mae West and Paramount film *It Ain't No Sin*.

"It is," their signs read.

The protest was, by extension, against Betty Boop as well, since Grim Natwick had partly based her hourglass figure on Mae West's. At the time, West was America's biggest box office star, famous for scenes in which she would lean against a bar, a cigarette dangling from her fingertips, and purr innuendo. "A hard man is good to find," she would say, or "When I'm good, I'm very good. When I'm bad, I'm better." Earlier that year, West had promoted *I'm No Angel* by claiming it was about "the kind of girl who climbed the ladder of success, wrong by wrong." She liked to characterize her relationship with the studios by saying, "I'm the kinda girl who works for Paramount all day, and Fox all night." To groups like the Legion, Betty Boop was just as tawdry, and they could point to films like *Betty Boop's Bamboo Isle*, in which her breast can be glimpsed peeking out from under her lei, as evidence.

The National Legion of Decency wanted none of it. For more than a decade, this and other similar organizations had been lobbying to create censorship rules for movies. American cinema of the 1920s and early '30s was surprisingly racy, giving audiences exactly what they craved. But, by 1933, the small but vocal protest groups were about to get their way, censoring and permanently altering not

just cartoons, but all of cinema. Reporting from the sidelines, the *New Yorker* predicted that movies were "about to observe a perpetual Lent."

The moral backlash had been a long time coming. Thirteen years earlier, in 1921, the film industry's biggest moguls had predicted it would happen and had attempted to stop it. On a winter's night, they met in a private dining room at Delmonico's, a New York steakhouse full of wood paneling and leather upholstery that crunched whenever guests shifted their weight. Adolph Zukor of Paramount led the meeting. If the film industry didn't protect itself, he told the other moguls, they all could face restrictive state and possibly federal regulations. It had happened to other industries, most notably the liquor trade, and could happen to theirs if they didn't take action.

Many of the moguls came from much the same background as Max Fleischer, who was born in Krakow, Poland, and emigrated to the United States when he was young. The Jewish ghettos of Eastern Europe were a factor in many of their beginnings. Louis B. Mayer, of Metro-Goldwyn-Mayer, was born in Ukraine. Adolph Zukor of Paramount and William Fox of the Fox Film Corporation were both born in Hungary. Harry Warner of Warner Bros. was born in Poland. Carl Laemmle of Universal was originally from Germany. Harry Cohn of Columbia Pictures was born in New York to parents who had recently immigrated from Russia and Germany. All had started somewhere near the dingy bottom, "dipped in a sewer," as Zukor put it.

The movie business was new and disreputable when they entered it, with few barriers to entry. WASPs had not yet stamped their arbitrary rules and protocols on it, as they had done for banking and law. The new industry provided ambitious Jews their own ladder for ascending upward into society. Many of the moguls had started in fashion or retail, industries that helped them hone a sharp eye for public tastes and trends, an essential skill in the movie business. They understood the immigrants and working stiffs who were the movies' first big audiences, because "they *were* the audience," one producer later told an interviewer. "They were the same people."

Movies had made the moguls some of the richest men in the nation. Even so, the faces around the table at Delmonico's that night

in 1921 were glum. The moguls knew that moral protesters, if able to successfully lobby for censorship legislation, would damage their industry. Earlier that year, a religious leader named Wilbur Crafts, from an organization called the Lord's Day Alliance, had organized a march on Washington. He led an army of mostly women while telling crowds that the "flickering filums" were endangering public morals. Then he waved a list of objectionable material over his head as if he were "Moses wielding a stone tablet," according to one observer. The list contained more than two months of research by Crafts, who claimed he had watched all the films, including cartoons, that had been shown in the nation's capital. "A product of the gutters!" he said of them, lamenting that the "sex thrill" was taking the place of "the alcoholic thrill" that had just been banned. Federal intervention was the only answer, he claimed, just as it had been for Prohibition.

During his tirade, Crafts claimed all this sin was the product of "the devil and 500 non-Christian Jews." This religious attack no doubt made the moguls wary. Even though Prohibition was never supported by a majority of Americans, reformers had attracted support for the legislation in part by stirring up nativist and anti-Semitic sentiment among mostly rural, Protestant voters. The same bigotry could be leveraged against the movie industry.

"Amen!" the crowd shouted when Crafts finished his speech, the white dome of the Capitol rising into the sky behind them, a giant finger pointing the way to God.

The moguls at Delmonico's recognized the need to take action. Zukor nodded to Jesse Lasky, cofounder of Paramount, who snapped open a briefcase and pulled out a new "code of rules" that would govern all material the studios put out, including cartoons. Then he started reading. "No picture showing sex attraction in a suggestive or improper manner," he began, only "wholesome love." No illicit love affairs unless they provided a moral lesson. No "close-ups of stomach dancing." No "unnecessarily prolonged passionate love scenes." No suggestive comedy, unnecessary bloodshed, or "salacious" titles, stills, or advertising. The list went on and on.

When Lasky was finished reading, the other moguls were skeptical. This new "code" would torpedo their profits. Did Zukor really think Crafts was that big a threat? Sensing the other moguls' apprehension,

Zukor asked them to hear him out. The code was basically just lip service, he explained. It was better to volunteer self-regulation, he reasoned, than be regulated by the government, which could only be worse. After Crafts was appeased and the dust settled, the studios could return to business as usual.

The new code was delivered to Crafts via William Brady, head of the National Association of the Motion Picture Industry. Brady wasn't particularly powerful in the industry, but he was a gabby, likable Irishman, who the moguls figured was less likely to stoke Crafts's anti-Semitism. After an agreeable and friendly summit with Brady, Crafts stopped his calls for federal regulation. As long as the studios agreed to police themselves, he announced, he didn't care how it happened.

This success was short-lived. After seeing little change, other reformers felt they had been swindled. More protests were organized, with calls for censorship legislation growing more fevered. By now, reformers had also realized they held a significant legal advantage: movies and cartoons weren't protected under free speech laws. In 1915, the U.S. Supreme Court had upheld censorship laws in Ohio by a vote of 9–0, claiming that "the exhibition of moving pictures is a business, pure and simple, originated and conducted for profit." Movies and cartoons were not "part of the press of the country, or as organs of public opinion." Because the court ruled that movies were a business, not an art, they were therefore subject to local and state laws, which could censor and regulate them however the legislators saw fit. (The decision wouldn't be overturned until the 1950s.) With the powerful tool of this legislation in hand, reformers again began organizing against movies in the same grassroots fashion they had used during Prohibition, utilizing local-option laws to put pressure on their opponents, starting with small victories, and gradually amassing power.

The moguls once again discussed their dilemma. They knew Hollywood and New York, but what they needed was help from someone who knew Washington. They set out to find a political fixer.

When Will Hays arrived in Hollywood, in July 1922, newspapers hailed him as the "Caesar of the Cinema." During his first week in town, 30,000 people filled the Hollywood Bowl to see him speak. Somebody

hired a formation of airplanes to drop white flowers which fell like snowflakes over the crowd. Hays then went on a tour of the studios he had been sent to "police," watching scenes from their upcoming films. After one screening, a reporter asked him his opinion of "America's Sodom."

"For the life of me," Hays replied, the sunlight reflecting off his smile, "I cannot see the horrors of Hollywood."

Earlier that year, Hays had resigned as U.S. postmaster general to take a position heading the Motion Picture Producers and Distributors of America, a lobbying group. The ten most powerful movie moguls in the industry wanted him to take the position. In a show of respect, Lewis Selznick hand-carried the letter asking him. It was signed by all his colleagues and offered Hays a yearly salary of $100,000. To prove how serious they were, they stipulated that if nine of them went bankrupt, the tenth would still have to pay. Before heading to Hollywood from Washington, Hays spent several months meeting with Zukor and other film industry executives, learning about their worries and concerns.

Hays was a small man, thin as a reed, who weighed barely a hundred pounds in one of his tailored suits. Before moving to Hollywood, he consulted with a dentist about getting his buckteeth fixed because he was worried about posing for photos alongside handsome men like Rudolph Valentino and Lionel Barrymore. But instead of fixing them, he ultimately decided to keep them as they were. He could use them to make self-effacing jokes at the beginning of meetings, thereby putting people at ease. What had been

Will Hays, political fixer and first chairman of the Motion Picture Producers and Distributors of America, helped establish Hollywood's self-censorship rules.

a source of insecurity was now a useful tool; going forward, he almost always smiled in photos.

The moguls saw Hays as a way to defuse a culture war, a man able to straddle two sides of a divisive issue. As Hays put it, he saw movies "not only from the viewpoint of men who [have] millions of dollars invested in them but from the viewpoint of the fathers and mothers of America, who have millions of children invested in them." Although he worked for the moguls, the reformers saw him as one of themselves. He had grown up on a farm in Sullivan, Indiana; was a good Republican; and had become chairman of his political precinct when he was barely old enough to vote, and an elder in his church around the same time. As chairman of the Republican National Committee, he had overseen Warren Harding's successful presidential campaign in 1920. This was all appealing to the reformers; the moguls were drawn to Hays because he knew where the levers of power were hidden in Washington. They also appreciated his sophisticated mind. Behind closed doors, he recognized the reformers as an "Anvil Chorus"— self-righteous, self-appointed arbiters of morality. He didn't always like what he saw on film screens, either, but knew that legislating morals is always a losing battle, as Prohibition proved. As he set forward to find compromises, he put his mission in the kind of business terms—"let the market decide"—that Americans typically don't resist.

Hays began implementing a new system, called "the Formula," in which studios could present questionable scripts to his office for review and suggestions. It lacked teeth but disarmed the critics, thereby limiting intrusive federal regulations. It wasn't terribly different from what the moguls had tried before, but now had Hays's reassuring face associated with it.

For the next five years, the Formula did what it needed to do: keep the wolves at bay. But it only slowed reform efforts; it didn't stop them. After the advent of sound strengthened cinema's cultural primacy, reformers became even more determined to control movies. Using the same legislative playbook they had used to pass Prohibition, reform groups began lobbying states to enact local censorship laws. In this way, Pennsylvania's censorship board snipped scenes of "a woman making baby clothes, on the ground that children believe that babies are brought by the stork." Other states enacted equally inane rules.

For the film industry, particularly distributors, this was problematic because it turned the entire nation into a patchwork of inconsistent laws. The industry would have to cater to these specifically, creating different versions of films for different parts of the country, sometimes on a county-by-county basis. It would be an overwhelming burden for studios and distributors.

Reformers attempted to put additional pressure on the film industry. In 1930, a priest, Father Daniel Lord, wrote a stricter "Production Code" and offered it to Hays. After working in a few loopholes to hamstring enforcement, the studios reluctantly agreed to his draft. Within three years, the emboldened reform effort, now organized by a strong contingent of Catholics, was able to organize a coalition willing to enact widespread boycotts. The coalition included Bank of America founder Amadeo Giannini, a major source of film funding.

In 1934, the film industry finally buckled. After a long string of celebrity scandals—many involving rape, drug overdoses, and other controversies—film executives realized they were losing a public relations battle against the general American public. It wouldn't be hard for reformers to argue for draconian regulations. Seeking to avoid the worst of what might come, the film studios decided that self-censorship, through an office it had a working relationship with, was a better option than whatever Congress might demand. The studios granted Hays's office the authority to enforce a stricter code, popularly known as "the Hays Code."

It was a pivotal moment for Hollywood, drastically altering the content of movies. In a sign of what was to come, that year saw Shirley Temple become a bigger box office draw than Mae West. Temple was known for quotes like "Don't forget to tell your favorite people that you love them," as opposed to West, who once joked, "I've been in more laps than a napkin."

One of the most noticeable casualties of the Hays Code was Betty Boop. None of the Fleischer animators remembered ever receiving a censorship order directly, but they described a rather vague process instead. According to animator Myron Waldman, a "request" would originate from some bureaucrat working for the Motion Picture Producers and Distributors of America, then make its way to Paramount, where a studio administrator would then contact someone in the story

his studio's artistry. Troubled economic times had also driven people into movie theaters, which were seen as an affordable luxury, helping boost cartoons' economic viability. *Three Little Pigs* cost $22,000 to make but grossed $250,000. According to *Fortune,* this helped boost the studio's yearly net profit to approximately $600,000 and, by the end of the year, the studio increased its staff to two hundred. After all the honor and accolades received by *Pigs,* including an Oscar, Disney felt that it "turned the attention of young artists and distinguished older artists to our medium as a worthwhile outlet for their talents." The film boosted animation's reputation. As Disney put it years later, "the main thing about the 'Three Little Pigs' was a certain recognition from the industry and the public that these things could be more than just a mouse hopping around or something."

hosted by an organization known as the Writers Club and did a little pantomime of the pigs in Walt's honor. Animator Chuck Jones said that *Pigs* proved "it wasn't how a character looked but how he moved that determined his personality. All we animators were dealing with after 'Three Pigs' was acting."

When Hays saw *Three Little Pigs*, he was ecstatic, praising what he found to be a wonderful message. In light of the Depression, it was uplifting, optimistic, and, perhaps most important, popular with audiences. To Hays, this showed others that they didn't necessarily need sex or violence to sell their work. Pundits also lauded the cartoon; they claimed that its plucky charm helped relieve the nation's anxiety over the economic turmoil. To them, the wolf represented economic adversity, while the industrious pig that builds a brick house embodied the New Deal—even President Franklin Roosevelt complimented the cartoon. In his annual report for 1934, Hays held up *Three Little Pigs* as an example, writing that "historians of the future will not ignore the interesting and significant fact that the movies literally laughed the big bad wolf of depression out of the public mind through the protagonism of *Three Little Pigs*."

Not everyone interpreted *Three Little Pigs* in the positive way that Hays did. Rabbi J. X. Cohen, director of the American Jewish Congress, wrote Walt Disney a letter claiming that the wolf's portrayal as a Jewish peddler was so "vile, revolting and unnecessary as to constitute a direct affront to the Jews." Roy Disney responded that the studio meant no harm, and that it had Jewish friends and business associates it by no means wished to offend. He also added, not incorrectly, that the depiction was no different from many others performed by Jewish comedians in vaudeville, live-action film, and other cartoons—a reason, although perhaps not an excuse. Even though the film broke the Hays Code's rule against "offensive depictions of any nation, race, or creed," Will Hays looked past the affront, reflecting the era's casual attitude toward some standards but not others.

Disney had a different take on *Three Little Pigs* and the Depression. He joked that, if it hadn't been for all the economic turmoil, he likely wouldn't have had all his top animators; many probably would have pursued other artistic careers instead. His studio offered a good, steady job, and Disney had a reputation for always striving to improve

his studio's artistry. Troubled economic times had also driven people into movie theaters, which were seen as an affordable luxury, helping boost cartoons' economic viability. *Three Little Pigs* cost $22,000 to make but grossed $250,000. According to *Fortune*, this helped boost the studio's yearly net profit to approximately $600,000 and, by the end of the year, the studio increased its staff to two hundred. After all the honor and accolades received by *Pigs*, including an Oscar, Disney felt that it "turned the attention of young artists and distinguished older artists to our medium as a worthwhile outlet for their talents." The film boosted animation's reputation. As Disney put it years later, "the main thing about the 'Three Little Pigs' was a certain recognition from the industry and the public that these things could be more than just a mouse hopping around or something."

For the film industry, particularly distributors, this was problematic because it turned the entire nation into a patchwork of inconsistent laws. The industry would have to cater to these specifically, creating different versions of films for different parts of the country, sometimes on a county-by-county basis. It would be an overwhelming burden for studios and distributors.

Reformers attempted to put additional pressure on the film industry. In 1930, a priest, Father Daniel Lord, wrote a stricter "Production Code" and offered it to Hays. After working in a few loopholes to hamstring enforcement, the studios reluctantly agreed to his draft. Within three years, the emboldened reform effort, now organized by a strong contingent of Catholics, was able to organize a coalition willing to enact widespread boycotts. The coalition included Bank of America founder Amadeo Giannini, a major source of film funding.

In 1934, the film industry finally buckled. After a long string of celebrity scandals—many involving rape, drug overdoses, and other controversies—film executives realized they were losing a public relations battle against the general American public. It wouldn't be hard for reformers to argue for draconian regulations. Seeking to avoid the worst of what might come, the film studios decided that self-censorship, through an office it had a working relationship with, was a better option than whatever Congress might demand. The studios granted Hays's office the authority to enforce a stricter code, popularly known as "the Hays Code."

It was a pivotal moment for Hollywood, drastically altering the content of movies. In a sign of what was to come, that year saw Shirley Temple become a bigger box office draw than Mae West. Temple was known for quotes like "Don't forget to tell your favorite people that you love them," as opposed to West, who once joked, "I've been in more laps than a napkin."

One of the most noticeable casualties of the Hays Code was Betty Boop. None of the Fleischer animators remembered ever receiving a censorship order directly, but they described a rather vague process instead. According to animator Myron Waldman, a "request" would originate from some bureaucrat working for the Motion Picture Producers and Distributors of America, then make its way to Paramount, where a studio administrator would then contact someone in the story

department at Fleischer Studios. From there it would trickle down to the animators.

The changes rarely dealt with violence in cartoons, which would largely remain as violent as ever. They primarily dealt with sex, the reformers' main concern. Over the next several years, Betty's hemline got longer, her garters became less visible, and she began showing less cleavage. Gone would be scenes like the one in *Chess-Nuts*, where two candles, reflected in the eyes of a man trying to seduce Betty, go flaccid after she blows them out. Also subdued were her surreal fantasies. She would no longer dream as big as she once did, or attempt what others thought impossible. She would stop running for president, as she did in *Betty Boop for President*, and would stop playing a doctor, as she did in *Betty Boop, M.D.* From now on, she would play more secretaries and schoolteachers, roles some protesters thought were more suitable for women. After the Hays Code, Betty's popularity plummeted. She was no longer an exciting sensation, she was just another rational adult.

Once the Hays Code went into effect, Will Hays found that he needed new allies in Hollywood. The new censorship rules weren't popular, and he needed artists and executives to support his agenda. In Walt Disney, Hays saw a possible ally. Disney's early cartoons were as bawdy and profane as anybody else's, but he was a little older now, in his early thirties, and his work had become somewhat cleaner over the past few years, particularly if compared with the material coming out of New York. He also had the most prominent studio in animation, setting the tone and standards for much of the industry.

Disney's success had taken another leap forward in 1933, after the release of a film entitled *Three Little Pigs* as part of his Silly Symphony series. To many animators, the film was another watershed moment for their art, a clear example of Disney's goal of creating characters with distinct personalities. Even though the pigs looked nearly identical, they seemed different because of the unique ways they moved and acted. Disney had pushed his animators to give them different gaits and other individual traits—the ways they might arch an eyebrow or smile, for instance. After the film debuted, Charlie Chaplin, the master of movement, climbed onstage during a ceremony

Chapter 16

"Looks Like
You're Having Fun"

Max Fleischer's children remembered him as generally good-natured, with one exception. Whenever he heard Walt Disney's name, he would clench his fists and mutter under his breath, "That son of a bitch!" The two men had never met each other, but a rivalry had formed between them. Throughout the 1930s, Fleischer was particularly annoyed by Disney's attempts to poach his talent. Whenever Roy Disney was in New York, he would lurk near the door of Fleischer's studio, waiting for the animators to leave for lunch. As they wandered out the doorway, he'd pounce on his prey. "Now look, you guys, we need animators. No matter what you get, we'll give you double," Essie Fleischer remembered Roy saying.

Few of the animators were inclined to turn down double pay. What they were making working for Fleischer, $150 to $200 per week, was very good for the times, but double that was exceptional. Fleischer's animators would leave in waves, corresponding with Roy Disney's visits. A few months after each departure, postcards from California would fill the Fleischer Studios' mailbox: snapshots of former coworkers, their skin tan as they stood under swaying palm branches. On the backside of the postcards were notes describing their adventures during the trip west. Animator Ben Sharpsteen wrote of visiting Yellowstone and seeing all the breathtaking wildlife. The Fleischer animators were taken by his account; many of them had barely ever left the environs of the Lower East Side and Brooklyn neighborhoods where they were born.

Better pay was one reason to work for Disney; artistic ambition was another. In 1935, animator Shamus Culhane coveted a job with

Disney for this reason. He was twenty-seven years old and had been an animator since he was nineteen, working his way through almost all the East Coast studios before landing at Max Fleischer's. He liked the work but felt he had hit a creative ceiling. Standing in front of the elevator one day, he spent an hour arguing with Max about creating cartoons with more plot and character. But Fleischer was unconvinced the public really wanted this. Years later, he would explain his thoughts to Culhane in a letter. "I did not welcome the trend of the industry to go 'arty,'" he wrote. "The 'animated oil painting' has taken the place of the flashiness and delightfulness of the simple cartoon. In my opinion, the industry must pull back . . . the true cartoon is a great art in its own right. It does not need the assistance or support of 'Artiness.' In fact, it is actually hampered by it."

After his argument with Fleischer, Culhane decided to quit. He bought a new Studebaker roadster and drove to California, enjoying the sights along the way: Kentucky's blue hills, Kansas's yellow wheat fields, Arizona's green cacti. Once in Hollywood, he cold-called the Disney studio and asked for an appointment with Walt. Disney's personal secretary, Dolores Vogt, told him to show up at nine the next morning.

Walt Disney's office was spacious, clean, and simple. Culhane remembered that it had none of "the usual Hollywood big-shot fripperies," like knee-deep carpets or damask curtains. Nevertheless, he felt anxious sitting there, smoking three cigarettes down to their last spark in just fifteen minutes. Disney did nothing to relax him after ushering him into his office, puffing on his own cigarette, his eyes half-closed, listening to Shamus ramble through his work history. Even though Walt dressed eccentrically, in battered sweaters and knickers with long wool socks—"very gay and colorful things, with lots of design in them," according to Vogt—Culhane felt nervous and intimidated; in part because of Disney's reputation, but also because of his focused intensity, which his outlandish wardrobe did nothing to soften.

"You directed *Jack and the Bean-Stalk*?" Disney asked, referring to a film Culhane had worked on for a previous employer. Shamus confirmed that he had, along with animator Al Eugster.

"Who animated the scene where the giant lights his pipe?"

"I did," Culhane answered.

"That's what I'd heard," Disney said, his cigarette dancing up and down on his lips. "I liked it."

Culhane finally relaxed, convinced he was about to get offered a job.

"Let me give you the situation," Disney said, reaching for another cigarette, his voice dropping a notch. "We've just hired three or four fellows from New York, and most of them are bringing a lot of god-damn poor working habits from doing cheap pictures. I've decided to take in more kids right out of school and train them my way. It's a lot easier than trying to retrain somebody who's used to doing crap. In fact, we have a batch of about twenty kids coming in next week. We'll run them through art school and they'll have a good start right off the bat with nothing to unlearn."

Disney then stood up, extending his hand. "Thanks for coming in anyway."

Culhane was crushed. This was precisely *why* he wanted to work for Disney, to push himself and move beyond sloppy habits. It's why many animators had done the same. When Milt Schaffer started at Disney in 1934, he described how intense it was. "Our whole focus was on animation, and if you couldn't animate, you might as well commit suicide."

"Listen, Walt, I really want to work here," Culhane interrupted, his instincts taking over. "I don't care about the money, I want to learn."

Disney shook his head, growing impatient.

"How about letting me come in with those kids?" Culhane asked, referring to the next incoming class of new recruits.

"Those kids are going to get fifty bucks a week," Disney answered, assuming that a salary far less than what Shamus had received from Fleischer would be a surefire way to finally end the discussion.

"I'll take it!" Culhane blurted, even though it was a 75 percent pay cut.

Disney looked at him, surprised. "I'll be a son of a bitch," he said. "You sure as hell want in." He extended his hand and broke into a grin. "All right, let's give it a try. Report to the in-between department on Monday."

* * *

Shamus Culhane remembered the walls of the Disney studio being painted in cheerful tints of raspberry, light blue, and clean white—not the "institutional greens or bilious browns" he remembered from the New York studios. Back east, desks were separated by shabby beaverboard, and the furniture looked as though it "had been stolen from the Salvation Army." Disney's studio, twelve buildings built on the Hyperion lot that Walt and Roy purchased when *Oswald* became a hit, had a pleasant Spanish look, with white stucco and red roof tiles. One employee compared the studios to "an Ivy League campus," with grounds dotted by grass courtyards and flagstone walkways. At the New York studios, animators sometimes spent their lunch break in alleyways that smelled of stale urine, playing a crude version of stickball using cardboard tubes and crumpled paper. At Disney, Walt installed volleyball courts because the game carried less risk of injuring his artists. According to Grim Natwick, the Disney studio was the "mythical sun around which the other studios orbited."

Culhane's first day was humbling. He was older than most of the other staff members, who averaged twenty-five, and was five or six years older than most of the artists chattering away in his entry-level class. Many of them already knew each other from college at USC and Stanford, and some had already attended several years of art school. As at the other studios where Culhane had worked, the room was mostly men. "Women do not do any of the creative work in connection with preparing the cartoons for the screen, as that task is performed entirely by young men," read the standard rejection letter the studio sent to female applicants. The few women who did get hired were typically limited to lower-level jobs such as inking or in-betweening. Although a small handful of female artists attained higher levels of responsibility during the 1930s and '40s—such as the artist Mary Blair and the writer-artist Bianca Majolie—women's roles and influence were thus largely limited, despite their obvious talents.

The room fell silent for the entrance of George Drake, head of the in-between department. In the sharp voice of a drill instructor, he explained that the new animators would start at the bottom of a three-person team. These teams would consist of an animator, an assistant animator, and an in-betweener. Animators would draw the most important poses, establishing major points in the action, and

the others would fill in the incremental poses in between them, adding details like buttons and wrinkles. Shamus already knew all of this but listened quietly.

Once Drake finished, the new artists received a pep talk from Dave Hand, who had left Fleischer in 1930 and was now one of Disney's top executives. "[You'll] never succeed as animators," Hand told them, until Walt determined you were ready and you "got the call." Culhane thought the speech was corny, mentally comparing it to the clichéd ramblings of a "high school football coach." But the others in the group ate it up. After Hand's pep talk, the rest of the day was devoted to drawing rough in-betweens. Unused to drawing roughly, Culhane produced stiff work compared with the youngsters who, unhampered by previous experience, drew well—it was just the thing Disney had complained about during their interview. When Drake saw his work, he yelled at Culhane.

The next morning was better. Culhane's class was told it would be spending the whole day in "art school," a luxury you would never see in New York, where most animation studios were run like sweatshops and animators were judged on the number of drawings they cranked out in an hour. Culhane had taken night classes at the Art Students League, but an older animator had warned him, "Don't go to art school—it'll stiffen you up." At Paul Terry's studio, Bill Tytla remembered asking for training and being told, "Anyone who goes to art school is a 'homo Bolshevik.'" Shortly thereafter, Tytla left for California.

Disney's "art school" symbolized how he invested in talent for the long term. In 1929, Disney had started driving his artists to attend Friday night classes at the Chouinard Art Institute, later known as the California Institute of the Arts. By 1932 he was tiring of the long drive back and forth, and accepted an offer by one of his newest artists, Art Babbitt, to host the classes at home.

Babbitt had thick brown hair and a thin mustache, and wore thin wire-framed glasses. He started at the studio only a few years before Culhane but had already risen through the hierarchy, proof that the studio typically functioned as a meritocracy (at least for the male animators; females typically weren't allowed to leave the ink and paint department). Originally Arthur Babitsky, a Jewish kid from the

Animator Art Babbitt in his later years.

Midwest, Babbitt moved to New York in the 1920s to study psychiatry at Columbia. He spent his first semester sleeping under a church stairwell and scavenging food from the trash. He got a job at an ad agency six weeks later, freelancing as an artist on the side, and soon landed an animating job at Paul Terry's studio, where he spent the next three years. After seeing Walt Disney's *Skeleton Dance*, which far surpassed anything Terry had ever done, Babbitt bought a train ticket to California. Like Culhane, Babbitt showed up at the studio without an invitation or appointment. He was turned away. Resorting to a trick he learned in the advertising world, he wrote Disney a "big letter"—twenty by twenty-four feet—and mailed it to his office. The stunt got him an interview and, two days later, a job offer. Two days after starting, he was promoted from in-betweener to animator. Within

three weeks of that, he continued his swift rise by starting to host art classes in his home, bringing in Chouinard instructors.

Babbitt invited eight artists to the first session, but fourteen showed up. The next week he invited the fourteen, and twenty-two showed up. They were hungry both to learn and to get a glimpse of the nude models Babbitt had hired. A couple of weeks later, Disney called Babbitt to his office. "Suppose it got in the newspapers that a bunch of Disney artists were drawing naked women in a private home," he said. "It wouldn't sit well."

"What do you suggest?" Babbitt asked.

"How much do models cost?" Disney asked. Babbitt mentally doubled the sixty cents per hour that most art schools paid and added twenty cents for carfare. His calculation would anger all the art schools, because now they would have to pay models more, but Babbitt didn't consider that his problem. Disney agreed to the price and offered the studio soundstage as a classroom. By 1935, the classes ran five nights a week, included approximately 150 students per session, and cost the studio an estimated $100,000 per year. No other animation studio invested in its artists so heavily.

The task of running Disney's art school eventually fell to Don Graham, a Chouinard instructor who was hired full-time. According to Culhane, Graham had more of an effect on Disney's cartoons than any other person, save Walt himself. Of all the art instructors Culhane ever encountered, the only one he respected as much as Graham was Arshile Gorky, a leading figure of abstract expressionism alongside Jackson Pollock and Willem de Kooning.

Graham was twenty-nine and handsome in the way of a young Montgomery Clift: athletic build, dark wavy hair, his jaw muscles tightening into cables as he worked. During lectures he always had a cigarette in hand, leaving the class to wonder if it would burn down to his fingers before he remembered it was there. As the Disney artists sat at their desks, heads bent over their work, Graham would wander along the rows like a gardener examining his prize roses. His feedback came in one of two ways. If he asked, "Having problems?" it meant that something wasn't working. These words made the artists cringe.

But if Graham said, "Looks like you're having fun," the artists knew they were on the right track. One animator called this "the supreme tribute, the ne plus ultra, because having fun meant that something was sinking in; the lessons were bearing fruit. I would rather hear Don Graham say, 'Having fun?' than win an Academy Award."

Graham had studied engineering at Stanford before becoming an artist. He had never worked as an animator, but this didn't matter to Disney, who wanted him to teach his artists what they *didn't* know. Graham prodded the animators to think deeper and observe tiny details. He often lectured about the effect of gravity on mass, pointing out how it makes flesh and muscle move. Because of him, many artists started posting signs above their desks that asked, "Does your drawing have weight, depth and balance?" In animating, Graham urged his artists to imagine a half-filled sack of flour, slumped on a floor, its volume fixed but its shape flexible. Or they should think of a rubber ball dropped from up high, lengthening as it falls and flattening when it hits the ground, its volume remaining constant. These lessons in mind, animation evolved from what was traditionally called the "rubber hose" style of the 1920s, loose and floppy, into a more precise and complex style that animators called "squash and stretch." Over the course of the Silly Symphony series, which ran for a decade, up until 1939, one could see Graham's lessons sink in as animation changed. It became more lifelike, an effect that Disney thought gave his characters more depth.

Of all the lessons that Shamus Culhane learned in Graham's classes, one achingly simple one stood out: "Laymen look at the world around them; artists *see* it." Taking this to heart, one animator decided to study a rainstorm by lying down on a city sidewalk, disrupting pedestrians. Police arrested him but let him go after he explained that he was studying the lightning.

Another of Culhane's favorite lessons came from a showing of a Charlie Chaplin film in which Chaplin approaches a door, unlocks it with a key, and enters. In the middle of the screening, Graham stopped the projector and began asking questions. Chaplin makes it look simple, right? It was not so simple, they soon learned. Graham rewound the reel and walked them back through it, a millisecond at a time, pointing out little details: how Chaplin shortened his steps; how he wiggled his fingers in his pocket, giving it a goofy bulge; how

he rotated the key into the lock ever so slightly, carefully catching the light for the camera. As Graham pointed out all these tiny details, Culhane suddenly realized that what seemed simple was in fact "as stylized as a ballet." Little details were what elevated the mundane into art. This is why Graham devoted so much class time to studying what others considered to be minutiae. The class watched slow-motion photographic studies of glass breaking, bubbles rising, and smoke curling into the air. They sketched the action as they saw it, trying to capture the effect. They took acting classes in order to understand motion, then took turns drawing each other dancing or somersaulting across the studio floor. They also studied zoo animals, until Disney realized that captive animals act differently from wild ones and hired photographers to film them in nature instead.

The classes included lectures from outside experts. Faber Birren, author of numerous books about color, lectured on color theory. Jean Charlot, a Mexican artist who had painted murals alongside Diego Rivera, a revolver strapped to his hip, provided lessons on composition and geometry. Rico LeBrun, an expert on animal anatomy, was a regular lecturer, frequently bringing in animal carcasses and dissecting them for the class. The architect Frank Lloyd Wright gave a lecture that nobody enjoyed because, thinking he had to be funny for a bunch of cartoonists, he insisted on telling bad jokes.

Wright's jokes weren't nearly as bad as those told by Professor Boris Morkovin, chair of USC's cinematography department. Morkovin was hired to lecture on "the theory of humor," although the animators couldn't remember anyone less funny. He spoke more like a scientist in search of general principles than a comedian. "Ve vill now explain vott iss a gak," Morkovin began one lecture in his thick Russian accent. Rumor had it he was getting paid $125 an hour, after convincing Disney that his "Morkovin System of Analysis" could break humor down into a science. The system was the result of Morkovin dissecting over two hundred gags into thirty-one basic types, which he claimed were all united by a central truth: "Shock is the soul of the gag," he said, a platitude which came as no shock to anyone in that particular room.

"I am making some very important discovery," Morkovin began another lecture, waving a handful of script pages through the air.

"There are three basic kind of humor, A and B!" he said, forgetting to add a third variable. He then began filling a blackboard with criss-crosses of quasi-scientific diagrams and equations. Culhane thought they "looked like skull practice for the football team of a lunatic asylum." If you used these tools correctly, Morkovin told the class, you were sure to "stimulate great hilarity." The lectures were a bust. Shortly thereafter, Disney fired him.

In 1935, just as the classes and lectures were coming into full bloom, Walt Disney directed *The Golden Touch*, a Silly Symphony based on the legend of King Midas. Anything King Midas touched turned to gold, a notion that might also have applied to Disney. But this cartoon wasn't particularly popular or impressive. Some considered it an outright failure, and Disney himself hated it, warning his staff to please not mention it in his presence ever again.

The Golden Touch was the first film Disney had personally directed in five years and was the last he would ever personally direct. He had come to realize that he wasn't the best animator, writer, or director at his studio. He was a superb storyteller, and Dick Huemer thought he had the "best gag mind I ever ran across," but it had become apparent that Walt Disney's finest skill was recognizing and cultivating others' skills, focusing them toward a greater vision. This in itself was a rare and valuable quality, although impossible to measure or gauge. Disney had a gift beyond technical ability, which, no matter how great, doesn't always add up to genius. Spanish poets call his gift *duende*, the mysterious thing that allows even a semiliterate artist to create a masterpiece. After *The Golden Touch*, Disney's role at the studio would be as a kind of oversoul, conducting everyone's unique talents as if they were all part of a symphony orchestra. His sensibility would remain its governing influence, providing all that invaluable *duende*.

The same year *The Golden Touch* was released, Disney sent Don Graham a ten-page memo explaining the studio's core philosophies. "The first duty of the cartoon is not to picture or duplicate real action," he wrote, but "to bring to life dream fantasies and imaginative fancies . . . our study of the actual is not so that we may be able to accomplish the actual, but so that we may have a basis upon which to go

into the fantastic . . . we cannot do the fantastic things based on the real unless we first know the real." This was a guiding force behind Graham's art classes. Tell the truth, Disney told him, but also know when to stretch it.

Graham passed this philosophy on to his students by instructing them to go out and observe real life, then draw it only from memory, using their imaginations to fill any gaps. One day a pupil challenged Graham on this approach, so Graham dug out a print by Peter Paul Rubens, the Flemish master painter of the baroque tradition. He then pointed out how the portrait seemed nearly perfect in form. Next he pointed at an arm in the painting and told the pupil to mimic it with his own arm; the student couldn't do it, wincing and straining as he tried. It looked natural in the Rubens painting, but there was actually so much torsion in the pose that the student would have had to dislocate his wrist to mimic it perfectly. Graham's lesson to the class was that Rubens had captured reality only by using an illusion. The painting wouldn't have looked right otherwise. This lesson applied to storytelling as well: the only thing truer than truth was the story.

Chapter 17

"Are You a Sailor?"

Max Fleischer knew from experience, and from watching others, not to put all his eggs in one basket. Star characters come and go, and it's a bad idea to stake a studio's success on just one. After the Hays Code ruined Betty Boop's popularity in 1934, Fleischer had a new star, Popeye, ready to take her place.

Popeye was originally a character in *Thimble Theatre*, a newspaper comic strip created by Elzie Segar in 1919. It was Fleischer's favorite, the first thing he turned to in his morning paper. The rambling, eerie narratives recalled the funkier America of Fleischer's youth, and were laced with messages about social justice, the spooky paranormal, or whatever other topic caught Segar's eccentric fancy. Modern in some ways and old-fashioned in others, Segar populated the strip with beguiling characters possessing Dickensian names: Pecksniff, Micawber, Quilp, Chizzleflint, Slink the Slicker.

Popeye wasn't introduced to the strip until 1929, first appearing alongside two of Segar's other main characters, Ham Gravy and Castor Oyl, as they hatched a plot to capture a legendary creature known as a "Whiffle Hen" and use its magical powers to win a fortune at a casino located on secluded Dice Island. Neither man knows how to operate the boat to get there, however, so they visit the local pier to recruit a sailor.

"Are you a sailor?" Castor asks a man whose sailor's cap and tattooed forearms suggest he might be.

"Ja think I'm a cowboy?" Popeye answers.

Popeye's "moxie," to use the slang of the day, made him an immediate hit. Readers were quickly disappointed, however, when they learned that Segar intended to use him for only a limited two-month run. After

a flood of irate fan mail poured in, Segar decided to reverse course and work Popeye into the regular cast by having him date Castor Oyl's sister, Olive, who was previously linked romantically to Ham Gravy, who now had to make way for the new suitor.

In 1932, Fleischer paid a visit to J. D. Gortatowsky, president of King Features Syndicate, which handled Popeye's rights, and said, "I want to make a cartoon of your Popeye."

"Out of that ugly looking thing?" Gortatowsky asked.

"The funnier he looks, the better the cartoon will be."

Popeye's animated debut, *Popeye the Sailor*, was in July 1933. It was a classic Fleischer cartoon, loose and spontaneous, defined by happy accidents rather than the tight precision of Disney's work. By this point, Disney's "stories were worked out more carefully, in much more detail," according to Fleischer animator Dave Tendlar, whereas Max's studio still allowed for ample off-the-cuff gags and physical humor. At the premier, Fleischer reserved a small, private section of the theater for Segar, an enigmatic and introverted man who shied away from publicity. Segar interpreted the world through his characters, and Fleischer wanted to give him a quiet space where he could process. "Popeye is much more than a goofy comic character to me," Segar said. "He represents all of my emotions, and he is an outlet for them . . . to me Popeye is really a serious person and when a serious person does something funny—it's really funny."

Segar's reaction to the Fleischers' adaptation of Popeye was "mixed emotions," according to Bud Sagendorf, his assistant. "He wasn't delighted, he wasn't disappointed . . . It's weird to see your characters all of the sudden moving."

The first scene of *Popeye the Sailor* began with Popeye strutting along the deck of a ship, punching an anchor and watching it explode into a thousand little fishhooks. Then he punches a large fish mounted on a plaque, splintering it into a cascade of sardine cans. "Well blow me down!" Popeye says.

As the ship pulls into harbor, Olive Oyl stands onshore, scanning the deck for her beloved. "Pawpoy?"

Nearby, another sailor sneers at her. "Who ya waitin' for, baby?"

When Popeye steps in to defend her, he establishes what would become the series's typical plotline: Olive Oyl somehow finds herself

Model sheet used by Fleischer animators to gauge
perspective in Popeye cartoons.

in danger, and Popeye comes to her rescue. Bluto plays the villain and
was likewise recruited from the original comic strip, where Segar had
described him as "Bluto the Terrible! Lower than bilge scum, meaner
than Satan, and strong as an ox." Wherever he appeared, his villainy
was versatile. Put a turban on him and darken his skin, swamilike, and
he would attempt to seduce Olive Oyl with mind tricks. Give him a
monocle and put him in a tuxedo, and he became a capitalist robber
baron, trying to corner the spinach market and limit Popeye's access
to the vegetable that gives him his incredible strength.

Popeye and Bluto never resolve their differences through
thoughtful discussion or by trying to understand each other's
perspective—they usually just start clobbering each other. The car-
toons were a constant parade of never-ending violence. A group of
concerned mothers eventually directed a letter campaign at Fleischer,
complaining "that the sailorman's pugnaciousness was constantly lead-
ing their sons into battle," according to an account of the matter in

the *New York Times*. Fleischer hadn't made the cartoons with children in mind—his audience was adults—but he made some adjustments nonetheless. Popeye would still be a fighting man, but never just for fun, and never without a just cause. He fought Bluto because he was bullied into it, not because he liked it. "That's all I can stands, and I can't stands no more!" he now warned his adversaries, letting them know his patience was exhausted before he gulped down his spinach and began cleaning their clocks.

Framing the violence as self-defense against tyranny was more acceptable to the American way of thinking, and helped calm the protests from mothers. Popeye now set an example, albeit a questionable one. The Abraham Lincoln Brigade, a group of idealistic young Americans who volunteered to fight Spanish dictator Francisco Franco's fascist army during the 1930s, even adapted Popeye's theme song into a battle cry, fitting new words to the familiar "I'm Popeye the Sailor Man" melody, punctuated occasionally by Popeye blasting "Toot! Toot!" from his pipe. As the brigade marched off to fight and die in Spain's dusty brown hills, they sang their cheerful adaptation: "In a neat little town called Jarama, we made all the fascists cry Mama! We fight for our pay, just six cents a day, and play football with a bomb-a."

Within a year of Popeye's debut, Fleischer began having problems with William Costello, the actor who voiced the character. Fleischer had never been a fan of Costello, who was known in vaudeville circles as "Red Pepper Sam" for reasons that remain unclear. He had always found Costello's voice too raspy, although the other Fleischer brothers disagreed, so Max relented and hired him. Once Popeye became a star, however, Costello began strutting around the studio like a peacock and making demands like a prima donna. If he wasn't asking for more money, then he wanted vacation time in the middle of the studio's production schedule—it was a never-ending headache. When he began showing up at work drunk, Max finally fired him.

Costello's replacement was Jack Mercer, an animator from the in-between department. Max's brother Lou, who was now working as the studio's music director, had overheard Mercer doing Popeye

impersonations for his coworkers and thought his bubbly, rubbery voice was a good fit. Max, however, wasn't convinced. Again, he thought Mercer's voice was too raspy. Nor did he think that the tiny Mercer—just five feet five and 110 pounds—had enough physical weight to give the voice proper depth. But Lou pushed back, arguing that Mercer's voice was funnier than Costello's, yet also more sympathetic. Max reluctantly agreed, suggesting that Mercer start a diet of spaghetti and Guinness to boost his weight.

Mercer's first recording sessions were choppy and uneven, his voice growing hoarse from the strain of contorting his throat. He medicated by sucking candies and gargling soda until it recovered. After that, he had few problems ever again, going on to voice Popeye for the next thirty-plus years.

By 1935, just two years after Popeye's screen debut, one poll declared him the most popular animated cartoon character in the country—more popular than even Mickey Mouse. Another poll of theater owners, taken three years later, confirmed the same result. In 1938, the *New York Times* reported: "From his newspapers Popeye graduated into the movies, where he became the Paul Bunyan of the screen . . ." This was good news to Fleischer, who felt Popeye put him back in the race against Disney. But, in a small way, Popeye's success was probably partly due to Walt Disney, who had challenged his competitors to write stronger plots, dialogue, and characters. Even though Popeye still possessed the spontaneous inventiveness the Fleischers were known for, he also exhibited more of the style championed by Disney; he wasn't as cartoony or surreal as the Fleischers' earlier work, and was less inclined to inhabit the sort of magical fantasy in which animals and humans live as equals in the same world.

At the height of Popeye's popularity, around 1935, Elzie Segar was earning more than $100,000 per year in royalties. As a way of saying thanks, he drew a life-size poster of Popeye and sent it to Max Fleischer and George Schaefer, an executive at Paramount. Popeye tells the two men, "I yam what I yam on account of ya made me what I yam—an' I yam a damn good swab so keep tellin' the world!!" Next to Popeye, on a side table, sit a bottle of rum and a giant mug with

stars and lightning bolts shooting out of them, indicating that the rum is extremely potent. In Segar's comic strip, rum was Popeye's drink of choice, and he ate spinach only rarely; for the animated version, however, the Fleischer animators decided that Popeye should eat more spinach and drink less rum. Nobody ever gave a specific reason, but sore attitudes from the recent controversy over Prohibition were a likely cause. In any case, the animated version of Popeye would get his incredible strength from spinach, not booze.

Within four years of Popeye's debut, the spinach industry claimed the character had boosted its sales by a third, although it didn't provide specific numbers. Newspaper articles of the time regularly talked of a "spinach boom" and often slipped funny Popeye references into their copy. In March 1937, Crystal City, Texas, the self-proclaimed "World Spinach Capital," erected a statue of Popeye in the middle of town. Spinach was having a moment. This was partly because of Popeye, but also because people of the era overestimated spinach's health benefits. Because chemists working in the nineteenth century had used improper cooking vessels to conduct tests to determine spinach's nutritional value, thus contaminating their samples, its iron content was widely misreported, gaining it an inflated reputation. By 1937 researchers were aware of the errors, but the myth of spinach's inflated nutritional value was firmly established.

The spinach fad, so often linked to Popeye, sparked a minor controversy among nutritional experts. At the 1936 annual convention of the New Jersey State Dental Society, dentists attempted to bring spinach's reputation back down to earth. They claimed that good dental health was achieved by eating many different kinds of foods, including "asparagus, peppers, peas, [and] beans." New Jersey's dentists urged Americans to consider other options. "Tomatoes—which have been called the poor man's apples—have a good all-around vitamin content" was one helpful suggestion. The American Medical Association also chimed in, pointing out that meat contained twice as much iron as spinach. But that claim was soon attacked by the United Brotherhood of Vegetarians, which announced, "There is no doubt in our minds that the speech was inspired by propaganda from the meat interests, which are fighting with their backs against the wall." Popeye cartoons often poked sly fun at all this business about special

interests and lobby groups. In *What, No Spinach?* and *The Super Duper Market*, a capitalist Bluto attempts to corner, or at least warp, the spinach market for his personal gain.

As the reputation of spinach fell under attack by people attempting to correct the record, a nutrition expert from Columbia University, Dr. Mary S. Rose, defended spinach. In her 1936 statement, she seemed to slyly reference Popeye's penchant for violence by writing, "It seems to me that any intelligent person has a moral obligation not to give such a good food a black eye."

In 1938, or thereabouts, a business executive named Walter Mack tried to acquire Popeye's rights so he could change the character's diet. Mack, a marketing genius, was the newly appointed president of Pepsi-Cola, then an up-and-coming brand. The brand was already sponsoring a comic strip about two policemen, Pepsi and Pete, who constantly find themselves on the verge of being outwitted by criminals: that is, until they pop open a couple of invigorating Pepsis, drink them, and then save the day. Mack figured that if Popeye drank Pepsi instead of eating spinach, sales of his drink would skyrocket. He may have been correct, but Fleischer turned his offer down.

Not until 1990, well after Popeye's producers had changed several times, was a marketer finally able to achieve the coup of upending spinach's primacy. "Can the spinach! I wants me Instant Quaker Oatmeal!" Popeye declares in an animated commercial. His famous jingle was likewise altered to "I eats me oatmeal and I'm stronger than steel. I'm Popeye the Quaker Man. *Toot! Toot!*"

"Oatmeal is good food like spinach," said Jeff Brown, vice president of King Features Syndicate, defending the oatmeal decision to the press. "Look, I'm not a dietitian but we really don't think it's a problem for Popeye to eat something besides spinach once in a while."

Members of the Quakers, known for their nonviolence, weren't keen on Popeye's new sponsor. "If Popeye is to be portrayed as a Quaker man, then he must behave as a Quaker man, and Quaker men do not go about resolving dispute and conflict by means of violence," said Elizabeth Foley, spokeswoman for one Quaker group. Nor did Quakers appreciate the gender stereotypes long found in Popeye cartoons. "Olive Oyl is constantly portrayed as a passive female who stands on the sideline and cheers as Popeye commits acts of violence,"

Foley continued. "Quaker women were responsible for beginning the suffrage movement in this country. Alice Paul, a Quaker woman from Moorestown, N.J., wrote the Equal Rights Amendment."

Responding to the Quakers' complaints, Quaker Oatmeal promptly apologized and stopped using the "Popeye the Quaker Man" reference.

When Popeye ate his spinach, he typically did so by squeezing a can of it in his fist, squirting a clump of spinach into the air, and then catching it in his mouth. Sometimes, though, he sucked the spinach through his pipe. This unconventional way of eating spinach caused some to wonder if it was really a sly drug reference. Was Popeye actually smoking marijuana?

It was a fair question. During the 1920s and '30s, "spinach" was a popular euphemism for marijuana. In 1938, the band Julia Lee and Her Boyfriends recorded "The Spinach Song," a jazz hit that was actually about cannabis. Her other hits, such as "Lotus Blossom" and "Pipe Dreams," also slyly reference the drug. Additionally, antimarijuana propaganda of the time claimed the drug gave criminals superstrength similar to Popeye's, which made them extra dangerous.

Poking fun at such bogus claims was just the kind of subversive satire loved by the Fleischer animators, who were the kind of hip young men who would frequent jazz clubs where the air was thick with illegal pot smoke. They were fans of the music, which had a culture that sometimes overlapped with drug culture. One of Louis Armstrong's first appearances on film was to provide the soundtrack to one of the Fleischers' greatest cartoons, *I'll Be Glad When You're Dead, You Rascal You*. Jazz superstar Cab Calloway, an old friend of Lou Fleischer's, was another regular at the studio, collaborating on some of the studio's best and most surreal material, titles like *Minnie the Moocher* and *Betty Boop in Snow-White*, in which Calloway provides Koko's voice—a spooky, low-slung howl—for a rendition of "St. James Infirmary Blues," a mournful ballad describing a visit to the morgue in order to see the dead body, laid out on a cold slab, of a woman who died of a cocaine overdose.

The Fleischers kept silent about any drug references, so curious fans would later search through Segar's comic strips for additional clues. Some of their theories were interesting, if perhaps they themselves were a bit carried away. One of the best connects Popeye's famous catchphrase, "I yam what I yam," with "I am that I am," God's statement to Moses through the burning bush. Members of some faiths, including Rastafarians and some early Christian sects, have linked the biblical story to cannabis, saying that God provided his vision through the burning plant. Popeye fans soon discovered another interesting plotline from Segar's strip. This one was published in 1934 and featured a boss from Vanripple's gold mine feeding his workers berries from a bush whose roots are soaked in a nasty drug that causes them to commit violent crimes on his behalf. When Popeye eats the berries, he too becomes surly and mean, but he overcomes their spell by somehow managing to soak the roots in "myrtholene," a drug that produces delirious happiness. After everyone has recovered, Popeye says, "When a man's happy he jus' couldn't do nothin' wrong."

Even if the drug references were coincidental at first, they eventually became intentional, a myth willed into reality after the fact. By the 1950s, long after Popeye passed from the Fleischers into the hands of other producers, the references were common. In *Greek Mirthology*, released in 1954, Popeye explains to his nephews how Hercules, an ancestor of theirs, came to possess his superstrength. At first, it came from sniffing white garlic, as if this were cocaine, then from eating spinach after his garlic supply is destroyed. "A strange weed this be . . . that restoreth my vitality," Hercules giggles when he discovers it growing in a nearby field. By the 1960s, Popeye would have a pet dog named Birdseed, another nickname for marijuana, alluding to how the cannabis plant was once a leading source of birdseed until it was banned. Other later cartoons showed Popeye tending his spinach plants as if he were a pothead caring tenderly for a precious marijuana crop; he takes careful cuttings, uses special fertilizers, and feeds the plants from a baby bottle. By the 1980s, cartoonists had given up all attempts at subtlety, portraying Popeye getting his fix from loads of "pure Bolivian spinach."

* * *

In 1937, *Popeye the Sailor Meets Sindbad the Sailor* was nominated for an Oscar, for Best Animated Short. Fleischer had been nominated for Oscars before, but this cartoon was particularly notable because, while producing it, he developed what he called the "stereoptical process." This involved using, instead of background drawings, miniature sets that were mounted on a two-and-a-half-ton turntable. Cels were mounted against the set and photographed in a way that would capture the three-dimensionality of the background as it turned, thus giving the cartoon stunning depth. This was also the first Popeye cartoon filmed in Technicolor, and some considered it the most technically advanced cartoon of its time. The production process was so stressful that Max Fleischer had developed an ulcer during it.

Max Fleischer did not win the Oscar that year. Instead it went to Walt Disney, for a mostly forgettable cartoon titled *The Country Cousin*. This prompted critics and aesthetes to question the Academy's judgment, claiming that the best film had been robbed. Others pointed

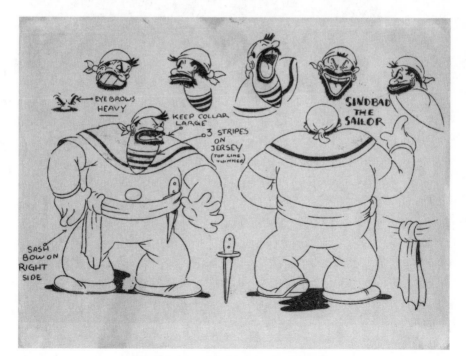

Model sheet for Bluto's character in
Popeye the Sailor Meets Sindbad the Sailor (1936).

out that the Oscars aren't just about merit, they're also about politics. Perhaps, some judged, Max Fleischer lost because he hadn't promoted himself aggressively enough, as Walt Disney did. Disney was in Hollywood and could work the system, while Fleischer was in New York, a continent away.

The most interesting thing about *Sindbad* might have been not the stereoptical process, but its running time. At sixteen minutes, it was more than double the length of the average cartoon short. Many in the industry didn't think audiences would have the patience for something so long, but *Sindbad* proved them wrong. Some theaters actually advertised the cartoon as the main attraction, givng the feature bottom billing and upending the traditional hierarchy of how

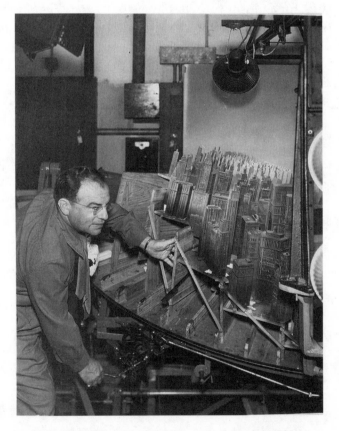

Dave Fleischer with the stereoptical model of New
York City used for *Mr. Bug Goes to Town* (1941).

films were promoted. Because of the film's success, and because of Popeye's strong box office appeal, Paramount authorized the Fleischers to go ahead with another longer film, *Popeye the Sailor Meets Ali Baba's Forty Thieves.*

Fleischer was getting closer to one of his longtime dreams: making a feature-length cartoon. With a feature, animators could show that cartoons were equal to live-action films. There had been cartoon features in the past, but these were niche art-house films, generally out of Hollywood's field of vision. In 1917, an Argentine filmmaker, Quirino Cristiani, had made *The Apostle*, a seventy-minute satire about Argentine President Hipólito Yrigoyen ascending to heaven so he can cleanse Buenos Aires of immorality using Jupiter's thunderbolts, but inadvertently burning the city to a crisp instead. (The only copy of the film was apparently destroyed in a studio fire.) Around the same time, American animator Carl Lederer attempted to adapt *Cinderella* into a feature, envisioning something artistic and subtle in the mold of Winsor McCay, but he died of influenza in 1918 before it was completed. In 1926, German filmmaker Lotte Reiniger released *The Adventures of Prince Achmed*, a pastiche of Arabian Nights themes animated by photographing the silhouettes of cardboard cutouts. But this was more similar to a shadow puppet show than to the kind of animated feature Max Fleischer was imagining.

One month after the release of *Sindbad*, Fleischer told a reporter, "We have an eye on an eight-reel feature, which in production expense will vie with some of Hollywood's most elaborate pictures. There will come a day when audiences can go to a theater and see only a cartoon feature, for the possibilities of the medium are limited only by the imagination of our artists." It was a bold dream, but Fleischer was already behind the curve. His main competitor and rival, Walt Disney, was already working on the same goal.

Chapter 18

"You Can't Top
Pigs with Pigs"

For years Walt Disney had dreamed of making a feature-length car-
toon. In the back of his mind, driving him, was a memory from when
he first arrived in Hollywood. During the long train ride from Kansas
City to Los Angeles, a random man had asked what business he was
in. The movie business, Disney told him.

What part?

"I make animated cartoons," Disney answered, watching the
man's nose crinkle at the response. Starting then, Disney wanted the
people to respect animation as much as live features.

Disney's employees recalled how the idea of a feature-length
cartoon was always incubating in the back of his brain. In 1933, shortly
after Disney hired him away from Max Fleischer, Dick Huemer remem-
bered Disney telling him about his ideas for a feature as they sat in
Walt's office. Even back then, Disney knew he wanted to adapt the
story of Snow White. "He started to tell me a little about the story,
how she eats the poison apple and dies, and how, as she's lying there,
all the goddamned little animals are looking in the window with tears
rolling down," Huemer recalled. Disney was such a good storyteller
that Huemer couldn't help becoming emotional. "My throat started
to get tight, and my eyes began to get moist—it was wonderful, the
way he was telling it."

Around the time of his meeting with Huemer, Disney established
a "special unit" next to his office. This was a "story laboratory" of sorts,
staffed with some of the studio's writers, including Ted Sears, Dick
Creedon, Larry Morey, and Harry Bailey. Their mission: experiment

with different adaptations of the classic Snow White fairy tale. In one, the Queen might imprison the Prince. In another, she might wear shoes of blazing-hot iron and dance herself to death at Snow White's wedding. They pondered different ways the Queen might kill Snow White: choke her with a corset, give her a poisoned comb, feed her a poisoned apple, and so on. The group passed outlines back and forth, then gave them to Disney for his thoughts.

By the winter of 1934, the special unit came up with a workable outline. Once it was ready, Disney approached another group of some fifty staff and gave them each fifty cents. It was near the end of the day, and he told them to go get dinner and then come back to the studio soundstage around seven-thirty. They returned to find him standing alone on the dark stage, waiting, lit by a single spotlight.

Disney was about to act out the movie for them. This was part of his process, something he often did just for staff, so they could understand his artistic vision for an upcoming film. During the performances he seemed to become possessed, running across the stage, his arms windmilling through the air, a schizophrenic blur doing all the separate voices and parts himself. His performance that night lasted three hours; he was drenched in sweat once he finished. Anyone who watched was mesmerized, lost in the boss's performance. Animator Joe Grant remembered it as being a real "spellbinder."

Alongside the ambitious *Snow White* project, the studio still had to produce all the shorts it was under contract for, an intense workload that drove Disney into exhaustion. Doctors gave him injections for a "defective thyroid," but these just made him jittery—what he really needed was rest. Roy convinced him they should both take their wives on an extended tour of Europe, which they did in June and July 1935.

The trip was a whirlwind. When the Disneys arrived in London, police had to protect them from crowds of fans pushing each other into barricades as they shouted Walt's name. In Paris Walt received an "international symbol of good will" from the League of Nations, a heavy gold medal that felt solid in his hand. At the celebration dinner he sat next to a Rothschild, a personification of power and prestige, who asked him to draw a picture of Mickey on his menu so he could give it to the president of France. In Italy he got audiences

with both Pope Pius XI and Benito Mussolini, who thumped his chest and bragged that he had made Italian trains safe from thugs. Between all these stops, Disney noticed something different about European movie theaters: some of them gave his shorts top billing over the features they accompanied, and many had strung together enough of his shorts to play for as long as a feature. To him, it confirmed that there was an appetite for a longer-length cartoon.

At the studio, the Snow White project alone pulled nearly five hundred staff members into its orbit, sparking a hiring spree for additional manpower. Roy, who often focused on financial and administrative matters, spent countless hours visiting potential investors. Cautiously, he discussed figures with an intimidatingly long series of zeros after them. The film's budget had started at $250,000 but quickly ballooned to $400,000, a considerable sum for any kind of movie, let alone a cartoon. *Fortune* magazine reported that, even though Disney's cartoons earned 50 percent more than other studios', their profit value to theaters was still less than live-action films, which typically were more popular with audiences and thus earned a higher fee from theaters. People in the industry began questioning Disney's judgment. After rumors that the budget had tripled, up to $750,000, executives at other studios gasped, nicknaming the project "Disney's Folly." When Louis B. Mayer heard about it, he asked, "Who'd pay to see a drawing of a fairy princess when they can watch Joan Crawford's boobs for the same price?"

Disney was shaken by his colleagues' doubt. "What should I do about all the bad talk?" he asked his friend Hal Horne, an executive at United Artists.

"Nothing," Horne said. "Keep them wondering. Let them call it Disney's Folly or any other damn thing, as long as they keep talking about it."

Many skeptics questioned Disney's plan to adapt "Snow White." It didn't seem like a good choice, so they offered alternative suggestions. The *New Yorker* cartoonist James Thurber suggested Homer's *Illiad* or *Odyssey*. Screen idol Douglas Fairbanks offered to collaborate on adapting Jonathan Swift's *Gulliver's Travels*. Actress Mary Pickford,

who was married to Fairbanks, suggested *Alice in Wonderland.* Others wanted an adaptation of "The Three Little Pigs," but Disney, wary of sequels and stale repeats, a curse that would eventually infect the Hollywood system, told them, "You can't top pigs with pigs."

As a boy, Walt had seen another adaptation of "Snow White" in the 12,000-seat Kansas City Convention Hall. This live-action version was projected simultaneously on four different screens arranged perpendicular to each other in a boxlike shape. Since each of the four cameras was hand-cranked, the timing of each grew different over time. After a while, you could turn your head and see what would happen next, or what had just happened, as the action began floating magically in its own dimension. The dreamlike experience had stayed with him into adulthood.

The story of Snow White originally started in Europe, passed down orally for generations. It was eventually written down by the Brothers Grimm in a basic version that had little in the form of character but much in plot. This helped give it built-in flexibility that allowed tinkering, an appealing quality to Disney. According to Joseph Campbell, the great expert on myths, this flexibility gave such stories something that could be "told and retold, losing here a detail, gaining there a new hero, disintegrating gradually in outline, but re-created occasionally by some narrator." As a fairy tale, it had a kind of democratic populism that also appealed to Disney—again in Campbell's words, "an art on which the whole community of mankind has worked." Fairy tales, according to C. S. Lewis, operated by a unique set of rules, "brevity, inflexible hostility to analysis, digression, reflections and 'gas.'" This appealed to Disney by inoculating the stories against pretentiousness."

The story's flexibility also offered Disney a chance to lighten its tone. The original story was dark and dangerous, pounding audiences with the heavy message that life is a brutal, never-ending cycle. But Disney didn't think this an appropriate message to calm the nerves of a nation mired in the Depression, unemployed and starving. He preferred something warmer and more upbeat. He had spun gloomy stories into something more positive before, most notably with *Three Little Pigs,* which was originally downright sadistic: after the wolf eats two of the pigs, he goes for the third by climbing down his chimney,

then suddenly finds himself in a boiling pot of water until he's cooked to death and eaten by his prey—a hard lesson in reality. Disney toned it down by just burning the wolf on the butt, teaching him a lesson and opening the possibility of redemption. Disney's wolf would get a second chance.

Disney also planned to use *Snow White* to push back against popular movie trends that bothered him. The cinema of the 1930s was moving toward documentary realism and high-contrast black and white, full of close-ups of the hard faces you might see in Walker Evans's photos, depicting labor unrest, soup lines, and economic depression. An optimist by nature, Disney wanted to offer something more uplifting, and in brilliant color. If the film didn't reach his high expectations, he told the *New York Times*, then "we will destroy it."

Dave Hand, one of Disney's supervising directors on *Snow White*, was a handsome man with an athletic build. The other animators nicknamed him "Shoulders" for the way his tailored sport coats draped across his strong frame. Hand's primary responsibility was making sure that everyone knew exactly what the boss wanted, herding the group toward Disney's ultimate vision. "What we are trying to do with Walt is build the picture as he sees it," Hand told staff on December 29, 1936. "We have got to trust in one man's judgment or we won't have a good picture." Disney wanted the foundation for *Snow White* to be strong characters.

For Snow White's voice, Disney envisioned someone who "sounded" as if she was fourteen years old—a "Janet Gaynor type," as he put it. One hundred and fifty girls auditioned while Walt listened to them from a distant room so their appearance wouldn't distract him from their voices. "That one sounds like a thirty-year-old woman," he said when he dismissed Deanna Durban, a husky-voiced fourteen-year-old who would later go on to become a soprano star at Universal. "She sounds to me like a fourteen-year-old girl," he said of Adriana Caselotti, who was actually eighteen, but got the part anyway. Once other studios heard that Caselotti had been chosen, other acting offers began flooding her way, but Disney

quickly forbade her to appear anywhere else. "I'm sorry," he said, "but that voice can't be used anywhere. I don't want to spoil the illusion of Snow White."

In the original Grimm tale, Snow White is aware of the power her sexuality holds, but Disney wanted his version of Snow White to be more innocent. In the original, Snow White and the Queen are basically the same person, but at different stages of life; it suggested that Snow White would grow up to be just as nasty as the Queen. Disney wanted his Snow White to have virtues—kindness, compassion, nurturing—that weren't in the original, but which he felt were needed in 1930s America.

The task of designing Snow White's look fell to animator Ham Luske. His first drafts, however, were a little *too* innocent—childish, soft, round. Disney was concerned that she didn't look old enough to fall in love with the Prince, thus making the Prince appear creepy when he pursues her. To remedy the problem, Disney teamed Luske with Grim Natwick, who had designed sex bomb Betty Boop for the Fleischers. Natwick's vision, however, went too far in the other direction. His Snow White resembled sultry Hollywood vamps like Myrna Loy or Carole Lombard—mischievous celebrities whose names regularly surfaced in the gossip columns. Working together, Luske and Natwick clashed constantly until they finally reached a compromise that included input from several other colleagues. This version of Snow White was softer than Natwick's vision but sharper than Luske's. Additional inspiration came from watching footage of Marjorie Belcher, the teenage daughter of a Hollywood dance instructor.

As Disney worked with staff to develop the Queen, he chain-smoked cigarettes, deliberating between two different options for her character. The first was "a fat, cartoon type; sort of vain—batty—self-satisfied." The second was "a high collar stately beautiful type." A dozen women auditioned for the voice but were immediately rejected: they all sounded the same, which the producers concluded was because they were all mimicking the same witch from a popular radio program of the day. Besides, the producers didn't want a witch, they wanted a queen; not to mention there was already a witch in the

cartoon—she was actually modeled after two men, Nestor Paiva and Moroni Olsen, who posed for their sessions while wearing drag.

Once actress Lucille La Verne auditioned to be the Queen's voice, the search ended. She had just played La Vengeance in David Selznick's *Tale of Two Cities* and definitely sounded like a queen—a cold and icy one. The story department described her as "A mixture of Lady Macbeth and the Big Bad Wolf—Her beauty is sinister, mature, plenty of curves." As she stepped to the microphone, La Verne's maniacal laugh—about to become one of the most famous in cinema—sliced the studio air into ribbons. For the parts that required La Verne to convert her voice into a cackle—when the Queen morphs into an old peddler woman—she slipped out her false teeth. As the animators tweaked the Queen's look, Disney suggested that they make her ghastly smile a little "more Lionel Barrymore."

Production drawing of the Witch from
Snow White and the Seven Dwarfs (1937).

In the original Grimm tale, the dwarfs were vaguely defined and didn't have names, but Disney wanted to amplify their role and make them "screwy" in order to provide additional color. On Tuesday nights, the animators met to dream up personalities for each. "Walt feels very strongly . . . that we have got to keep these little fellows cute—mustn't get grotesque," Perce Pearce told his colleagues after learning that Walt's wife, Lillian, had expressed doubts about using dwarfs at all. "There's something so nasty about them," she had said.

The animators drew up a roster of potential dwarf names that read like nicknames at a frat house: Awful, Baldy, Bashful, Biggo Ego, Blabby, Burpy, Chesty, Cranky, Daffy, Deafy, Dirty, Dizzy, Doc, Dopey, Flabby, Gabby, Grumpy, Happy, Hickey, Jaunty, Jumpy, Lazy, Nifty, Puffy, Scrappy, Shorty, Silly, Sneezy, Sniffy, Stuffy, Tubby, and Wheezy. They pondered the choices for months, eliminating the offensive ones that drew their humor from making fun of handicaps. Some worried that Dopey would be mistaken for a pothead, but Walt said it was okay because Shakespeare had used the word. Since nobody bothered to fact-check him and learn that Shakespeare had not, in fact, used that word, the name stayed.

The studio hired three actual dwarfs—named Erny, Tom, and Major George—to model for the animators. In that era, many show business dwarfs had come up through the raunchy vaudeville and carnival circuits, and behaved in the ways one might imagine in those colorful environments. They had often had careers as part of freak shows, mocked and laughed at as they traveled from one town to the next. Many were grizzled and hard, didn't take guff from anybody, and typically didn't carry the kind of upbeat energy Disney wanted to pair with the virginal Snow White. Looking at the models, Disney began having second thoughts. "To me, Erny, Tom and Major George are not very cute," he wrote in a memo. "I can't help but feel sorry for them."

Ham Luske suggested they bring in child actors instead, but Disney rejected this idea. The dwarfs weren't kids, they were men, and needed to act like it. Eventually, the studio decided to model the individual dwarfs after real actors: Will Rogers for Bashful, Roy Atwell for Doc, Otis Harlan for Happy, and black comedian Stepin Fetchit for Sneezy. Dopey would be a combination of Harpo Marx and the silent-era comedian Harry Langdon, star of the colorfully named

films *Boobs in the Woods* and *Hallelujah, I'm a Bum*. Disney made it clear, however, that Langdon shouldn't be invited to the studio, because "he is not sober half of the time and not dependable."

Of all the dwarfs, Dopey was the most difficult to conceptualize. The film needed him both for comic relief and for sympathy, a delicate balance. "He is not an imbecile," Disney told the staff when their ideas began wobbling off course. "He is full of fun and life . . . it is more that he is a little guy that hasn't grown up." At first, the animators thought of Dopey as a two-year-old baby; then they came to envision him more as a "human with dog mannerism and intellect." "He has a sort of dumb personality—in a way, like Pluto," Disney said. The animators gave Dopey the ability to move one ear independent of the other, like a dog shaking off a fly, and a habit of pawing his face with his hand while dreaming, mimicking the mannerisms of a burlesque comedian from Atlantic City named Eddie Collins.

Animator Art Babbitt pushed his colleagues to give these characters more depth than they had ever done before. Building upon superficial mannerisms might have worked for shorts, but not for features. "You have to go deeper than that," he said during one session, urging his colleagues to get inside their characters' minds. Squeezing his fist into a ball for emphasis, he reiterated the point again. "You have to go *inside*."

In 1937, deep in the middle of production for *Snow White*, a rumor began circulating among the Disney staff that Bank of America, the studio's main financier, was about to take over. The film's cost had spiraled out of control, up to $1.5 million, six times its original budget. When that figure was reached, "Roy didn't even bat an eye," Walt remembered. "He couldn't, he was paralyzed." The studio seemed caught in a permanent storm, with staff working eight-hour shifts, twenty-four hours a day, seven days a week. Nobody was sure they would finish by their deadline, the end of the year. Walt cabled to his friend, film producer Hal Roach: THE SUPER COLOSSAL SNOW WHITE HAS ME HOGTIED . . .

One day, Joe Rosenberg, an executive from Bank of America, showed up at the studio for a tour. He was grim-faced, wearing a dark

suit, and holding a briefcase—all business, no nonsense. Roy, who was more sensitive to financial matters than Walt, quietly asked Rosenberg to talk some sense into his brother. As Rosenberg remembered it, Walt then began shouting that bankers were all "a bunch of SOB's." Walt later disagreed with Rosenberg's account, claiming he had only called them a bunch of "goddamn bankers."

Rosenberg's tour of the studio was quiet and uncomfortable; the whole time, he held his cards close to his vest, showing nothing but a poker face. Walt showed him around, the two poking their heads in here and there. In order to give Rosenberg a sense of what the film would feel like, Disney showed him some rough pencil sketches. These were preliminary drawings done on paper before the images were committed to cels and paint. Handled like a flipbook, they provided a sense of how everything would look, allowing animators to correct errors. They were a measure of quality control used by Disney but rejected by other studios because they were time-consuming and expensive. "If an animator doesn't know exactly what he's doing, he's no animator," Max Fleischer once said of pencil tests. Showing these to Rosenberg, an outsider who knew little about animation, was a risky move because the sketches were an unfinished product. But Disney decided to show him anyway. Rosenberg responded only with grunts and monosyllables. Once the pencil tests were finished, he rose silently, not saying a word.

In another room, Disney showed Rosenberg the paint department. The studio ground all its own pigments—1,200 distinct hues— with disc mills typically used for food. Many of the colors were created specifically for *Snow White*: earth tones that were easier on the eyes for a feature-length film, versus the vibrant colors typically used for shorts. The department also had a spectraphotometer—one of only twenty in the world—to measure the colors precisely. A poster on the wall showed how the tones would translate into Technicolor.

In yet another room was a multiplane camera, developed by the studio's machine shop to give the images 3-D depth. The effect was similar to Max Fleischer's "stereoptical process," used for *Popeye the Sailor Meets Sindbad the Sailor*, although the mechanics were different. The multiplane camera was twelve feet tall, composed of four layers of glass shelving for holding drawings and backgrounds. A camera at the top shot down through each of the layers, each of which could be

adjusted a hundredth of an inch at a time. As many as eight men were needed to handle it at a time, each of them wearing a sweat-soaked T-shirt because of the 500-watt light bulbs installed at each level. It was a clunky piece of machinery, but when used properly, it created effects that helped the animators express "the beauty of the wind," or "the real feeling of the rain," according to animator Eric Larson.

As Disney and Rosenberg moved toward the soundstages, to hear the music for *Snow White,* Rosenberg continued to remain quiet, his face expressionless. Not a fan of modern pop music, Disney explained that he wanted to keep the soundtrack subdued in order to maintain a broad appeal. "Audiences hear a lot of hot stuff. If we can keep this quaint, it will appeal more than the hot stuff," Walt said. "I don't like the Cab Calloway idea or too much OH DE OH DO," he said of the jazz musician who had performed the music for some of his main competitors' best work.

The room where the Foley artists worked was littered with pieces used to create various sound effects. In one corner sat an old dresser hauled in from one of the sound engineers' homes; one of its squeaky drawers was perfect for scenes of the dwarfs pushing open their front door. Scattered across another table were bottles full of different amounts of water, used to create the murmured sounds of the dwarfs' pipe organ. A long tube along another wall led to a slab of marble mounted with a microphone, used to record the spooky voice of the magic mirror.

Most studio visitors were enchanted to learn the tricks of the trade, but not Rosenberg. He was all business. Before his visit, he had asked around about Disney, hearing both good things and bad. He had a hunch of what to expect and showed up to see for himself. After the tour, Disney walked him to the parking lot, still trying to get a sense of his impression. He looked Rosenberg over, searching for some kind of sign. "Good-bye," Rosenberg said, climbing into his car, still stone-faced. Just before driving off, he finally offered Disney his assessment. "That thing is going to make a hatful of money."

Disney's secret weapon during the production of *Snow White* was a man named Albert Hurter. He was one of the studio's best artists,

whom Walt had tasked with designing the entire movie's mood and feel.

A tall, gaunt, mustachioed man of fifty-three, Hurter began work precisely at eight each morning, drawing frantically until he left, exactly at five. He chain-smoked cigars the whole time and didn't say good-bye when he clocked out. As he left, he hobbled across the parking lot with a limp due to the fact that he kept his money in his shoe instead of in a wallet—he lived in a bad neighborhood, despite getting paid well, and was afraid of getting mugged. This was just one of many eccentricities. A man who kept to himself, he made the other artists wonder what he did in his free time. Eric Larson, who liked to visit the desert on weekends, told his colleagues that he once spotted Hurter out there. He was alone in a sports car, driving furiously across the flats, going nowhere in particular, kicking up a plume of tan dust in his wake.

Soon after Hurter joined Disney, in 1932, Disney decided that his job was just to sit and draw. He was a decent animator, nothing special; his real talent was coming up with interesting ideas and visions, and he was a superb draftsman. Before every new film, Hurter would allow his imagination free rein, then pass his sketches to the animators for inspiration. For *Snow White* he drew fifty to one hundred sketches a day, anything in the film, from character prototypes and the dwarfs' cottage to the castle furniture and the forest. The film's vaguely Teutonic look—as well as that of other early Disney features, like *Pinocchio* and *Bambi*—came from Hurter's European upbringing. He had a "Black Forest type of mind," according to a colleague. Born in Zurich, Switzerland, with a weak heart, Hurter had spent much of his childhood indoors, passing the time by drawing. He studied art and architecture in school and moved to the United States around 1912, although the exact date was never entirely clear (Hurter didn't even tell the Disney human resources office his birthday). He worked briefly as an animator for Raoul Barré in New York, then made his way to California because he was fascinated by the open, wild desert.

While Hurter's taste tended to drift toward old-world European, he sometimes dabbled in the modernist and surreal: ambulating eyeballs, monsters, weird creatures in the shape of human hands or other body parts. Other Disney artists often pocketed these drawings and

took them home as mementos. They accorded Hurter special respect, as did Walt, who gave him the rare authority to approve certain style and design decisions. In fact, Disney on occasion rejected others' work if he learned that Hurter hadn't signed off first. He once did this for some sketches of nothing more than rocks being used for background art. "Albert knows the character of the picture better than anyone," he said.

On December 21, 1937, *Snow White* premiered at Los Angeles's Carthay Circle Theater, the 1,500-seat movie palace where Disney's masterpiece short, *The Skeleton Dance*, had premiered in 1929. That night, searchlights swept the sky as crowds pressed against the velvet ropes strung along the red carpets. Limos pulled up to deliver glamorous celebrities, their footsteps crunching on the glass shards left by the popping camera flashbulbs. When Disney arrived, he carried in his pocket a telegram wired to him that day by his idol, Charlie Chaplin: AM CONVINCED ALL OUR FONDEST HOPES WILL BE REALIZED TONIGHT . . .

Once everyone settled into the seats, the film started rolling. As the opening credits flickered onto the screen, the mood became electric. When the Queen first appeared, gliding through the fog in her boat, actor John Barrymore bounced up and down in his seat. The dwarfs inspired rounds of applause every time they appeared. Gasps echoed through the room during the scene of the threatened Snow White stumbling through the forest, chased by a posse of swirling leaves, the sharp branches clawing at her clothes. After the poisoned apple rolled from Snow White's limp hand, Clark Gable and Carole Lombard could be heard sobbing quietly, according to animator Ward Kimball, who was sitting a few rows away.

When the final credits rolled, the applause was deafening, everyone shouting praises over the din. It was more than just a good movie; it was a cultural moment.

The newspaper coverage of what followed—ecstatic reviews, from popular broadsheets to obscure literary journals—was monumental. "It is a classic, as important cinematically as 'The Birth of a Nation,'" said the *New York Times*. "An authentic masterpiece," raved

Time. "Among the genuine artistic achievements of this country," the *New Republic* purred. Film director Sergei Eisenstein, who revolutionized cinema thirteen years earlier with *Battleship Potemkin*, called it "the greatest motion picture ever made!"

Nobody looked at it as a "kids' movie." British censors actually banned children under sixteen from seeing it without an adult. "English young folk are unused to excitement," the Associated Press reported. "They are more easily upset by fairy stories than their 'tougher' American cousins." This was hyperbole, of course; years later, Dr. Benjamin Spock said he heard that *Snow White* had forced Radio City Music Hall to reupholster its seats because so many American kids had wet them.

After the theater critics finished with their praise, the financial reporters took their turn. By May 1939, eighteen months after it debuted, *Snow White* had film receipts of $6.7 million, making it the highest-grossing American film ever. Audiences had formed lines running around corners and down blocks. Some theaters took reservations three weeks in advance and started morning showings to satisfy demand. Within two years, the film had played in forty-nine countries and was dubbed into ten languages. Merchandizing revenues were equally huge: for example, 16.5 million *Snow White* drinking glasses and nearly $2 million worth of *Snow White* handkerchiefs were sold. A *New York Times* editorial speculated that maybe animation was the answer to the Depression.

The spring after the film's debut, Disney decided to use part of the financial windfall to reward his staff. "They deserve it," he told the press. "They made the picture possible, didn't they?" They certainly had—their Saturday work hadn't come with overtime pay and their animation lightboards sometimes grew so hot they got burns. In June, everybody received a bonus of three months' worth of salary, which cost the studio roughly $750,000. Also, after years of requiring them to work on Saturdays until noon, Disney announced a five-day week for the summer.

They had done the cinematic equivalent of building a Gothic cathedral. In what amounted to well over 200 years' worth of man-hours, nearly 600 employees had created nearly 2 million cels, of which 250,000 were used for the film.

All things considered, they had worked well together. But by the end of it, they had also reached a breaking point. Artistic young men, the studio's main demographic, were volatile under normal conditions, let alone these. Their habits near the end were a warning signal. They had begun summoning a delivery boy every day at four o'clock for beer, igniting legendary benders. They blew off more steam by sketching outrageous pornography: Snow White consorting with the dwarfs, the dwarfs with each other. "Even the old witch was involved," Shamus Culhane said. In later years, after people began to mistakenly think of their work as "cutesy," they relished telling stories of their powerful libidos, chuckling at the memory of how Milt Kahl once wrote "sexual intercourse" on a company questionnaire asking about his favorite hobby. During the production of *Snow White*, they had increasingly disobeyed strict orders not to fraternize with women from the ink and paint department. Pairing off in visits to local hotels, they signed the registers as "Ben Sharpsteen," an unpopular supervisor.

Sensitive to the pressure his staff had endured, Disney in June 1938 decided to treat everyone to a weekend getaway. He chose a resort on Lake Norconian, nestled among the mountains of the California desert. It was a private place where celebrities went to relax, away from the paparazzi. It had golf courses, horseback riding, and swimming pools reflecting the bright yellow sun. Most important, the resort had a magnificent bar. After everyone arrived, events began innocently enough: golf, knapsack races, a pleasant lunch under swaying palms. This was followed by poolside lounging, drinks, and then more drinks. Soon people started walking wobbly, their speech getting louder.

Then, as if the cork popped from the champagne bottle, someone threw a fully clothed ink and paint girl into the pool. Others quickly splashed in to join her. The bartenders were pouring furiously, and everyone's speech was now both loud and slurry. Things were getting sloppy. Drunken Freddie Moore, the man who had redesigned Mickey years before, fell out of a second-story window but landed in a bush, stumbling away unhurt. Somebody else drunkenly galloped a horse into the lobby, trotted up a stairway, and thundered down a hall.

Most witnesses describe what came next as an "orgy." Abandoned bathing suits left floating in the pool. Moaning from the bushes.

Random couples searching the hotel for empty rooms. People later had a hard time recalling whom they had slept with. Ken Anderson remembered that some wife swapping had occurred, but memories of that night were as fuzzy as the hangovers. Everyone remembered it a little differently. Bill Givens, who was married, thought it was "a disaster." Bill Justice, single, thought it was "one hell of a party." Disney had slipped away early, probably because he saw where things were headed and knew he couldn't stop it. He chose to bury the memory somewhere very deep. "He never referred to that party again," according to Bill Justice. "If you wanted to keep your job, you didn't mention it either."

After the release of *Snow White*, Disney received many awards, including honorary degrees from Yale and the University of California. But one accolade was missing: an Academy Award. Disney had received Oscars before, in the cartoon shorts category, but *Snow White* could compete on a more prestigious level, perhaps Best Picture. At the tender age of thirty-six, he had put animation on a par with live action. He started asking around the Academy, dropping in on members, casually bringing up his chances.

"The Award Committee might consider it for special honors," he was told. In Academy lingo, "special honors" meant "consolation prize." When a "special" award did come, in 1939, something about it didn't seem entirely serious: one big Oscar statue followed by seven little ones, for each of the dwarfs. It felt like a gag gift, not an honor. The Academy chose child star Shirley Temple to present it, another choice that made it seem as if they weren't taking Disney particularly seriously. "Isn't it bright and shiny?" she chirped while handing it over. Disney smiled politely, but in other photos from that night he doesn't look as happy as one might imagine. His lips are tight, as though he's weathering an insult. He usually tried to hide such feelings, especially when he knew people meant well, but sometimes they slipped out. *Time* magazine reported that Disney once snapped at a journalist who casually called *Snow White* a "cartoon." But it was more than that. Disney nipped back, saying, "It's no more a cartoon than a painting by Whistler is a cartoon."

Chapter 19

"Max Fleischer
Killed Dan Glass"

Perhaps the only people in the world not thrilled with *Snow White* were the Fleischer brothers. Disney's film consumed all the oxygen in the room; everyone was talking about it. Adding insult to injury, the New York premiere of *Snow White* occurred at Radio City Music Hall, built on the site of the Fleischers' boyhood home, before the family moved to Brooklyn. The home was razed to make way for the theater, and when Max walked by the *Snow White* marquee, he was forced to look down at the pavement to avoid seeing his competitor's name in lights on his home turf. Lou Fleischer's son Bernie remembered how depressed his father was after *Snow White*, and how his mother had rubbed all the brothers' noses in Disney's success. "Disney is doing art," she said, "and you guys are still slapping characters on the butt with sticks!"

For years, Max Fleischer had begged Paramount to let him make a feature. He asked to adapt *Captain Kidd, Neptune's Daughter,* or *Peter Pan,* which Paramount owned the rights to. He also suggested Popeye, reminding the executives that the longer two-reel Popeyes had done better at the box office than the shorts. Every time, Paramount executives said no. They were skeptical about Fleischer, who didn't project the same inspiring charisma as Disney. In early 1938, the executives discussed the matter in a series of memos. "There seems to be grave doubt about the Fleischers' ability to compete against the *Snow White* idea . . . the whole doubt here is whether Fleischer has the imagination and the ability to compete," read one. Another executive said, "I just don't think that Fleischer has what Disney has."

A month after the premiere of *Snow White*, when its incredible success was obvious, the executives reconsidered. By March, their memos spoke of Fleischer differently. "Fleischer has been urging Paramount for at least three years to permit him to make a feature cartoon," one executive wrote. "Fleischer's past reputation and experience, and his very successful results to date entitle him to the opportunity that people here feel to fulfill his long cherished ambition of making a feature picture."

On April 4, 1938, *Film Daily* announced Fleischer's upcoming feature, an adaptation of Jonathan Swift's *Gulliver's Travels*. Fleischer was quick to differentiate this project from Disney's. In Fleischer's opinion, *Snow White* was too "arty," whereas *Gulliver* would be a "real cartoon."

Fleischer also made clear that his adaption would not be a fairy tale. Rather, it was a political satire. Fleischer had long been a fan of Swift, a writer known for his sophistication and nuanced thinking as both an establishment voice—a propagandist for the Crown—and a cultural bandit who regularly skewered his nation's living heroes. His writing was entwined with mischief and subtext, creating as many enemies as it did fans. When Swift first published *Gulliver's Travels* in 1726, he said his intent was "to vex the world rather than divert it." So too with Fleischer, who was eager to counterbalance Disney's relentless optimism. Fleischer said he wanted his film to show "the smallness of human beings regardless of how great they think they are."

But Fleischer also understood the importance of good showmanship and didn't want his feature to be heavy-handed or didactic. He suggested giving the film a lighter tone by casting Popeye as Gulliver, an excellent fit considering that both characters were globetrotters familiar with various cultures. In each of Gulliver's escapades, he confronts a dilemma that offers him a fresh lesson about humanity, widening his perspective and capturing mankind's constant nagging doubts about its universal status. To have a worldly sailor like Popeye play this role seemed a good idea at first, but less so over time. It was eventually scrapped.

Adapting *Gulliver's Travels* was a passionate project for Fleischer. It was one of his favorite books, one he regularly read to his kids before bed. His son Richard remembered these sessions fondly, how Max's

voice would fall to a low murmur before he closed the pages softly and clicked off the light. Even though the Fleischers were American Jews and *Gulliver's Travels* was a story about British society in the eighteenth century, the story was treasured as if it were a family heirloom. Fleischer wanted to do it justice.

Knowing that the tale was too epic for a single movie, Fleischer chose to adapt just one section: Gulliver's visit to Lilliput, a land of little people who are always getting upset about trivial things. In Swift's version, the Lilliputians go to war with their neighbors in Blefuscu because they can't agree which end of an egg is the proper one to break. It was a great story, rich and snappy, but Fleischer knew that some adjustments would be needed for American audiences. In his version, the tribes would instead fight over which country's national anthem to play at the wedding of Prince David of Blefuscu and Princess Glory of Lilliput. These characters weren't in Swift's original, but were created by Fleischer's story department, as a way to add the kind of love story that studio executives were always asking for. It would also allow them to work in some romantic love ballads from Paramount's music catalogue.

For the ending, Max wanted the two countries to unite in friendship after agreeing to combine their national anthems into one song. Dave Fleischer hated that idea, as did the film's chief songwriters, Leo Robin and Ralph Rainger, skilled pros who had written the chart-topping "Thanks for the Memory" for Bob Hope and Shirley Ross. They felt the songs they had to use for the two anthems, "Faithful" and "Forever," were difficult to combine in a way that didn't sound strange. But eventually they found a way, creating "Faithful Forever," the kind of warbly ballad one croons while holding his hand over his heart. Nevertheless, the song was nominated for an Academy Award, although it ultimately lost to "Over the Rainbow" from *The Wizard of Oz.*

Another reason Fleischer chose to adapt *Gulliver's Travels* was that he thought it had "universal appeal," meaning the potential to connect with foreign audiences. French film director Georges Méliès had produced a successful silent live-action version in 1902, and Walt Disney's *Gulliver Mickey,* a short parody released in 1934, had done well with worldwide audiences. In 1935, Soviet filmmaker Aleksandr Ptushko adapted a successful version, *The New Gulliver,* which won

several awards on the European film festival circuit (Fleischer probably didn't see the film, but Charlie Chaplin, who regularly traveled to Europe, was a fan). *The New Gulliver* was a combination of animation, live action, and puppets. It featured a Ukrainian boy, Petya, who falls asleep while reading Swift's book and dreams himself into Gulliver's role. Just as Fleischer planned to mold his adaptation to American tastes by inserting a love story, Ptushko catered to the Communists in his. When Petya wakes up in Lilliput, he's quickly outraged by all the corruption he sees among aristocrats. Rallying oppressed miners from the countryside, he leads them in armed revolution against their capitalist masters.

If there was any great meaning to Ptushko's adaptation of *Gulliver's Travels* and its economic message, it does not seem to have occurred to Fleischer. In hindsight, he might have given it more thought. The Great Depression meant many Americans were stuck in soup lines, muttering complaints about capitalism under their breath. In 1935, the year Ptushko's film came out, the United States Congress passed the Wagner Labor Relations Act, protecting Americans from unfair bosses and affirming their right to organize. The legislation seemed tailored for places run the same way most animation studios were, as if they were sweatshops. For the previous few years, Fleischer had struggled with labor problems at his studio. He had tried to broker solutions, but they proved weak. Just as work on *Gulliver* began, these issues boiled to a head.

Max Fleischer's labor problems began with an animator named Dan Glass. Originally from Arkansas, he had moved to New York to become an artist. Shortly thereafter, Fleischer hired him to work at the studio for $22 a week, most of which he sent home to his family. Glass was a good employee and well liked, but one day, in the fall of 1934, he failed to show up for work. A few more days went by, but still no Glass. His desk sat empty, an unsettling calm spot amid the busy atmosphere.

Glass didn't have a phone, so Fleischer dispatched someone to investigate. Glass lived alone in a small, simple apartment. When the colleague arrived, he found Glass curled up in his threadbare sheets, sick with pulmonary tuberculosis, his cough sounding like somebody

crumpling a paper bag. When his colleagues in the in-between depart-
ment learned of his condition, they took turns caring for him.

Fleischer paid for Glass to spend a week recuperating at a New
Jersey resort. But at the end of his stay, the doctor wore a grim expres-
sion. Dan's condition had worsened. A collection was taken and Dan
was sent back home to Harrison, Arkansas. Fleischer paid for the
train ticket. Others at the studio thought this was a nice gesture but
were bothered that he hadn't seen Glass off at the train station, as
the rest of them had.

Two months later, the studio received a note. On January 17,
1935, Glass had died.

Staff at the Fleischer studio began wondering whether the office
environment had killed him. The whole tenth floor was sectioned into
tiny cubicles, with no windows and poor circulation. The air quality was
foul. Nor was there any air-conditioning; the hot, damp summertime

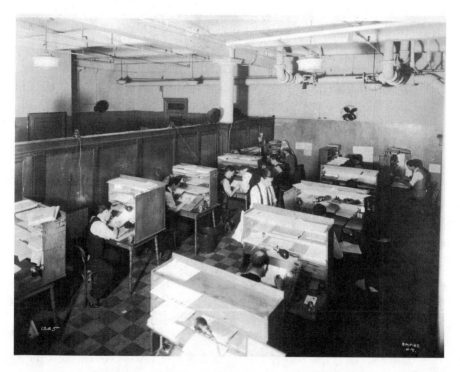

One of the Fleischer animation rooms, circa 1933.

air felt like an armpit. Added to that were fumes from all the inks and paints. And the days were long: forty-five hours a week, including a half-day on Saturday, with no paid vacations or sick time. These conditions affected everyone; if you got sick it was hard to recover properly. And Glass wasn't the only one who had gotten sick. Lillian Oremland had contracted tuberculosis several years before Glass and would die a year after him.

Some thought that Fleischer could do more to ensure their rights, benefits, and general welfare. He was a decent boss and generally liked by the staff, but he sometimes ran the studio according to his whims and fancies; working for someone so unpredictable could be stressful. Sometimes he would stroll through the studio and call out, "Who hasn't had his name on a cartoon yet?" and then give out screen credits regardless of that person's contribution. It felt like a family business, and essentially was. Max had hired all his brothers and his daughter, who married Seymour Kneitel, one of the animators, who himself had family at the studio. Sometimes it was nice being part of such a close-knit group, but the arrangement also created a sense of mystical loyalty to the studio's management. This bothered some employees.

Pay was another sore issue. Across the entire animation industry, it was generally falling. When Shamus Culhane started at the Fleischer studio in 1930, he made $100 a week. When Dan Figlozzi started in 1935, he made only $27 dollars a week. The reason for the drop was that the industry had become increasingly specialized, like a factory. It had been building toward this since the days of John Bray, who chose to call his supervising artists "foremen," and his in-betweeners and inkers "cheapmen." In the early days, a few people, often more broadly talented, did everything: story, art, layout, and inking. By the 1930s, tasks were more specialized, as on an assembly line. This made production faster and cheaper because lesser-skilled people made less money, even though the studio boss might be earning more. The top animators still made good money, but the crowd of people beneath them often struggled financially.

As the studio became more like a factory, Fleischer's staff complained that they weren't being treated as artists. This complaint echoed a trend happening industry-wide. Lower-ranking staff at Disney

needed hall passes to use the bathroom, as if they were schoolchil-
dren. The Fleischer staff had it even worse than that, hounded by
supervisors timing their breaks with a stopwatch. An in-betweener at
Fleischer who took too long in the bathroom would come back to his
or her desk and find Edith Vernick, head of the department, standing
there, tapping her toe. "She looked at her watch and wanted to know
if you had diarrhea," Irv Levine remembered. Vernick had started
there when she was eighteen and had been promoted up through the
ranks, becoming almost like family to Max. Even though she made
only half as much as her male counterparts—another grievance—she
demanded that employees give the studio the kind of dedication to
be expected in a cult.

Six months after Glass's death, Congress passed the Wagner Act,
guaranteeing the basic rights of employees to organize and collectively
bargain. Once President Franklin Roosevelt signed it into law, anima-
tors began to meet, sometimes in secret. They huddled in basements
or in diners after a long shift. They stole glances over their shoulders,
looking for men sent by their bosses—men with bulges under their
coats or scars on their knuckles. Some animators began distributing
pamphlets letting others know there was strength in numbers. One
pamphlet in particular began floating around the Fleischer studio.
It read, "MAX FLEISCHER KILLED DAN GLASS!"

On May 7, 1937, a strike broke out at the Fleischer studio. It was two
years after Dan Glass's death; the time in between had been filled by
countless hours of negotiations between management and the work-
ers' new union representatives. They resembled military summits, the
lawyers sitting across from each other at long tables, pushing papers
back and forth. Next came the picket signs, their slogans funny in a
way one would expect from gagmen. "I'm Popeye the Union Man,"
or "I make millions laugh but the real joke is our salaries," or "We
can't get much spinach on salaries as low as $15." During the protest,
Dave Fleischer stared down at the strikers from his window. His anger
rose when he realized their signs were made from supplies taken from
the art department.

Down on the picket line, fights broke out. People piled on top of each other like football players trying to recover a fumble; some strikers lost teeth in the resulting scrums. Shortly thereafter, Dave Fleischer's house was stink-bombed, although the striker who did it confessed he meant to bomb Max's house. Max hired a bodyguard and started carrying a gun to work, creating an awkward bulge in his tailored suits. The strikers were met with more violence and intimidation. Men gripping lead pipes would sometimes creep up behind them as they entered their apartments. At other times, the phone would ring but the only sound at the other end was heavy breathing. There was speculation that these tactics weren't ordered by Fleischer but had come from anti-union executives at Paramount.

The arguments were never black and white. Fleischer had set up a Studio Relief Fund for needy cases, and while nice, it was not the entire solution. On a few occasions, Fleischer agreed to increase pay. Every time the opposing sides were about to shake hands, however, the airing of some new grievance would force everyone back to the negotiating table. An outside union, the Commercial Artists and Designers Union, known as CADU, had positioned itself to represent the Fleischer employees. Its demands were ambitious: a thirty-five-hour workweek, double overtime pay, paid vacations and sick leave, and a 12 percent raise for everybody. The representatives probably knew they wouldn't get everything but negotiated aggressively, hoping to settle somewhere in the middle.

Compared with other industries, the union movement at Fleischer Studios was relatively slow to start. Many employees saw themselves as artists, not as the kind of laborers one might typically find in unions. Nor were the fault lines dividing the employees very clear. Many junior employees, who stood to gain the most from organizing, were against the union, either out of loyalty to Max or because they were afraid of being labeled as Reds. Some senior employees, although well paid, were pro-union, their moral compass not tied just to money. One thing that did unify the staff was that most were immigrants or the offspring of immigrants, transplanted from cultures with their own prickly labor problems. They may have liked Max personally but they also remembered lessons from the old

country about individual men holding too much power: the czar, the jefe, the szlachta, the padrone, the junker. Capitalist barons were no different. The staff didn't buy into the message once voiced by President Calvin Coolidge that "he who builds a factory builds a temple. He who works there, worships there."

Some employees, torn between the two sides, decided to leave. Inker Charles Addams took a job drawing cartoons for magazines, going on to eventually create *The Addams Family*. In-betweener Jacob Kurtzberg took up the pen name Jack Kirby and began drawing comic books. Working with colleagues Joe Simon, Stan Lee, and others, he eventually helped create characters like Captain America, the Fantastic Four, the X-Men, and the Hulk, among others in the Marvel Universe.

The employees fought with the wind to their backs. Popular sentiment was behind them—one of the most popular songs of the day, reflecting the general mood, was "Don't Tell Mother I Work on Wall Street, She Thinks I Play Piano in a Whorehouse." They also benefited from the Wagner Act's newly minted provisions. Other outside unions rallied in solidarity behind the Fleischer strikers: the Screen Actors Guild lent financial help, the musicians' union refused to record soundtracks, and the projectionist unions refused to show Fleischer cartoons, helping to force boycotts at powerful theater chains like Loews.

Max Fleischer's response was vicious. He couldn't believe that so many of his staff would turn against him like this. Advising him was an attorney on loan from Paramount, Louis Nizer, a hatchet-faced man in a crisp suit who sat behind him during meetings, occasionally leaning forward to whisper in his ear. Fleischer refused to negotiate with CADU, claiming that it didn't represent most of his staff. Soon he began firing pro-union employees in stages, laying down these periodic bursts of gunfire as a way to increase pressure on his opposition. Even though the Supreme Court had forbidden the firing of employees for union activities, the studio found its way around the ruling by creating convenient alternative explanations for the terminations.

CADU petitioned the National Labor Relations Board for an election certifying that it spoke for all the Fleischer artists. Three days later, Fleischer responded by firing thirteen more employees. Fire was fought with fire. Alden Getz, a pro-union artist, claimed Fleischer

had taken this strategy from an anti-union pamphlet he had seen on his boss's desk, entitled *How to Break a Strike*, which promoted tactics violating the Wagner Act.

A small group of animators finally convinced Fleischer to accept a partial arbitrator, a measure endorsed by CADU. They also convinced him to rehire the employees he had fired. It seemed like progress, but Fleischer soon altered direction, claiming that pay increases for low-level staff would be taken from the pay of high-level staff. This was a surefire way to stoke controversy among the employees, turning them against each other. The labor organizers warned the artists that it was just a tactic to divide them, but the artists didn't listen. Fleischer's countermove had its desired effect: the artists were weakened, bickering among themselves. Max soon seized more ground, backtracking on his arbitration agreement and saying that he would now rehire only half the fired staff. This confrontation would thus become a template for other disputes after it: suspicion, intimidation, stonewalling.

On June 16, 1937, the National Labor Relations Board examined the Fleischer case. Hearings began to determine if CADU did, in fact, represent the artists. Nizer responded with a masterful demonstration of delay tactics: wonky motions about jurisdictions and interstate commerce, requests for petitions, various bureaucratic appeals wrapped in red-taped points of order. Despite his countermeasures, the final vote tally was unanimous: all the artists would be represented by CADU. Negotiations started by autumn. Witnesses to the talks claimed that Fleischer looked ill, saggy faced and gray, as if he had aged rapidly. Dave just sat quietly in the room holding, for reasons nobody could explain, a fake sword from the prop department. Lou Diamond, a tone-deaf negotiator sent over from Paramount, asked the artists why they needed vacation time when they had weekends off and lived so close to Coney Island.

The agreement marked the first time an artists' union signed a contract with an animation studio. It was a fair deal. Fleischer agreed to a 20 percent raise, a forty-hour week, one week of paid vacation, holidays, sick leave, and screen credits. Fired employees would be rehired. Going forward, animators' other grievances would be heard by Manhattan District Attorney Thomas Dewey, the racket-busting

crusader and governor-to-be who would later lose to Harry Truman in the 1948 presidential election.

It seemed the artists had won, but Max Fleischer still had another move. He and Dave both owned vacation houses in Miami, Florida; during visits there, they had chatted up local politicians and the Miami Chamber of Commerce, discussing possible tax breaks if they were to move their studio. They had also discussed the plan with Paramount, convincing its executives that this would be a cheaper place to make *Gulliver's Travels*—a brand-new studio located far out in the swampland, away from pesky labor agitators. The deal looked even sweeter after they pointed out that Florida was a right-to-work state. Fred Cone, the doughy-faced governor, boasted that he would "have all union organizers hanging from lamp posts." It wasn't long before Max Fleischer announced he was moving the studio to Miami.

Chapter 20

"I'll Make Money"

Max Fleischer's announcement about Miami permanently altered New York's status within the animation scene. The city had been the cradle of the industry, giving rise to its earliest talents, infusing cartoons with the culture and flavor of its streets and neighborhoods. But now there was no question the industry's center of gravity lay elsewhere—not in Miami, of course, but in California, where Disney was established, and where other studios had mushroomed since the advent of sound, including cartoon units associated with MGM and Universal. By the time of Fleischer's announcement, however, one of the new California studios, associated with Warner Bros., was beginning to distinguish itself from all the rest, even from Disney. As Disney increasingly defined animation's rules and standards, the Warner Bros. animators took special delight in breaking them, offering a compelling new idea of what cartoons could be.

When the Warner Bros. studio opened in 1929, it had no great artistic vision. In fact, it spent much of its first decade churning out lackluster, forgettable material. A film producer named Leon Schlesinger had found himself with some money to burn and figured: why not open a cartoon studio? What kind of cartoon studio did not matter to him. "Disney can make the chicken salad, I wanna make chicken shit," he once joked, before adding his real goal: "I'll make money."

Schlesinger's rise through the Hollywood hierarchy had happened mainly on the practical, business side of things. During the early silent era, he was a film company press agent and salesman. Then, in 1919, he founded Pacific Art & Title, a profitable company that made title cards for silent films. With money from this venture he was on the lookout for other investment opportunities, and seized

a chance to become involved with *The Jazz Singer* when Warner Bros. was seeking financing. Two years later, in 1929, people at the studio remembered Schlesinger's earlier favor when he pitched them the idea of starting a new cartoon studio. He had likely heard through his brother Gus, a Warner Bros. executive, that the studio was interested in having its own animated series. Warner Bros. wasn't particularly fond of cartoons, but, like Paramount, realized that they could be used to promote new songs from the studio's catalogue—Warner Bros. owned three music-publishing houses.

Leon Schlesinger's first hires, in January 1930, were Hugh Harman and Rudolf "Rudy" Ising, two animators who had defected from Disney during his confrontation with Charles Mintz. Later they struck out on their own, creating the Harman-Ising Studio and a new character, Bosko. After meeting with Schlesinger, they signed a three-year contract with him. Their studio would provide Schlesinger with one cartoon a month, which Schlesinger would use to fulfill his obligation to Warner Bros. Schlesinger would pay their production costs up to $4,500 per cartoon (that ceiling would rise to $6,000 in the second and third years); his two-year contract with Warner Bros. stipulated that the studio would pay $5,000 for the first cartoon, with an option to buy eleven more at $6,000 each, then twelve more after that at $7,500 each. The arrangement would eventually grow to include the rights to two series names Harman and Ising had also created: Looney Tunes and Merrie Melodies.

Both series would later become iconic (their differences were almost indistinguishable, defined mainly by which characters would, over time, appear in each). Their credit sequence—famously featuring bold concentric circles and the elastic crescendo of a theme song ending in "That's all folks!"—would become a cultural touchstone. This achievement wouldn't happen immediately, however; the beginning was far from glorious. Both series' titles were nothing more than derivative attempts to draft in the jet stream of success created by Disney's Silly Symphonies. The same went for Bosko. When Harman and Ising were creating Bosko, animator Jack Zander remembered Harman asking him if he had seen a particular scene from a recent Mickey Mouse film. "You want almost the same thing?" Zander asked.

"No," Harman answered. "I want *exactly* the same thing."

When Jack Warner saw Bosko's Looney Tunes debut, titled *Sinkin' in the Bathtub*, he watched only halfway through before standing up and leaving the room, ordering a dozen more as the door slammed shut behind him. He cared nothing for what was in the cartoons so long as they contained at least one Warner Bros. song and generated ancillary income. He never asked what Bosko even was. A dog? A human? It was a mystery—not even the animators working on him really knew. "We never knew what Bosko was," Ising said. "He was just a character with a southern voice." The blackface caricature and minstrel-show mannerisms were not destined to age well, but Bosko nonetheless achieved limited popularity for a brief period. This sparked an argument between his creators and Schlesinger over money, with Harman and Ising wanting more. After their contract expired, the two animators cut their ties with Schlesinger in 1933 and went to make cartoons for Metro-Goldwyn-Mayer, taking a sizable chunk of their staff with them. Because they still held Bosko's rights, they also took the character.

This put Schlesinger in a bind. He was obligated by contract to still make cartoons for Warner Bros. but had nobody to make them. Desperate, he formally created his own studio, Leon Schlesinger Productions, and convinced Warner Bros. to give him space on its lot. Then he began hiring new staff the way a pirate captain might hire a new crew, by poaching able-bodied men from other crews, offering them a little extra silver. Animator Don Williams remembered having just accepted a job at another studio when he was intercepted by Ray Katz, Leon Schlesinger's brother-in-law.

"Were you looking for a job up here?" Katz asked, pointing to Harman and Ising's new studio at MGM.

"Yes," Williams answered.

"What did they offer you?"

"Sixty bucks a week."

"Will you go to work for me for sixty-five dollars?"

"Yes, but where are you?"

"There's a friend of mine opening a new studio over at Warner Bros., called Leon Schlesinger."

Animators soon began filling Schlesinger's doorway, looking for work. Bob Clampett, one of the first new recruits, remembered

watching many former colleagues walk past his window to ask about jobs—"all these guys who had told me, don't, under any circumstances, work for Leon," Clampett recalled. Many were figures who would later enter animation lore: the McKimson brothers, Robert and Thomas; Friz Freleng; Fred "Tex" Avery; Frank Tashlin; Chuck Jones; and Clampett himself, among many others. From the minds of this pirate crew—assembled haphazardly by a man desperate to stay afloat—would come animated icons that included Bugs Bunny, Porky Pig, Elmer Fudd, Daffy Duck, Wile E. Coyote, the Road Runner, Sylvester, Tweety, Yosemite Sam, and Pepé Le Pew.

Schlesinger kept an aloof distance from his staff. He was the boss and enjoyed constantly reminding his employees that they weren't. When a group of animators asked him if he would give them a ride on his yacht, christened the *Merrie Melodie*, he chuckled and said, "I don't want any poor people on my boat." Nor did he ever let their names detract from his, calling his directors "supervisors" in the credits, and making sure his name was the biggest one in the titles, although creatively he contributed very little.

The Warner Bros. animators returned the disdain. They would call him out for dressing in the flashy, lowbrow style of a "vaudeville hoofer," as one of them put it, and they said his breath constantly reeked of the violet-flavored lozenges he used to hide the stink of his cigars. Whereas the Disney animators worshipped their boss, those at Warner Bros. constantly poked fun at theirs, creating an atmosphere of rebellion that quickly became part of the studio's DNA. In the end, this turned out to their benefit, giving the animators a sharp edge that would define their style. "I've always felt that it was a vital factor to have people you fight against," animator and director Chuck Jones recalled of the antagonistic relationship with his boss.

Mock him as they did, Schlesinger let his animators get away with it. As long as their cartoons made money, he was hands-off. "I will say this for Leon, when he finally found a director he had confidence in, he left him alone," director Bob Clampett remembered. "And he let us try new ideas." And even though they ridiculed him, they appreciated the job protection he afforded during the throes of the Depression. Likewise, Schlesinger understood that they weren't easily replaceable. Since the advent of sound, the demand for talented

animators was high. "Animators were so scarce that you could get away with murder," Nelson Demorest remembered. "You could drink, or come in at any hour you wanted . . . they were on us every minute, to keep working—but they wouldn't fire you." All these factors led to a special atmosphere. Clampett compared the new Warner Bros. studio to "a gold-rush town . . . we all had our picks and our bags, and we've all got a chance to make it."

By the middle of the 1930s, each of Hollywood's major film studios was associated with its own distinct persona. "Studios had faces then . . . their own style . . . they had a certain handwriting, like publishing houses," director Billy Wilder remembered. Warner Bros. was known as the studio for underdogs and outsiders. It made the films of Humphrey Bogart, Jimmy Cagney, and Bette Davis: film noirs that were blunt, tough, and fast, and liked to question authority. Jack Warner once said that whenever he heard the phrase "You can't do that," he knew "we must be on the right track."

The Warner animators were outsiders even among outsiders. From the beginning, they were like orphans, working out of various abandoned buildings on Warner's Sunset Boulevard lot. They were finally given their own building, but it was so decrepit they nicknamed it "Termite Terrace." In order to block out excess light, which interfered with their tracing boards, the animators covered the windows with old cardboard. From the outside, it resembled a stash house. On the inside, "it looked like a shantytown," according to animator Phil Monroe. To create privacy, the artists constructed makeshift cubicles out of old beaverboard, flimsy material that was full of holes, through which the animators chatted and passed contraband: dirty pictures, firecrackers, condoms, water balloons. Sometimes they passed notes to each other by taping them to the backs of cockroaches. The janitor, an elderly black man named Russell Jones, was so arthritic he used his broom mostly as a cane; when he did sweep, it was in a way that mostly just stirred the dirt around, rearranging the patterns "in mysterious halting ways of his own," according to one animator. Because the splintered-pine floorboards were too difficult to sweep or mop, the floor had to be sluiced with some sort of unidentified oil, which, over

time, turned rancid, making it smell like "a slave ship," according to another animator. When Schlesinger made his infrequent visits down to the floor, usually to pass out paychecks, he would bid everyone farewell by saying, "Pew! Let me outta here! This looks like a shit house." After Schlesinger left for the day, the animators working late would let Jones into his private bathroom to take a forty-five-minute nap. They couldn't find enough ways to rebel against their boss.

The atmosphere of Termite Terrace inspired certain patterns of behavior. A long-running prank was devised against Ray Katz, Leon Schlesinger's brother-in-law, who was occasionally sent to check on the staff. Animator Elmer Wait rigged the desks with tiny red lights, hidden under shelves or in drawers, alerting everyone to Katz's impending arrival. Whenever he dropped by, he would always find the animators drawing away furiously, faster than would seem possible. The writers

"Termite Terrace" was the nickname of the building on the Warner Bros. lot where *Looney Tunes* and *Merrie Melodies* were made.

and directors, however, would suddenly stop working, using the lights as a signal to begin other tasks: shining shoes, reading the newspaper, napping, doing anything but working, just to confound Katz before he shuffled back to the corporate suite. If Katz returned a few hours later, the staff made sure they were doing whatever it was he saw them doing before. "Since he didn't know what we were supposed to be doing, he had no way of criticizing us for not doing it," Chuck Jones remembered. It was a guerrilla tactic meant to separate him from them, to expose his ignorance of their craft. They were artists and he was a suit. "We had been doing work, of course, before the little red lights went on. But our energetic love for what we did we were reluctant to demonstrate in the face of the enemy."

After Hugh Harman and Rudy Ising left the studio in 1933, taking Bosko with them to MGM, Leon Schlesinger was left in desperate need of a new character. His first priority was finding one that would be commercially successful. Walt Disney's recent success was no doubt on his mind when he assembled his staff and told them, "From now on, boys, we're going to make 'em cute."

Design of the new character fell to Earl Duvall, an animator who had previously worked for Disney. He came up with Buddy, who called to mind one of the prepubescent children from the Our Gang series. He sported a bow tie and a choirboy haircut, and had enormous, innocent eyes. Typical Buddy storylines usually involved him cheerfully rallying other characters to join him in singing sugary songs from the Warner Bros. music catalogue.

The public was not impressed. "The Buddy cartoons are generally devoid of style or anything resembling humor," one critic said. Nor were the other Warner Bros. animators fans. Buddy was basically "Bosko in whiteface," Bob Clampett said, with "even less personality than the original." By 1935, the Warner Bros. animators were looking to replace him. Brainstorming sessions resulted in two cats, Beans and Kitty; two puppies, Ham and Ex; and a bespectacled owl named Oliver. All boring, none passed muster. Then a pig was proposed, grabbing everyone's attention. As they began developing the pig's personality, someone mentioned a popular stuttering comedian of

the time, Roscoe Ates. Everyone liked the idea of their pig stuttering as well and began building on the concept. Isadore "Friz" Freleng came up with the new character's name, based on two of his childhood playmates, "a little fat kid called Piggy and his younger brother, who was called Porky."

Porky's voice was provided by Joe Dougherty, a Warner Bros. contract actor whose own stuttering problem had cut short his promising film career after the silent era ended (ironically, he was cast in *The Jazz Singer*, although without any lines). In order to make his voice seem more rubbery, his taped lines were sped up. But during the recording sessions, people soon noticed that Dougherty was struggling with a very real handicap. After watching him perform, the animators inadvertently began transferring his anguish into their work. For instance, in *Plane Dippy*, Porky's face works like a frustrated accordion, wrestling with a word that refuses to leave his mouth. In the sound booth, the engineers watched while endless reels of expensive audiotape were devoured as they waited for something usable from Joe. The cost started worrying some of the staff. "[Dougherty] would begin to recite, but then he'd get stuck," recalled Friz Freleng. "He just couldn't get off certain words. We were recording on film at the time, and the film was running, and I figured, boy, if they find out how much film I used just to make a cartoon, they'll kick my ass off the lot."

Word eventually did get out. By 1937, the tight-walleted Leon Schlesinger was looking for Dougherty's replacement.

Voice actor Mel Blanc had auditioned for Warner Bros. cartoons countless times but was always rejected. The casting director, a fellow named Spencer, always gave him the same answer, "Sorry, we have all the voices we need." Spencer got so used to rejecting Blanc that sometimes he didn't even look up from his newspaper when he did it. Blanc never let it bother him, however; constant rejection was just part of showbiz.

Still, it was odd for Blanc to get rejected so unceremoniously. He wasn't an unknown nobody; he was respected in the industry. He had been a popular attraction on the Jack Benny radio show and had developed hundreds of voices for other shows, starting with *Hoot Owls*

for KGW in Portland, Oregon, in 1927. Born in 1908, Blanc had grown up in Portland, a regional crossroads where he was exposed to countless different accents—Yiddish from his neighborhood, Brooklynese from his father, and the Japanese he heard in the market, which was his favorite "with its lilting, almost musical quality." As a boy, he watched silent cartoons and dreamed up voices for the characters, his favorite being *Felix the Cat*. During class he told jokes in the different accents he was constantly practicing. "The kids would laugh and clap their hands; the teachers would laugh and give me lousy grades."

"You'll never amount to anything," Mrs. Washburn scowled at him after he answered a question using four different voices. "You're just like your last name: *blank*." The comment stung so badly that he began spelling his name with a *c* rather than a *k*, which was the usual way for many Russian Jews. He later changed it legally, a common showbiz defense against anti-Semitism.

Blanc started his showbiz rise in vaudeville, then quickly moved to radio. From the beginning, people immediately recognized his talent. Job offers came steadily, each one leading to a bigger market. All these offers were for radio work, however; nobody wanted him for movies because his looks weren't quite right. From a young age, he had dark bags weighing down his shoe-button eyes and he had the muscle tone of a sack of flour. What everyone wanted was that voice, which Blanc had been curing with a pack-a-day cigarette habit since the time he was eight. After examining X-rays of his throat, a doctor had once told him that he had the exact same musculature as the Italian tenor Enrico Caruso.

By the mid-1930s, Blanc was living in Los Angeles and had become interested in doing cartoons, which were only now starting to attract compelling voices. "While I wanted to work for Walt Disney because he was the best," Blanc remembered, "I wanted to work for Warner Bros. because it was far from it." Aside from Dougherty and a few others, the cartoon voice actors used by Warner Bros. were typically extras pulled randomly from the lot, asked to perform without any extra pay. Blanc was simply interested in the challenge. One day in late December 1936, he once again approached the auditions desk and found somebody other than Spencer there.

"Excuse me," Blanc asked, "what happened to the guy who usually sits here?"

"He dropped dead last week," the replacement answered.

"Jeez, that's too bad," Blanc finally answered, showing a modicum of sympathy before quickly moving on. "Say, pal, how about giving me an audition."

"Sure, let's hear what you've got."

Spencer's replacement at the desk that day was Tregoweth "Treg" Brown, a new sound editor whose previous job was working for the impresario-director Cecil B. DeMille. His primary job now was creating sound effects for the cartoons; he spent his days dropping armfuls of metal objects from high ladders to create crashes, or firing a .45-caliber pistol to mimic doors slamming shut. Working alongside Brown was another recent hire, Carl Stalling, who was in charge of music. Stalling had previously worked as an organist in the old theaters, building his reputation during the silent era. When he arrived at Warner Bros., scores for their cartoons resembled Leigh Harline's music for Disney's Silly Symphonies, but Stalling brought a new style. Instead of returning to bits of the same tune, as others often did, he linked together many different bits and tied them together with original music. These manic-sounding interludes, tumbled together in a schizophrenic mosaic, had a comic, almost zany appeal, bringing to mind someone operating a machine spewing confetti. In his days as a theater organist, Stalling had typically used written music for features, but improvised the music for newsreels and comedies. It was this latter style that he decided to use for cartoons. Of his Warner Bros. days, he said, "I just imagined myself playing for a cartoon in the theater, improvising, and it came easier." Together, by drastically altering the soundtracks, Brown and Stalling were changing the soul of Warner Bros. cartoons.

During his audition for Brown, Blanc did a rendition of a World News Report: an odd choice, but also a sign that Blanc was thinking differently. Brown listened, pondered for a moment, then told Blanc he wanted a second opinion. He left and came back with four directors from Termite Terrace—Friz Freleng, Frank Tashlin, Bob Clampett, and Tex Avery. They all came stumbling through the doorway, holding sloshing glasses of booze from an office holiday party happening next door. Rowdy and drunk, they were ready to give Blanc a listen.

Avery liked Blanc's routine best. Explaining that he was working on a new character, he pulled a crumpled drawing from his pocket to show Blanc a draft. "We need a drunken bull," he said, asking if Blanc was up to the task.

"Asking Mel Blanc if he can sound like a drunk is like asking Marcel Marceau 'Can you mime?'" Blanc later wrote in his memoirs. His rendition of a drunken bull was perfect, thus pulling him into Warner Bros.' regular rotation. Shortly thereafter, Leon Schlesinger called him into his office and shut the door.

"I've got a problem here, Mel," Schlesinger said, flicking ashes from his cigarette with one hand while patting down his comb-over with the other. Schlesinger wanted to talk about Joe Dougherty. "Joe's a nice enough fellow, and he does his best, but . . . I was wondering if you'd try Porky's voice."

"You want me to be the voice of a pig?" Blanc asked. "That's some job for a nice Jewish boy."

"Well?" Schlesinger asked, not laughing at the joke.

Blanc thought for a second, then asked for a few days to "research" the role. "You know, Leon, method acting . . ."

"You're kidding, right?"

Blanc actually wasn't kidding; he took all his roles seriously and gave deep thought to his characters' mindsets. His colleagues later remembered how, during recording sessions, he would twist and turn in the sound booth, attempting to meld himself into his characters' personalities. When playing Bugs Bunny, he would jut out his front teeth. When playing Sylvester, he would puff out his cheeks to achieve a slobbering effect. When playing Pepé Le Pew, he would arch his eyebrow, just a *leetle beet.*

Blanc prepared for the Porky role by driving to a pig farm near Saugus, north of San Fernando. When he stepped from his car into the dirt, a layer of dust settled over his impeccably shined shoes. Then the farm's owner came strolling up and looked him over, listening to Blanc explain the reason for his visit. The farmer shrugged. "Just don't fall in the mud," he said.

Blanc spent the morning wandering among the grunting pigs. Watching them root around in the mud and slop, he worked up a formula for a running gag. Porky would repeatedly try and fail to

say a word, then try an alternative word but also fail at that. Finally, he would settle on an entirely different word to express his original thought. This would help make the audience sympathetic to Porky's plight, and feel good once he solved his problem. Blanc returned to Schlesinger's office and explained his idea with an example, "So, Porky would say good-bye like this," he began. "'Bye-b—, uh-bye-b—, so lo—, us-so lon—, auf Wiede—, auf Wiede— . . . Toodle-loo!'"

Then he added one more line, "Th— uh-th— uh-th—that's all folks!"

"You're it!" Schlesinger shouted, jumping from his seat.

Mel Blanc never rehearsed at home; he did so only in his car—which, at the peak of his popularity, was a Rolls-Royce. In the winter of 1937, shortly after Blanc started at Warner Bros., he spent his commute

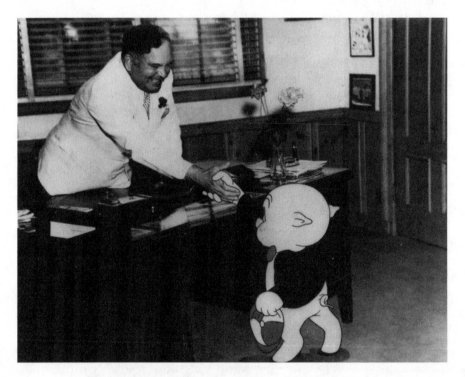

Film producer Leon Schlesinger, a distant relative of
the Warner Brothers, poses in a publicity still with Porky Pig.

practicing for another new character, which in time would be called Daffy Duck. Daffy's role was to assault Porky with gags, rudely interrupting his otherwise peaceful life. His zany, out-of-nowhere behavior would serve as a rebuttal to the kind of realism favored by Disney. The Warner Bros. cartoons would hark back to the wild earlier years of animation, when cartoons were full of surreal, bizarre, and free-associative images. Daffy was set to debut in April 1937, in a cartoon titled *Porky's Duck Hunt.*

At first, the artists envisioned Daffy as little more than a jerk. "Daffy gallantly and publicly represents all the character traits that the rest of us try to keep subdued," Chuck Jones recalled. "All he wants to do is survive, and be triumphant, without having to do the work that was necessary, and without having to be particularly nice." But, over time, Daffy's behavior would eventually become more sophisticated. According to Jones, "A social amenity to Daffy Duck is simply an unfair block to his desires. To desire, in Daffy's rationale, is to need . . . to need is to acquire, and acquisition is the essence of living. To achieve his ends, he cheerfully and always rationally chews up moral codes by the yard."

Steadfastly committed to the idea of slyly subverting authority, the Warner animators decided that Daffy's voice should reflect that of their boss, Leon Schlesinger, who had a lisp. Blanc came up with the voice, converting "despicable" into his famous "de*sth*picable," and so on. During recording, the lines were recorded at 18 percent below normal speed but played back conventionally, raising the pitch but keeping the clarity. They were then sped up slightly on a variable-speed oscillator, a step that injected an extra touch of manic insanity. Before showing *Porky's Duck Hunt* to Schlesinger, the artists prepared resignation letters in case he got mad, so they could quit before they got fired. When the cartoon started rolling, Porky appears in a marsh wearing a sportsman's cap. Shotgunning Daffy from the air, he sends his dog to retrieve him.

"Hey, that wasn't in the script!" Porky complains when Daffy turns the tables, bringing the dog back to Porky and flinging him up on the shore.

"Don't let it worry you, *sth*kipper. I'm just a crazy darnfool duck!" Daffy whoops as he bounces away across the water in a defiant rebuttal of the forces of nature.

Porky tries to fire again, but his gun jams. Daffy returns, grabs it, and blasts off a shot while maniacally screaming "It'*th* me again!" before pinballing wildly back across the water. Disregarding any notions of whatever was in "the script," he was not only the opposite of a Disney character; he was a sign that the Warner animators were finding their groove. When the film was finished, Schlesinger wasn't mad at the depiction at all. In fact, he was thrilled. "Jeethus Christh, that's a funny voithe!" he laughed. "Where'd you get that voithe?"

Chapter 21

"That Goddam Holy Grail"

The space where art is created matters, its energy and atmosphere coloring and flavoring the material. In the squalor and isolation of Termite Terrace, cartoons took on a feel of rebellious insurrection. In Walt Disney's sunny Hyperion studio, they carried a brighter vibe. In New York, the Fleischers' cartoons absorbed the bustle of the city's energy. By the late 1930s, however, widespread change loomed on the horizon, as Disney began planning to build a new studio in Burbank and Fleischer prepared his move to Miami.

Plans for Disney's new studio happened alongside preparation for his next feature. It was originally supposed to be *Bambi,* but there had been difficulties unraveling the creative knots of Austrian author Felix Salten's poetically episodic narrative, so Disney instead decided to produce *Pinocchio,* a more manageable story based on Italian writer Carlo Collodi's novel. The release date of early 1940 would pit it against *Gulliver's Travels* at the box office: two different studios and visions going head-to-head amid atmospheres of great disruption and upheaval.

The site of Disney's new Burbank studio was about seven miles from Hyperion, nestled in the faint green foothills of the Verdugo Mountains, crisscrossed by trails overlooking the San Fernando Valley. The estimated cost was $500,000, although that would eventually increase to nearly $3 million—Disney's ambition always had a way of inflating prices. The architect was the German-born Kem Weber, champion of the sleek, rounded lines and no-frills efficiency of the Moderne style—a perfect aesthetic for an industry merging art with technology.

Disney's staff helped with the design. During meetings, in a room full of models and mock-ups, they offered helpful functional suggestions, such as how to position the windows to get the best light. To filter out glare, windows were fitted with slotted awnings, which also helped capture that unique cast of northern light generally loved by artists. The staff also helped design new drawing desks, featuring rotating platforms that could hold paper that was 30 percent larger, making drawing easier.

Three times a week, Disney met with his engineers and architects, beginning the meetings by rolling out massive sets of blueprints across his desk. He always liked how the Hyperion studio had often been compared to a college campus and wanted the same feel at Burbank. The site was fifty acres, and would be lined with streets named after Disney characters, such as Dopey Drive and Mickey Mouse Avenue. The buildings, low and horizontal, were designed to feel comfortable rather than imposing. Each was three stories high, designed so the production process would gently flow down, like rain. The top floor held Walt's office and the story department; the second floor was where directors and layout men staged scenes; the first floor held the animators; and the basement held cameras and machinery. Inside, the walls were painted in bright colors that got the creative juices flowing. Outside, the exteriors were different shades of beige and red, designed to match the idyllic desert nearby. On the grounds, the pathways between buildings were wide, running through broad green lawns studded with oaks. During the morning the air was still and quiet, scented by desert sage; by afternoon it smelled like freshly cut grass. In all, the Burbank studio was about four times larger than Hyperion so it could accommodate the ballooning staff—numbering around 1,200—that had come aboard in the wake of *Snow White*'s success, as Disney's focus turned to producing more features.

Disney often took his daughters, Diane and Sharon, to visit the construction site. They would stand in the empty, cavernous rooms—the soundstage was five times bigger than the old one—and scream at the tops of their lungs, the sound ricocheting like gunshots and startling the construction workers. Disney would shush the girls

and, later, would tell the *Bambi* story crew to use those shushings as inspiration for the film's Owl character.

Few luxuries were spared. On the top floor of the studio was the Penthouse Club ("Men Only! Sorry, gals," according to the employee manual). Next to it was a nude sunbathing area where animators could get a little color on their pasty limbs. The roof also hosted workout sessions led by a former Olympic athlete named Carl Johnson, a broad-chested Swede who resembled those men in ads for fitness programs commonly found in the back pages of comic books. Animator Robert Carlson remembered how, if you preferred to eat rather than exercise, you "could pick up a phone and have a soda delivered, or hot coffee, hot chocolate, ice cream—anything. And a waiter dressed in white would come running down the hall."

Shortly after construction was completed, in December 1940, a reporter from the *Atlantic Monthly* came to write a profile of the new studio. Discussing the new space, one animator told him, "[Y]ou can't help feeling that you're going to grab that goddam Holy Grail."

It was a heady time for Disney, but also a sad one. In the fall of 1938, his mother, Flora, died from carbon monoxide poisoning. The heating system had malfunctioned in the beautiful new home Walt had built for her and his father. A neighbor had noticed something wrong and dragged them both outside; Elias had sputtered back to consciousness, but Flora remained limp on the front lawn. Reeling in the aftermath, Walt hoped to lift Elias's depression by inviting him out to see the new studio, hoping this might also improve their relationship—despite his success, Walt had always struggled for his father's approval. As he led Elias through the studio's vast hallways, Walt excitedly pointed out all the various gadgets. "It's all air-conditioned," he bragged, showing off his new toy. "You can get any kind of weather, anytime you want."

Elias wasn't outwardly impressed. He was a stolid midwesterner, wary of the complicated debt structures and financial arrangements he knew the studio had required. As Walt waited eagerly for his father's reaction, Elias just grumbled. "What else is it good for?"

Elias's question punctured Walt's enthusiasm a little. "A hospital," Walt answered, reluctantly. Part of the bargain with his financiers at

Bank of America was that the buildings could be repurposed into a hospital if the studio failed. The offices were designed so they could be converted into wards, if need be, with extra-wide corridors to accommodate trundle beds and wheelchairs. The wall alcoves, housing soda and candy machines, could be repurposed into nursing stations. The bankers had been impressed enough with Walt to finance his new palace, but not so impressed that they didn't hedge their bets.

As Disney prepared to move to Burbank, Max Fleischer prepared to move to Miami. Upon arriving, he set up a series of press announcements to help him spin some of the issues surrounding the relocation. The move was not because of labor problems, he told reporters, but because he thought his artists might enjoy living in paradise. "They need loose clothing so their imaginations can work," he joked.

In 1938, Miami was still mostly a swampy backwater, flanked by citrus groves and turpentine distilleries. A few years earlier, the city had begun promoting its beaches in an attempt to change its grubby image. Next came the state's repeal of income and inheritance taxes, which began converting the region into a desirable winter getaway for the wealthy. Wanting to maintain the momentum behind these efforts to reinvent itself, Florida then began promising lower taxes to the film industry, hoping to lure it away from California. In reality, most movie people in California had no desire to move to Florida, but the giveaways did provide a useful bargaining chip whenever California state legislators threatened to raise taxes.

Max Fleischer's decision excited the locals. "Miami's dream of a motion picture industry at long last seems about to be realized," the *Miami Herald* said. "Establishment of Fleischer Studios here will be the beginning of that industry which has been so eagerly sought," the paper wrote. "Miami wants, needs this new enterprise."

The new studio broke ground on March 1, 1938. As soon as the shovels hit the soft earth, a group of picketers, protesting the use of nonunion labor, crowded around the plot of cheap land in the shabby northwest corner of Dade County. Next door was the Musa Isle Seminole Indian Camp, a depressing theme park where tourists

watched Native Americans make beads and wrestle alligators. The land developer building the studio, John Ware, hoped that its construction would help convert the rest of the working-class neighborhood into an upscale housing development called Delaware Park. Anticipating that it would one day be filled with film people, he billed it as "an ideal community—with every home a modern, permanent concrete and steel reinforced structure, with absolutely no fear of destruction by hurricane, fire, or termites." But, according to animator Myron Waldman, the homes were "blocky little factories," while another local observer called them "profoundly unbeautiful." Like the new studio, they were built of ugly steel-reinforced poured concrete, a relatively new building technology for the time.

The Fleischers' new studio was painted a shade of cream that matched the nearby beaches, and was powered by a rumbling diesel generator stuffed in the back corner of a courtyard. Inside, it wasn't nearly as plush as Disney's Burbank studio, but it was still state-of-the-art. Dark corridors and recessed lighting helped animators rest their eyes during breaks, while custom blinds reduced glare. It was the first fully air-conditioned building in the state; the air-handling system was designed not to recirculate air from the restrooms, a design the developers billed as a courteous bonus. The only time the studio got hotter than seventy degrees was during recording sessions, when the air-conditioning was turned off so its vibrations wouldn't upset the sound equipment.

When Max Fleischer announced the move to his staff, he asked who in the room wanted to come to Florida. Not every hand shot up. Many of these native New Yorkers had little interest in moving to the middle of nowhere. One of those who declined was Mae Questel, the woman who voiced Betty Boop; because the character had long been in a post–Hays Code decline, Questel's refusal to move meant that Betty was finally retired. About 250 employees did agree to relocate, about two-thirds of the staff, but this still presented a manpower problem. In order to make *Gulliver's Travels*, Fleischer needed roughly 700 employees. To fill the gap, he struck an arrangement with the Miami Art School. If the school began offering a three-month animation course, he would hire anyone who completed it. Said one animator,

"They scoured the town for anyone who had even cherished the ambition to paint moonlight scenes on black velvet, or burn pictures on coconut shells for the tourist trade."

Fleischer could afford the manpower additions because he now had an influx of new Paramount money behind him. He could also selectively pay experienced animators higher wages—sometimes even more than Walt Disney paid. In this way, he was able to rehire some of his old staff who had moved to California, including Grim Natwick, Bill Nolan, and Al Eugster. Fleischer also hired back Shamus Culhane, but Culhane wasn't particularly pleased about it. He didn't want to leave Disney, which he considered the premier studio. He had developed a rare form of neuritis, however, that was aggravated by Los Angeles' sudden swings in barometric pressure. His doctor told him he would die in six months if he didn't move. Culhane was reluctant to tell the news to Disney, who dismissed the diagnosis. "Those goddamn doctors don't know what the hell it's all about," he said. "What you need is some good exercise. Tell you what, you go over to the Hollywood Athletic Club and work out with the wrestling coach a couple of times a week. Tell them to put it on my bill."

Culhane spent two weeks wrestling intensively, then spent the next two weeks in bed, curled up in pain, ruing the first day he stepped onto a wrestling mat. After his doctor told him it was foolish not to move, he went back to Disney, who this time set him up with his personal doctor—"He'll fix you up because this guy's a real genius. Tell him to send me the bill." But Disney's physician turned out to be what might best be described as a "Hollywood doctor." He tried to get Culhane to quit smoking by hypnosis, then started loading him up on odd vitamin supplements. The illness worsened and Culhane began to miss every other day of work. He told Walt he intended to wire to Fleischer Studios for a job.

"Look, Culhane," Disney said, pacing the room. "For Chrissake you have a great future here . . . don't be a goddamn fool." He no doubt wanted to prevent his biggest rival from poaching his talent.

"Adam didn't leave paradise more reluctantly than I left Disney," Culhane wrote in his memoirs. On his last day, he went around the office making sad good-byes. When he stopped by Disney's office, he had "a lump in my throat as big as a baseball." Disney's secretary,

Dolores Vogt, tried to be sympathetic, but had a painful message, telling him, "Walt said he didn't want to see you."

Shamus Culhane wasn't impressed by Florida. "Miami might just as well have been in Tibet," he complained. While visiting a local movie theater, he found it odd that the locals laughed so hard at the Okies in *The Grapes of Wrath*. They were practically the same people, he thought; also, the movie wasn't meant to be a comedy. "Florida in those days seems to have been in need of a frontal lobotomy!"

The New Yorkers were in for a culture shock. Arriving at the construction site of their new studio, they were horrified to find prisoners being forced into labor to build the sidewalks around it. The state of Florida, hoping to promote its film industry, had offered them up as slave labor, as well as an all-black prison chain gang to cut the studio's lawn every week. Culhane wrote, "[A]n obese white cracker guard sat in the shade," watching them, "a huge cud of tobacco bulging out one cheek and a double-barrel shotgun cradled against his belly." One day, when a group of animators ventured out to offer the crew bottles of ice-cold Coca-Cola, the fat guard leveled his shotgun in their direction and told them to stay away.

Some of the differences between the North and the South began making their way into the studio's cartoons. In Florida's depressed economic conditions, the senior Fleischer animators could now afford maids, most of whom were black. The short cartoons, particularly *Little Lulu* and *Little Audrey*, soon began including gags about domestic help and "Old Mammy" stereotypes.

Within a few weeks of moving, Culhane discovered the source of his mysterious "neuritis." It wasn't neuritis at all, in fact; it was actually an abscess underneath his tooth that was eating away his jawbone. "You're being poisoned!" the doctor exclaimed, telling him that surgery would easily fix it.

Once he got this news, Culhane considered moving back to California, but didn't, out of personal honor. He didn't want to break his contract, nor was he sure Disney would have him back, so he filled his remaining time by trying to make the best of his circumstances, establishing an art school like the one Don Graham ran at Disney.

But the atmosphere in these classes—held in his garage, among the gasoline cans and the rakes—wasn't nearly as sophisticated as Graham's. "I need to know something about that space and volume shit," a young animator named Nick Tafuri said when he signed up. Nor was Tafuri impressed by the caliber of nude models that Culhane enlisted for his classes. "Hey boss," he said of a model named Jackie, "this is the first time I ever drew from a live model, so how come we have to draw one with funny-lookin' tits?"

"I was depressed for weeks," Shamus wrote of the experience, but "Victorian tradition demanded that I fulfill [that contract] to the letter."

Max Fleischer had told his staff that, if they didn't like Florida after a year of living there, he would pay for their return trip to New York. Some, who had never felt comfortable in the South, took him up on the offer. Many locals had insisted on treating them like carpetbaggers, although these locals were no doubt glad to get the economic boost from said carpetbaggers. Some broadcast their prejudices with signs such as "No Jews or dogs allowed." On the mornings after Ku Klux Klan rallies, the air sometimes smelled like the turpentine used to burn the crosses. The Klan had even once slipped a note under Lou Fleischer's door after he hosted his friend Cab Calloway from New York, "Don't have any more niggers in your house."

Culhane noticed other tensions. During his first week back, Max invited him to lunch in the studio cafeteria. As he got his food, he saw that staff sat according to rivalries created during the strike. "The strikers and the non-strikers, they hated each other," he remembered. And both groups were suspicious of what Myron Waldman called the "California discards," who the other animators suspected had left Disney because they couldn't hack it there. None of the factions— union, nonunion, Californians—even bothered learning the names of the rookies hired from Florida.

His lunch tray in hand, Culhane found Fleischer sitting at the head of a long table, fingers laced around a coffee mug. He looked like "an old, wounded lion," Culhane remembered. Members of the anti-union camp surrounded him, forming a clique. Occasionally, they stared coldly across the room at the strikers, whom Fleischer had

agreed to hire back. "Look at them, Max, eating your good food!" Willard Bowsky grumbled.

Absent from the table was Dave Fleischer. Culhane soon learned that he and Max were barely on speaking terms. Max didn't like how Dave's bookie had followed the studio to Florida and would regularly surface at dinners with his animators—a recipe for trouble, in Max's view. Nor did Max like how Dave had a red do-not-disturb light over his door that he would flip on whenever he was gambling.

There was another reason Max was upset with Dave. Sometimes the red do-not-disturb light over his door meant he was having sex with his secretary, Mae Schwartz (Dave later married her, after divorcing his wife). Max complained to Dave about it once, in front of visiting Paramount executives, and Dave responded by sharply reminding Max—while still standing in front of the executives—that Max was sleeping with his own secretary. The tryst soured Max's already stormy relationship with his wife, Essie, who at one point had to be taken to the hospital after trying to commit suicide by drinking a bottle of iodine. Otherwise, Essie was occupied with her gambling habit. In order to reach her bookie at any hour, she had wired the palm trees of their estate with telephones, the cords running through their garden like jungle vines. Visitors to the home sometimes glimpsed her in the yard, leaning over into a bush and placing her bets in the branches.

Overall, it was a hectic and chaotic environment; Culhane didn't find it conducive to creativity. Despite the nice weather, it was a sour place to be. When not gambling or infighting, the staff spent its time struggling to make *Gulliver's Travels*, on which the studio's future depended.

Chapter 22

"We Can Do Better Than That with Our Second String"

Production of *Gulliver's Travels* got off to a rocky start, partly because of creative meddling from Paramount. The studio executives couldn't quite decide if it should be a combination of live action and animation, or entirely animation. If it combined the two, they wanted Gary Cooper to play Gulliver. Then they changed their minds and chose Bing Crosby, a new star they wanted to promote. After changing their minds yet again, they decided the film should be entirely animated and scrapped Crosby. Gulliver would instead be modeled after Sam Parker, a lantern-jawed local radio host that Max Fleischer had met in Florida.

Parker would be filmed using the rotoscope, Max Fleischer's invention that allowed live-action films to be traced onto animation cels, ensuring fluid movement. This caused debate among the staff, many of whom had misgivings about the device. Shamus Culhane hated rotoscoping "because animation is essentially a *caricature* of real life," he said, echoing one of the many lessons he had learned from Disney. To him and many others, rotoscoping weakened a cartoon's sense of spontaneity, giving characters the feel of taxidermy. They thought the device undermined one of animation's greatest assets as a medium: transporting audiences into different realms. Even Walt Disney, whose cartoons were known for their realism, used a rotoscope very sparingly during *Snow White*. Nevertheless, Fleischer wanted to champion his invention.

Production for *Gulliver's Travels* was rushed. When the film was nearly finished, in November 1939, Dave flew to Los Angeles to handle

final production tasks such as editing and synchronizing—tasks that the Miami studio wasn't fully equipped to handle. After his plane landed in California, its tires barking on the hot runway, he met with a group of reporters and started plugging Florida's movie industry. "Florida is a great place for our studios," he told these reporters before suddenly remembering where he was and quickly adding, "But the best technical facilities are still in Hollywood."

Many of Dave's duties in Hollywood were promotional. He spent his days giving interviews to reporters, wowing them with technical details about the film; it had required 4 tons of ink and 2,000 reams of paper—spectacular numbers. He also made sure to differentiate his studio's feature from *Snow White*, particularly the evil Queen's character. "*Gulliver's Travels* contains no horror stuff—no evil spirits or creatures to scare the youngsters," he explained. Parents didn't have to prevent their kids from seeing the film, he said, "for fear they'd be scared to death." Coming from a studio known for its bawdy material, Dave's play for the youth demographic was a rather odd way to differentiate the film, but there was another reason likely in play. After production delays, *Pinocchio* would now be released two months after *Gulliver's Travels*, and reporters had begun covering the two features as competitors, pitting them against each other in a contest comparing the studios' respective visions. For the Fleischers, the stakes were rising.

On December 18, 1939, *Gulliver's Travels* premiered in Miami, at the Sheridan and Colony theaters. Eager to promote its budding film industry, the local police department donated velvet ropes and a special unit to keep gawkers off the red carpets. Meanwhile, someone at the studio hired a seven-foot-tall local man to dress up like Gulliver and wander around, delighting attendees. Fleischer and a handful of Paramount executives and local politicians wore tuxedos, although almost everybody else was in shirtsleeves. Shamus Culhane, who had also attended the *Snow White* premiere, couldn't help noticing a significant difference between the two events. Whereas Disney animators showed up at their premiere nervous and plagued by self-doubt, the Fleischer animators were strutting around boastful and confident. Willard Bowsky was slapping people's backs, crowing that they had done better than *Snow White*. Culhane remained skeptical,

however—the film had turned out better than he thought it would, but it was still far from being a sure hit.

The morning after the premiere, the *Miami Herald* gave the film a glowing review—a surprise to no one, considering Miami's eagerness to promote its local economy. The big test would come in a few days, after *Gulliver's Travels* premiered in New York.

On December 22, 1939, the film played at the Paramount Theatre in New York. By three in the afternoon, it shattered the movie palace's attendance record: nearly 14,000 people. Galloping through its two-week run, it then moved to the Roxy, where it continued to smash records. The financial figures were fuzzy, but it would make a profit of at least a million dollars that season, according to some estimates. Once the enthusiastic reviews starting coming in, doubts about the Fleischers' abilities melted away. Paramount immediately green-lighted another feature and the Fleischer storymen began working up ideas. Their early favorite was a cartoon about Mount Olympus and the gods. Dave Fleischer, who wasn't a theologian, casually told a colleague that the story of Mount Olympus was "all in the Old Testament."

From the Disney studio in Burbank, Walt watched the response to *Gulliver's Travels* closely. *Pinocchio* was set to debut two months later, in February 1940, and he wanted to stay up on the competition. Director Frank Tashlin, whom Disney had recently hired away from Warner Bros., remembered that Disney remained steadfastly confident he had made the better movie, despite the critical buzz that his competitors were currently enjoying. He told Tashlin, "We can do better than that with our second-string animators."

Pinocchio was a hard story to adapt, and its production delays were the result of extensive rewrites—once, after Disney decided the film's entire concept needed reframing, he had his writers scrap eight months of work to start over afresh. The original version, *The Adventures of Pinocchio: Tale of a Puppet,* was written in 1883 by Carlo Lorenzini, using the pen name Carlo Collodi, and was long and episodic, taking unwieldy routes through bizarre literary terrain. It was originally published as a magazine serial, under pay-by-the-word rates, meaning Collodi was rambling and long-winded on purpose.

The story's rambling narrative was only the beginning of its complexities. Another difficulty in *Pinocchio*, Disney told his writers, "is that people know the story, but they don't like the character." Collodi had written Pinocchio as a mean-spirited brat, "a skinny, brash, cocky piece of cherry wood," according to animator Frank Thomas. As with *Snow White*, Disney wanted to adapt a dark European tale into something more cheerful. Collodi's Pinocchio was a miscreant and thug, but Disney wanted to convert him into a helpless innocent who lands in trouble after inadvertently getting swept up by a bad crowd. This was a story that good-hearted Americans could sympathize with; as with the wolf in *Three Little Pigs*, it allowed for the possibility of redemption.

In order to brighten Collodi's dark story, the studio decided to beef up Jiminy Cricket's character, a distinctly American voice in an otherwise very European film. The cricket in Collodi's original was an annoying minor character, constantly nagging Pinocchio about his

Still photo from *Pinocchio* (1940).

bad behavior; Collodi's Pinocchio responds to his preachy lectures by crushing his head. Disney's cricket, however, was based on the actors Mickey Rooney and W. C. Fields, with a voice provided by vaudeville actor Cliff Edwards, popularly known as "Ukulele Ike." Jiminy served as Pinocchio's conscience, steering him away from trouble. Through his voiceovers and soliloquies, he steered the narrative to a place as earnest and cheerful as a Norman Rockwell painting.

Pinocchio premiered at New York's Rockefeller Center on February 23, 1940. As a publicity stunt, RKO, Disney's distributor, hired eleven dwarfs to show up dressed in Pinocchio costumes and spend the morning on top of the theater's big red marquee, waving down to the crowds. To help the dwarfs battle the unseasonably warm weather, someone hoisted beers up to them at lunchtime. Relaxed and a touch drowsy, they soon began shedding unnecessary layers of their itchy costumes. More beers followed and then a friendly game of craps started. Events then reached a bizarre climax: by three o'clock the Pinocchio actors were plastered, bombarding passersby with curse words and leering menacingly. Soon the actors were naked, urinating over the ledge into the faces of any startled pedestrians who happened to look up. The police used pillowcases to cover the naked Pinocchios, their bodies worming around inside, before hauling them down.

This misstep aside, reviews of *Pinocchio* were glowing. Serious writers gave it their full attention. In the *New Republic*, Otis Ferguson wrote that it "brings the cartoon to a level of perfection that the word cartoon will not cover. We get around the problem of no old word for a new thing by saying, it's a Disney." In the *New York Times*, Frank Nugent called it "the best cartoon ever made." Many considered it Disney's masterpiece, better even than *Snow White.* The consensus was that *Snow White* was a better-told story, but that *Pinocchio* addressed messier themes and was more technically breathtaking in terms of its beautiful animation.

Frank Nugent, in his review of *Gulliver's Travels* two months earlier, couldn't resist comparing Fleischer and Disney. "We wish we did not have to make the comparisons demanded by professional responsibility," he wrote. "But, by any other standards than those of the juvenile audience, [*Gulliver's Travels*] is so far beneath the level of Mr. Disney." Other than that criticism, he offered praise for Fleischer's

film—as many critics did—but had seized on something unique about it. *Gulliver's Travels* seemed aimed at juvenile audiences, which was oddly out of character for the Fleischers. This new look didn't fit the studio very well, and others agreed. The consensus was that the film was competent but unnecessarily compromised, dumbed down for younger audiences who, in reality, don't need to be dumbed down to. Its strong box office run declined once *Pinocchio* was released.

Earnings for *Pinocchio* were strong, but didn't come close to matching those of *Snow White*. One possible reason was the film's tone; *Snow White* provided an escape from reality, while *Pinocchio* was about the drudgery of becoming a responsible adult. The primary reason, though, was the war in Europe, which now undermined the lucrative foreign market that had buoyed *Snow White*'s astonishing box office success. As the conflict grew, it weakened the financial potential of *Pinocchio* and *Gulliver's Travels*, and the market looked as though it would be troubled for some time. This worried Walt Disney, because his next film was expensive and would need to recover its cost. It was also a particularly special project to him, one that he wanted people to consider his masterpiece.

Chapter 23

"Highbrowski by Stokowski"

In the summer of 1937, Leopold Stokowski sat dining alone at Chasen's, a restaurant in Los Angeles. As conductor of the Philadelphia Orchestra, he was America's most popular classical music figure. In many ways, he had forged for the public imagination the image of what many people thought a conductor should look like: a brooding maestro with a shaggy mane of white hair, always clad in white tie and tails, frantically stirring the air with his conductor's baton as if battling a swarm of hornets. His public profile was given extra prominence by an endless string of tawdry celebrity romances that were constantly landing him in the tabloids.

As Stokowski ate, another diner began waving at him from across the restaurant, inviting the conductor to come join him. Squinting across the room, Stokowski suddenly realized he had actually met Walt Disney before.

Three hours later, after the waitress had topped off their coffee mugs countless times, Walt and Leopold were eager to work together. So eager, in fact, that Stokowski even agreed to waive his normal fee. Disney's idea was a cartoon short based on Paul Dukas's symphonic scherzo, *The Sorcerer's Apprentice*, about a wizard whose magical hat and scepter are borrowed by a young protégé who can't handle their power. Mickey Mouse would play the apprentice.

Disney wanted Mickey in the role because the character's popularity had declined in recent years. Not only was Max Fleischer's Popeye now more popular, so was another of Disney's characters, Donald Duck. "Of course you know Donald is the big thing now," Walt told a friend at the time, "but it won't last. Mickey is forever. He'll have his moments in the shade, but he'll always come out in the bright lights

again." To address Mickey's declining popularity, Walt's animators had redesigned his look, giving him more mass and placing an oval around his pupils to make his eyes more expressive. Fans thought the changes made him look cuter and less rodentlike, while critics complained that they undermined the rude energy that had given Mickey his original appeal. For *The Sorcerer's Apprentice,* animator Bill Tytla designed Mickey's specific look, which included a floppy wizard's hat and robe. He also gave Mickey the same cocked eyebrow Walt had when he was critiquing staff ideas during creative sessions—a look the animators had come to associate with his unyielding perfectionism. Tytla nicknamed this sorcerer Mickey "Yen Sid," or "Disney" spelled backward.

Disney hoped *The Sorcerer's Apprentice* would place Mickey within a vigorous new narrative format. The story he envisioned wasn't really a story at all, but rather something more like a poem or an abstract experiment. "I would like to have this thing kind of weave itself together and complete itself, but not have a plot," Walt told his staff. "This is different—we're presenting music," where "sheer fantasy unfolds to a musical pattern." He wanted none of it to be restricted by the "illusion of reality."

"I have never been more enthused over anything in my life," Disney wrote to Stokowski in November 1937. The early planning stages of *The Sorcerer's Apprentice* overlapped with the production of both *Snow White* and *Pinocchio,* but Disney's attention was beginning to drift, refocusing elsewhere—in his creative life, he was always eager to begin pursuing the next big thing. In this way, his projects matched different periods of his life. *Snow White* was full of themes representing his youth, while *The Sorcerer's Apprentice* would be about what loomed ahead: the task of wrangling his newfound power within the entertainment industry.

Shortly before Stokowski traveled to Los Angeles to begin work on the project, Disney asked his staff to generate a little exciting publicity by exploiting the conductor's recent breakup from actress Greta Garbo. This was part of Disney's shameless promotional instinct, but one he shared with Stokowski, who was well aware of how his dandelion puff

of white hair perfectly reflected the bright white stage lights. The two men had similar ideas about their roles in the entertainment hierarchy. Stokowski harbored grand ambitions to bring classical music to a universal audience through mass media, to be a conduit between high and low culture, an ambassador bringing the fine arts down to earth from the mountaintop. His image as a long-haired *artiste,* moody and temperamental, was carefully curated and engineered to grab attention. This wasn't just to popularize the music, but also to popularize himself. In this way, Disney was similar. The aesthetics of the two men's shticks didn't match, but the mechanics of how they worked did.

Stokowski walked a fine line with this strategy. He aimed to make classical music more appealing to the average person by saddling it with a kind of energy—blistering cymbal crashes and sweeping string arrangements—that the original composers never intended. This often sparked controversy. He popularized Bach among American audiences by injecting the master's music with a melodramatic lushness far removed from the cool and intellectual Bach prized by listeners who actually knew his music. Those with deep knowledge of classical music often despised Stokowski's manhandling of its great works. To these connoisseurs, he vulgarized composers' delicate creations and drained them of sophisticated nuance, relying too much on heavy-handed shock value.

Before recording the soundtrack for *The Sorcerer's Apprentice,* Stokowski asked for an army of musicians so big that Disney had to rent a bigger soundstage. The session was held from midnight to three in the morning, requiring the musicians to drink coffee to stay awake. "It makes everybody alert," Stokowski claimed. Once the session was over, Stokowski was so drenched in sweat that two bath towels were needed to dry him.

As work progressed, Disney and Stokowski hungrily fed off each other's energy. They were ambitious men who pushed each other further. Showing up in the mornings, his arms piled with additional musical scores, Stokowski began urging Disney to consider expanding the film's scope. It should be a feature, he argued. Disney eventually agreed, tentatively calling the expanded project *Concert Feature.*

Stokowoski then flew to Europe to secure music rights from dead composers' relatives, including Claude Debussy's widow and Maurice

Orchestra conductor Leopold
Stokowski in his younger days.

Ravel's brother. Every day, the project grew more complex, taking
on eccentric dimensions—Stokowski and Disney's correspondence
was even done in a secret code so nobody would figure out what
they were up to. Upon Stokowski's return, the pair spent a month in
Room 232 of Disney's studio, listening to records and dreaming up
possible accompanying visuals. Inevitably, the two strong personali-
ties eventually clashed. Stokowski blew up at Disney's habit of always
adjusting the volume—"What is loud should be loud and what is soft
should be soft!" he screamed—while Walt poked back by saying that
Stokowski's long hair made him look like Harpo Marx. But these brief
tantrums passed quickly.

Animators and story editors occasionally joined the listening ses-
sions. They all knew Disney, but still weren't quite sure what to make
of Stokowski. It seemed that he was always putting on a show—"the
biggest poseur since Richard Wagner," one of them remarked.

One day, as they were listening to music, the studio beverage cart
rolled by. "Care for a Coke?" Disney asked Stokowski.

"What is that?" Stokowski replied. The animators in the room wondered if he was actually serious—Coca-Cola was the most advertised liquid on earth. They were even more surprised when Disney, in all seriousness, began carefully explaining to Stokowski what a carbonated beverage was. Holding up his glass, Stokowski examined the liquid like a fine wine.

"Quite good," he murmured after taking a taste, swirling it around in his mouth like a rare vintage. "Really quite good."

This kind of thing did not sit well with the artists, many of whom had started their careers as bawdy gagmen whose greatest ambition was to bring people like Stokowski back down to earth. To them, he was a pretentious ass. When Disney later asked his staff for alternative titles for *The Concert Feature*, many seized the chance to poke fun at their guest, offering titles like *Highbrowski by Stokowski*. In all, eighteen hundred suggestions were made, but the one chosen was just a single, simple word that meant the same thing in many different languages: *Fantasia*.

During the production of *Fantasia*, Disney enlisted the help of another outsider: Oskar Fischinger, an abstract artist recruited to help design some of the film's visual sequences. Well known for collaborating on special effects with German filmmaker Fritz Lang, and for experimenting on abstract animation set to music, Fischinger had fled to America from Germany in 1935 after Hitler's crackdown on what the Nazis called "degenerate" art. His imprimatur would give the film the sort of higher status Disney desired. As soon as Fischinger arrived at the studio, Disney set him to work animating a portion of the film set to Bach's Toccata and Fugue in D minor, a sequence planned as a stunning series of abstract lines and shapes all moving to the music, recalling the paintings of artists like Wassily Kandinsky and Joan Miró. This choice was a bold move: abstract art, still considered relatively avant-garde, was held in suspicion by many Americans who mocked it as elitist and pretentious. Some even thought it was dangerous, a visual manifestation of the foreign politics of the artists making it.

Up to this point, Disney had kept abstract art at bay. He was keenly aware that he was running a movie studio, not a struggling art

gallery in Greenwich Village. New employees at his studio remembered being warned not to casually use the word "abstract." Sometimes his staff interpreted his suspicion of things he didn't know as philistinism. Art Babbitt remembered how, in 1933, he had hung a copy of Paul Cézanne's *The Green Jug* on his wall. "I don't like it," Disney said, walking by.

"Why not?" Babbitt asked.

"Well, the top of that goddamned jug is crooked."

Babbitt tried to find some common ground with his boss, citing the principles about perspective and space taught in Don Graham's classes.

"Anyhow, I don't like it," Disney said, stomping away.

A few months later, Disney was breathing over Babbitt's shoulder on a different project. "You know what I'd like to see you get in this character here?" he asked.

"What?" Babbitt responded.

"You know, some of that exaggeration, some of that sensitivity and stuff, you know, like Cézanne gets in his still lifes," Walt said. Babbitt later said that, when Disney made the Cézanne reference, he made it sound casual—"you know, like Cézanne"—as if there had never been a time when he wasn't familiar with the great artist's work. Babbitt didn't mean for the story to be critical, however; he used it to illustrate how Disney's rejections were never final, and that Disney remained open-minded. A groundbreaker by instinct and intuition, Disney would return to concepts he didn't understand if he thought they could help him improve something he did understand. By the time he made *Fantasia,* Disney had realized that abstract art offered a way to plumb the psyche. "This is more or less picturing subconscious things for you," he told staff. "It's a flash of color going through a scene, or movement of a lot of indefinite things." *Fantasia* could do for abstract art what Stokowski hoped to do for classical music: demystify it for the masses and make it less intimidating.

Disney liked Fischinger's work but did not like the man personally. Fischinger showed up at the studio looking like a European intellectual from central casting: aloof, precise, dressed all in black, listening to everything through half-closed eyes, speaking in puzzles. He was the aesthetic opposite of Disney, who constantly dressed in

mismatched plaids and peppered his speech with folksy asides. But one trait they shared was that each was used to having complete creative control, to being the captain of his own ship. Unlike Stokowski, whose expertise in music didn't directly threaten Disney's own expertise in visuals and story, Fischinger trod heavily on Disney's turf. His collaboration with Walt was bound to go badly, finally crumbling after a series of contentious confrontations. When Fischinger angrily quit— leaving to accept a grant from the Guggenheim Foundation—he asked that his name not be used in the film's credits. As he stormed out the door, he lobbed the worst insult imaginable at the Disney staff, saying that the studio had "no artists" but "only cartoonists."

As the production of *Fantasia* moved along, Disney's staff began worrying more and more about how their adaptations would upset serious aficionados of classical music. Were they meddling too much, making too many changes that would annoy purists? Disney dismissed their concerns. "I wouldn't worry a damn bit about the stiff shirts that are supposed to be the ones that this music is created for," he said. Instead, he wanted them to focus on the average person, who was unsophisticated about classical music but might appreciate it better after hearing it alongside the studio's animation. He illustrated his point by playing Bach's Toccata and Fugue. "There are things in that music that the general public will not understand until they see the things on the screen representing that music," Disney said. People who got bored and walked out of performances of the Toccata did so only "because they didn't understand it," he continued. "I am one of those people; but when I understand it, I like it."

During one listening session, Roy sat in the back of the room. He was taking a break from his normal business role to help provide creative input. It seemed to him that all the talk about classical music was getting out of hand, too abstract and intellectual, so he attempted to bring things back down to earth. He asked why they couldn't just pick some music that an "ordinary guy like me can like?"

Walt's stare was hard and cold. "Go back down and keep the books," he snapped, pointing to the door. This sent a sharp message to the rest of the staff, that *Fantasia* would have few distinctions between

what was considered "high" and "low" art. More and more, Walt had been inviting to the studio acclaimed artists known for their intellectual pedigrees, nurturing a loftier, headier feel. Painters Thomas Hart Benton and Grant Wood were regular visitors, and writer Thomas Mann was invited to examine the film's storyboards. Mann loved the fact that Goethe, the subject of Mann's recent book, had written *Der Zauberlehrling,* the poem that had inspired Dukas to write his music for *The Sorcerer's Apprentice.*

Walt later apologized to his staff for outbursts like the one leveled at Roy. "Excuse me if I get a little riled up on this stuff, because it's a continual fight around this place to get away from slapping somebody on the fanny or having somebody swallow something," he said. He wanted to move away from the old gags and start going for "humor . . . rather than just belly laughs" and "beauty . . . rather than just a flashy postcard." He told them he wanted *Fantasia* to "change the history of motion pictures."

In this way, Disney was channeling the spirit of Winsor McCay. Even his language started sounding like McCay. "We have worlds to conquer here," he told staff at the beginning of one story session. He wanted to tell a sweeping story on an epic scale, his ambition growing. Turning to Stokowski during another session, he asked, "Say, is there any kind of music that would support the idea of the creation of the world?"

"Why, yes! The *Sacre!*" Stokowski exclaimed. "*Sacre du Printemps* by Stravinsky!"—otherwise known as *The Rite of Spring.*

"Yeah?" Disney replied. "Maybe that's what we're looking for." He wasn't familiar with Igor Stravinsky's dissonant masterpiece, however; it was still considered avant-garde, not nearly as famous as it would later become. The piece's musical debut in 1913 had almost caused a theater riot. Some in the audience thought that its dissonant sounds were a bizarre prank mocking their taste. Using it in *Fantasia* was a bold move.

Before merging Stravinsky's score into the film, Stokowski needed to clarify a few things for the staff. "It isn't really about the creation of the world," he started, "but it is music that was written to depict life in primitive Siberia among the wild, almost stone-age people—their dances, and their religious rites. It's very, very weird, out-of-this-world music."

"Let's hear it," Walt said.

After Stokowski walked him through *The Rite of Spring*, Disney purchased its rights for $6,000. Then he invited Igor Stravinsky, who was originally from Russia but now lived in America, to the studio in December 1939. Wandering around, Stravinsky seemed to have a good time; poking his head into a random office, he discovered an animator listening to his music in reverse. "Sounds good backwards, too!" he laughed. As opposed to being set in Siberia, the adaptation of his music would now begin with images of a primordial Earth, seen from outer space, and move through sequences of dinosaurs, carefully avoiding scenes depicting human evolution so as not to upset Christian fundamentalists. Since the time frame was now shifted to prehistory, other adjustments also needed to be made. The music's original choreography, for an accompanying ballet, had contained the ritual sacrifice of a maiden, but would now be adapted into a scene of animals fighting. "We could base it on the 'dog eat dog' idea," Disney replied. "We could have a battle and build it to a grand climax. It is the fight for life."

Once again, concerns arose that the adaptations were running astray from the composers' original intents. These concerns came not from staff, however, but from Disney himself. "Should we stick as closely as possible to the original ideas behind this music?" Disney asked Stokowski.

Stokowski urged Disney not to worry about what a classical music snob might think of their work. He and Disney were not preservationists, he reiterated, but creators. They were trying to bring "this music to the consciousness of people so they will see how great it really is." Unfortunately, Stokowski said, the critics "are trying to down it. The men who are not creators sneer at it." Then he reassured Disney: "We shouldn't worry, if the spirit of the music is with us." Dick Huemer, also in the story meetings, put a finer point on it: "Who cares what they think? I mean, we're in the entertainment business."

One time, however, Stokowski tried to dial back Disney's creative impulses; this was over the adaptation of Beethoven's *Pastorale* Symphony. Instead of scenes from nature, Disney wanted something inspired by Greek mythology, involving Mount Olympus, gods, centaurs, and fauns. Stokowski disliked this idea but offered his criticism

diplomatically. "I don't want to come out of my own field—I'm only a musician," he said, "but . . . the idea of [Greek] mythology, is not quite my idea of what this symphony is about. This is a nature symphony—it's called *Pastorale*." This particular work was sacred ground, he said; among aesthetes, this composition by Beethoven involved red lines that shouldn't be stepped over. The composer was "worshipped" among classical music aficionados, he explained. Vandalizing the master's music could unleash their furious anger.

Disney listened to Stokowski's warnings but held his ground. He still thought the nature scenes sounded boring and wanted to give viewers something more exciting. "I defy anybody to go out and shoot centaurs or gods making a storm," he replied. "That's our medium, and that's how I feel about this." To spice it up even more, the centaurettes were initially drawn topless, although pressure from the Hays Office later forced them to have bras. Overall, Walt was sure of his instincts, confident that they would bring success. He was so confident, in fact, that he told his staff, "I think this thing will make Beethoven."

Vladimir "Bill" Tytla, the artist who designed Mickey for *The Sorcerer's Apprentice* sequence, had also wanted to design the centaurs for the *Pastorale* sequence. A polo player whose father had been in the Ukrainian cavalry, he thought he was a good fit for the job. Disappointed after Disney assigned the centaurs to another artist, Tytla was even more disappointed when he saw the final result. "They looked gutless," he said. "They should have been big stallions with dark, Mediterranean faces on them. Instead they were castrated horsies with a type of Anglo-Saxon head."

Disney denied the assignment to Tytla not because he lacked confidence in him—Tytla was actually one of his best artists—but because he wanted Tytla to work on the sequences for Russian composer Modest Mussorgsky's *Night on Bald Mountain* instead. It would feature Chernabog, a hulking demon who would spiral up from a column of flames, summoning dead souls to rise from the ground like wisps of smoke. Disney assigned characters to animators whose personalities were a good match, and he thought Tytla was a good fit

for this deity from Slavic folklore, whose name meant "black god." During the production of *Snow White*, Tytla had likewise been assigned the role of animating Grumpy.

Born in Yonkers to immigrant parents, Tytla had piercing eyes and a dark mop of hair that looked as if it was chiseled from coal. His powerful shoulders and arms likewise contributed to his imposing aura, but tapered down into a surprisingly delicate set of hands—an artist's hands. Even though many mistook him as dark-natured and temperamental, he was actually quite sensitive and kind. His artistic pedigree was also impeccable. He had studied art in Europe under a disciple of Rodin, the renowned French sculptor Charles Despiau, who called Tytla the Daumier of his generation. Other Disney artists credited Tytla's sculptural abilities with giving his animation such breathtaking dimension. Tytla had given up sculpture, however, because his sense of perfectionism had turned sculpturing into a tormenting struggle—he doubted he would ever be as good as he wanted to be, which was to be the best. Instead, he decided to divert his attention to animation. As a young boy, he had seen Winsor McCay's *Gertie the Dinosaur,* and he could never forget it. Before joining Disney, he animated for Paramount, Raoul Barré, and Paul Terry.

Tytla prepared for his animation assignments using the Stanislavski process of "method" acting. During *Pinocchio,* when he animated Stromboli, the old man who creates the Pinocchio puppet, he prepared by spending weeks hanging out in Italian neighborhoods, absorbing the rhythms and moods of their cafés and butcher shops. For Chernabog, to create the right mood to get inside the devil's head, he kept his office dark, decorating it like the lair of a fortune-teller. He also convinced Bela Lugosi, the *Dracula* actor, to send him film footage for reference. His colleagues remember the sounds rattling his office door and echoing down the hallway as Tytla acted out the role in his office, just as Disney did to find his own vision of a film. When he came out, hours later, he resembled a miner emerging from underground into the sun, blinking in the bright hallway lights.

When Disney saw Tytla's footage of Chernabog, he was stunned. He had originally considered ending *Fantasia* with Mussorgsky's score, but decided that a trip into Bill Tytla's dark imagination was simply too terrifying for the film's finale. Thus, the Mussorgsky sequence

was moved up in the film and the new ending became Schubert's *Ave Maria*, depicted as a sequence of pilgrims holding candles as they pad through a forest cathedral of soaring trees. Disney thought *Ave Maria* would be a good chaser for *Night on Bald Mountain* because it helped "portray the triumphant return of holiness and sanity after a night of orgy and evil."

"I'm serious about this whole perfume idea," Disney told Stokowski about his idea to pump theaters full of scents to match the action on the screen during *Fantasia*. He wanted every sequence in *Fantasia* to be accompanied by appropriate smells. Scenes with flowers would involve perfume, the sequence involving *Ave Maria* would involve incense, and the sequence for *Night on Bald Mountain* would perhaps involve sulfurous fumes.

Stokowski loved the idea, rooting Disney on like a schoolboy daring his buddy to attempt bigger and bigger stunts. "You're going to give them a million dollars in beauty," he said.

Disney soon realized that the perfume idea was highly impractical. Abandoning it, he refocused his attention on the film's sound instead. His Foley artists had invented a way to blow air through vats containing mixtures of oil and soapy water, perfectly capturing the sound effect of bubbles bursting. For the sound of bees buzzing, dozens of condoms were stretched to their limit and plucked like guitar strings, creating a humming roar. These effects were timed out in their own little symphonic scores, to keep time with the action.

Disney's main obsession with the soundtrack, however, was a new idea called Fantasound. Envisioned as a way to create the illusion of a live performance, the system would consist of sixty-four speakers scattered throughout the theater, enclosing the audience within the music in an early predecessor of surround sound. To begin the design process, $200,000 was paid to RCA to design a new recording system that was up to handling the daunting task of capturing the many different layers of sound that Disney and Stokowski wanted to preserve. Stokowski described it as the audio equivalent of pointillism, the painting style made famous by French postimpressionist Georges Seurat.

The *Fantasia* recording sessions were held in a variety of locations, including the Philadelphia Academy of Music, the home of Stokowski's orchestra. Old and stately, built of red bricks the color of a fine wine, the theater was sacred. Abraham Lincoln had once given a speech there, and it had hosted performances by Maria Callas, Enrico Caruso, Gustav Mahler, Pyotr Tchaikovsky, Sergei Rachmaninoff, and countless others. The Philadelphia *Fantasia* sessions began in 1939 on Good Friday, a holy day. Thirty-three microphones were placed on the stage, their wires crisscrossing in the air like rigging on a ship. The wires snaked their way down into the basement, where nine different command centers were set up for each of the film's different tracks. A round brick wall in the middle of the basement space, with beams laid over the top, helped the entire theater reverberate, like the soundboard of a musical instrument.

Engineers recording the *Fantasia* soundtrack in Fantasound.

After the Fantasound systems were designed, however, they proved prohibitively expensive to implement in a large number of theaters nationwide. A single unit cost $30,000, weighed 7,000 pounds, and took a week for installation, which involved an additional fee of $8,000. Only a few lucky theaters would be able to get Fantasound, including the Broadway Theatre in New York, where Mickey Mouse had debuted barely a decade earlier (it was then known as the Colony Theatre). Fantasound's effect, however, was marvelous. "Whereas Mickey Rooney in full cry creates only about twenty-five decibels of sound, *Fantasia* will at certain climaxes reach eighty decibels," William Garity, Disney's chief sound engineer, told a reporter from the *New Yorker*. The sound would be loud but not uncomfortable, he reassured everyone, because it wasn't coming from a single source—it would wrap itself around the audience like a warm blanket. Still, it would be a mighty force to reckon with; Garity couldn't resist a little showmanship as he promoted the system, bragging that Fantasound at full blast could reach 165 decibels, enough to kill "elderly members of the audience, knock the others cold, and deafen the survivors for life."

"Don't worry about it, though," the magazine reassured readers; "you're safe with Walt Disney."

On November 13, 1940, *Fantasia* premiered at New York's Broadway Theatre, where *Steamboat Willie* had also premiered (when it was still known as the Colony Theatre). Disney spent much of the day giving interviews, explaining how he hoped the film would raise the audience's appreciation of classical music. He used himself as an example, explaining the service *Fantasia* had done for him. "I never liked this stuff," he told the *New York Herald Tribune* about his previous uninterest in classical music. "Honest, I just couldn't listen to it. But I can listen to it now."

Dark skies dumped rain on the city all day, but the clouds cleared just as the theater opened—a positive omen. Disney used the event to benefit British War Relief, and the wives of various business moguls arrived in support, stepping out of curtained limousines onto red carpets rolled across the puddles: Mrs. Henry du Pont, Mrs. William

Randolph Hearst, Mrs. Henry Luce, Mrs. William K. Vanderbilt, and Mrs. Kermit Roosevelt, among others.

The next morning, Disney read the reviews. "Motion picture history was made last night," Bosley Crowther wrote in the *New York Times*. "[*Fantasia*] dumps conventional formulas overboard and reveals the scope of films for imaginative excursion." Otis Ferguson, writing for the *New Republic*, thought it "one of the strange and beautiful things that have happened in the world." Assessments by other film critics were equally glowing.

Music critics, on the other hand, took several more days to process what they had just witnessed. To them, Disney had broken some sacred rules and tracked his muddy boot prints across the clean white carpets of their temple. "When Mickey Mouse and Donald Duck gave way to Bach and Beethoven, the results were as far out as Pluto," Franz Hoellering wrote in *The Nation*, noting that the film had its merits but didn't live up to its potential. "*Fantasia* is a promising monstrosity," he wrote. Olin Downes, music critic for the *Times*, thought it generally "distracted from or directly injured the scores." Nor did he think it had combined sight and sound nearly as well as, say, ballet. Many thought Stokowski had laid it on too thick. Igor Stravinsky, appalled at Stokowski's manhandling of his score, told people, "That's not my music, that's Stokowski's music." Stravinsky then addressed the visuals, growling, "I do not wish to criticize an unresisting imbecility."

Disney always knew that *Fantasia* would be a "slow money maker." The film cost roughly $2.3 million, a whopping number that would require time to recover. American audiences were enthusiastic, but the war in Europe was again an obstacle. Since *Pinocchio*, international markets were now almost entirely inaccessible.

Critics struggled to separate *Fantasia*'s message from world events. Many insisted on treating the film as an allegory, injecting current politics into the discussion even though those politics weren't Disney's priority in making the film. "The forces of evil are not shown as the exploiters and war makers," the *Daily Worker* complained, "but as a mythical devil on a mountaintop against whom human powers are helpless." The paper argued that Disney had abandoned his social responsibility by not addressing more important issues. Hitler's swelling power could no longer be ignored, and escape

Winsor McCay, the patron saint of animation, dressed with his typical sartorial elegance, circa 1906. During the first fifty years of animation, it was extremely rare to find an American animator who didn't claim McCay as a major inspiration.

Émile Cohl, whose animation was inspired by the playful surrealism of the Incoherents, a short-lived French art movement started by his friend Jules Lévy. After Cohl moved to New Jersey, U.S. immigration officials cited "sanitary reasons" when they asked him to shave the glorious mustache he wore in honor of the French political cartoonist André Gill. Cohl promptly regrew it.

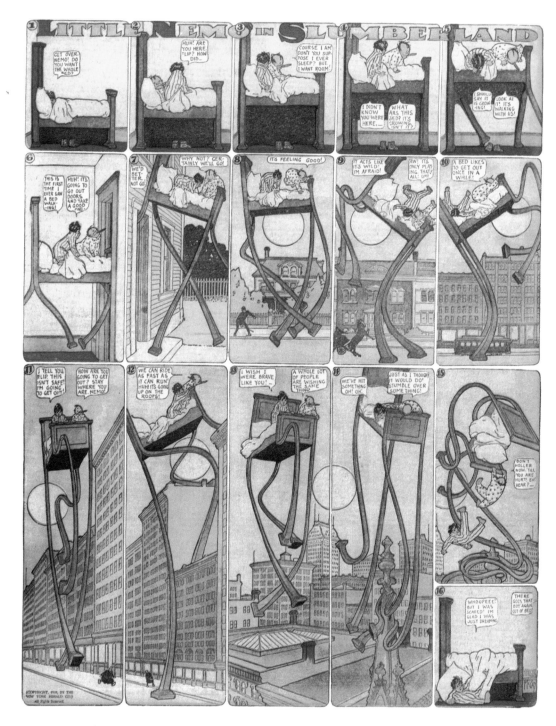

Winsor McCay's *Little Nemo in Slumberland* comic strip from July 26, 1908.
Wild and surreal, the strip often explored the psychology of dreams,
and was adapted into McCay's earliest animation.

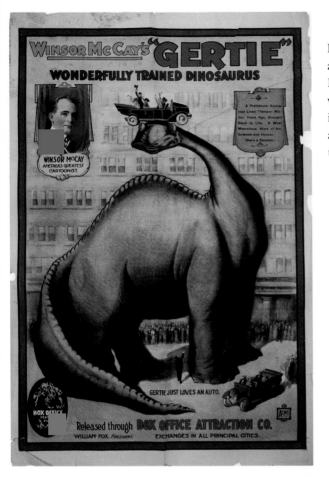

Poster for *Gertie the Dinosaur*, the animated cartoon that Winsor McCay used as part of his interactive vaudeville act. Countless animators, including Walt Disney, cited *Gertie* as the cartoon that inspired them to become animators.

"His Best Customer," February 21, 1917. Winsor McCay's editorial cartoons provided stark commentary on war and geopolitics. This attitude was later channeled into his landmark animated cartoon, *The Sinking of the Lusitania* (1918).

An early animation studio circa World War I, before studios were organized similar to factories. Equipment often consisted of second-hand desks, homemade shelves, and makeshift adaptations of motion picture equipment.

An early promotional poster for Mickey Mouse, circa 1928. Note the prominence of Ub Iwerks's name. Iwerks drew almost singlehandedly many of the earliest Mickey Mouse and Silly Symphonies cartoons, including *Steamboat Willie*. Chafing under Walt Disney's control, Iwerks left to start his own studio.

The Fleischer Studio, 1929. Front row, left to right: Sidney Wallick, Edith Vernick, George Cannata, Seymour Kneitel, Max Fleischer, Charles Schettler, Sid Marcus. Second Row: Fred Lewis, Rudy Zamora (white hat), Al Eugster (dark hat), George Ruffle, Abner Kneitel, Joe Fleischer (suspenders), William Henning (in hat, gripping window ledge), head of Bill Nolan (between Fleischer and Schettler). Man behind Max and man in window unknown.

The Fleischer Studios inking and opaquing department at 1600 Broadway in New York. Note the factory-like setting compared to earlier animation studios. As the division of labor became more precise and controlled, wages for many animators were squeezed, erupting in a series of labor strikes at many studios.

Max Fleischer publicity photo with Betty Boop.

Still from *Betty Boop in Snow-White* (1933). Fleischer Studios' version of the classic fairy tale was dark and surreal, incorporating a rendition of "St. James Infirmary Blues" by the jazz musician Cab Calloway. Calloway's famous dance moves are included in the scene where Koko the Clown morphs into a ghost and dances in front of Betty Boop, whose body rests inside a coffin made of ice.

Employees from the Fleischer Studio pose for a holiday card, circa 1936.
Left to right: Tom Johnson, Jack Ward, Joe Stults, and two unknowns.

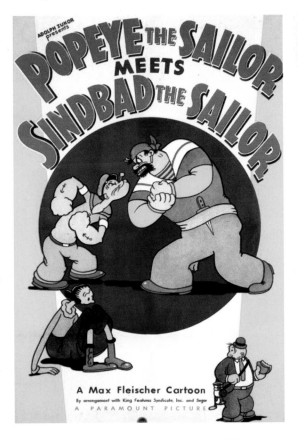

Theatrical poster for *Popeye the Sailor Meets Sindbad the Sailor* (1936). Fleischer Studios' first two-reel cartoon was a critical and commercial success. Utilizing the "stereoptical process" to achieve greater visual depth, it was also a technological breakthrough.

Groucho Marx at the premiere of Fleischer Studios' *Gulliver's Travels* (1939). The film was the studio's first feature, and a response to the success of Disney's *Snow White and the Seven Dwarfs*. By adapting the work of Jonathan Swift, Max Fleischer was attempting to take animated features in a different direction.

Still from *Gulliver's Travels* (1939).

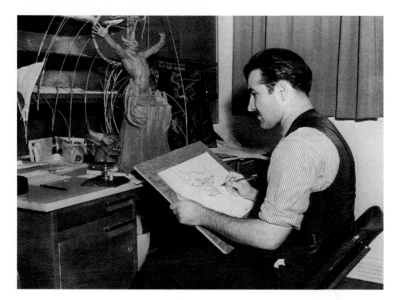

Vladimir Peter "Bill" Tytla animating Chernabog, the Black God from the "Night on Bald Mountain/Ave Maria" sequence from *Fantasia*. He is also known for his work animating the Seven Dwarfs from *Snow White*, Stromboli from *Pinocchio*, and the title character in *Dumbo*. He met his wife, the actress Adrienne le Clerc, when she posed nude for drawing classes at the Disney studio. She later claimed that the only way to get her husband's attention while he was working was to stand naked in the doorway.

Still from *Hollywood Steps Out* (1941), the *Merrie Melodies* cartoon directed by Tex Avery, whose off-kilter directorial style was partly credited to his losing an eye during an office prank gone wrong. The cartoon skewered many notable Hollywood personalities of the day, including Leopold Stokowski (pictured here), the famous orchestra conductor who collaborated with Walt Disney on *Fantasia*. Animators from Warner Bros. rarely missed a chance to satirize the work of their rival, Walt Disney.

An example of the support that many cartoon studios lended to the U.S. government during WWII. Not only were popular characters used to raise money through war bonds, they became mascots for many fighting units.

Theodor Geisel, aka Dr. Seuss, who spent WWII writing propaganda for the U.S. government. He later used the relationships he made with animators in the First Motion Picture Unit to pursue animation projects with Warner Bros. and UPA.

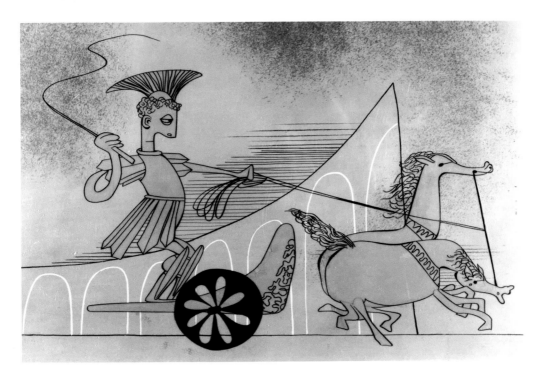

Still from *Brotherhood of Man* (1946), the cartoon that UPA made for the United Auto Workers to help improve race relations at automobile factories. The studio experimented with new design principles that would greatly influence the work of other animation studios.

John Hubley, one of the founding members of UPA. Although he started his animation career working for Walt Disney as a background and layout artist, Hubley founded UPA partly as a "revolution" against many of Disney's design principles.

Study by John Hubley for *Rooty Toot Toot* (1951). Representative of UPA's aesthetic, the cartoon incorporated a sultry musical score and was an adaptation of the story told in the song "Frankie and Johnny," about a woman who goes on trial for killing her piano-playing lover.

Still from UPA's *Christopher Crumpet* (1953). The studio's stripped-down aesthetic was representative of the "limited" animation style that helped studios save money and increase output in response to the different economics brought by television.

Warren Foster poses in front of the storyboard for *The Mouse-merized Cat* (1946), one of the first Warner Bros. cartoons directed by Bob McKimson. Seated in front of McKimson is Edward Selzer, a producer who rarely ever contributed creatively. The animators relished opportunities to reject the bland decision-making of executives such as him, thus injecting their work with an additional layer of rebellious cool.

Walt Disney planning the construction of Disneyland in 1954. By this point, Disney had adopted a corporate look for his television appearances, but here he favors a few of the eccentric wardrobe choices that defined his earlier career.

UPA artist Jules Engel sitting in the office space designed by the architect John Lautner, a modern showpiece reflecting many of UPA's design principles.

Background art for UPA's *Giddyap* (1950).

Still from UPA's *Gerald McBoing Boing* (1950). The landmark cartoon
was adapted by Bill Scott and P. D. Eastman from a story by Dr. Seuss. Despite
their service during WWII, Scott and Eastman were both victims of the
House Un-American Activities Committee's investigations.

John Hubley's concept art for the unproduced feature "Men, Women and Dogs,"
a collaboration between UPA and James Thurber, who was best known
for his cartoons and stories in the *New Yorker*.

Poster for UPA's *A Unicorn in the Garden* (1953). Based on
a story by James Thurber, the cartoon was originally
supposed to be part of the feature *Men, Women and Dogs.*

On January 4, 1956, Max Fleischer and Walt Disney finally met, seen here
having lunch in the cafeteria at Disney's studio. After seeing the two men
together, Richard reflected on their rivalry, writing of his father, "I had the
feeling that Goliath had defeated David." Left to right: Gerry Geronimi,
Walt Disney, Ben Sharpsteen, Ted Sears, Max Fleischer, Dick Huemer,
George Stallings, Richard Fleischer, Andy Engman, and Wilfred Jackson.

was no longer an acceptable mission for Hollywood. *Fantasia* was a "caricature of the Decline of the West," Dorothy Thompson wrote in the *Herald Tribune*. "Nazism is the abuse of power, the perverted betrayal of the best instincts, the genius of a race turned into black magical destruction, and so is 'Fantasia.'"

Walt Disney was not a particularly political man and didn't seem to take this criticism personally. Stokowski had already told him not to worry about the naysayers. Walt joked to one friend that the critical brouhaha "couldn't have been sweeter" and had probably helped boost advance ticket sales. He was no doubt worried about a looming war, but, like many Americans, not worried enough. Heading west for the Los Angeles premiere of *Fantasia,* he was upbeat about the movie's prospects, writing to a friend that he was "walking on air." This was perhaps too optimistic. In addition to the coming war, Disney had another serious crisis looming.

Chapter 24

"Law of the Jungle"

On February 11, 1941, Walt Disney gathered his staff together for a speech. A tense mood filled the air as they filed into Studio Theater A. Everyone knew the studio's financial situation was precarious and suspected that the meeting would address this problem. Three months had passed since the release of *Fantasia*, and profits hadn't been as high as expected, largely because the war in Europe had cut off lucrative foreign markets. As people took their seats, nobody expected good news as they watched Disney restlessly pace the stage, back and forth, a lion in a cage. They also knew that Walt probably wanted to address other contentious labor issues that had been the talk of the industry. The looming war and Roosevelt's New Deal had actually stimulated the economy; newly unionized workers in other industries were enjoying wage increases, as were animators who had unionized at other studios. Some had called their friends at Disney and urged them to do the same, and Walt was eager to address the issue.

This was a different Walt Disney from the one staff had known several years earlier. Studio veterans knew him as a close collaborator: someone whose office door was always open. But during the previous five years, the studio had grown from 300 to 1,200 people, and Walt no longer knew everyone's name. Newcomers remembered him as a distant boss. To reach his office in the new Burbank studio one now had to climb two flights of stairs, trek down a long corridor, and maneuver through a phalanx of gatekeepers occupying two offices, a reception room, and a secretary's cubicle. This reality wasn't lost on Disney. The night before he moved into the Burbank office, he dreamed about walking through empty halls, hearing only the echo of his own footsteps.

Disney began speaking once the seats were full, his voice honest and sincere. The current financial problem was partly his fault, he admitted. He planned to slash his own salary by 75 percent, and asked others to also consider a cut. This would prevent mass layoffs or a buyout, he explained, and was the only way the studio could continue its mission: "to show skeptics that the animated cartoon was deserving of a better place; that it was more than a mere 'filler' on a program; that it was more than a novelty; that it could be one of the greatest mediums of fantasy and entertainment yet developed."

Disney's three-hour speech reflected two different sides of his personality. "It's my nature to be democratic. I want to be just another guy working in this plant—which I am," the kind uncle side of him said. Then the corporate boss side of him issued a threat: "It's the law of the universe that the strong shall survive and the weak must fall by the way, and I don't care what idealistic plan is cooked up, nothing can change that!"

The strong tone shocked the staff. "We were disappointed in him," one animator recalled, "in the promise of the big happy studio where everyone would be taken care of—that was simply not working out in reality." They began calling the incident Disney's "law of the jungle speech" and felt that Walt was ignoring their legitimate grievances about labor issues. Among their worries was the lack of a consistent policy regarding wages. Disney historically doled out bonuses and raises however he saw fit—he was often generous but passed them out like a child passing out candy, according to his whims and mood, not necessarily based on concrete benchmarks. Also annoying was that Disney gave them little credit for their work, frequently reminding everyone that his name was ultimately the brand. Some had worked on his features for years, never to see their names in the credits. Said one artist, "He's a genius at using someone else's genius."

Disney had missed important signs coming from his staff, as well as lessons from the Fleischer strike, which was caused by similar grievances. Nor did he see that his staff was ripe for rebellion, or that his speech only stoked everyone's anger. "This speech recruited more members for the Screen Cartoonists Guild than a year of campaigning," *The Nation* reported. In addition to the Fleischer strike, MGM's cartoon unit had unionized, and in only six days the animators at

Warner Bros. had broken Leon Schlesinger, who reluctantly signed a union agreement. Eager to see a rival fall, Schlesinger then asked union boss Herb Sorrell, "Now, what about Disney?"

The guild increased pressure on the studio, demanding negotiations. The talks soured immediately, infected by a toxic mix of personalities. In the pro-union corner was Art Babbitt, who, even though he had been one of Disney's best animators since 1932, also had a tendency to push all his boss's "wrong buttons," according to one studio executive. Babbitt flagrantly disregarded office politics and regularly harassed female staff, drawing Disney's disapproval ("My attitude was if it moves, screw it!" Babbitt once said). Joining Babbitt was Herb Sorrell, head of the Conference of Studio Unions, which included the Screen Cartoonists Guild. As the most powerful union organizer in Hollywood, he earned his reputation by breaking arms, not by sweet-talking his opposition. By age twelve he had escaped daily beatings from his drunken father by taking a job in a sewer pipe plant in Oakland—a tough job in a tough city. Then, after surviving the bloody trenches of World War I, he capitalized on his powerful shoulders and lantern jaw to become a champion prizefighter, measuring his record by the pile of teeth he knocked out of other fighters' heads. He later took a job painting movie sets and became a union organizer after getting fired for no reason. Upon meeting Walt's staff, he told them he was ready to "squeeze Disney's balls 'til he screams."

Opposing the union organizers was Disney's chief lawyer, Gunther Lessing, tough as nails and the only person at the studio who was always addressed as "Mister." After graduating from Yale in 1908, Lessing started his law career defending against the state a gang of Mexican revolutionaries headed by Francisco Madero. He rode horses alongside them—a revolver strapped to his hip, dirt under his fingernails—galloping into Mexico City when Madero took over the government. After Madero was assassinated in 1913, blown to bits in a hail of angry gunfire, Lessing represented the cigar-chomping bandit Pancho Villa. Describing himself as an "idealist" and prone to dramatic mood swings, Lessing arrived at Disney's studio in the early 1930s as the kind of surly conservative who scared even those who shared his

politics. His negotiation style with rivals was to answer questions with a dramatic eye roll, breathe out a deep sigh, and stare up at the ceiling.

Union negotiations went poorly from the start. On the day Babbitt was scheduled to testify before the National Labor Relations Board, somebody arranged to have him arrested and jailed on bogus charges of carrying a concealed weapon (most suspected that Lessing set him up). By March 1941, Disney announced pay cuts and a new "austerity plan," upsetting staff further. Feelings hardened on both sides. "You know how I am, boys," Disney told his staff several weeks later, reiterating that he refused to bargain. "If I can't have my own way . . . if somebody tries to tell me to do something, I will do just the opposite, and if necessary I will close down the studio."

On May 20, about twenty employees, most of them guild members, received a personal memo from Disney: "Will you please be in 3-C-12 [a projection room] at 5:15 this afternoon?" Once they were gathered, Disney fired them. When one of them asked, "What do we do now?" Disney answered, "I don't know. Start a hot-dog stand."

The strike began within a week. Roughly a third of the staff participated, most of them lower-level employees. They held signs as clever as the ones at the Fleischer strike: "Snow White and the 700 Dwarfs" and "Michelangelo, Raphael, Titian, Rubens, Da Vinci and Rembrandt all belonged to guilds." Sorrell set up the strike headquarters nearby, in a eucalyptus grove at the end of the street, close enough for him to smell the smoke from Gunther Lessing being burned in effigy outside the studio gates. Leon Schlesinger let his Warner Bros. staff out early to join the Disney strikers and then headed over himself, convincing a man with a bullhorn to announce, "Herb Sorrell is now speaking to Leon Schlesinger, who has signed a very nice agreement with the Cartoonists Guild."

Inside his studio, Disney seethed as he pored over photographs of the picket lines, squinting at the faces. "Damn, I didn't think *he'd* go against me," he said of one. "We can get along without him," he said of another. His tone made animator Jack Kinney uncomfortable, giving him "the uneasy feeling that [Walt] was filing his feelings away in his prodigious memory for some future revenge." Some of the staff found themselves demoted or verbally humiliated after they returned.

Maurice Noble remembered coming back to work and being shown his new "office": a former broom closet.

Disney eventually enlisted the help of rival union organizer Willie Bioff, a gangster who had once worked with Al Capone and, a few months earlier, had been indicted on federal racketeering charges. "As long as the guy's fighting with you, you welcome him on your side," Roy Disney said of Bioff. Shortly thereafter, two events helped settle the strike. First, Bioff resolved differences with Sorrell about another, unrelated union matter—a murky quid pro quo involving details nobody completely understood. Second, Sorrell began pressuring Disney's main financier, the Bank of America. This vague process appears to have been done in the mysterious ways of union organizers; it ended with Doc Giannini, the bank president's brother, saying of Disney, "I guarantee he'll arbitrate or he won't have any studio."

It was a clear union victory. The studio agreed to numerous benefits, including screen credit and wage increases. Base pay for inkers went from $18 a week to $35, while animators' pay went from $35 to $85. Fired workers—many of them let go in defiance of the Wagner Act—were rehired. "Walt wasn't really a villain," Shamus Culhane wrote. "He just had a blind spot: he didn't understand working conditions of business. He couldn't see that there was a need for an industry-wide organization."

Disney fumed at losing total control over his studio. "I have a case of the D.D.'s—disillusionment and discouragement," he wrote in a rambling three-page letter to Westbrook Pegler, a right-wing columnist whose acquaintance Disney was starting to cultivate. "The entire situation is a catastrophe," he told Pegler, explaining that the strike was "Communistically inspired and led." The comment was tinged by a paranoid flavor of conspiracy, suggesting that Disney might be drifting away from the bright idealism of his youth. Something inside him was turning pessimistic, curdling like milk left out in the sun. Years later, he explained how the incident affected his politics, which would in turn influence his art. He wrote, "Gradually I became a Republican."

* * *

Disney retreated from public view as the labor dispute was settled. Restless by nature, he searched for a distraction, preferably something that would help generate much-needed revenue for the studio.

An invitation soon arrived from Nelson Rockefeller, the multimillionaire oil heir. He had recently established the Office of the Coordinator of Inter-American Affairs, an organization that sought to improve relations between the United States and Latin America. After many trips to South America—to fill his home with its art, and his bank account with money from oil and hotel investments in Venezuela—Rockefeller had become alarmed by the region's poverty. He had seen children wearing rags picking through trash in the streets, while their parents begged for charity. Rockefeller wanted to help bring the two Americas together through culture, starting with goodwill tours of the region by American celebrities: actor Douglas Fairbanks Jr.; actress Dorothy Lamour; the Yale Glee Club; and perhaps Disney. Not only would Walt get a break from his labor troubles, he could sip caipirinhas in Brazil, eat steak in Argentina, and have his smiling photo taken in Caracas, surrounded by adoring fans.

By the time Disney accepted, the trip had another dimension: propaganda. The war in Europe was worsening and Rockefeller and U.S. lawmakers worried about Germany's growing influence abroad. Nazis were surfacing in South American capitals, lunching in the cafés and cheering at soccer matches. They were there courting the politicians of neutral countries, urging them to pick a side. In an effort to block the Nazi effort to win hearts and minds, Rockefeller enlisted his friend John Hay Whitney to provide films for theaters that might otherwise show movies from Axis countries—*The Power of Thought*, a German propaganda film, was already popular. Rockefeller proposed that Disney's films could provide an important counterbalance to the Nazi campaign. The trip would last three months, paid for by Washington. While overseas, Disney would collect material for a series of animated cartoons to help bridge the different cultures.

As Disney prepared for the trip (and when he would be away), his staff continued work on *Dumbo*, the story of a baby circus elephant that learns to fly using its enormous ears. Originally written by Helen Aberson-Mayer and Harold Pearl as a prototype of a new storytelling device known as a Roll-A-Book, similar in principle to a panorama,

it was one of dozens of properties the studio acquired in 1938 and 1939 with the profits from *Snow White*. At first, the studio wanted to make it as a short, but, as with *Fantasia*, the project quickly became a feature. Utilizing a simpler aesthetic than Disney's other features, *Dumbo* was moving through the production process quickly.

As the South America trip approached, Disney handpicked a crew of fifteen—none of them strikers—to accompany him. After traveling through the Caribbean, they made their first stop in Brazil at Belém, gateway to the Amazon, descending from the clouds into the green jungle in a Boeing Strato Clipper. During a refueling stop in a remote outpost, hundreds of schoolchildren from nearby villages crowded around Walt, all of them aware of who he was. Next came Rio de Janeiro, Brazil; Buenos Aires, Argentina; and La Paz, Bolivia. A boat ride along the coast took them to Peru, Ecuador, and Colombia. They soaked up the customs and folklore as much as they could from their luxury hotels, taking the occasional hike into the jungle, their guides making sure they had plenty of snacks. Even though their intended goal was to soak up atmosphere, their itinerary suggested the real business was to display Walt to adoring fans and government officials. As Frank Thomas said, "Mainly we were wined and dined all over the place, where it was real hard to do any work." When they did do work, storyboarding and brainstorming ideas for potential films, it usually happened in the middle of the day. Their research mostly consisted of filming their adventure with 8mm cameras, recording themselves wearing local garb—guayabera shirts in the hot climates, or gaucho hats on the Argentine plains. At night they filmed themselves out dancing, like the heroes in calypso songs.

The travelers never discussed the strike during their trip. Their adventure in South America was supposed to be a break from all that. Back in California, a crew finished work on *Dumbo*, using the villainous clowns in the film to parody the striking workers when they decide to "hit the big boss up for a raise." When the film debuted, in October 1941, reviews were ecstatic. Bosley Crowther in the *New York Times* said it was "the most completely precious cartoon feature film ever to emerge from the magical brushes of Walt Disney's wonderworking artists!" Otis Ferguson, in the *New Republic*, told readers, "I have never seen anything to approach it and neither have you." Many animation

historians would later express the opinion that *Dumbo* was one of their all-time favorite Disney films. Because of its significantly reduced costs, which were evident in its simple, less realistic style, *Dumbo* also made money. As the first Disney feature not to feel Walt's constant presence—although he did have significant influence—*Dumbo* also demonstrated just how talented his staff was on its own.

When Disney finally returned to Burbank, he found it changed, more restricted. Bank of America, his main financial benefactor, now insisted on delaying all features until earlier features earned back their costs. The films he had planned to make about South America—intended as shorts—were delayed as well and wouldn't be released until a few years later. Everyone's focus narrowed as increased attention turned to the war in Europe.

Chapter 25

"Okay, Go Ahead"

Walt Disney might have chosen not to use *Fantasia* to address global political turmoil—and suffered criticism as a result—but others were eager to use their art in service to a political message, such as the creators of the *Superman* comics. In February 1940, *Look* magazine commissioned an installment featuring the popular character, entitled "How Superman Would End the War." In the final panels, Superman flies over the Alps carrying Adolf Hitler and Joseph Stalin, who dangle loosely from his grip like two sacks of garbage.

"Where are you taking us?" Hitler asks.

"Next stop—Geneva, Switzerland!" Superman answers as he hauls them off to the World Court.

When the strip ran, America hadn't yet entered the war in Europe, and isolationists in Congress were still arguing that it shouldn't get involved. Many in America disagreed—unlike some political leaders, they knew that America's security relied on global security. As the sons of Jewish immigrants who had fled European pogroms decades earlier, Superman's young creators, Joe Shuster and Jerry Siegel, were not on the fence about the issue. When it came to issues of social justice, either international or domestic, Superman would speed along progress being held up by obstinate bureaucrats. A one-size-fits-all vigilante, he would apprehend dictators, prevent Klan lynchings, or save trapped workers from coal mines run by top-hatted men without an idea of "how the other side lives," as Shuster and Siegel put it.

In Germany, the Nazi Party was wary of Superman's activism, especially the part about holding Hitler to account. It banned the character. "Superman is a Jew!" *Das Schwarze Korps*, the official newspaper

of the SS, declared in April 1940, warning that Superman endangered impressionable youth. "Instead of using the chance to encourage really useful virtues," the paper fumed, "he sows hate, suspicion, evil, laziness, and criminality in their young hearts."

The controversy raised Superman's profile. By November, Paramount secured the comic strip's film rights and asked Max Fleischer if he would be interested in creating a "realistic" cartoon series about Superman.

Fleischer was hesitant. Not only would he not be able to collect merchandising revenue on the character, as he did with Betty Boop and other cartoons; the move to Florida had swamped him in debt, and he knew that *Superman* would be expensive to do right. There were also concerns about Paramount's request for something "realistic." *Gulliver's Travels* had been designed to look "realistic," and, although it had made money, the style wasn't the studio's strength; it was much better at doing the outrageous and surreal. Fleischer Studios' next feature, already well under way, was *Mr. Bug Goes to Town*, a tale about insects living in the city.

Paramount refused to back away, prodding Fleischer Studios to estimate how much the films would cost. According to Dave Fleischer, the studio figured that an exorbitant bluff would end the discussion. It tossed out an outrageously high figure: $100,000 per *Superman* short, compared with the $16,500 the average *Popeye* short cost. The Fleischers figured there was no way Paramount would bite.

But Paramount surprised them by responding, "Okay, go ahead."

Superman was first created in the early 1930s, when Joe Shuster and Jerry Siegel were still high school students in Glenville, Ohio, a dingy suburb of Cleveland. The skies over town always seemed gray, but it was hard to tell if the reason was the weather or pollution from the steel mills. Much of Shuster and Siegel's early work, created in the spare pockets of time when the boys weren't hating high school, dealt with themes of escape (Shuster's favorite childhood comic strip was Winsor McCay's *Little Nemo in Slumberland*).

The boys' earliest incarnation of Superman—entitled "The Reign of Super-man," and covertly printed out on the high school

mimeograph machine—portrayed the hero as a kind of devious hobo who derived his superpowers by ingesting a serum made from meteor fragments. Those powers were then used to commit crimes: robbing pharmacies, manipulating the stock market, cleaning up at the horse track. This version of Superman was obsessed with making money so he could escape town, just as Shuster and Siegel were desperate to escape Glenville. As the boys struggled to focus Superman's identity, they experimented with a series of other personas, each one tried on and cast off like a thrift-store overcoat. In one, set in the future, a "super-powered scientist-adventurer" travels back in time just before the Earth explodes. In another, the scientist instead sends his baby, who is later found and raised by a couple with the last name of Kent. Shuster and Siegel borrowed that name from the actor Kent Taylor and then combined it with the name of actor Clark Gable. Thus was born Clark Kent, Superman's mild alter ego, who resembled both Shuster and Siegel: bespectacled, unathletic, bullied, and afraid of girls. Shuster was painfully scrawny, and Siegel, whose voice squeaked like chalk on a blackboard, had a crush on a classmate (named Lois) who wanted nothing to do with him.

Superman continued evolving in a way that would "combine the best traits of all the heroes of history," Shuster recalled. Old Testament heroes like Moses and Samson, the most interesting tales the boys heard in synagogue, were combined with pulp magazine icons like Doc Savage, a character also known as the "Man of Bronze." Shuster and Siegel spent five years pitching their idea to various comic book publishers, marking time with a pile of rejection slips. They finally signed a contract with National Allied Publications (which would eventually evolve into DC Comics), selling the strip's rights for $130. Both creators would immensely regret this deal, but in the early years it probably didn't seem too bad. Even though they no longer owned the rights or reaped royalties, they were paid handsomely to stay on as the comic's principal writers. (In 1942 they were paid a combined $63,776.46.) In later years they would ultimately lose creative control over Superman, but in those early days Shuster and Siegel guided the character's creative direction.

In *Action Comics #1*, published in June 1938, Superman's vigilantism is far more vindictive than it would be later: bad guys are tossed

from skyscrapers, plummeting through the air and then splatting on the ground, or hanged indefinitely from telephone wires. His efforts seemed focused on exacting brutal revenge on the kind of hoodlums who once robbed the garment store run by Siegel's father, an incident that caused him a fatal heart attack and left his family destitute.

The cartoonist Jules Feiffer once wrote that Superman's original home was not Krypton, but "the Planet Poland, from Lodz maybe, possibly Crakow, maybe Vilna." The history of American comic books owes much to the Jewish immigrant experience, but Superman owes a particular debt of gratitude. Both Shuster's and Siegel's parents had been forced to flee Europe after pogroms. Like them, Superman survives the destruction of his people by settling in America. Shortly before Krypton explodes (a sound that Foley artists later re-created in the Fleischer cartoons by ripping an apple in half), Superman is sent to Earth by his father, Jor-El, in a crib-size rocket, just as Moses was sent away after the Pharaoh's order to kill all Jewish males (Superman's name on Krypton, Kal-El, contains the Hebrew suffix for "all that is God"). Careful not to betray Superman's outsider status, Shuster and Siegel made sure the character had no clear ethnic background, accent, or political affiliation. Raised in the country but now living in the city, Superman was the ultimate foreigner, and yet also a product of the heartland. Via his alter ego, Clark Kent, he could fit in anywhere, or hide in plain sight.

By the time Fleischer Studios began adapting Superman into cartoons, Shuster and Siegel had toned down the character's nasty temper. He appears to have absorbed the lessons of *tzedakah*, the Jewish principle of helping those less fortunate and standing up for the weak. Bringing justice to social issues now held his attention: roughing up crooked politicians, stopping greedy industrialists, bringing brutal dictators to stand trial. This crusading Superman, so loathed by the Nazis, also embodied another Jewish concept, *tikkun olam*, which translated literally means "to repair a broken world."

Joe Shuster and Jerry Siegel's relinquishment of complete creative control over Superman allowed others to alter and interpret the character. When Fleischer Studios began making Superman cartoons,

some details that it modified would become permanent changes. When Superman first debuted in *Action Comics #1*, he could leap "an eighth of a mile" but could not yet fly. Instead, he just jumped over tall buildings or canyons. By the time Fleischer Studios started its adaptation, Shuster and Siegel had given Superman the ability to fly, but he didn't do so very much—he still vastly preferred jumping. But since it was easier to animate Superman flying rather than jumping, the cartoon studio decided he should fly more. The Fleischer artists also came up with the idea of Superman's using a phone booth to change clothes, which was easier to animate because the phone booth essentially hid the character from view. Fleischer Studios also coined, or at least helped popularize, several Superman catchphrases: "faster than a speeding bullet," "more powerful than a locomotive," and "Look, up in the sky—it's a bird . . . no, it's a plane . . . no, it's Superman!"

Fleischer Studios designed its version of Superman using two sources: model sheets provided by Joe Shuster, and film footage of Karol Krauser, a gladiator-chested actor with the physique of those musclemen who advertised workout regimens in the back pages of comic books. (Krauser would later become a star on the early professional wrestling circuit—the kind of theatrically scripted events where people were sold a ticket for the whole seat, but would need only the edge.) In one promotional stunt, the 114 female employees at Fleischer Studios were asked whether they would prefer this hunky Superman as a husband or as a boyfriend. All said "boyfriend," with one woman explaining that "trying to live with so super a husband might be awfully fatiguing."

Storylines for the Fleischer Superman cartoons mirrored the stories found in the comic books. Jingoistic saboteurs were foiled and evil robots were subdued. Even though the cartoons' budgets were less than the $100,000 that was allegedly originally quoted—somewhere in the range of $30,000 to $50,000, still much more than the average short—the visuals in the cartoon Superman were breathtaking. Special lights extended shadows and added depth, while oblique angles, freeze frames, double exposures, and other camera tricks captured the same expressionist feel as Orson Welles's *Citizen Kane* or Fritz Lang's *Metropolis*—exactly what the studio was aiming for.

Fleischer Studios began releasing *Superman* cartoons in September 1941, prompting strong reactions, both good and bad, from critics. *Time* called them "the movie cartoon at its worst. Superman looks and acts like a wooden puppet." But others argued that what *Time* hated about the cartoons were actually their strengths. They thought *Superman* was the Fleischer Studios' best work, that the stiff-limbed rotoscoping and minimal dialogue helped capture the comic book's unique feel—a case that was strengthened when one cartoon was nominated for an Academy Award.

On December 7, barely two months after *Superman* debuted, the Japanese bombed Pearl Harbor. Two days earlier, on December 5, Fleischer Studios had released its second feature film, *Mr. Bug Goes to Town*. It was competent work but cratered at the box office in light of everything else going on in the world. Economically distressed, the studio was further rocked when, amid all the global turmoil, Paramount decided to stage a corporate takeover.

Paramount's takeover of Fleischer Studios started quietly, earlier that year. In May, a Paramount executive named Dick Murray appeared in Max Fleischer's doorway and handed him a manila envelope. Stuffed inside was a sixty-five-page contract.

The contract began with the termination of "all understandings and agreements of whatever nature" between Paramount and Fleischer Studios. "That first paragraph killed the studio; the rest of the document stripped the corpse," Fleischer's son Richard remembered. The paperwork went on to demand that "all assets, including patents, trademarks, and copyrights," be turned over. Max could stay on, but only as an "employee," no longer as owner. The demands were brutal, but Fleischer had little leverage. In order to finance the move from New York to Miami, he had indebted himself to Paramount with a loan amortized over ten years, using the studio's back catalog of cartoons as collateral. (This was the kind of arrangement Disney had avoided after losing his first studio.) Even though Fleischer had been given ten years to pay back the loan, Paramount now wanted repayment after only three years, in the form of all the studio's assets. If Max didn't sign, bankruptcy loomed.

Fleischer made a breathless call to his lawyer in New York, N. William Welling, and explained the situation. How could Paramount call in the loan early? Welling advised him to sign in order to avoid the disgrace of missing a payroll. "We can take care of that matter later on and have the ownership returned to you," he counseled. Since Dave Fleischer was a co-owner, he also needed to sign. But since the brothers still weren't on speaking terms, Max sent him a copy with a note telling him what to do; it came back five minutes later with Dave's signature, a strong indication that he probably hadn't read it. In the agreement, both brothers committed themselves to working at least another twenty-six weeks at the studio but were required to put up their stock shares to guarantee their performance. They also gave Paramount "resignations in blank" that could be exercised at the larger studio's discretion after the twenty-six weeks expired.

Once everything was signed, Murray stuffed the paperwork back into his manila envelope. The next day, May 24, the studio's name was changed from Fleischer Studios to Famous Studios. The Fleischer name never had the same clout as Disney, and Paramount thought a name change was appropriate. Even if Max wanted to start another studio using his own name, he couldn't because Paramount held the rights to it.

Under this uncomfortable arrangement, the studio labored on for another six months, beginning the Superman series and releasing *Mr. Bug Goes to Town*. Then, two weeks after Pearl Harbor, which was now well within the period when Paramount could accept the Fleischer brothers' blank resignations, it decided to detach Max Fleischer from his studio entirely. Everyone else would stay under new management; Max and Dave, who had quit in November, would be gone.

On December 28, Barney Balaban, president of Paramount Pictures, called Max to a meeting in New York to deliver the news. Fleischer traveled on an overnight train, arriving in the city just as the sun came up. Walking into Balaban's office, he was ushered into a conference room filled by a platoon of men wearing dark suits. Balaban motioned to an empty chair and began to speak. "Max, we have decided to accept your resignation."

"What is the purpose of all this?" Fleischer asked.

"That's our decision."

Perhaps Dave's earlier resignation made Paramount more comfortable firing Max. Dave had sent in his resignation from California, where he had been working on postproduction for *Mr. Bug Goes to Town*. While Dave was gone, Max had sent Paramount a telegram demanding that it fire his brother—their feud had risen to a boil. To Paramount, the brothers' ceaseless bickering was worrisome, and their leadership undependable. Dave was actually wanted by the Florida authorities for matters related to his divorce from his wife; the subpoena had arrived just as he was leaving for California. As he fled town, Dave told the judge he would be back soon, then cleaned out his bank account as the plane waited on the tarmac. He had never planned on returning and hadn't bothered telling anyone.

Soon after Max was fired, he met with Paramount's legal team. He wanted to discuss the patents he had hastily signed over. Many had actually been private, having nothing to do with the studio, including a valuable rearview projection system. He wanted them back and claimed that Paramount's own records would probably win the case for him. Then he pushed harder, saying, "No sane man would turn over to Paramount his patent ownership shortly before leaving his own company unless . . ."

"Unless what?" asked Lou Phillips, Paramount's attorney.

"Unless duress was introduced," Fleischer answered. Duress was a significant charge, indicating Fleischer might claim that Paramount had compelled him to do something against his will under the threat of some sort of harm. If proved true, it would be calamitous for Paramount. By issuing this threat, Fleischer was pushing the stakes higher.

When Fleischer arrived home that night, he received a message from Seymour Kneitel, his son-in-law. When Max was fired, Kneitel had been put in charge of the studio—a shrewd move on Paramount's part to create awkward family dynamics. Kneitel had suffered a heart attack in March, at age thirty-three, and needed the money to provide for his family: Fleischer's daughter Ruth and their three kids. One imagines that, while he was on the phone with Max, Kneitel's voice sounded like a hostage relaying a message from his captor: Phillips had just called and told him about Fleischer's visit, making clear what would happen if Max pushed things any further.

While Fleischer was in New York, Paramount sent a crew of temporary workers down to Miami under the eye of Dick Murray. Almost everyone was away over the holidays. Ozzie Fleischer, who was the son of Charlie and worked as an occasional handyman around the studio, happened to drop by and see the outsiders carting papers from the building: tax filings, production records, invoices, payroll statements, and twelve years' worth of other documents. They formed a line like ants, hauling everything to a roaring bonfire.

Fleischer learned of the fire later, after he tried to access the records so he could quietly mount a lawsuit. He had asked some loyal colleagues to send them, but they were nowhere to be found; that's when Ozzie piped up and shared what he had witnessed. Fleischer's son Richard remembered his father using the incident to illustrate an important lesson about show business: "The only way you'll see a profit from a movie is if they make so much money so fast they don't have time to hide it all."

Details of Paramount's takeover of Fleischer Studios would forever remain murky. Records were burned, or if they weren't burned, as Dick Murray claimed, then they nonetheless disappeared. Two years after the takeover, Paramount moved the studio, still employing Max's old staff, back to New York—avoiding the unions was more trouble than it was worth.

In 1969, Dave Fleischer discussed the Florida years in an interview but wanted certain details, the thorniest ones, sealed until after his death. He said that Paramount executives once tried to blackmail him and Max by setting them up with prostitutes. After arriving at a shack in the Florida Keys and seeing the women, the brothers quickly realized it was a setup and avoided controversy by sleeping on the porch. The rest of Dave's account described how his relationship with Max deteriorated. He complained that Max never gave him proper credit for his role in the studio's success, and he was bothered when Max lectured him for having extramarital affairs, since Max was carrying on affairs of his own. He also said that Max was siphoning money to shell companies to avoid sharing profits (a variation on what Max claimed Paramount was doing to him). Dave also claimed to have

heard rumors that Max and Paramount were plotting to put him in an insane asylum. While no evidence of this has appeared, Dave's assertion nonetheless illustrates how dismal the brothers' relationship was. Max later admitted that Paramount probably used their falling-out to turn them against each other. Dave confessed that the experience tempted him to write a book titled *There's No Greater Hate Than Brotherly Love.*

Members of Max's side of the family remember him recalling his own lurid accounts of the Florida years. One fishing trip with Paramount executives was billed as a relaxing getaway, but once they were out in the ocean, bobbing on the water, the boat's engine was cut off and Max was given a gruff proposition: give up the studio or swim to shore. This story strains credulity, and such claims were usually muttered in private, but it does paint a picture of Hollywood's ruthless style in that era. Max Fleischer accused Paramount of siphoning profits that were due to him but stopped pressing the issue after talking with Kneitel, for fear of hurting his family.

In Paramount's view, the brothers were far from ideal partners. They had moved their studio to the middle of nowhere and were constantly making threats and demands. Even though *Popeye* had become a valuable property, Max was growing out of touch, and Dave was literally being chased by the authorities. Film historians would later speculate that what Paramount did was probably illegal—but in the absence of records, it is impossible to know. No matter the specifics, Max and Dave had signed the contract and blank resignations, on the advice of Max's lawyer.

Richard Fleischer would later propose another reason for Paramount's takeover: to acquire material for television. It was still a nascent technology, but some were starting to see its potential. In 1936 the *New York Times* asked, "But who will guide the destiny of television when it does come?" In another report that year, the Motion Picture Producers and Distributors of America forecast that the film industry would provide programming. Two years later, Paramount purchased a stake in the television set manufacturer DuMont Laboratories, a visionary move. For the 1939 New York World's Fair, which had the theme "World of Tomorrow," commercial sets were introduced to American consumers in an exhibit (transparent cases

were used to prove television wasn't a trick). During the fair, NBC transmitted its first night of broadcasting to the two hundred television sets known to be in New York, including in its lineup a Walt Disney cartoon, *Donald's Cousin Gus*. (Disney had shrewdly insisted he control all future television rights while negotiating with distributors in 1936.) To those looking far enough out on the horizon, such as Disney and Paramount, television would someday be important. The value of old material, punctuated by advertisements, would vastly increase.

After Paramount's takeover, the Fleischer brothers became further estranged. Now living in California, Dave rented a small apartment off Hollywood Boulevard and spent two years directing cartoons for Columbia, spending his free time occasionally drawing comic strips for the *Hollywood Citizen News*. He later took a job at Universal, where he spent fifteen years directing various projects that often involved animation, including opening titles and sequences, such as the animated titles for *Abbott and Costello Meet Frankenstein*. In 1963, as Alfred Hitchcock prepared to release *The Birds*, Dave created a promotional campaign using special projectors to cast animated bird shadows across the walls of theater lobbies. Hitchcock loved the idea of scaring his audiences as they arrived, but axed it at the last minute, likely because of the expense and installation hassle.

As Max prepared to leave Florida, he put his home on the market. He regretted the loss of its four-car garage, which he had converted into a workshop where he could tinker—inventing things was his first love, and a way to escape. With all the gambling going on around him, be it on sports or cards, he had invented a betting calculator, patent number 2,325,761, which resembled a complicated piece of navigational equipment on an old ship. Another concept he worked on was a system to harness endless power from the sea, capturing the movement of the tides and waves—a good idea, except that Biscayne Bay, where he lived, had a tide of just six inches, and the only waves were tiny ones from boats cruising by. Fleischer's other ambitious invention was a never-wind clock, which he claimed worked perfectly. Mounted on his pier, it reflected Florida's bright yellow sun. When Max moved away, the clock stayed, apparently

keeping perfect time until it corroded away in the salt air. Then it slipped quietly into the bay.

After leaving Miami, Max landed a job in Detroit, Michigan, working for the Jam Handy Organization, a maker of industrial and training films. The company did most of its business with General Motors, but Fleischer went to work on military training films. The company's founder, Jamison Handy, had first met Fleischer during World War I, when the two worked together making training films for John Bray.

During his time in Detroit, Fleischer lamented the loss of his studio, smoldering inside. He spent his free time writing letters back and forth with former employees, quietly trying to collect evidence he could someday use in a court case against Paramount.

He also wrote a book, *Noah's Shoes*, published in 1944. Its content prompted at least one later film historian to speculate that Fleischer was suffering a breakdown when he wrote it. Presenting himself as the central narrator in a retelling of Noah's Ark, Fleischer refashioned the biblical story into an allegory about the animation business and his experience with Paramount. Fleischer's assistants—helping him build the Ark and herd animals onto it—stand in for his chief assistants at the studio, while the Ark represents Florida, offering an escape from his union troubles. The story unfolds with Fleischer tackling the many logistical challenges of his massive undertaking, sprinkling his text with curious figures—"Adding 567 thousand birds to the 196 thousand animals, we have a total of 763 thousand. This animal parade would reach from New York City to Detroit, Michigan, some 660 miles, and we must get that army into the Ark."

In his book, Fleischer sets to inventorying all the different animals on his Ark; each seemed to be a proxy for the different kinds of people one found in the animation industry, although Fleischer didn't make clear who was what. Once again, the summaries were peppered with made-up information, which was slyly funny just like his cartoons, especially the parts where Fleischer includes handling and feeding instructions for his animals:

Clouded Leopard: Very choosey. Prefers peacock. Memo: Keep

safe distance when feeding. Eats viciously. Toss peacock
at Leopard.

Dragon Fly: Will eat about forty houseflies in a few hours . . . If
allowed to go too long without flies, it will bend its head
back and eat itself. Stand by!

Hyena: Feeds on garbage exclusively. (May solve annoying prob-
lem.)

Ocelot: Relishes only the heads of birds. Memo: Headless birds
can be served to animals less fussy.

The themes Fleischer explores in *Noah's Shoes* aren't particularly
surprising: betrayal and his confrontation of failure. In a passage
where he worries about missing the boat, he expresses both guilt and
resentment. "My assistants are calmly but rapidly preparing to close the
heavy door as I approach the Ark . . . My incompetency has marked
me unfit to take part in beginning the new world, I will bow out with
the old. I can't even claim credit for putting the worms aboard."

Fortunately, Fleischer doesn't miss his Ark, stepping aboard
just as "the door is slammed with frightening finality." A tumultuous
journey then unfolds, forcing Fleischer to realize that "we are at the
mercy of a hidden world of dangerous stowaway monstrosities. The
world of the ENTOZOA—the vast world of parasites," which Fleischer
probably meant to mean pro-union employees. After the journey is
complete and the Ark has safely landed, Fleischer steps off the boat
and sees God. "There he is—standing in the ocean in his bare feet,
the surface of his big toenail ten miles above sea level." After Fleischer
gets his bearings, he imagines taking God's place. "I can't shake off
the temptation to walk in that enormous man's footsteps," he writes.
"[S]o, just as soon as my physical condition permits, I plan to step
into that giant's shoes. I'll give you a ring when I'm ready."

These final words in *Noah's Shoes* were a message from Max to
the animation world, and to Paramount, that he still had some tricks
up his sleeve. He was down, but not out.

Chapter 26

"That Horse's Ass!"

America's entry into World War II created a vast demand for propaganda and military training films. The animation industry was mobilized, with animators either lent to the government or drafted. Some cartoon studios had direct contracts with the government, while others contributed staff to the U.S. Army Air Forces First Motion Picture Unit, known as the FMPU, which had a special animation division. Its main headquarters, nicknamed "Fort Roach," was located at the old Hal Roach Studios in Culver City, famous for making the Laurel and Hardy and Our Gang comedies.

The overlap of two different cultures—freewheeling artists and the military—wasn't as awkward as one might expect. The FMPU was technically part of the U.S. Army Air Forces, which, as the military's newest branch, was the least tradition-bound. It tolerated a lot. Much of its artistic staff barely passed boot camp, casually waving at officers instead of sharply saluting them. Nor did the Army Air Force care that some enlisted animators got their uniforms from the studio costume departments in order to avoid driving to a real military base.

A hard-nosed Army colonel named R. M. Jones sat atop the FMPU's command structure. By his own admission, he knew nothing about the movie business. But he was a confident leader, wise enough to let his artist subordinates do what they did best, without imposing the stricter codes of military life on them. Still, the animators wished to prove their military mettle, requesting that Jones do a white-glove inspection of their quarters. The first swipe of Jones's gloved hand turned up a dark smudge from under an animation board; but instead of blowing his top, he laughed, asking, "Does anyone here have a black glove?"

Beneath Colonel Jones in the chain of command were other Hollywood professionals, including Major Frank Capra, the impresario director behind *It Happened One Night* and *Mr. Smith Goes to Washington*. Reporting to Capra was the animation unit, nicknamed "The Foreskin Fusiliers," which was commanded by Major Rudy Ising, a veteran of the cartoon studios at Disney, Warner Bros., Universal, and MGM. Even though Ising outranked most of his subordinates, he didn't let military decorum upset his unit's special chemistry. When he arrived fresh from Officer Training School, neat and trim, he didn't get upset when another animator greeted him with, "Hiya there, Rudy! I see they took some of that lard off your ass."

Ising promptly told his unit there would be no creative restrictions on their work. Since the cartoons were technically classified, not intended for the general public, they didn't have to flatter Hays Code rules or local state censorship boards. They could be as raunchy as needed in order to hold the attention of young troops, just so long as they effectively conveyed their messages. For animators, hearing this order was like watching a piñata get split open; they had a ball making sure the FMPU's cartoons were in gloriously poor taste.

This mandate—do whatever it takes to grab people's attention—came from Capra after he noticed how often troops fell asleep during traditional, boring training films. Bored soldiers failed to absorb the films' lessons: the importance of taking one's antimalaria pills, or of not blabbing in spy-infested ports, or how to avoid catching a venereal disease during shore leave. When films involved humorous cartoons, however, the lessons were absorbed. Capra set out to create a character—a lowly private, kind of a boob, to whom the troops could relate. The character would be a screwup who always did things incorrectly, thereby illustrating through his fiascos how to do them correctly. Private SNAFU's name was military slang for "Situation Normal, All Fouled Up," although everyone knew that "Fouled" was just a sanitized word for the censors.

Production of the Private SNAFU shorts was first offered to Walt Disney, but Disney insisted on having exclusive character and merchandising rights, a demand that bothered the military brass. The contract thus passed to Leon Schlesinger, who didn't insist on keeping the rights and underbid Disney by two-thirds. Private SNAFU's

Private SNAFU'S name stood for "Situation Normal All F***** Up."

design was assigned to Chuck Jones, a rising talent at Warner Bros. who was sly and mischievous and had a dirty sense of humor—a perfect temperament for appealing to wiseass young soldiers. Jones modeled Private SNAFU after Elmer Fudd, recruiting Mel Blanc for the voice. *A Lecture on Camouflage*, one of SNAFU's early appearances, ended with a shot of topless mermaids. *Booby Traps* featured SNAFU ogling a nightclub full of female mannequins meant to be honeypot spies, eagerly patting them down to discover bombs where their butts and breasts should be. Many troops preferred these training films to those shown strictly as entertainment.

The FMPU animators urged each other to make their cartoons spectacularly raunchy, consistently raising the ante on each other. They eventually created a game out of their creative process: a writer would provide a ridiculous line or concept, and an animator would respond with an illustration. When one writer sent Jones the line "It's so cold it would freeze the nuts off a jeep!" Jones responded by storyboarding a cutaway to lug nuts freezing off a shivering Army vehicle. The writer

behind this particular line—who was assigned the scripts for the first dozen SNAFU shorts—knew little about animation but had been a popular newspaper cartoonist and author in New York before the war. After he moved west to join the unit, he and Jones became fast friends. Jones loved their shared sense of lunacy and desire to communicate "through idiosyncrasies." Both men also fancied bow ties, although they often argued about how to properly tie them. The writer, Major Theodor Geisel, was much better known by his civilian pen name, Dr. Seuss.

Theodor Geisel's rendezvous with animation was a long time coming. Years before the United States entered the war, he would spend mornings at his drawing board, sketching whatever thoughts popped into his mind. The process was broken up with coffee breaks and brisk strolls up and down Park Avenue. During one break he left his window open, returning to discover that a breeze had blown one sketch, drawn on transparent paper, atop another, so that an elephant appeared to be sitting in a tree. Geisel noodled over the image and began asking himself questions. What is an elephant doing in a tree? How did the egg get there? If it's from a bird, where did the bird go?

This incident evolved into the beginning of the book *Horton Hatches the Egg.* "I've left a window open by my desk ever since," Geisel later remembered, "but it never happened again." Before the book was published, in the fall of 1940, a draft landed in the hands of Leon Schlesinger, who secured the motion picture rights for $200 (in 1942 it became a Merrie Melodies short). Upon its publication, people quickly noticed how the book departed from Geisel's previous work, praising how he wove together subtle lessons about human frailty without undermining his sense of humor. "A moral is a new thing to find in a Dr. Seuss book," the *New York Times Book Review* noted, "but it doesn't interfere much with the hilarity with which he juggles an elephant up a tree."

This new habit of weaving subtle messages into his books represented an awakening in Geisel; he later attributed it to the horror of watching war unfold in Europe. "I had no great causes or interest in social issues until Hitler," he said. But America's failure to get

involved, which left so many to die, caused his head to pound. After *Horton* came out, he put children's books aside for seven years and focused instead on drawing political cartoons for newspapers and magazines. *Newsweek* called the cartoons "razor-keen" in a story titled "Malice in Wonderland." Geisel's angriest scorn was aimed at isolationist groups like the America First Committee, which Geisel found racist. In one cartoon, Geisel showed the Committee on Mount Rushmore alongside a smug-faced Hitler and a pig-faced Hirohito. In another, he used long intertwining beards—a favorite Seussian motif—to make Siamese twins of Nazis and America Firsters.

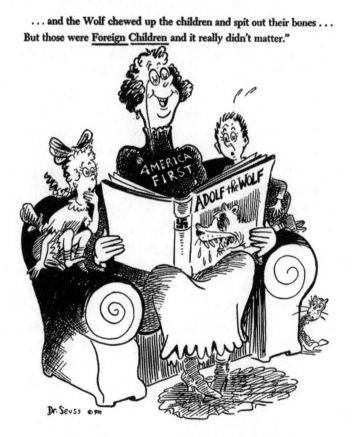

. . . and the Wolf chewed up the children and spit out their bones . . . But those were <u>Foreign Children</u> and it really didn't matter."

One of the cartoons that Theodor Geisel,
aka Dr. Seuss, produced during World War II.

Four months after America entered the war, Geisel sat fuming as he listened to a radio broadcast by Senator Gerald P. Nye, a Republican from North Dakota. An anti-Semite, Nye argued that America's involvement in the war was nothing but a Jewish conspiracy, because of Jews in Hollywood trying to "drug the reason of the American people" with their "war-mongering" films.

"That horse's ass!" Geisel growled.

"Ted, don't use language like that!" his wife, Helen, responded.

"But he *is* a horse's ass! I'll draw a picture of him as a horse's ass and put it in *PM*!" Geisel shouted, referring to a then-popular newspaper that survived on subscriptions rather than corporate advertisements, thus allowing its contributors to more bluntly speak their minds. He had been a regular contributor to it ever since submitting a cartoon lampooning the Nazi sympathizer and aviator Charles Lindbergh. After Nye's speech, Geisel submitted a cartoon of a circus horse with its various body parts labeled after America Firsters; as promised, Nye was the ass.

"You're going to get in an awful lot of trouble," Helen said when she saw it, worrying about lawsuits.

"It will get a lot of laughs," Ted answered, "and nothing will happen."

Four days later, Geisel received an unexpected letter from Nye. The senator liked the cartoon and wanted the original. Ted asked Helen if he should send it.

"No, he's a horse's ass!" she answered.

Once Frank Capra saw the cartoon, he wanted Geisel's talents for the FMPU. But Geisel had already applied for a commission in naval intelligence and was waiting on his background check. When a suspicious background investigator asked an executive from Standard Oil, a company Geisel had lampooned in a cartoon, why the cartoonist worked for a liberal newspaper, the executive replied, "Oh, Geisel isn't a Communist; he just does it for the money!" Capra eventually cajoled Geisel into abandoning his naval commission and joining the Army as a captain instead, working as a writer on propaganda and training films. Geisel reported for duty by strolling through the doorway wearing a crisp uniform custom-tailored at Brooks Brothers, his sidearm hanging upside down in its holster. He had failed to

qualify on the shooting range, and joked that his "best bet in enemy action" was "to grab it by the barrel and throw it."

Aside from the animators, Geisel's colleagues in the FMPU included the writer Munro Leaf, creator of Ferdinand the Bull; the writer P. D. Eastman; the novelists John Cheever and William Saroyan; film directors John Huston and John Ford; and screenwriters Ben Hecht and (from *Casablanca*) Julius and Philip Epstein. At one point, Geisel interviewed the young army lieutenant Ronald Reagan to do voice work on *Your Job in Germany,* a propaganda film, but found the actor "didn't seem to have the understanding, that morning, of the vital issues." He turned Reagan down in favor of actor John Beal.

Geisel eventually earned a Legion of Merit for "exceptionally meritorious service in planning and producing films, particularly those utilizing animated cartoons, for training, informing, and enhancing the morale of troops." While this was a high honor, those wartime films would later become controversial, known for painting their subjects with a broad, ugly brush. They sometimes blamed other countries' problems on race rather than on flawed political and economic institutions. The Japanese were often depicted as rats, sending a message they were a nonhuman species that could be killed without regret. Germans were sometimes depicted as a lost cause, a people permanently anchored to a wrong way of thinking, incapable of change.

Military and political leaders sometimes intervened to prevent reckless messages from becoming part of the FMPU's work, especially when they involved propaganda that might incite American troops to commit inhumane crimes. The Office of War Information, OWI, endorsed the notion of depicting a humiliated foe, but not as comic victims. Regarding *Scrap the Japs,* a Popeye film, it warned of "propaganda on the absurd side [that] laughs at the enemy in such a way as to discredit the real danger." OWI also warned against racial stereotypes depicting Asians as subhuman, because Chinese allies—"our gallant friends"—were just as Asian as the Japanese. Having second thoughts after Hiroshima was bombed, General Douglas MacArthur became squeamish about *Know Your Enemy: Japan,* which Geisel helped write, and refused to show it to his troops. MacArthur also rejected *Our Job in Japan,* a film designed to prepare troops for the occupation, because he thought it too sympathetic. Geisel continually struggled with the

fine line of writing in a way that could inspire men to kill, but still leave space for them to switch off the instinct when it wasn't needed.

Geisel left the military as a lieutenant colonel when the war ended. Impressed by his work, Jack Warner offered to pay him $500 a week to help write *Rebel Without a Cause*. But Geisel disliked the editing process and quit after several months, refocusing his attention on books but continuing to dabble in Hollywood. He was excited when RKO approached him to discuss converting *Our Job in Japan* into a documentary; like many, he looked back on the war with regrets, but had also learned valuable lessons. Thirty-two revisions later, he scripted a version that was more nuanced, depicting the Japanese as victims of class dictatorship and racketeering; he did not blame their societal problems on race. The documentary now also reflected Geisel's concept of the Little Guy versus the Big Shot: "the top men of these families got together . . . and divided up the spoils," the script read. The film was retitled *Design for Death*, and was directed by Max Fleischer's son, Richard Fleischer, now an up-and-coming young Hollywood director. It won an Academy Award in 1947.

A decade after the war, Geisel traveled to Japan with his wife and came to appreciate its culture. He resumed writing children's books and published *Horton Hears a Who!* in 1954. The book's theme—"a person's a person no matter how small"—grew out of his visits to Japanese schools, where the importance of the individual was now taught as an exciting new concept. Geisel dedicated the book to his "great friend" Mitsugi Nakamura, dean of Doshisha University in Kyoto, and later worked with Chuck Jones to convert the book into an animated television show. (He and Jones also worked together to make *How the Grinch Stole Christmas*). Geisel's propaganda had caused a stir, but *Horton Hears a Who!* marked a change in his work. One reviewer described it as "a rhymed lesson in protection of minorities and their rights." A year after it was published, Geisel received an honorary doctorate from Dartmouth, his alma mater. The citation said of Geisel's work that "behind the fun there has been intelligence, kindness, and a feel for humankind." As he accepted the award, Geisel smiled and joked that his name was now "Dr. Dr. Seuss."

Chapter 27

"A Tough Little Stinker"

During the war, a Warner Bros. animator named Ben Hardaway occasionally received calls from Vice President Harry Truman's office. They came whenever Truman was going to be in Los Angeles on official business, perhaps to meet with military contractors or christen a new naval ship. During World War I, Sergeant Major Hardaway had been assigned to Captain Truman's regiment. Whenever Truman traveled, he blew off steam by having a poker night with his old war buddies, filling the air with cigar smoke, laughter, and the smell of bourbon, which Truman drank with a splash of ginger ale. All formalities were dropped during these nights: Hardaway called Truman "Harry," and Truman called Hardaway by his nickname during the war: "Bugs."

This nickname had carried over into Hardaway's civilian life. During the late 1930s, when Hardaway worked for Leon Schlesinger's studio on the Warner Bros. lot, the nickname became attached to a rabbit character the studio was creating.

Bugs Bunny evolved through several iterations before getting an official name. The rabbit first appeared in 1938 in *Porky's Hare Hunt*, but little thought was put into him; he was just an obnoxious hayseed with an oval head and a nose shaped like a jellybean. "Hardaway needed a story," Friz Freleng recalled, "and I remember that he told me, 'I'm just going to put a rabbit suit on that duck.'" The animators quickly realized that the rabbit's persona didn't work, since Daffy Duck already owned the role of obnoxious doofus. In *Hare-um Scare-um*, the rabbit's appearance was adjusted, gray with white cheeks and belly, but the animators still found him too obnoxious. They slimmed him down and improved his posture, making him more a sly urban rascal than a country hick. "A tough little stinker, ain't he?" Hardaway

remarked of the redesigns. Animator Charlie Thorson then drafted a model sheet with more redesigns. Because Ben "Bugs" Hardaway was set to direct the rabbit's next cartoon, Thorsen scribbled "Bugs' Bunny," using a possessive apostrophe, across the top of the sheet. The other artists immediately knew it was a perfect name if they just dropped the apostrophe: Bugs Bunny.

Bugs Bunny didn't have a single creator: he reflected the studio's many different personalities, all of whom contributed to his persona. "We made every effort to keep Bugs in character," according to Bob Clampett, "but this never meant keeping him at all times exactly the same." Mel Blanc provided the voice, eventually abandoning the boisterous, Daffy-like quality for something more street smart—"joik" rather than "jerk." "So I thought, 'What are the toughest voices I know?'" Blanc remembered. "They've got to be Brooklyn or the Bronx, so I put the two of 'em taggedda, Doc." The role required Blanc to constantly nibble carrots, which was problematic—not only did a mouthful of carrots prevent him from saying his lines fast enough, but Blanc was allergic to them. "They make my throat tighten up to the point where I don't sound like the character," he said. Celery and apples were substituted, but didn't provide the right crunch on tape. It seemed Blanc would just have to live with the carrots, spitting the pulp into trashcans. The studio finally decided to start recycling older recordings of the crunching sounds and splice them in when necessary.

In 1940, Bugs Bunny appeared in what most film historians consider his "official" debut, titled *A Wild Hare*. Even though others, such as Ben Hardaway, had directed earlier, unnamed iterations of the rabbit, the director of *A Wild Hare* was Tex Avery, whose curiously off-kilter style was often attributed to his lack of depth perception. An office prank—the Warner Bros. animators were always playing pranks on each other—had taken out his left eye when a thumbtack or a paperclip, nobody could remember which, was launched across the room by a rubber band. Avery's style gave the cartoons a sense of madness, as if they were injected with a drug, full of abrupt pacing changes and a defiance of logic. They opposed Disney's realism by constantly reminding audiences that they weren't real. Avery was a disciple of satire's greatest traditions, a gospel he preached to his

Mel Blanc provided
voices for many of
the most iconic
Warner Bros.
cartoon characters.

coworkers: all pieties must be skewered, all pretenses of high culture deflated. He had spent his childhood growing up among wiseasses in Dallas, Texas, and decided that Bugs Bunny should use the same greeting they did: "What's up, Doc?"

A Wild Hare was the first time Bugs Bunny's character exhibited "what you might call controlled insanity, as opposed to wild insanity," according to Chuck Jones. Bugs started as a surrogate for Daffy, but he was now the opposite of the duck. Whereas Daffy would fly into a dither for no reason at all, Bugs would always maintain perfect control, even when staring down the barrel of Elmer Fudd's shotgun. The Warner Bros. artists eventually decided to emphasize this aspect of his personality by adjusting his appearance. Instead of standing with both legs bent, as if ready to flee a predator, Bugs was given a looser, more confident stance. "[H]e never bent his legs again," said Jones. "He stood with all his weight on one leg and the other leg loose—the

classic posture of a man about town. Bugs knows where he's going; he can go anyplace."

World War II reached its full gale as Bugs Bunny became the most popular cartoon character in North America, according to a poll of exhibitors by *Motion Picture Herald.* He was the nation's wartime mascot: his likeness was emblazoned on the insignia of numerous military units and painted on the nose cone of the lead Liberator bomber that first attacked Davao, beginning the Allies' march to the Philippines. Warner Bros. director Bob Clampett remembered: "Just as America whistled the tune from Disney's *Three Little Pigs*, 'Who's Afraid of the Big Bad Wolf?' in the dark days of the Depression . . . so, Bugs Bunny was a symbol of America's resistance to Hitler and the fascist powers."

Bugs Bunny was animation's first real movie star, the first character that seemed to exist outside the parts he was playing. Though he was just a cartoon, viewers sensed a real personality being injected into an individual role, the same as with live-action stars like Charlie Chaplin, Mae West, or Humphrey Bogart. For writer Bill Scott, this point was driven home when he told his grandmother he was writing scripts for Bugs Bunny cartoons and she responded, "I don't see why you have to write scripts for Bugs Bunny. He's funny enough just the way he is."

The Warner Bros. artists carefully created Bugs Bunny to represent an ideal. He portrayed how the nation wanted to see itself, especially during war. Bugs at first always sees the best in people, turning on them only if they give him reason to. While stranded on a remote island in *Wackiki Wabbit*, he at first thinks he's just getting a hot bath when the natives plop him into a pot of hot water; he doesn't assume they're going to cook and eat him. "We always started Bugs out in a natural rabbit environment and somebody came along and tried to do him in," Jones explained. "And then he fought back." He defends himself only after his peace is disrupted. "He was never mischievous without a particular reason. Only when he was disturbed did he then decide the time had come to war."

Warner Bros.' wartime cartoons had clever names: *Herr Meets Hare, The Ducktators, Confusions of a Nutzy Spy, Tokio Jokio, Yankee Doodle*

Title card for Bugs Bunny in *The Wacky Wabbit* (1942).

Daffy. But in 1944, Warner Bros. released *Bugs Bunny Nips the Nips*, a particularly racially insensitive title. In the cartoon, Japanese soldiers on a deserted Pacific island buy Good Rumour ice cream bars from Bugs, only to find that hand grenades are hidden inside. Says Bugs while doling them out, "Here y'are, Slant Eyes." If Bugs Bunny was a reflection of the nation's psyche during wartime, as Clampett said he was, then it was of both the good and the bad. He said racist things but he also outsmarted bullies, kept his wits, and always ended up on top. As Clampett put it, "Like all we humans, he has varying moods."

Bugs Bunny was supposed to represent a kind of American ideal, but he was also designed to demonstrate the difficulty of reaching that ideal. "You'll dream about being like Bugs Bunny, and then you wake up, and you're Daffy Duck," Chuck Jones said. "Bugs is what I would like to be: debonair, quick-witted, very fast on the comeback, a sort of male Dorothy Parkerish D'Artagnan." People want to be Bugs Bunny, but they never are, because Bugs is always a winner, and

nobody in real life is always a winner. This is what made Bugs Bunny different from the typical underdog comic character—he was a foil to the kind of characters most people can actually relate to, described by Jones as "inept contenders with the problems of life: Wile E. Coyote, Elmer Fudd, Yosemite Sam, Daffy Duck, Foghorn Leghorn, Sylvester the Cat, like Chaplin, Keaton, Woody Allen, Donald Duck, Goofy, Tom (of Tom and Jerry), Richard Pryor, are all mistake-prone, low men on a short and poorly carved totem pole. We recognize their simple ambitions. Their public mistakes, I think, help compensate for or at least make understandable our own private mistakes."

During the war years, a special rivalry developed between Warner Bros. and Disney. Warner Bros. artists were awed by Disney's technical skills but rebelled against a tone they increasingly saw as mawkish and sentimental. Warner Bros. artists preferred a more riotous energy. They wanted their cartoons to reflect how modern art had become more abstract, jazz had gained a harder edge, and film noir had gotten darker. As Warner Bros. director Frank Tashlin put it, "We showed those Disney guys that animated cartoons don't have to look like a fucking kid's book."

The Disney animators envied their counterparts at Warner Bros. "Many of us wished we had the freedom they had," Disney animator Jack Kinney recalled. A Disney picture might be "cute and people kind of chuckle at it," Disney storyman Leo Salkin said, "but Warners cartoons get *laughs*." Ever since the Hays Code, Disney shorts had become more sanitized; the Warner Bros. animators seemed to pick all the rejected dirty bits off the cutting room floor and make masterpieces out of them. Disney animator Dick Huemer said his admiration of Warner Bros. cartoons was like "admiring the kind of dame that you couldn't introduce to your mother."

The Warner Bros. animators delighted in launching guerrilla attacks against Disney. These often came in the form of spoofs such as Bob Clampett's *A Corny Concerto*, mocking the parts of *Fantasia* Clampett found pretentious and lambasting that showboater Leopold Stokowski. Every second of a Clampett cartoon seemed to hold its own tiny hand grenade, pushing the limits of absurdity and aggressiveness.

"After I had decided what my story was, I used to conduct what I called a 'no-no' session," Clampett recalled. "I would encourage each of us to think up the wildest, most impossible ideas imaginable, and no matter how wild the gags got, no, but no one was allowed to say, 'Oh, no!' Thus the name, a 'no-no.'" In 1943, he directed the studio's boldest spoof ever, an all-black parody of *Snow White*, destined to become one of the most controversial cartoons in history.

According to Clampett, the idea first surfaced in 1942, after he saw Duke Ellington's musical revue *Jump for Joy*. An avid jazz fan, Clampett wandered backstage after the show to chat with the musicians. When the musicians learned that Clampett made cartoons for Warner Bros., they asked why black people didn't appear in more of them. "They said to me, 'Why don't you ever use us?'" Clampett remembered, "and I didn't have any good answer for that question." The musicians and Clampett soon hit it off, their conversation flowing from one place to another. Talk eventually turned to *Carmen Jones*, a black version of the famous opera *Carmen* that would be released as a Broadway musical in 1943, and an idea struck. "We sat down together and came up with a parody of Disney's *Snow White*," Clampett said.

Clampett started work by studying *Harlem as Seen by Hirschfeld*, a book of caricatures of black entertainers drawn by the legendary Al Hirschfeld, of *New York Times* and *New Yorker* fame. Clampett then gathered together a group of animators for field trips to Central Avenue, a black section of Los Angeles known for its thriving jazz scene. "Bob took us into downtown Los Angeles, into the nightclub section, to watch the latest dances and pick up some atmosphere," animator Virgil Ross remembered. A frequent stop was Club Alabam, a boiling-hot venue run by bandleader Curtis Mosby, known in the scene as "the mayor of Central Avenue." According to saxophonist Marshal Royal, "It was *the* club."

For authenticity, Clampett made sure he included black artists in the film's production, inviting them to help write the story and create gags. Vivian Dandridge, sister of Dorothy Dandridge, voiced "So White," a satirical version of Snow White whose name was meant to question racial assumptions in the original film. Dandridge's mother Ruby voiced the Queen, and Lou "Zoot" Watson voiced the Prince. Louis Armstrong had originally wanted to voice the Prince but couldn't

because he was away on tour. Mel Blanc did most of the other voices, but received credit for all of them, per his contract. Clampett also hired an all-black band, Eddie Beals and His Orchestra, to perform the music. When it came time to record the score, however, Leon Schlesinger balked at hiring outside musicians because he already had Carl Stalling under contract. The black musicians, apparently for free, agreed to sit down with Stalling anyway and help him capture their sound's proper feel; bits and pieces of their work, such as their trumpet solos, eventually did end up in the final score.

Clampett originally wanted to call the cartoon *So White and the Seven Dwarfs*, a title that teased at how *Snow White* carried implied assumptions about ethnicity and racial purity. But this title was awfully close to the cartoon it was satirizing, and the studio worried about potential lawsuits. Instead, it was released as *Coal Black and de Sebben Dwarfs*, a title that was impossible to confuse with the original. This new title, along with the cartoon's use of stereotypes and other uses of dialect—Prince Charming converted to Prince Chawmin'—would not help the cartoon age well. Prince Chawmin' is a notorious gambler with dice for teeth, dressing in flashy zoot suits and zooming around town in pimped-out cars. When "Murder Incorporated," a group of black gangsters, is hired to "black out So White," the gangsters provide the Queen with a menu of their questionable services:

MURDER INCORPORATED
WE RUB OUT ANYBODY
$1.00
Midgets—½ Price
Japs—FREE

Much of the response to *Coal Black*, including the reception from black audiences, was enthusiastic. Many saw it as a celebration of jazz culture, a film that accomplished the rare feat of success-fully capturing the musical genre's energy and verve. But its images weren't always flattering, sparking debate about how it should be interpreted. The Office of War Information called it a "vulgar parody," although the board did admit that it had "excellent boogie-woogie background music." The Library of Congress disapproved of the

dwarfs not because they were black, but because they were depicted as U.S. soldiers, and the Library found this disrespectful to service members. The National Association for the Advancement of Colored People (NAACP) agreed. In April 1943, the civil rights group boycotted the film, calling it a "decided caricature of Negro life and an insult to the race . . . The production is made even more disgraceful by the fact that the 'Sebben Dwarfs' represent seven miniature Negro soldiers." These depictions, the NAACP argued, gave ammunition to Japanese propaganda campaigns targeting black soldiers, reminding them of how their own countrymen discriminated against them. "The soldiers are subjected to indignities which are damaging to national unity. Ironically, the American flag floats over the camp in which the soldiers are quartered," another NAACP official said. The group sent a formal protest to Warner Bros.' president Harry Warner, asking him to "take appropriate action." Warner took it under consideration, but decided no changes were needed.

Coal Black and de Sebben Dwarfs would thus enter the complicated minefield of the American debate about race. Was it an homage to black culture, as some said it was, or something uglier? Was it racist, or somehow ahead of its time? Defenders argued that its portrayal of black music was welcome, and a much-needed antidote to Disney's sentimentality. They claimed that it at least broke from the stale conventions, common in other cartoons, of depicting blacks in a countrified loll of minstrelsy—a claim that then launched a healthy debate about whether this really made its depictions any better. Detractors claimed it reinforced other unfortunate stereotypes. Others avoided the film's racial issues altogether, focusing instead only on its artistry. Film critic Leonard Maltin wrote, "It takes one kind of talent to find new paths for established characters, but it's even more impressive to create whole new worlds with the framework of a six- or seven-minute cartoon. Clampett did both. Many independent film makers have labored for years to create a short film as personal and unique as *Coal Black*."

Bob Clampett would always defend the cartoon. "There was nothing racist or disrespectful toward blacks intended in that film at all," he said decades later, frustrated that his intent was being misinterpreted. "Hopefully, someday all this overreaction to these innocently-intended

cartoons, which we finished in 1943, will settle down and people will be able to see them in their proper historical context."

In 1968, *Coal Black and de Sebben Dwarfs* would be placed on a list known as Warner's "Censored Eleven," alongside ten other animated shorts the company would no longer exhibit because of potentially offensive material. It would remain a subject of debate, both as a historical artifact and as an example of censorship; copies would regularly surface at film festivals and in classrooms, always prompting lively discussions. In 1979, when it was scheduled to show at a Los Angeles Film Festival, a protest by the Black Panthers resulted in its removal from the schedule. Later that day, the Panthers met with Tom Bradley, who was the first black mayor of Los Angeles and a veteran of World War II. While everyone chatted away in Bradley's office, one of the Panthers casually mentioned they had spent the morning at a screening of Bob Clampett cartoons. Before he could say why, Bradley lit up, exclaiming that Clampett had actually made his all-time favorite cartoon. He had been able to see it only once, though, when he was a young soldier stationed in France during the war, he explained. No doubt to the Black Panthers' chagrin, he then told them the film's title: *Coal Black and de Sebben Dwarfs*.

Chapter 28

"Greetings, America!"

Days after the Pearl Harbor attack, the U.S. Army took over Walt Disney's Burbank studio. The location offered a perfect outpost for defending Lockheed and other military contractors in the area. Employees were fingerprinted and issued bright orange ID badges to show the armed guards who now stood at the gates. Green military jeeps swarmed the lot, antiaircraft guns dotted the nearby hills, and soldiers used the offices as barracks. Sitting at his desk, Disney could hear a naval officer in an adjacent room wash his uniform in a bucket. Because the studio soundstage was lightproof, it was converted into a repair shop that could be used during blackouts. Since the studio would now be working on more military training and propaganda films, Roy Disney lobbied the government to reclassify it as a "strategic defense industry." Anticipating the need to draw explosions for these training and propaganda cartoons, the animators began launching fireworks from the roof so they could study what the explosions might look like, creating tiny, unexpected detonations that constantly startled the soldiers.

All the different cartoon studios designed insignia for various military units, but the Disney studio alone contributed about 1,200, including some for foreign units in Allied countries. These were worn on patches, painted onto plane fuselages, and stenciled on the sides of tanks. Of all the Disney characters, Donald Duck, a short-tempered and rowdy fighter, was the most requested. Snow White represented military nurses; Flower the Skunk, from *Bambi*, represented at least three different chemical warfare units; and Jiminy Cricket, because of his strong conscience, was a favorite of chaplains. When no suitable Disney characters existed for a particular unit, they were invented,

including those for the Mosquito Fleet, the Flying Tigers, and the Seabees. The insignia cost about $25 apiece to create, but Disney did it for free, saying he owed it to soldiers who had grown up on Mickey Mouse. Walt forbade Mickey Mouse to represent combat units, however, reserving him instead only for industries defending the home front. The character saw action only when "Mickey Mouse" became the password, whispered into a sentry's ear, used by naval officers picking up their secret orders for the Allied invasion of Normandy.

Amid the stressful wartime atmosphere, Disney staff continued working on *Bambi*, which was scheduled for release on August 21, 1942. The film had been in production for years, receiving the same close attention as Disney's other features. To prepare, animators spent one four-month stretch drawing only deer; Rico LeBrun, the expert on animal anatomy who regularly appeared in Don Graham's classes, dragged a deer carcass into the studio and, over the course of several sessions, peeled back layers of pink tissue until he finally struck bone. By that point, the carcass was so rotten the stench filled the building. The only animator who could stand it was Eric Larson, who had grown up on a farm where such smells were common, and so he copied his drawings for his weaker-stomached colleagues. Another time during production, a buck wandered in from the nearby hills to mate with a doe kept penned in the studio zoo. Staff tried to shoo him away but were suddenly met by an angry snort and antlers dipped to charge. Just before it attacked, Larry Lansburgh, a toothy-grinned director who had once been a rodeo stunt rider, sauntered out of a doorway casually twirling a lasso, and wrestled the deer to the ground in a few quick moves.

These incidents were remembered as funny at the time, but *Bambi* was not an upbeat film. The stressful atmosphere surrounding its production was manifest. Three months before its premiere, Frank Churchill, the doleful alcoholic composer who had written the score for *Snow White,* became so depressed he killed himself with a shotgun. His last request was that "Love Is a Song," a tune he had written for *Bambi,* be dedicated to his wife, Carolyn. The request was denied because the song had already gone to the publisher.

Decades after *Bambi*'s release, many would call it a classic. When it debuted, however, many critics were disappointed; they had judged it mainly within the context of its immediate time and come away

disappointed. People were starting to consider animation as inherently juvenile and inappropriate for handling serious issues, according to a Gallup survey, whereas the format had been seen as plucky and uplifting during the Depression. Many felt that Walt Disney's continuing embrace of realism undermined the sense of fantasy and escape that was animation's biggest advantage. Manny Farber, an iconoclastic critic who often focused on a film's expression of raw energy rather than on its plot or social message, wrote that by attempting to "ape the trumped up realism of flesh and blood movies, he [Disney] has given up fantasy, which was pretty much the magic element." In *The Nation*, esteemed critic James Agee simply wrote that *Bambi* "depresses me."

Other critics chose to see *Bambi* as an antiwar film. The book was banned in Nazi-controlled Germany owing to author Felix Salten's Jewish heritage and the text's metaphors about anti-Semitism. Salten's butterflies experience a diaspora similar to that of marginalized Jewish communities, and were described by Bambi as "always searching farther and farther because all the good places have already been taken." Later, when the deer in the story ponder peaceful integration with the human world, they ask each other, "Will they ever stop persecuting us?" Disney helped amplify these motifs. For a print adaptation of *Bambi* featured in *Good Housekeeping* magazine, he even allowed the owl's dialogue to be adjusted to say, "But one of these days perhaps folks'll get to understandin' each other better and that'll bring peace and contentment for everybody everywhere . . ." Disney had also pushed for, but ultimately decided to cut, a scene of Bambi being led to a hunter's charred cadaver. The message here was clear: man doesn't rule the animal kingdom; he's just another mortal victim, one whose presence disrupts nature's otherwise careful balance.

Regarding those critics who thought his work had become sappy, or should be used only as a fantasy escape, Disney used *Bambi* to push back, reminding them that he was a nuanced artist. "Life is composed of lights and shadows," he responded, "and we would be untruthful, insincere, and saccharine if we tried to pretend there were no shadows."

Even though Bambi would become financially profitable over time, its initial receipts fell almost $100,000 short of its cost. For a time, some wondered if this was because the film had a pacifist message;

to this question, business-minded Roy Disney responded, "*Bambi* was a sweet little story about please don't kill deer, when we were talking about killing human beings, and it just didn't sell."

Within a week of Pearl Harbor, Walt Disney received a phone call from Washington, D.C. The Treasury Department wanted him to fly there to meet with Secretary Henry Morgenthau and discuss the prospect of producing a public-service film about the importance of paying taxes. Washington was well aware of how unpopular taxes were, but if anyone could sell the idea of paying them, it would be Walt. Assistant Secretary of the Treasury John Sullivan told Morgenthau, "What John Barrymore can't do, maybe Mickey Mouse could."

Disney agreed to the project and began working up ideas with his staff. On January 4, he arrived in Washington, accompanied by Roy Disney and storymen Dick Huemer and Joe Grant. The stern-faced Morgenthau, suffering from a crippling migraine, greeted them at his home wearing slippers. Collapsing into a chair, he listened to Disney's pitch. But upon hearing Walt's idea to feature Donald Duck in the film, he frowned. He didn't much care for Donald Duck. A serious man given to serious ideas, Morgenthau had actually envisioned something more sober, perhaps some kind of "Mr. Average Taxpayer," he explained. A political aide sitting next to Morgenthau piped up to say that he agreed with his boss.

Disney collected his thoughts for a moment and then carefully pushed back. As Morgenthau knew, the nation's new tax laws would require its poorest citizens to pay taxes for the first time—a fun character would help make the experience less painful, he explained. Also, his offer of Donald Duck was like MGM giving them Clark Gable. Disney also emphasized that, because the short would be shown in theaters for free, receipts from his other shorts, rented at full fees, would be hurt. Once Disney made his case in these terms—which a banker would understand—Morgenthau relented.

Disney returned to Burbank to begin making *The New Spirit*. The cartoon would open with Donald grumpily complaining about having to pay his taxes; then, after hearing a radio broadcast about the threats of Germany and Japan, he realizes that paying taxes is

actually the highest form of patriotism. When the film was released, IRS agents were sent with notebooks to huddle in the back of dark theaters and scribble down the audience reactions. "Very popular," wrote collector John Drabicki, adding that the "public wishes to see more movie shorts of this type." Another collector wrote that lower-income audiences—the film's primary target—had responded based on "the various actions of Donald Duck . . . When Donald groaned at the mention of Income Tax, the audience groaned; when he decided to do his bit by paying it, they cheered him."

Other opinions weren't so positive, arriving in a flood of angry letters that piled up in Morgenthau's office. Some expressed the predictable outrage one would expect over any government effort to collect more taxes. Others worried that Donald Duck hadn't treated the flag respectfully in the film. The angriest reactions, however, came from people concerned about the money paid to Disney. Some even called him a war profiteer, an idea that soon gained leverage among fiscal hawks looking for political leverage. "My God!" Republican Congressman John Taber thundered on the House floor. "Can you think of anything that would come nearer to making people hate to pay their income tax than the knowledge that $80,000, that should go for a bomber, is to be spent on a moving picture to entertain people?"

What Taber failed to mention was that Disney had actually lost money on the film. After hastily signing a contract with the U.S. government, he had paid $6,000 in additional production expenses from his own pocket and lost another $50,000 in forfeited bookings of other shorts. Nor did Taber mention how Disney's film, by convincing people not to evade taxes, probably helped generate far more in tax revenue than his films had cost to make. According to a Gallup poll, 32 million Americans saw *The New Spirit,* and more than a third of them said the film made them more willing to contribute. Disney hadn't permanently changed people's attitude toward taxes, but, according to the *Chicago Tribune,* he had at least converted "a national bellyache into a national bellylaugh."

The U.S. government was happy with *The New Spirit.* Many in Washington quickly realized that cartoons were a perfect medium for

delivering controversial messages because the format seemed so benign. They wanted Disney to make more films like this, but Walt was wary. He didn't mind making simple training films—of which he made many—but overt propaganda such as *The New Spirit* was another matter. He worried that too many films of this nature would cause a backlash among audiences. During a dinner at Morgenthau's home, Lowell Mellet, head of the Bureau of Motion Pictures within the Office of War Information, asked Disney a sensitive question. "Aren't you afraid that you will hurt your reputation by this sort of thing?" Disney replied that he was. Later, a note was circulated among Treasury officials, "Disney is fearful of being labeled as a propagandist in the public mind, with consequent damage to his reputation as a whimsical, non-political artist."

Despite his misgivings, Disney agreed to do more propaganda—films designed to influence rather than just educate. To mitigate any reputational damage, Roy Disney insisted that the financing for these projects was best kept "in the background."

Work quickly began on a short cartoon entitled *Reason and Emotion*, adapted from *War, Politics, and Emotion,* a book by Geoffrey Howard Bourne about the collapse of rational thinking in Nazi Germany. The text explored the idea of how a people's emotions short-circuit their sense of logic—how the heart overtakes the mind. Adolf Hitler's reasoning, the film explained, relied purely on his emotions. "Americans should control the emotion inside our heads lest it control us, and make us vulnerable to Hitler's vile fearmongering," it warned. Similar messages seeped into the studio's entertainment-focused shorts. *Donald Duck in Nutzi Land* was a satire of Hitler featuring Donald Duck (it was also sometimes known as *Der Fuehrer's Face*, after a song on its soundtrack by bandleader Spike Jones). The three pigs were also revived, with the wolf cast as a Nazi who could no longer blow down the pigs' house because it had been reinforced with government bonds. Likewise, the diamond mine scene from *Snow White* was revised to show the dwarfs exchanging their gems for government bonds, which were imperative to fund the war effort.

Thus far, Disney's propaganda films had only reinforced public opinion—they hadn't changed it completely, or reversed it. He wanted to make a bigger impact. Then, while shuffling through his

mail one day, Walt found a copy of *Victory Through Air Power*, a new book promising to rewrite thousands of years of military strategy and reinvent modern warfare. It declared that air warfare, only a budding concept during the First World War, now made it possible "to reduce an enemy nation to helplessness without the time-honored preliminaries of invasion." Disney wanted to adapt the book into a cartoon, but received strong pushback from Army and Navy officials who disagreed with its highly controversial opinions; they had strong opinions about land and sea warfare, their own specialties, and warned that the splashy bestseller (it was the fifth-best-selling book of 1942) made winning a war solely with airpower appear too easy. But Disney was confident the public would find the cartoon's thesis as thrilling as he did: so confident, in fact, that he planned to finance the cartoon mostly himself and release it theatrically.

Disney found a strong ally in the book's author, Major Alexander P. de Seversky, a flamboyant, attention-seeking raconteur who was the military equivalent of what Leopold Stokowski was to music. The son of an opera singer and a Russian nobleman, Seversky as a young man had been an excellent combat pilot during World War I. Even though he had lost a leg in an airplane crash while fighting, his skills were so highly prized by the Russian military that they allowed him to keep flying anyway; he managed to down thirteen more planes before being transferred to the United States as a military attaché. Not keen to return to a Russia torn apart by revolution after the war, he became a U.S. citizen and began devoting his attention to developing new aerospace technologies and rethinking military theory. Perched in an office on the thirty-fourth floor of Rockefeller Center, Seversky was forty-eight when Disney met him, his salt-and-pepper hair swept back from an imposing widow's peak that crowned a pair of hooded green eyes. After sitting in his office listening to him pontificate on his grand ideas, Disney was hungry to adapt his book into a cartoon and do for military theory what he had tried doing for music with *Fantasia*. When the press questioned Disney about the book's controversial assertions, he pushed back like a prophet spreading a message. "People need to know about it," he told the *New York Times*. "A lot of them are still bound by traditional ways of thinking and a movie like this can break through a lot of misconceptions."

Victory Through Air Power was a rare moment of Disney misreading audiences. He was captivated by Seversky's message and assumed that audiences would be too. One theater chain executive warned him that the public didn't want a "scientific exhibit," but Disney ignored him. The executive was ultimately proved right, though; during the film's brief run, theaters sat unfilled as Seversky's thick Russian accent, narrating the film, echoed across barren rows of empty seats. The Disney studio lost around $500,000 against the film's $800,000 cost. (Years later, after the studio cut it up and used parts of it for different films, it barely broke even.)

Disney was never one to obsess over money and didn't appear worried that *Victory Through Air Power* took financial losses. Its goal of changing military theory was never really aimed at general audiences, which had little say over the matter, but was ultimately aimed at those who decided military policy, or who at least had some kind of influence over policy. William Randolph Hearst wrote Disney a letter saying he thought it was "truly a great production." Winston Churchill was so impressed that he showed it to Franklin Roosevelt, who in turn screened it for his Joint Chiefs of Staff. Henry "Hap" Arnold, commanding general of the U.S. Army Air Forces and a leading advocate of airpower, also saw it. Since Arnold was in the midst of advocating for a separate air force, he kept his opinion of the film to himself for political reasons, although the idea of an Air Force separate from the Army did eventually succeed. In the end, the influence of *Victory Through Air Power* outweighed the revenue it generated.

Nelson Rockefeller was excited when he saw *Victory Through Air Power*, telling Disney that he thought it not only helped the war effort, but also expanded the possibilities of film in general. Two years had passed since Walt's trip to South America, sponsored by Rockefeller, and Disney was now ready to release the film based on that trip, in the hope that it would counter Nazi influence in the region. *Saludos* was a forty-two-minute feature made by stringing together four shorts (it was later released in the United States as *Saludos Amigos*). Goofy starred in a segment focused on Argentina; Donald Duck in segments about Bolivia and Brazil; José Carioca, a sexy parrot, was created to star alongside Donald Duck in the

Brazil segment; and Pedro, an anthropomorphic airplane, was created to deliver mail to Peru.

Just before the film's debut, controversy erupted. During a preview, Florencio Molina Campos, an Argentine artist hired by Disney as a consultant, stalked out of the screening, exasperated and offended by what he had just seen. In a letter to Secretary of State Cordell Hull, he complained that *Saludos* was nothing but a parade of ignorant gringo misunderstandings of Latin American cultures. Many State Department officials agreed. "I believe we should put a stop to the insulting of our neighbors and the revealing of ourselves as having little knowledge of their lives and habits, while we pose as good neighbors," one U.S. diplomat wrote in a letter to Secretary Hull.

According to Campos, "One picture in particular—I think it will be called *Goofy Gaucho*," was especially galling. Goofy's depiction of a gaucho, a figure as iconic to Argentines as the rugged cowboy is to northern Americans, was nothing but a cheap drugstore impostor, all dolled up

Walt Disney dressed as a gaucho during the Argentina leg
of his South American tour.

in a brightly colored costume that no self-respecting gaucho would ever be caught dead wearing. Campos speculated that, because of tone-deaf depictions like this, *Saludos* would hurt Washington's relationship with South America, not improve it. But his complaints were ignored, and this prompted him to suspect that his "advisor" role was being used as a rubber stamp to give the film an appearance of authenticity.

Rockefeller's office was sensitive to Campos's concerns—especially the notion of economic imperialism—but didn't insist on changes. *Saludos* would be released as it was, premiering in South American markets in August 1942. The film stressed continental unity, asking Latin audiences to enlist in the U.S. war effort. The opening credits—in Spanish and Portuguese—began like a friendly neighbor waving from the other side of a picket fence:

> *Greetings America!*
> *The time has come*
> *To become good friends!*
> *Greetings friends,*
> *Neighbors!*
> *We must now come together as one.*

While some South Americans no doubt reacted to *Saludos* negatively, as Campos and others said they would, the general reaction was the opposite of their predictions. The film was a smash hit. The only riots were those threatened by audiences if theaters didn't show repeat screenings of it. *Saludos* quickly racked up profits, and one Bolivian diplomat informed Disney that he was "completely adored in South America since *Saludos*." When complaints did come in, they were often from countries that felt left out because they hadn't been included. This prompted the studio to leak word that a sequel would be coming, entitled *The Three Caballeros*, which would feature popular characters from *Saludos*: Donald Duck (wearing a sombrero); José Carioca (also wearing a sombrero); and Panchito, a gun-waving rooster (yet again, in a sombrero). When it was released, *The Three Caballeros* was the "best thing Disney has made so far," according to the Brazilian newspaper *A Noite*. The Mexican magazine *Tiempo* called Disney "one of the greatest creators in the motion picture world."

Saludos Amigos debuted in the United States six months later, its tone adapted for northern audiences. The overt political overtones were dropped, the word "neighbors" wasn't used, and the suggestion of any kind of formal alliance was eliminated. Thus altered, it made $623,000 in the U.S., more than double its $300,000 price tag. Disney later received a cable from the Office of the Coordinator of Inter-American Affairs stating that "everybody in our office is most enthusiastic about SALUDOS." After Rockefeller screened it for President Roosevelt, he wrote that the film "quite exceeds our highest expectations." Rockefeller was also pleased with a short roster of other educational films—mainly about health issues—that Disney had made for South American audiences: *Water: Friend or Enemy, The Winged Scourge* (about mosquitoes); and *The Grain That Built a Hemisphere* (about the wonders of corn).

Disney was finding a way out of the financial rut created by the war. With assistance from the government (he was now Washington's biggest contractor of media), he was again profitable. But there was a wrinkle in this turn of good fortune. Critics who had once championed his work now saw something new and scary in it. The literati were beginning to grow tired of him. "[*Saludos Amigos*] depresses me," James Agee wrote in *The Nation*. "Disney's famous cuteness, however richly it may mirror national infantilism, is hard on my stomach." In the *New Yorker*, Wolcott Gibbs argued that Disney's work had become cloying. He particularly hated *The Three Caballeros*, which he found to be "a mixture of atrocious taste, bogus mysticism, and authentic fantasy, guaranteed to baffle any critic not hopelessly enchanted with the word 'Disney.'" Barbara Deming, writing in *Partisan Review*, saw "something monstrous" in *The Three Caballeros*, and questioned what it indicated about the times. Whereas Disney's gift had always been to reflect the national outlook—*Snow White* providing hope during the Depression, *Pinocchio* articulating the moral commitments that would be needed in the upcoming war—*Caballeros* depicted something queasy. Its characters constantly changed form, trying on different identities as if they were secondhand Halloween costumes. According to Deming, the film was all a big jumble in which "nothing holds its shape."

Chapter 29

"How Is It Spelled?"

As the war drew to a close, many animators began noticing how the experience had changed their perspective. Some thought military life had actually made them more creative. The Army never cared if their work looked "like regular cartoons or not," animator Gene Fleury remembered; it just cared that the job got done. When former Disney artist Dave Hilberman began working with the First Motion Picture Unit, he encountered "problems that called for solutions other than Disney solutions," prompting him to think in new ways, and to question the status quo.

Hilberman had left Disney's studio during the strike. Not only did he think Walt's aesthetic was stale, he disagreed with his boss's politics. After leaving, he joined his friend John Hubley and several other artists and began moonlighting at other studios and freelancing, making educational and training cartoons for military and industrial clients. In 1943, the group started a new studio called Industrial Film and Poster Service, which soon changed its name to United Productions of America, better known as UPA. All of UPA's founders—a group that loosely included Dave Hilberman, Zach Schwartz, Stephen Bosustow, John Hubley, and Robert "Bobe" Cannon—had worked for Walt Disney at various points in their careers. They had all learned much from him but now sought something new.

UPA's first office was a rented space in the Otto K. Olesen Building on Vine Street in Hollywood. "It was the strangest building I'd ever seen," Zach Schwartz recalled: a seedy communal space that hosted a random collection of struggling writers, voice coaches, and other peripheral Hollywood players—a kind of real-life Island of Misfit Toys. Eager to prove it was different, UPA refused to organize

in the factorylike way of other studios, according to narrow special-
ties like in-betweener or inker. Instead, the studio took a communal
approach, allowing artists to do whatever "came handy," artist Paul
Julian remembered. This gave staff more variety as they changed roles
from film to film. To many, this arrangement was appealing in theory,
but highly impractical—the old studios were arranged by specialties
for good reasons. UPA was able to pull it off, however, because the
entire staff, even entry-level people, was highly trained and capable.
Many had started working for Disney in the exciting years leading into
Snow White, when Disney was eager to hire the best talent he could
find. These younger artists differed from Disney's old guard by their
fancier diplomas and edgier tastes. At home, their bookshelves sagged
under the weight of art theory books. They were more independent
than their seniors, and "didn't have stars in their eyes about Walt,"
artist Bill Hurtz recalled.

John Hubley, one of UPA's most charismatic ringleaders, had
a curly pompadour and the jawline of a movie gunslinger. He rebel-
liously defined the studio's early aesthetic as being the opposite of
Disney's. "We were doing a lot of crazy things that were anti the
classic Disney approach," he said. At UPA, Disney was treated as
a bogeyman. Anything deemed too "Disney" was instantly taboo:
realism, visual depth, sentimentality. Nor did many UPA artists
celebrate the work of Warner Bros., the other counterbalance to
Disney's style. As UPA artist Bill Scott recalled, "at UPA any kind of
slam-bang rowdy and raunchy slapstick was referred to—icily—as
'Warner Bros. humor.'"

One day in 1944, Hubley sneaked away from his job animat-
ing for the military to meet a prospective client offering work on a
political campaign. The other UPA artists later rushed to Hubley's
house, gathering around to hear him excitedly explain the details:
the United Auto Workers union was looking for animators to pro-
duce a cartoon for President Franklin Roosevelt's campaign against
New York governor Thomas Dewey. It was an unprecedented event:
Roosevelt—seen as a national hero by many—was running for a
fourth term; the election was happening in the middle of a war, and
many saw it as an important crossroads for the nation. The UAW
couldn't pay much and needed the cartoon fast; but, recognizing

the importance of the job, the animators agreed to work for free and started brainstorming.

Many of the UPA artists favored a clean, modern style conducive to animating quickly and cheaply, skills that were needed for their UAW assignment. All were fans of the flat, two-dimensional look of avant-garde artists like Paul Klee, Wassily Kandinsky, Raoul Dufy, and Fernand Léger. Among themselves, during downtime working for the FMPU, they had passed around a dog-eared copy of *Language of Vision* by Gyorgy Kepes, a Hungarian designer who had moved to the United States in 1934. As an advocate for Bauhaus—the idea that "form follows function" and that good design performs its job without indulging in frivolous extras—Kepes blurred the line between commercial and fine art, arguing that advertising as an "art" could "disseminate socially useful messages." "The task of the contemporary artist is to release and bring into social action the dynamic forces of visual energy," he wrote. With these tenets and aesthetics in mind, the UPA artists began working on FDR's reelection cartoon, entitled *Hell-Bent for Election*.

The script for *Hell-Bent* was written by Robert Lees, author of numerous Abbott and Costello comedies (and, later, episodes of *Lassie* and *Alfred Hitchcock Presents*). Chuck Jones was enlisted from Warner Bros. to direct the cartoon. Two years earlier, Jones had produced two films, *The Aristo-Cat* and *The Dover Boys*, which had used the same flat style that UPA now wanted to achieve. These films had reminded Hubley of a Russian cartoon that architect Frank Lloyd Wright once showed during a lecture at Disney's. "It was very modern," Hubley said, "with flat backgrounds, highly stylized characters, modern music." At the time, Hubley thought it a "revolution" against the "characteristic Disney round and opaque forms."

Once finished, *Hell-Bent for Election* was a gorgeous gem of sleek new modernism, depicting the election as a contest between two locomotives. The Republicans were represented by the "Defeatist Limited," a wheezy old clunker struggling to haul a "Business as Usual" sleeper and a "Jim Crow" caboose. The Democrats' "Win the War Special" was portrayed as a silver bullet train emblazoned with FDR's smiling face. With backgrounds that were flat and economical, the cartoon

avoided what Kepes drily called "a dead inventory of optical facts." Even though the cartoon's movement was stiff—not nearly as rich or fluid as the typical Disney film—the minimal design didn't hamstring the overall effect; energy and passion shone through. Winsor McCay might not have agreed with UPA's minimalist economy, but you could practically hear his ghost whispering encouragement, championing the studio's thoughtful commitment to artistic ideals.

Impressed by UPA's work, the UAW later commissioned another cartoon, this one called *Brotherhood of Man*. UAW was having problems getting southern whites and blacks to join the same local unions and thought a good cartoon could help combat racial prejudice. The script, a simple message of tolerance and understanding, was based on a pamphlet by two Columbia University anthropologists; it was adapted into a script by a collection of writers: John Hubley from UPA; Ring Lardner Jr., who had worked on Otto Preminger's *Laura* and would later pen the Oscar-winning movie script *M*A*S*H*; Maurice Rapf, who had worked on a slew of films, including several for Disney; and P. D. Eastman, who had previously written for Disney, Warner Bros., and the FMPU.

Brotherhood of Man refined UPA's style into a sharp point. Animation wasn't a servant to film, as it was at Disney, or to comic strips, as it was at other cartoon studios—animation at UPA was a servant to design principles. During creative meetings, UPA artists didn't discuss character development or gags; they discussed how shapes played on flat surfaces. To them, animation was a product of high art, not of popular culture; when UPA artists did address popular culture, it was with the same disembodied aloofness found in the *New Yorker* cartoons (in 1950, the studio actually announced plans to make a feature-length film based on James Thurber's *New Yorker* cartoons, but it never followed through). The studio's artists presented their aesthetic as inherently political, even moral, and insisted that their modern design principles carried a strong message. According to Zack Schwartz, "Our camera is closer to being a printing press, in the way we use it, than it is to being a motion picture camera."

* * *

During the earliest paranoid years of the Cold War, populist American congressmen waged bitter cultural warfare for political gain. UPA was a stridently political outfit, championing abstract design principles taught by artists with foreign backgrounds and hard-to-pronounce names. Not surprisingly, in the summer of 1947, the studio received a visit from the FBI.

Several UPA artists had, at one point or another, belonged to the Communist Party. When FBI director J. Edgar Hoover learned about the animators' links to Communism, he advised his military contacts of the Bureau's findings. UPA had only one military contract at the time—for a Navy training film called *Marginal Weather Accidents*—but the studio's hope of similar future contracts was all but ruined. Already operating on a shoestring budget, UPA was forced to move from the Otto K. Olesen Building to an even dumpier building on Highland Avenue. It shared space with the producer of a sex-education film called *Understanding Ourselves*. To make ends meet, UPA produced for this an animated film-within-a-film, called *Human Growth*. The studio's shaky footing would be destabilized even more as it was pulled into a firestorm of complicated Cold War politics.

It was the age of the Red Menace: investigations, hearings, political attacks, Joseph McCarthy snarling at the cameras. In the wake of World War II, Republicans were desperate to return from the political exile they had been in ever since Roosevelt was elected in 1932. Seeking an issue to rally around, they chose Communism. It was a legitimate concern, shared by Democrats, but to build their personal power politicians often wildly exaggerated the threat. The tactic worked: Republicans gained seats in the House and Senate during the 1946 midterms, electing for the first time both Joseph McCarthy and Richard Nixon. Emboldened by this success, they began launching more attacks and investigations, dragging witnesses into hearings before the House Un-American Activities Committee. The strategy, widely compared to witch hunts, was engineered to generate publicity. It involved numerous attacks on Hollywood because celebrities guaranteed flashy headlines.

Those accused suffered civil rights violations as they appeared in what were essentially show trials. HUAC members used the committee

to intimidate political opponents and other groups they resented, such as the Jewish Hollywood moguls who had overwhelmingly supported President Franklin Roosevelt and his New Deal. This no doubt made UPA's founders—many of whom were Jewish—feel uneasy. "You should tell your Jewish friends that the Jews in Germany stuck their necks out too far and Hitler took care of them and that the same thing will happen here unless they watch their steps," a HUAC investigator told one of the committee's targets. John Rankin, a Mississippi congressman on the committee, likewise ranted that Hollywood Jews "want to spread their un-American propaganda, as well as their loathsome, lying, immoral, anti-Christian filth before the eyes of your children in every community in America."

The FBI agents who darkened the doorway of UPA asked to speak with John Hubley and at least one other artist, probably Stephen Bosustow (the name was concealed in documents later released by the FBI). The men's names had surfaced during other investigations. Hubley had in fact once belonged to the Communist Party, among other UPA staff that included Dave Hilberman, Zack Schwartz, and P. D. Eastman. Many of their connections were old, stemming from the Depression years when many frustrated Americans were curious about alternative ideas that might help their government run better. "Naturally, being an artist, why, I am fundamentally concerned in not how things are, but maybe how things could be," UPA artist Eugene Fleury told a HUAC investigator. His interest in Communism was "fundamentally that of kind of a philosophical background to my art instead of my political background. In fact, my action then consisted mostly of conversation and that's about all." Political meetings were little more than "the coffee-and-doughnut kind," according to Fleury's wife, Bernyce, when she testified during a HUAC hearing. "We mainly talked about how we could improve the animation business," she said. According to David Raksin, who composed scores for UPA, "It was kind of a study group that met in somebody's apartment in Westwood. We punished ourselves one night a week." The group tried to read Karl Marx's *Das Kapital* but got only a few pages in before the conversation drifted to cartoons and art. Once World War II started, most of the animators abandoned their interest in Communism and served

with distinction in the U.S. military, some in combat and others as part of the FMPU.

But these were show trials, focused on political revenge. The HUAC's "friendly witnesses" were often provided by the Motion Picture Alliance for the Preservation of American Ideals, a group founded in 1944 by Sam Wood, a director who had resented the city's elite ever since they denied him an Oscar for *Goodbye, Mr. Chips* in 1939. Inside his pocket he carried a little black book filled with the names of enemies he hoped to purge from the city—most of them supporters of Roosevelt's New Deal, which he despised. His organization was stacked with prominent Hollywood figures whose politics leaned right: Ronald Reagan, John Wayne, Clark Gable, Ayn Rand, Barbara Stanwyck, and Cecil B. DeMille, among others. At the top of the MPA's leadership structure, serving as its vice president, was Walt Disney.

Walt Disney's politics had never been extreme, but they had noticeably changed since the strike in 1941—his disapproval of unions strongly influenced his leanings. He had voted for Democrat Franklin Roosevelt in 1936, before the strike, but voted Republican afterward, donating heavily to the party and aggressively supporting presidential candidate Thomas Dewey in his unsuccessful 1948 bid against Harry Truman.

As Disney's politics changed, so did his art. In 1946, he released his first major feature since the war: *Song of the South*, a blend of live action and animation set in the Deep South during Reconstruction. Based on a series of stories by Joel Chandler Harris, it featured Tar Baby, Br'er Fox, Br'er Rabbit, and the song "Zip-a-Dee-Doo-Dah." Some film historians regard this as Disney's turn toward more conservative thinking, marked by a stronger impulse to romanticize an idealized past. The melodramatic film was nostalgic, reimaging a deeply flawed era in cheerful Technicolor, full of scenes in which singing field hands, wearing freshly pressed clothes, march off to toil in the plantation's muddy fields. Many would later call the film racist, suggesting Disney was racist as well, but the film is probably

better described as simply tone-deaf and poorly timed. Like much of his generation, Disney could be racially insensitive, though he never, privately or publicly, made disparaging remarks about blacks or advocated white superiority, according to Neal Gabler, one of Disney's most thorough biographers. Disney was fully aware of the racial minefield *Song of the South* represented, and actively sought input from black Americans, inviting the NAACP to assist with script revisions. NAACP secretary Walter White declined the offer, however, explaining that the organization didn't have a representative on the West Coast. When the film was released, it performed respectably at the box office—$226,000 profit on a cost of $2,125,000—but received mixed reviews. There was criticism from the National Urban League and the NAACP, both of which objected to its tone, although neither did so stridently. Later, when Disney heard that a group of black newspapers planned to protest *Song of the South*, he didn't make any disparaging comments about race, but asked only if Communists controlled those newspapers.

Not only had Disney's politics changed since the strike; his personal look had changed as well, from a carefree style into something more sober. In 1939, colleagues remembered him spending much of the year "addicted" to regularly wearing the same Tyrolean jacket—purple on the outside, red satin on the inside, with silver buttons the size of half dollars—because he liked the "sensation it creates," according to one reporter. But now he regularly appeared in public wearing somber gray suits, although his neckties were sometimes a little flashy. This is how he dressed on October 24, 1947, when he appeared as a friendly witness before the HUAC to talk about Communist infiltration of the animation industry.

Disney's testimony—following the friendly testimony of Gary Cooper and Ronald Reagan—offered him a chance to air grievances against UPA, a studio that characterized itself as "anti-" almost everything he represented. Sitting at the hearing table, he leaned into the microphone, his expression serious. "I definitely feel it was a Communist group trying to take over my artists," he told the committee about events from six years earlier. When asked to name names, he provided only one. "He was the real brains of this," Disney began, "and I believe he is

a Communist. His name is Dave Hilberman," he said of the man who had helped organize the 1941 strike before cofounding UPA.

"How is it spelled?" asked Representative H. A. Smith.

"H-i-l-b-e-r-m-a-n," Disney offered, adding that Hilberman had "no religion" and that "he had spent considerable time at the Moscow Arts [*sic*] Theater." He then added, bizarrely, that he thought the League of Women Voters was also a Communist front, although he later retracted the comment, after his lawyer combed through old records and discovered that Disney probably meant to say League of Women *Shoppers*, a small group that had shown up to join the picketers during the strike. The entire incident would put a dark blemish on Walt Disney's otherwise cheerful legacy.

By now, Dave Hilberman had left Hollywood for New York to work in advertising. Because UPA was often a place of clashing egos, Hilberman had sold his portion of the studio after having creative differences with UPA's other members. It was an odd career transition for someone who was supposedly a dyed-in-the-wool Communist, and one that he chose over an offer to help establish animation studios in the Soviet Union. He was deeply wounded when he heard Disney's testimony. Yes, he had once belonged to the Communist Party, but he had drifted from the ideology once the war erupted and had served in the U.S. Army during the war's final years, while he still held a stake in UPA. Hilberman thought Disney's comments were misleading, especially the attempt to smear him by claiming he once worked for a theater company in the Soviet Union before working for Disney. What Disney omitted from his testimony was that the studio's own public relations office had considered Hilberman's USSR experience a bonus when hiring him. Besides, Hilberman told his friends, he had spent his entire stay there feeling homesick.

Once the investigations of UPA stopped—no formal charges were ever filed—the studio's fortunes began to improve. It animated dream sequences for a live-action adaptation of John Steinbeck's *The Red Pony* and began attracting commercial clients—so many commercial clients, including the Ford Motor Company and Carrier, the air-conditioning company, that any suggestion of Communist

tendencies was put to rest. Still, the studio yearned for something more, realizing that it needed the same thing that had built the legacies of the other great studios: a regular series with a popular star.

UPA thus began making speculative cartoons with characters it hoped would blossom into celebrities. According to its principles, these were usually based on unconventional material. One, entitled *The Wonderful Ears of Johnny McGoggin,* failed to capture anyone's attention. Then UPA acquired rights to an edgy book by Juliet Lowell, entitled *Dear Sir,* a fictional collection of letters that derived their humor from quirky misspellings and other faux pas—one letter, addressed to the "Bureau of Assessment," asked, "Why is my ass. so much bigger this year than it was last year and what are you going to do about it?" Failing to see the charm of Lowell's book—despite the fact that it had sold more than 400,000 copies in 1944—film distributors weren't interested.

In this moment, UPA's politics turned to its advantage. "If I happened to be talking to a Democrat—which I did at Columbia— and he saw *Hell-Bent,* I was in the front office," Stephen Bosustow remembered. Traveling to New York, home to Columbia's corporate and distribution office, Bosustow met with two executives who would turn out to be advocates for the studio: Abe Schneider, who regularly donated to the Museum of Modern Art; and Leo Jaffe, whose eye for talent had given (or would give) breaks to several Hollywood figures: Sam Spiegel, Otto Preminger, Stanley Kramer, and Steven Spielberg, among others. In 1947, UPA and Columbia struck a trial deal for two entertainment cartoons, with an option for Columbia to acquire two more if it liked them. There was just one catch: Columbia insisted that UPA base the first two cartoons on two animal characters, a fox and a crow, that Columbia already owned.

Applying UPA's stylistic concepts to the fox and crow characters, John Hubley directed two cartoons: *Robin Hoodlum* and *The Magic Fluke,* which would both go on to be nominated for Academy Awards (to help with gags and the script for *Robin Hoodlum,* he recruited talent from Warner Bros., including Chuck Jones, Friz Freleng, Michael Maltese, and Tedd Pierce). Columbia was impressed with the work and suggested expanding their partnership; the larger studio had

long been considered an also-ran in the field of animated shorts, a reputation it hoped to change. By 1948, newly successful and with financial support from both its commercial clients and Columbia, UPA began planning to build a new studio designed by a disciple of Frank Lloyd Wright, architect John Lautner, who promised a modern showpiece of glass, steel, and cement.

Eventually, Columbia granted UPA permission to create its own new characters. John Hubley, who could be temperamental, announced that he disliked the boring fox and crow characters and wanted to ditch them. "We want to do original shorts, and we're stuck with tired animals," he said. "Our strength and our vision is to do human characters." But Columbia was uneasy about the idea—cuteness was profitable— and insisted that UPA include animal characters, although agreeing to allow it to experiment with a human character or two.

UPA grabbed its chance. With Columbia's blessing, Stephen Bosustow called the best writer he knew to begin working on a script: Millard Kaufman, a Baltimore native whose life brimmed with colorful stories. After working as a merchant seaman, he had studied English at Johns Hopkins University, then took a job as a reporter for the *New York Daily News*. During World War II, he enlisted in the Marines, earning a Bronze Star for fighting at Iwo Jima, Guadalcanal, and Okinawa, contracting both malaria and dengue fever somewhere along the way. When he returned home, he volunteered for a science experiment that involved drinking cobra venom, which is how he met his wife, Lorraine Paley. Bursting with life experience, Kaufman was a perfect fit.

Kaufman spent a weekend brainstorming with Hubley, the two passing ideas back and forth, their excitement building. During their conversations, they discovered that both had rich uncles similar in temperament—stodgy and opinionated old men who shouted down people they didn't agree with. This led to talk about the paranoid hysteria of the Red Scare and the Hollywood Blacklist (Kaufman would later lend his name as cover to blacklisted screenwriter Dalton Trumbo, for the script of *Gun Crazy*). As the conversation moved to lighter topics, the men joked about the "weirdness" of place names in California—towns like Rancho Cucamonga, Tarzana, and a place near Sacramento called Rough and Ready.

Hubley and Kaufman's new character was born out of these conversations. Like their uncles, the character would be an "irascible millionaire"—nearsighted, mean-spirited, and full of opinionated rants. He would also be prone to making grand misjudgments based on poorly interpreted information, meandering through life doing things like mistaking a walrus for a tennis partner, mistaking a severed head for an old college chum, or wandering into a loud movie theater and mistaking the noise for a foreign invasion. His buffoonery was intended to reflect the behavior of the House Un-American Activities Committee, and his name was taken from one of those "weird" California places the men had discussed, a spot above Malibu known as Point Mugu, which they modified into Mr. Magoo.

Hubley and Kaufman now focused their creative attention on Mr. Magoo, but they still owed Columbia an animal character, per their agreement. For this "compromise," as they called it, the men quickly threw together a character called Ragtime Bear and named the short after him. Once Columbia saw the cartoon, it reluctantly agreed to release *Ragtime Bear*, but only because of that bear, which was really nothing more than a Trojan horse for Mr. Magoo. After the cartoon played in theaters, in 1949, anyone watching it knew who the real star was.

Mr. Magoo debuted in theaters just as UPA finished construction of its new studio: a gleaming fortress of modern design principles. Located in Burbank at 4440 Lakeside Drive, it sat just down the road from Disney's studio, its modern exterior challenging the aesthetic philosophy of UPA's main rival.

One day, soon after the new studio was finished, Theodor Geisel came strolling through the shiny lobby, admiring architect John

Mr. Magoo counting a stack of cash.

Lautner's work. He had just finished lunching with his old friend
P. D. Eastman, now a writer at UPA, and discussing the current state
of animated cartoons. "All the cartoons being made are obsolete,"
Eastman complained. "Mice keep outsmarting cats and rabbits are
always wiser than foxes . . . but UPA has a fresh outlook. You must
have a story for us."

Indeed he did. As Geisel walked through the office, greeting all
his old friends from the FMPU, he held under his arm a record he
had made for Capitol, featuring a story about a boy named Gerald
who speaks through sound effects rather than words. Rejected by his
friends and parents because of his handicap, Gerald is given a job by
a radio station to provide sound effects for its programs (the story's
mechanics weren't all that different from Disney's *Dumbo*). After buy-
ing the rights for $500, UPA gave the record to Eastman and writer
Bill Scott to adapt into a cartoon called *Gerald McBoing Boing*.

Directed by Robert Cannon and released in 1950, it captured
all the different ideas UPA had been working on up to that point:
the design was two-dimensional; the colors were expressionistic; the
animation was precise and lean, with a cool, modern jazz score by
Gail Kubik. After winning the Academy Award for Best Animated
Short that year, the film was said to represent a watershed moment.
Time predicted that Gerald's "boing! . . . may prove as resounding
as the first peep out of Mickey Mouse." With this and the success of
Mr. Magoo, which would harvest its own share of Academy Awards
throughout the 1950s, UPA's cartoons were poised to become Amer-
ica's new cultural darlings. Writing in *Saturday Review*, Gilbert Seldes
said UPA's films "are likely to recapture the sensation you had when
you first saw *Steamboat Willie*." Other critics noted how UPA's charac-
ters defined the dawn of a new era, as Felix had done in the 1920s
and Disney's films had done in the 1930s. "[Mr. Magoo] is a creation
of the 1950s, the age of anxiety; his situation reflects our own," one
wrote. "[He] represents for us a man who would be responsible and
serious in a world that seems insane."

Exactly how much UPA influenced its era, or to what extent the stu-
dio's feel was simply a product of that era, is hard to know. Either

way, UPA's look matched the times. Andy Warhol's early commercial work looks as though it stepped out of a UPA short, and the studio's aesthetic echoed the mid-century design principles commonly seen in architecture, interior decoration, and graphic design. UPA cartoons also sounded like the times. The studio regularly commissioned independent jazz musicians, rather than in-house performers, to create its soundtracks (jazz star Chico Hamilton performed UPA's theme music). Animation fans regularly called UPA the bebop equivalent of Disney's swing—a changing of the guard. Many UPA artists, such as Gene Deitch and Jim Flora, designed artwork for jazz album covers from Columbia and other labels.

To many, UPA, not Disney, was now the vanguard of animation. Not surprisingly, Disney cared little for the new style. "There isn't enough money in the world to make me go back and try to make cartoons the way they're making them now," he told a colleague about UPA's films. This was during the years surrounding production of his *Cinderella, Alice in Wonderland,* and *Peter Pan*—films that would entertain audiences and bring respectable profits but not earn the kind of excited buzz Disney had once received from cultural tastemakers. He was still immensely popular with the masses but increasingly falling out of vogue with the cognoscenti.

Although Disney was not generally a fan of UPA's style, he did understand that it addressed a new reality of needing to make cartoons cheaper and faster. He also knew that many of his artists were itching to experiment with these new styles. Ward Kimball wanted to use an aesthetic similar to UPA's for *Toot, Whistle, Plunk, and Boom,* a short cartoon about the history of musical instruments. "Everybody said you'll never get this by Walt . . . straight lines, things like that, unheard of . . ." Kimball remembered. Kimball then gained creative control of the film by directing most of it while Disney was on a trip to Europe. Released in 1953, the cartoon was a charming hit, matching UPA's material on many levels. *Time* wrote that "*Toot* takes Disney in one jump from the nursery to the intellectual cocktail party." When Disney saw it, he loved it, and the film later won an Academy Award. It was a reminder to doubters that he couldn't be counted out of the game just yet.

* * *

In 1952, riding high on success, UPA suffered another round of uncomfortable FBI investigations. It was an election year, and Republicans once again targeted Hollywood as a way to rally their political base. By this point, the show trials had reached an absurd fever pitch, as the HUAC accused UPA animator Paul Julian of being an Armenian Communist simply because his last name ended in *ian*. "This is untrue," said Julian, who was born in Illinois. "I am neither a Communist or an Armenian."

UPA artist Bill Scott described the committee's demand for names as a shakedown, a way to extort money from its victims. "In those bad old days, you would be approached by a representative or a friend of a representative from the committee, who would assure you that for *x* amount of dollars, they could see that your file was at the bottom of the pile," he said. "In other words, if the hearings lasted long enough, you would be called up, but the chances were that you wouldn't be called up publicly, because your dossier kept slipping to the bottom of the stack. The going price, I believe, at that time was four to five thousand dollars, though it may have been more as far as, maybe, a head of a studio was concerned. At any rate, that was the current wisdom, the conventional wisdom and the underground chatter. That's what happened at—and to—UPA."

Many succumbed out of fear. Frightened phone calls from Columbia, which owned 20 percent of UPA's common stock, resulted in firings. Columbia executives also demanded that they vet future hires and that employees sign loyalty oaths; they also denied a request for Pete Seeger, the lefty folksinger, to do soundtrack work at UPA (Seeger had once given a concert at the studio). In 1952, Columbia provided UPA with the names of eight people it wanted fired, including John Hubley. When Hubley refused to quit, he was fired and blacklisted.

"Hubley just sort of disappeared from sight," Bill Hurtz remembered. In his absence, Mr. Magoo's character changed as well; he became warmer and less irritable, and his nearsightedness was exaggerated in a way that invited more pity than before. Whereas the earlier Magoo possessed the ability to mold the world into whatever he wanted it to be—highlighting the political dangers that Hubley

and Kaufman had set out to criticize—now it seemed that the studio was just making fun of a cranky old man.

Hubley moved to New York and began animating television commercials. As more television sets appeared in homes, commercial animation was growing as a field. It was also a refuge for blacklisted animators; since television commercials weren't credited, their creators could work anonymously. The irony of this was apparent to all: artists accused of being Communists were forced into making commercials for the most capitalist corporations on earth.

One animator who now owned a commercial studio, although he was never blacklisted, was Shamus Culhane. He was the mind behind the Ajax cleanser elves—"Use Ajax—boom boom—the foaming cleanser"—and the classic Muriel cigar commercial parodying the Mae West line, "Why don't you come up and smoke me sometime?" In an act of solidarity, Culhane hired Hubley's UPA colleague and fellow war veteran P. D. Eastman, who was blacklisted around the same time as Hubley, to write eighty commercial spots for the U.S. Air Force, as well as commercials for Budweiser beer—again, the irony of "Communists" working on these campaigns was lost on nobody. "He worked for months in a back room in the studio and nobody on our staff ever informed," Culhane wrote. "If they had we would have been out of business in 48 hours."

A month before the HUAC called Eastman to testify, Arthur Miller debuted his play *The Crucible*, an allegory linking the Salem witch hunts to McCarthyism. This set a tone for the later proceedings; Eastman's family had deep roots, going back centuries, in the part of Massachusetts around Salem known for the witch trials. When he appeared before the lawmakers, he drew from this history, telling them, "I feel this committee has imposed cruel and unusual punishments upon me in keeping me under subpoena for the better part of the year." Then he shared a personal story, explaining that his "great, great, great, great, great, great grandmother," Mary Bradbury, "was convicted of consorting with the devil, despite the fact that 117 of her neighbors testified that she was a good and pious woman. Because I believe she would not have been convicted of witchcraft had she had the privilege of the fifth amendment available to her, the privilege

against self-incrimination, I not only do stand on my privilege, but I am proud to stand on it."

His animation career all but over, Eastman would, within a decade, reinvent himself as one of the most popular children's book authors of all time, writing and illustrating such classics as *Are You My Mother?* and *Go, Dog. Go!*

Chapter 30

"They Can Kill You, but They're Not Allowed to Eat You"

In 1949, Chuck Jones was thirty-seven. Blond and handsome, like the boyfriend in a Beach Boys song, he was young but had already been working in animation for nearly twenty years, mostly for Warner Bros. Bubbling away at the back of Jones's mind was an idea for a new cartoon series that would eventually become one of the most iconic of all time.

Jones said his career choice was a result of having grown up in Hollywood, near all the action—"If I'd been born in Butte, Montana, the chances are pretty good that I'd have ended up a cowhand." When he was a baby, Jones's family moved to Hollywood because his father, Charles A. Jones, was chasing yet another get-rich-quick scheme, the kind of scheme Chuck would later lampoon regularly in his cartoons. "He formed companies that attempted to sell avocadoes when people called them Alligator Pears and thought of them as either poisonous or Communistic . . . he offered vineyards for sale when Prohibition was in full astringent swing," Chuck Jones remembered. At one point, the senior Jones struggled to start a geranium farm, quitting when the ground failed to push up flowers. Only after he sold his option did everyone realize the flowers couldn't grow because the soil was saturated by crude oil. The new owners became millionaires instead of the Jones family.

Every time Jones's father started another business, new pencils and stationery were printed with the company name. When the companies inevitably went out of business, Jones senior would give the supplies to his kids and urge them to draw to their hearts' content,

thus disposing of materials that reminded him of his recent failure. "We were forbidden—actually forbidden—to draw on both sides of the paper," Jones remembered. Charles Jones Sr. explained his logic to his children this way: "Suppose you were Leonardo da Vinci and you painted the *Mona Lisa* on one side of your canvas and *The Last Supper* on the other—how would you ever hang it?"

The Jones family moved from rental to rental in the Los Angeles area. One house was located near where the comedian Mack Sennett shot his films, such as the Keystone Kops series, and Jones was often hired as an extra. "They didn't pay you; they'd just say 'You wanta be in the picture, kid?' Don't look at the camera.' So you'd walk into the mob and be part of it," he recalled.

Another rented house was two blocks from Charlie Chaplin's studio at La Brea Avenue and Sunset Boulevard. The movies were still silent then, before the need for sound stages, and Chaplin would often shoot outside as Jones and other children watched through the fence. "He was a kind of hero to us, and we loved his films," he said. Chaplin regularly reshot scenes forty or fifty times, the crew growing exhausted as he called for yet another take. "When we watched them in theaters, it never occurred to us that anything was done over and over," Jones recalled. This offered the budding animator an important lesson: "how difficult it was to get it just right . . . on many occasions, I have drawn over fifty drawings to get one right." Jones learned a lot from spying on the greats: the way the Keystone Kops hopped around turns, or how Buster Keaton paused the action to cast "little eye flicks toward the camera." Later, in Jones's own films, when his characters realize that a boulder or an anvil is about to fall on them, they react with similar eye flicks. According to Jones, the most important lesson provided by the great silent comedians was how they "did not think of themselves as profound." They were artists, not philosophers, and their job was to create art, not spend time talking about it. Said Jones, "To me, the artist who postulates stops being an artist while he's postulating."

Harry Carr, book editor for the *Los Angeles Times*, owned one of the homes that the Jones family rented. "[E]very place in the house, it seemed, was filled with books," Jones recalled. When Chuck was three, Charles Sr. taught him to read as a way to keep him occupied

and self-sufficient. Young Chuck soon started devouring any book he could get his hands on. A few years later, he noticed that he reacted differently to writers like Horatio Alger, whom he read "with derision and hoots of mocking laughter," as compared with humorists like Stephen Leacock, who gave Chuck "joy and joyous laughter." When Chuck mentioned this to his father, Jones Sr. explained the difference this way: "It's simple. The truth is tart, the false is sweet."

For the rest of his life—he would die in 2002—Chuck Jones read widely and randomly. "Chuck always read the encyclopedia as if it were the latest best-seller," his good friend Ray Bradbury, author of *Fahrenheit 451*, remembered. "Whenever he called me up and asked, 'Did you know that the male whale swims around the Atlantic with a permanent erection?' or 'Did you know that when the engineers on the trans-Egyptian railway ran out of fuel they burned mummy cases?' I knew he'd been at the Britannica again."

When Jones was five or six, he discovered *Tom Sawyer*, by Mark Twain. "I picked it up, flipped it open to the first page, and saw: 'Tom. No answer. Tom. No answer.' I knew right away what was happening." Jones then read everything Twain ever wrote, "with the exception of the two volumes he did on Christian Science." He particularly enjoyed *Roughing It*, Twain's semiautobiographical account of traveling in the West, and one of literature's greatest explorations of the American Myth. In those pages, Jones discovered a character that would bounce around his brain until he brought it to life some thirty years later. "In the fourth chapter of *Roughing It*," Jones wrote, "I found the coyote."

Mark Twain wrote about the coyote: "The coyote is a living, breathing allegory of Want. He is always hungry. He is always poor, out of luck, and friendless . . . He is so spiritless and cowardly that even while his exposed teeth are pretending a threat, the rest of his face is apologizing for it."

Twain's words lingered in Chuck's mind when he dreamed up Wile E. Coyote and Road Runner. His partner on the cartoon was Michael Maltese, one of Warner Bros.' most gifted writers. The idea began forming as the men sat discussing cartoons built entirely around the concept of one character chasing another—commonly

referred to in the industry as "chase" cartoons—and what they liked and didn't like about them. The format was a perennial favorite of cartoon studios: it was pure action, perfect for shorts, and could be loaded with gags. Ever since 1940, one chase series in particular had been especially popular: Tom and Jerry, created by two animators at MGM, William Hanna and Joseph Barbera. Often brilliant, though not always, Tom and Jerry cartoons were extremely popular and inspired countless imitators. Jones and Maltese thought the format was growing stale, however, and wanted to turn it on its head by creating a parody. Said Jones, "We would do a satire on chases, show up the shallowness of the whole concept, and become the Dean Swifts and H. L. Menckens of our day, be honored at learned societies, and probably welcomed at unemployment agencies nationwide."

Jones and Maltese discussed how, in chase cartoons, the character being chased almost always outwits his pursuer. But they wanted to twist the convention: Road Runner would never outwit Coyote; instead, the coyote would always defeat himself through his own ineptitude. In September 1949, Warner Bros. released the first Wile E. Coyote and Road Runner cartoon, *Fast and Furry-ous.*

Jones and Maltese envisioned it as a onetime short, not a series. After seeing the favorable reviews, however, they started developing more. Both thought the absence of dialogue in the cartoon was a strength, just as it had been for Chaplin and Keaton, who had distilled their comedy to its purest essence using only action and movement. Jones and Maltese decided that not having dialogue would be a rule. The only words would be Road Runner's "beep, beep," which Jones borrowed from background painter Paul Julian, who would shout, "Beep, beep" whenever he was carrying a large painting down the hall. They recorded Julian saying this and then speeded it up, using the same tape for years afterward (Mel Blanc also recorded a version of "beep, beep," which was used in some of the shorts). Wile E. Coyote never speaks except during guest appearances in other series (showing up opposite Bugs Bunny in *Operation: Rabbit,* he has the calm, self-confident baritone of a man in a smoking jacket swirling a snifter of brandy).

Whenever Jones thought about characters he was working with, he pondered how to channel his own personality into them. For

instance, whenever he directed Daffy Duck cartoons, he thought back to his sixth birthday party, and how he had blown out the candles in a way that sent smoke up his little brother's nose—a memory he wanted to reflect in Daffy's personality. For Road Runner and Coyote, this was particularly challenging. By design, Road Runner wasn't supposed to have much depth as a character. His role would be as a foil, a doofus whose success comes as the result of sheer, dumb luck. Wile E. Coyote, on the other hand, would be the clever one, but never clever enough. Coyote was the character Jones and Maltese wanted audiences to relate to—he never catches lucky breaks, is a perennial loser, and is "his own worst enemy," Jones recalled. "[T]he Coyote never wins. Never. He's out to get a bird that wouldn't even make a good meal."

Jones looked inside himself most when working with the Coyote, building the character's personality by reflecting on his own clumsiness with power tools—as an artist, he was good with his hands, but this somehow didn't translate to handiwork around the house. "The coyote is victimized by his own ineptitude," he said. "He's not at war with the gods, but with the minuscule things of everyday life." Coyote's struggle wasn't epic or important; it was the struggle to just make it through the day. Jones never wanted to show the coyote getting hurt or in pain; the biggest tragedies he ever experienced were that "he was insulted, as most of us are when we suffer misfortune." The message here was that the worst fate isn't maiming or death, it's embarrassment. Jones envisioned Wile E. Coyote as his own alter ego: a reminder that no one but himself was to blame for his misfortunes.

Ingenious ideas often seem simple, and that is their genius: seeming simple when they're actually very complex. As the Coyote and Road Runner series gathered steam, Jones and Maltese established an elaborate set of guidelines, in addition to the rule about never having dialogue. Jones once said of his comedy heroes—actors from the silent era—that the ones who placed more rules on their art often had the funniest films. "Everyone I've ever respected always used restricted tools," he said. "The greatest comedians were the ones who wore the simplest costumes and worked in prescribed areas—such as Chaplin." In this way, the series worked according to the same mechanics as a haiku poem, providing a rigid structure that, while highly restrictive,

Poster for *Hip Hip Hurry* (1958), starring Wile E. Coyote and
the Road Runner. This series reinvented the chase cartoon.

was in some ways very liberating. At one point, Jones wrote up the
series' rules:

> RULE 1: THE ROAD RUNNER CANNOT HARM THE COYOTE
> EXCEPT BY GOING "BEEP-BEEP!"
> RULE 2: NO OUTSIDE FORCE CAN HARM THE COYOTE—
> ONLY HIS OWN INEPTITUDE OR THE FAILURE OF
> THE ACME PRODUCTS.
> RULE 3: THE COYOTE COULD STOP ANYTIME—IF HE
> WERE NOT A FANATIC. ("A FANATIC IS ONE WHO
> REDOUBLES HIS EFFORT WHEN HE HAS FORGOTTEN
> HIS AIM."—GEORGE SANTAYANA)
> RULE 4: NO DIALOGUE EVER, EXCEPT "BEEP-BEEP!"
> RULE 5: THE ROAD RUNNER MUST STAY ON THE ROAD—

OTHERWISE, LOGICALLY, HE WOULD NOT BE
CALLED ROAD RUNNER.

RULE 6: ALL ACTION MUST BE CONFINED TO THE NATU-
RAL ENVIRONMNET OF THE TWO CHARACTERS—
THE SOUTHWEST AMERICAN DESERT.

RULE 7: ALL MATERIALS, TOOLS, WEAPONS, OR MECHANI-
CAL CONVENIENCES MUST BE OBTAINED FROM THE
ACME CORPORATION.

RULE 8: WHENEVER POSSIBLE, MAKE GRAVITY THE COY-
OTE'S GREATEST ENEMY.

RULE 9: THE COYOTE IS ALWAYS MORE HUMILIATED
THAN HARMED BY HIS FAILURES.

Jones provided this list of "rules" in his autobiography, *Chuck Amuck*. In other settings, he occasionally expanded on them. Even though he called them "rules," he allowed some wiggle room. For instance, while the cartoons had to be set in the American Southwest, which helped capture Americans' romance with the frontier, the desert's specific look could vary. In the earliest cartoons, the desert was given a realistic feel by background artist Robert Gribbroek, who had studied art near Taos, New Mexico. Later cartoons had more abstract background art—similar to the look of UPA's cartoons and reflecting popular trends in modern art at the time—provided by background artist Maurice Noble (Noble had previously worked for Disney, on *Snow White* and on the *Rite of Spring* sequence for *Fantasia*).

A number of rules surrounded ACME, the company from which Coyote was required to buy all his tools and gadgets. Ever since Chuck was a boy, he and his sister Dorothy were fascinated with ACME as a company name, which many struggling young companies used to get their name at the top of the Yellow Pages. The name was infused with a sense of both entrepreneurship and snake oil—perfect for a cartoon that was already channeling Mark Twain, the great chronicler of America, as well as poking fun at America's hucksterism. Since Jones and Maltese were creating their cartoon during America's earliest efforts to explore outer space, their portrayal of ACME drew inspiration from an article reporting how an unmanned rocket costing half a billion dollars had exploded because of the failure of one small part costing 35

cents. Jones wanted ACME products to always be "*almost* perfect" but inevitably fail because of an undiscovered glitch. He also made it a rule that you never saw Coyote and ACME involved in financial transactions. When an interviewer asked Jones the reason for this, he laughed. "It is just fun for me to imagine that somewhere there is a company that provides, absolutely free, their inventions to coyotes."

In addition to the "rules" for the Coyote and Road Runner series, Jones had a set of rules for animation in general. These were distilled from lessons he had learned from other great minds he had met at Warner Bros.—Tex Avery, Friz Freleng, Mike Maltese, Tedd Pierce, Bob Clampett, and Robert McKimson—and can be adapted to many other creative endeavors:

1. You must love what you caricature. You must not mock it— unless it is ridiculously self-important, like those solemn live-action travelogues.
2. You must learn to respect that golden atom, that single frame of action, that 1/24 of a second, because the difference between lightning and the lightning bug may hinge on that single frame.
3. You must respect the impulsive thought and try to implement it. You cannot perform as a director by what you already know; you must depend on the flash of inspiration that you do not expect and do not already know.
4. You must remember always that only man, of all creatures, can blush, or needs to; that only man can laugh, or needs to; and that if you are in that trade of helping others to laugh and to survive by laughter, then you are privileged indeed.
5. Remember always that character is all that matters in the making of great comedians, in animation, and in live action.
6. Keep always in your mind, your heart, and your hand that timing is the essence, the spine, and the electrical magic of humor—and of animation.

Between 1949 and 1959, Jones and Maltese made sixteen Coyote and Road Runner shorts together (the series continued after that, but with outside writers and directors circulating in and out). Not only

did the series reinvent the format of chase cartoons, it became the genre's standard-bearer. And yet, it never won its creators an Academy Award for Best Animated Short. Tom and Jerry, on the other hand, would win seven Oscars between 1940 and 1958. Some film scholars have described this discrepancy as a cosmic injustice. Then again, perhaps it's appropriate, considering how Wile E. Coyote is supposed to be the quintessential loser. In any case, Chuck Jones never seemed bothered by the lack of recognition. He had another "rule" he turned to whenever he felt slighted. This rule had been passed down from his favorite uncle, Uncle Lynn, who once told him, "Chuck, they can kill you, but they're not allowed to eat you."

Even though Chuck Jones never won Academy Awards for the Coyote and Road Runner cartoons, he did win his share of them in the long run. The first came in 1949, for a cartoon titled *For Scent-imental*

Chuck Jones as a young man.

Reasons. It featured the debut of Pepé Le Pew, the amorous skunk that constantly falls in love with cats he mistakes for other skunks.

"Absolutely not! No skunks!" Warner Bros. executive Eddie Selzer shouted when he first heard the idea. Wearing spectacles resembling those of an accountant, Selzer had been in charge of the animation unit since 1944, after Leon Schlesinger officially sold his studio to Warner Bros. and moved into an advisory role. Some suspected that Selzer was put in charge of the animators because nobody in the Warner Bros. executive suite knew what else to do with him—the executives just wanted him out of the way. Jones couldn't stand Selzer—"He looked like Mr. Magoo and was a very strange man," he remembered. "He was just one of those people who spend their lives saying 'No,' which is a word anybody can use." (Selzer also rejected the idea of the Tasmanian devil, after seeing one for the first time and thinking it too grotesque.) Other Warner Bros. animators remembered Selzer constantly comparing things with the Warner Bros. executive dining room, which was off-limits to the rest of them. "He'd be talking about his living room and he'd say, 'It's two-thirds the size of the private dining room.' Or he'd say, 'I bought my new Cadillac and it's maybe one and a half times the size of the private dining room.'"

After Selzer rejected the Pepé Le Pew pitch, the animators pursued their skunk idea anyway, testing it in one-off films like *Odor-able Kitty* and *Odor of the Day* (they didn't yet use the name Pepé). "[Selzer] said there wasn't anything funny about talking French double talk, nobody would understand it, and he *forbade* me utterly to do it," Jones later said. "I did it anyway, just because he forbade me."

"No one is going to laugh at that shit," Selzer fumed after sitting through a screening of *For Scent-imental Reasons*, the first film to use Pepé Le Pew's name.

As they had done for Road Runner and Coyote, Chuck Jones and Mike Maltese designed Pepé as part of their grand strategy to upend the stale conventions of chase cartoons. "The entire cat-mouse cartoon cycle, the chase cycle, might be called 'oral' today," Jones later said. "But in those days, it was a matter of eating somebody, like a cat eating a mouse. Nourishment. Sustenance. Survival. Today, if you say that a character is going to eat somebody—well, it has a different meaning. But the skunk Pepé was unique in chase cartoons of

the period in the sense that he was after the cat, well, to screw her, I suppose."

Pepé Le Pew's dating habits would trouble later generations. If the cartoon had been created a half-century after it was, one suspects that its creators probably would have reassessed a few things. When asked, in 1972, which character audiences were supposed to relate to—Pepé or the cats he pursues—Chuck Jones wasn't quite sure. "I've never been able to discover that," he said. Then he added a caveat that would complicate his answer for more modern audiences: "Because all the girls I've ever known adore the Pepé character as a sex object, you might say—he was really irresistible."

Jones and Maltese's intent with Pepé Le Pew wasn't to glorify bad behavior, or to outrage younger generations. The character started as a way to poke fun at their friend Tedd Pierce, a Warner Bros. writer who was always baffled when women didn't return his attentions.

Chuck Jones and Michael Maltese created Pepé Le Pew in part to poke fun at the narcissism of a Warner Bros. colleague.

"Tedd could not really believe that any woman could honestly refuse his honestly stated need for her," Jones said of his friend. "It would have been impossible to have worked with Tedd and *not* come up with the idea of Pepé Le Pew."

Jones also used Pepé to explore his own youthful insecurities from the past. "I wanted to be irresistible," he said of his vulnerable teenage years. "Not only was [Pepé] completely sure of himself, but it never occurred to him that anything was wrong with him. Ever! I was always aware of my broken shoelaces or my body odor, or whatever." Pepé was a fantasy vision of all the things young Chuck Jones wasn't: "I was a wimp-nerd-nebbish. I was 6'1" and weighed 132 pounds. I was transparent to the other sex; girls could look through me to admire other boys," he said. "Pepé was quite the opposite of that."

Mel Blanc modeled Pepé's bedroom-murmur voice after French matinee idol Charles Boyer, who played a character named Pepé Le Moko in the 1938 film *Algiers.* Blanc said he thought of the character as poking fun at narcissists. "Pepé is so intoxicated by *amour*, he doesn't realize he is kissing his own paw; what's more, the skunk is so unashamedly full of himself, he doesn't particularly care."

Barely three months after Pepé's debut in *For Scent-imental Reasons*, the film won Jones his first Academy Award (he would direct nearly a dozen more Pepé Le Pew cartoons by 1962). But Eddie Selzer accepted the statue at the ceremony, since he was technically credited as the producer, even though he originally hated the idea and had contributed nothing creatively to the series. Selzer strolled confidently across the stage to accept the award, waving at the audience and smiling warmly at the presenters. Then he took the statue straight home, leaving the animators to wonder if he put it on his mantle or just stashed it in a drawer somewhere.

Chapter 31

"And It's Going
to Be Clean!"

Walt Disney was at a crossroads concerning the future of his busi-
ness, now well into its third decade. A corporation ages like a person.
The youthful years are creative and forward-looking, then give way
to middle age, which is more careful and conservative. The company
doesn't want to destroy what once made it great, but needs to adapt
if it wants to stay great. As the 1940s ended and the 1950s began, this
is the position Walt Disney found himself in, figuring out how his
corporation should adapt.

In 1946, Disney began corresponding with edgy artists about
starting new projects, looking to inject his career with a little adrena-
line. He became a trustee of New York's Museum of Modern Art and
started having meetings with artist Thomas Hart Benton to discuss
working on something together. He also met with Salvador Dalí to
discuss collaborating on an animated film of "Destino," a Mexican
folksong about how destiny shapes two lovers' lives. "The thing I
resent most is people who try to keep me in well-worn grooves," he
told the *Los Angeles Times* about the project, for which Dalí spent eight
months at the studio, creating 22 paintings and 135 storyboards for
the film (they never finished it together, although a version would
be released in 2003). Disney also met with Orson Welles—who had
approached him—about adapting Antoine de Saint-Exupéry's *Little
Prince* into a feature cartoon. Disney ultimately declined, muttering
as he left his lunch meeting with Welles, "There is not room on this
lot for two geniuses."

None of these potential projects with other artists came to full fruition. Behind the scenes, Roy was telling Walt that money was a problem and that investors were wary of speculative gambles. Heading into the 1950s, the studio focused its attention on making the kind of features it was good at, all of them safe bets. Throughout the decade it would release *Cinderella, Alice in Wonderland, Peter Pan, Lady and the Tramp,* and *Sleeping Beauty,* while also expanding into the production of more live-action features such as *Treasure Island, 20,000 Leagues Under the Sea,* and *Old Yeller.* Most of these features were popular and successful but didn't attract the exciting buzz once enjoyed by *Snow White* or *Fantasia,* when the release of a new Disney movie was a true cultural moment. Critics had long since complained that Disney's storylines were less ambitious than ever, plagued by sentimental kitsch. Bosley Crowther of the *New York Times,* once a fierce champion of Disney's work, scolded him for "adjusting his art to what he considers the lower taste of the mass audience."

Truth be told, Disney was losing interest in his films. He no longer gave them as much attention as he used to, attended production meetings less frequently, and was happy to hand more control of the films over to his staff. He also began allowing shortcuts that would have been forbidden before. The detailed chiaroscuro effects of *Pinocchio* and *Fantasia* were replaced by sharper lines and brighter surfaces, which were easier and cheaper to animate. He also started surrendering his once impeccable instincts to judgments from the Audience Research Institute, consultants who would stand outside theaters, clipboards in hand, polling audiences. The use of ARI was a sign to some that the company had reached those saggy middle-aged years, of trying to maintain rather than build. "We're through with caviar," Disney told *Time* in 1954, when it was clear that his taste for ambitious film projects was dwindling. "From now on it's mashed potatoes and gravy."

But even though Disney's empire seemed to be running out of breath, the man himself was actually becoming more ambitious. He didn't see himself as just a filmmaker; he was a builder, a shaper of culture. He had already conquered the world of cartoon shorts and features and was now shifting his attention to something new.

* * *

Those who knew Walt Disney often said that 1947 was the year his focus changed away from movies. It was also the year of a powerful symbolic moment: Walt officially stopped voicing Mickey Mouse, a role he had performed since the beginning. Years of filterless Camel cigarettes had turned his voice into a thick growl; Mickey was starting to sound like a gangster. In a passing of the baton, Disney assigned Mickey's voice to sound effects artist Jimmy Macdonald, who would perform it for the next thirty-eight years. Macdonald remembered Disney assigning him the duties casually, with little nostalgia, ready to move on.

Disney discovered a new passion that year: collecting miniatures —figurines, furniture, automobiles, even tiny liquor bottles and crates. They started as a hobby and then quickly became all he talked about. He bought them through catalogues and hobbyist magazines, frequenting all the local shops that sold them, scheduling his business trips to coincide with miniatures conventions. The hobby dovetailed nicely with Disney's fondness for model trains. He spent much of his free time building elaborate miniature landscapes for them at his house—popping out like a prairie dog, a conductor's hat atop his head, when his family called him for meals. In 1948, after Disney visited the Chicago Railroad Fair with fellow train enthusiast and animator Ward Kimball, Kimball wrote that Walt was "in a state of unrestrained bliss" the whole time.

Disney wrote to his sister that these hobbies—miniatures and model trains—offered refuge "when studio problems become too hectic." Previous escapes—his studio and cartoons—were now the things that needed escaping from. He had lost his total control over them—because of either labor problems, his reliance on government contracts, or financiers that wanted him to stick to safer material. This sense of losing control was a common mood of the times—a unique malaise infected the culture, despite the booming economy. Suburbanization, the Cold War, McCarthyism, and disruptive changes in mass communication and travel had upset many familiar patterns of American life. Other big-name artists of the era—Jackson Pollock, James Dean, Albert Camus—all played with themes of trying to understand this new chaos. An existentialist dilemma was in the air and was interpreted by many as individuals—or the individual—losing

control to unknowable outside forces. Disney's new hobby of collect-
ing miniatures and model trains, then creating alternative worlds out
of them, was a way to regain that control.

By the early 1950s, Disney contemplated taking his miniatures
on a U.S. tour. His plan was to use them to build a model of a small
American town around the turn of the century—not unlike Marceline,
Missouri. He told friends the traveling exhibit would double as a way
to promote traditional values. One day, Disney cornered studio layout
artist Ken Anderson and asked for help starting the project. "You can
paint some paintings like Norman Rockwell," he told Anderson, "and
I'll build them."

The planning was done secretly. Disney put Anderson on his
personal payroll and hid him away in an unused room in the Anima-
tion Building (only he and Anderson had keys). Anderson got down
to painting, depicting a nostalgic vision of America that made Currier
and Ives prints look downright edgy: a general store, a grandmother
knitting in front of the hearth, a blacksmith taking a break, a minister
in the pulpit guiding his flock. As Anderson painted, Disney would
go missing for days, suddenly reappearing in the room holding sacks
full of material to use for his miniatures. One miniatures vendor
remembered Disney telling him, "I become so absorbed that the cares
of the studio fade away."

As with many Disney projects, the size and scope quickly grew.
Sculptors and additional sketch artists were quietly enlisted. After
Disney decided that the scenes couldn't be static—they would need
to move—a machinist named Roger Broggie, who had helped Disney
build a model train, was hired to help create animatronic figures. Dis-
ney described the various tableaux as "visual juke boxes," and came
up with a name for the exhibition: "Disneylandia." Soon Disneylandia
would be used as a test run for something much larger. As historian
Jackson Lears would note, "The quintessential product of the [Disney]
empire would not be fantasy, but simulated reality."

Disney was pondering getting into the amusement park busi-
ness, a move that confused some. Disney himself considered many
such parks "dirty, phoney places, run by rough-looking people." In
that era, amusement parks were scary: the grimy cousins of travel-
ing carnivals, where sneering carnies lurked under the creaky rides,

hoping to collect the loose change falling out of people's pockets. Many were modeled after Coney Island, where Dave Fleischer had once worked as a boardwalk clown harassing women. In a way, amusement parks were an analogue to Warner Bros. cartoons: chaotic and noisy.

On the surface, an amusement park seemed like an odd choice for Disney. But Walt was a visionary who saw how recent demographic changes in America now gave amusement parks new potential. After the war, Americans had more disposable income, more children that needed entertaining, and a growing federal highway system that would make travelling to parks easier. As for the poor reputation of amusement parks, Disney had a fix. He told a friend, "I'm going to build an amusement park—and it's going to be clean!"

Disney began researching amusement parks in the same way he had once made movies, sparing no expense. Jack Cutting, head of foreign operations, was sent to scout merry-go-rounds in Europe. Disney likewise began scouting ideas by touring other parks: Colonial Williamsburg in Virginia; Knott's Berry Farm south of Los Angeles; and Henry Ford's Greenfield Village in Michigan, which reconstructed the Wright brothers' bicycle shop and Edison's laboratory. During the trips, he would whip out a tape measure and record the width of the walkways, jotting down notes about traffic flow and crowd management. The notes were then put on a board—like a storyboard—that Walt would sit in front of for hours, moving them around like storylines in a plot, describing the park's layout like the different parts of a movie: "This is scene one, this is scene two, and this is scene three."

In 1952, Disney sat down with the architects William Pereira and Charles Luckman to chat about his idea. When they were done, Pereira said he had fallen for the project "hook, line, and sinker." The two architects, childhood friends, were known for a flamboyant and futuristic style that was popular in Los Angeles. By choosing them, Disney signaled his desire to capture the eccentric and unruly feel of his adopted hometown; his park would be a mishmash, inspired by the same movies that had built the city. He told a designer to model the park's Old West saloon after the one filmed in *Calamity Jane,* and to model the jungle ride on *The African Queen.* The park's castle was

modeled after Neuschwanstein Castle in Bavaria, the heart of Grimm fairy-tale country.

Disney planned to build a high embankment around the park's edge to hide the surrounding world from view—no outside reality would penetrate here. "[W]hen you enter DISNEYLAND," read a promotional brochure, "you will find yourself in the land of yesterday, tomorrow, and fantasy. Nothing out of the present exists in DISNEYLAND."

Disney hired a research firm, the Stanford Research Institute, to begin scouting potential sites. SRI determined the park should be in Orange County, just south of the city. The area was growing in population (lots of potential customers), was situated well for transportation, and had good weather: the least rainfall and humidity in the area, with relatively stable temperatures. SRI examined more than forty sites, eliminating one because it was in view of ugly oil wells, and another because it was close to a housing development for Mexican laborers. The researchers finally settled on a 160-acre plot of orange trees that swayed in the breeze as they walked among them during a site visit. The price was relatively cheap and the owners were willing to sell. Now the only problem was getting the money.

Walt Disney had an elegant solution for financing his park: television. By embracing the new technology, he stood in contrast to Hollywood's other moguls, who were skeptical of television's future. "How can anyone watch a big picture on that little box?" Jack Warner had asked. The film industry responded to the threat of television in the same way it had responded to the threat of radio: by launching a PR offensive against it—"Get More Out of Life, Go Out to a Movie," read one advertising campaign. The film executives then ignored television after various research groups assured them, foolishly, that there was nothing to worry about. "Moviegoing has become a fixed habit with the American people, and it is unlikely to be shaken by the advent of television," the Twentieth Century Fund, a think tank, reported in 1948.

While other moguls lobbied against television, Disney embraced it. "Television is the coming thing," he told his staff in 1947, after

spending an entire week watching it day and night. He saw it as an ally of the motion picture, not an enemy. Even though television might kill off the B-movie, he told the *New York Times*, it would make up for this by offering a platform to show reruns and would provide studios another way to advertise movies.

In early 1950, Disney began developing a television show. By summer he made arrangements with NBC to air a Christmas special, sponsored by Coca-Cola. It would feature a few cartoons and a teaser for his upcoming feature, *Alice in Wonderland*. After it aired, Disney read a Gallup poll about how well the special had promoted the film. Thereafter, he suddenly began using the words "television" and "point of sale" in the same sentence. He was getting a sense of how it all worked. Walt and Roy then discussed creating a series, and how that series could attract investment for their park. Various ideas included a daily fifteen-minute program called *The Mickey Mouse Club*, aired live from Disneyland; and a thirty-minute World of Tomorrow series, pondering mankind's past and future, that would combine live action with animation.

Disney began pitching the idea to networks, but NBC passed and his meeting with CBS fell through. Missing out on the two biggest networks wasn't good—NBC then had sixty-three affiliates and CBS had thirty. The best option left was ABC, a less established network with only fourteen affiliates. The good news was that ABC was eager to do business. It wanted to catch up to its rivals by partnering with motion picture studios, a smart strategy that would help it avoid the expense and time of developing its own material. With an eye on the growing demographic of "youthful families," ABC Chairman Leonard Goldenson told Disney his company would be a perfect match. By means of looping in outside investment—Karl Hoblitzelle, a Texas investor looking to spend a recent windfall of cash—a deal was arranged, with Hoblitzelle underwriting the series for $5 million. It was called *Walt Disney's Disneyland*. Said Disney, "ABC needed the television show so damned bad, they bought the amusement park."

As Disney and his staff began planning the show's format, he told them, "The main idea of the program is to sell." The show would be a mix of animation, live action, and documentaries—there were no restrictions, so long as the segments promoted both the studio's films

and the park. Separate production units came up with material specifically for each of the "lands" in the park: Fantasyland, Adventureland, Frontierland, and Tomorrowland. In theory, a documentary on, say, Africa, would promote Adventureland, while a show about American folk heroes like Davy Crockett would promote Frontierland. The genius of it all was captured in a quote from a parent interviewed by *Time*. "Why, every kid in the country will be hounding his father for a trip to California."

Walt Disney's Disneyland premiered on October 27, 1954. Most television programs of the era were still so bad that the show couldn't fail to become a gargantuan hit, attracting more than 50 percent of television audiences during its time slot. The *New York Times* wrote that the rest of the industry should just give up and "suspend operations between 7:30 and 8:30 Wednesday nights." Even the repeat airings beat all other shows, save *I Love Lucy*. *Disneyland* accounted for half of ABC's billings and put the network on the map, giving it an identity.

Disney always hosted the show wearing a dark suit, his hair neatly combed. He resembled some kind of national uncle. Weighing 190 pounds, he was now huskier than he had ever been; gone was the youthful intensity, traded in for his image as the postwar corporate figure that later generations would come to remember. To his detractors, such as historian Jackson Lears, he was now the "most flagrant example of that widespread phenomenon in American cultural history: the innovator presenting himself as a traditionalist, the mortal enemy of folk life declaring himself its chief defender, the capitalist tricked out as a populist." Film critic Richard Schickel claimed that none of Disney's admirers seemed to notice that their "loved object was less a man than an illusion created by a vast machinery." Or perhaps those admirers simply didn't care. Instead, they chose to remember Walt just as *Time* portrayed him on the cover of its issue of December 27, 1954, in an article entitled "Father Goose."

Ground was broken for Disneyland, the park, on July 12, 1954. During construction, Disney resembled how he had been during the happy years leading up to *Snow White*. He even dressed as he had back then—losing the gray suits for loud shirts and floppy hats. "He

walked over every inch of Disneyland," Ward Kimball remembered. Staff recalled him cresting the parks' hills, walking fast and shouting orders; sometimes they would find him down on his hand and knees, examining some small detail, and have to swerve in order to avoid tripping over him.

The park would reflect Disney's persona and outlook the same way his movies did, as well as the suspension of reality. At the end of Main Street sat Sleeping Beauty Castle; radiating out from it were "lands" offering guests different options—fantasy, adventure, the frontier, the future—"so that a trip through the park became a metaphor for possibility," noted historian Neal Gabler. Different parts of the park were built to varying proportions, usually smaller than life-size, to help create the sense of being in a different reality. "This costs more," Disney explained, "but [makes] the street a toy, and the imagination can play more freely with a toy." In most cases, this gave guests the sense of being bigger than they were. "You know, tyrants in the past built these huge buildings—look how big and powerful I am," Disney explained. He wanted people to feel the effect of a smaller scale, as if they towered over the buildings, as if they had power.

Park staff was trained at "Disney University." There were no old circus carnies here; employees were carefully chosen. "We don't hire for jobs here," the training program's director told a reporter from the *New Yorker*, "so much as we cast for parts." The strict dress code contained a double standard—no facial hair, even though Disney had a mustache. The head of personnel explained the grooming guidelines to a reporter: "No bright nail polish, no bouffants. No heavy perfume or jewelry, no unshined shoes, no low spirits. No corny raffishness." Even though the studio had never overtly discriminated, some questioned why the park hired so few blacks. In 1963, the Congress of Racial Equality raised the matter with Disneyland's board of directors and was told requests would be looked into, but not necessarily acted upon. If anyone was being discriminated against, according to the first manager of Adventureland, it was probably heavy people like himself. "Walt doesn't like fat guys," he said.

When the time came to hook the park up to power, Disney tried to honor the capitalist principles he had been honing since his falling-out with the unions. Power was supposed to be purchased from a

local municipality, but a local utilities baron told Disney that doing so would be socialist, and convinced him instead to buy power from a privately owned firm, which the utilities baron just happened to own. Disney agreed and then watched in horror as the company ruined the beautiful atmosphere of his park with ugly poles. "I stood in the middle of *my* park and all I could see were high tension lines," he recalled. "It was awful." The company refused to bury the lines unless Disney paid the exorbitantly high cost, which he did.

Countless hiccups occurred during construction. Anaheim's sandy soil didn't accommodate the Rivers of America ride; the water seeped through, leaving dry gulches requiring mountains of clay to be trucked to the site. Unions also created problems, no doubt to Walt's rage, and at one point threatened not to install the drinking fountains. Another group of workers sabotaged the Mr. Toad ride because they felt they were being worked too hard.

As the July 17, 1955, opening neared, some worried that the park wouldn't be finished in time. Disney quickly schemed up ways to hide projects that weren't ready. Unable to control the weeds growing next to the rides, he told his groundskeepers to label them with Latin names, as if they were specimen plants. Explaining why some parts looked unfinished, he told reporters, "The park means a lot to me, in that it's something that will never be finished, something that I can keep developing, keep plussing and adding to."

Three days before the grand opening, Disney celebrated his wedding anniversary at the park, inviting guests for a sneak peek. Along with his family, countless celebrities participated, including Gary Cooper, Cary Grant, Louis B. Mayer, and Spencer Tracy. The celebration stretched long into the night, winding down with everyone crowding around the bar at the Golden Horseshoe Saloon. Walt swayed drunkenly up in the balcony, shooting imaginary bullets from his fingers down at the stage. His daughter Diane drove him home later, remembering how he sat beside her, "tootling" into a rolled-up map of Disneyland, as if it were a trumpet. Then he mumbled himself to sleep with a song.

Opening day was both a disaster and a success. The park's capacity was 15,000, but an estimated 28,000 showed up. Someone had printed counterfeit tickets, and somebody else leaned a ladder against

the embankment, letting cheapskates in for only $5 a head. As the sun warmed up, women's high heels sank into the hot asphalt. People complained about how the unions hadn't installed enough drinking fountains. Guests on the Tomorrowland ride wondered why it ended so abruptly in an ugly field of brown dirt.

These setbacks were just the downside of a much larger success, however. For every reporter who said "Walt's dream is a nightmare," many more said things like "Mr. Disney has tastefully combined some of the pleasantest things of yesterday with the fantasy and dreams of tomorrow," which is how the *New York Times* put it. ABC's opening-day broadcast reached 70 million viewers and was cheerfully hosted by Art Linkletter, Ronald Reagan, and Robert Cummings. People showed up in droves. Within three years, Disneyland would surpass Yellowstone, Yosemite, and the Grand Canyon as a tourist draw. Earnings of Disney stock rose from 35 cents in 1952, on revenues of $7.7 million, to $2.44 on revenues of $35 million five years later.

Disney's studio had always struggled with money problems, but his park finally made him a true tycoon. He had crossed over. People began to see him as more than just an entertainer; he was a special kind of leader, able to accomplish great feats of epic scale. Several years later, the writer Ray Bradbury asked Disney if he would consider running for mayor of Los Angeles. The city, infected by sprawl and pollution, was spiraling toward disaster. Bradbury thought Disney was the only one with enough imagination to fix it. Walt was flattered by the idea but politely declined. "Ray," he said, "why should I run for mayor when I'm already king?"

Chapter 32

"Silly Rabbit . . ."

Gradual shifts in economics, technology, and politics shape culture in the same ways that glaciers, rivers, and wind shape landscapes. The process seems slow, but sometimes outside catalysts—a bolt of lighting, an earthquake, a wildfire—speed things along. In the late 1940s and the '50s, three such catalysts forever changed animated cartoons: the studio system's fall, television's rise, and demographic changes spurred by the postwar baby boom.

In 1948, the Supreme Courted decided a landmark case, *The United States v. Paramount Pictures, Inc.*, which broke up the studio system. It was one of the biggest antitrust decisions in U.S. history, forever changing the movie business. Among other things, the ruling banned the unpopular practice of "block booking," which the studios had long used to force theater owners into renting films they didn't want. With block booking, theater owners were presented with a menu of feature films, each packaged with a lineup of other films that might include a newsreel, a cartoon, a serial or documentary, a comedy short, a B-picture, and then, finally, the A-picture. If a theater owner wanted to rent only the feature, he or she still had to rent everything that came with it—to get a jewel, one had to accept a pile of garbage. Once block booking was banned, however, theater owners could pick and choose just the parts they actually wanted. Soon the least popular parts of the package—newsreels, documentaries—were headed toward oblivion, and cartoon shorts were likewise on thin ice. Theater owners had never much liked paying for them—aside from the most popular offerings—knowing that most audiences were really there to see the features. Theatrically released cartoon shorts wouldn't immediately go extinct, but they were now living on borrowed time.

A year after the Supreme Court's decision, Americans spent a smaller share of their incomes on movies than at any other time since the Great Depression. It was the beginning of a trend. According to the U.S. Census Bureau, weekly attendance at movie theaters dropped from 90 million in 1946 to 60 million in 1950, and would drop to 40 million by 1960 (staggering figures, considering that the population was increasing as these numbers fell). This was not because of the court's decision, but more likely because more people were choosing instead to stay home and watch television. Between 1950 and 1955, the number of TV sets in U.S. households increased from 3.9 million to 30.7 million. Television was bound to change the content of cartoons because the economics of television were so different from those of movie theaters. TV made money not from ticket sales, as theaters did, but from advertising. Those footing the bill were no longer audiences sitting in dark theaters, just wanting to be entertained; they were now advertisers with something to sell, and the message needed modifying accordingly.

The third factor affecting the nature of animation was a dramatic shift in audience demographics. Between 1944 and 1961, more than 65 million children were born in the United States. At the peak of this baby boom, one child was born every seven seconds, and by the mid-1960s four out of every ten Americans were under the age of twenty. This shift coincided with Americans migrating to suburbs, where there were fewer theaters per capita than in cities. In the suburbs, kids and television sets blossomed like mushrooms, and parents soon realized that those sets could be used as free babysitters. Advertisers hungrily eyed those parents' disposable income, brought on by the booming postwar economy, and soon realized that those kids provided a way into their parents' pocketbooks.

The earliest days of mainstream television programming were dismal. Airwaves were a great empty space, seemingly infinite, that needed to be filled. Programmers were so starved for material that they were willing to air anything, no matter how bad. They desperately filled the airtime with horrible variety shows and stale routines from comics whose careers had cratered during the Hoover administration.

According to comedian Fred Allen, television was "a device that permits people who haven't anything to do to watch people who can't do anything." Groucho Marx joked that he found television "very educational," because "every time someone switches it on, I go into the other room and read a book."

In 1950, as television programmers struggled to figure out their medium, a watershed moment occurred: a new cartoon series surfaced, entitled *Crusader Rabbit*, created by Jay Ward, a television producer; and Alexander Anderson, an animator who had previously worked for Paul Terry. Produced on a shoestring budget allowing for only the most limited kind of animation—imagine cardboard cutouts floating across a screen—the series was built around the adventures of a small crew of characters: the companions Crusader Rabbit, Ragland T. Tiger ("Rags"), Garfield the Groundhog, and their adversaries Dudley Nightshade, Whetstone Whiplash, and Billious Green. Even though the satirical plots were simple, they could also be clever, in the way of a sly wink, and seemed intended for the tastes of in-the-know adults. What made them really stand out, however, was their short length—only four minutes—which, combined with the show's humble production values, allowed an astonishing number of them to be produced: 195 episodes in two years. The most remarkable thing about *Crusader Rabbit*, however, was that it was the first animated series produced specifically for television, not theaters.

Even though *Crusader Rabbit* had an adult feel to it, television programming began to change in the years immediately following its debut, as programmers cast an eye toward the nation's growing demographic of children. For programmers, the most problematic part of their schedule was Saturday morning, when people tended to be running errands or enjoying their weekend, and were not likely to be watching television. Children, however, were not in school, and it stood to reason that parents might appreciate a way to occupy them. Sensing an opportunity, CBS in 1953 premiered a cartoon called *Winky Dink and You*, which aired at 10:30 A.M. on Saturday, a good time for exhausted parents to catch their breath by putting their kids in front of a TV. The show's main character, Winky Dink, enlisted participation by kids who would place a plastic sheet over the television screen and help him "connect the dots" using special "magic" crayons. Just

as this programming was adapted to children, so was the marketing associated with it, like a virus to a new host. The show's masterminds amassed an additional fortune by selling the children's parents "kits," which were basically just the same wax paper and crayons that could be purchased at a grocery store for much less money.

The idea of using cartoons to generate ancillary income was long known—in the 1920s, *Felix the Cat* sparked a merchandising bonanza; in the sound era, studios were adept at using cartoons to promote songs from their music catalogues. But *Winky Dink and You* represented another level of salesmanship: it doubled as an actual commercial for a product, specifically promoting it. Advertisers must have eyed this strange new ecosystem in front of them—populated by television, kids, and advertisements—and spoken of it in the way that gold prospectors in 1849 once talked about California.

The powerful new forces shaping this advertising ecosystem were bright and shiny on the outside, but strange and dark on the inside. Advertisers' jobs were made easier by a loophole in the National Association of Broadcasters Television Code: while prime-time "adult" programming couldn't contain more than nine-and-a-half minutes of advertising per hour, "children's" programming had no such restraint, and could be filled with sixteen minutes of advertising per hour— children could be bombarded with advertising at almost double the rate of adults. Advertisers, ever shrewd, began asking what kind of products children would be most susceptible to on Saturday morning. Logically, they concluded it was breakfast cereal.

In 1954, General Mills introduced a breakfast cereal called Trix, a sweeter version of Kix, a healthier alternative that was historically marketed to adults. Made from 46 percent sugar, a recipe kids were sure to love, Trix was marketed with a cartoon rabbit and the slogan "Silly rabbit, Trix are for kids!" Over the next two decades, grocery-store cereal aisles became flooded with similar cartoon characters appealing to children. When children saw commercials for these products on Saturday morning, they could hardly tell the difference between the advertisements and the programming.

Over time, the connection between cartoons and specific commercial products became even more pronounced. By 1964, a cartoon called *Linus the Lionhearted* was created solely to promote a

Traditional cartoon studios suffered financially as they struggled to compete within the new television paradigm. Many began looking for alternative sources of revenue. In 1954, Warner Bros. accepted money from the conservative Sloan Foundation—founded in 1934 to honor General Motors CEO Alfred P. Sloan—to make three short films glorifying shopping and consumerism, all directed by Friz Freleng. The first was *By Word of Mouse,* about a German mouse named Hans who visits America, where his cousin, Willie, lives in a shopping mall and can't stop talking about the glories of "mass consumption and mass production." The second, *Heir-Conditioned,* from 1955, featured Elmer Fudd trying to convince Sylvester the Cat to invest his inheritance rather than spend it. The third, *Yankee Dood It,* from 1956, was based on the classic fairy tale *The Elves and the Shoemaker* and cast Elmer Fudd as King of the Industrial Elves, explaining capitalist theory to his minions and showing them how to run a profitable factory.

What was most interesting about the Sloan Foundation–sponsored cartoons, besides their message, was how cheaply they were made—less than $30,000 each. Shortcuts meant choppier motion and fewer fine details. The visuals seemed borrowed from the faded industrial documentaries of World War II, all cheaply made, about the systematic movement of machines and weaponry. It was a look that was becoming more common among both new studios and traditional ones as they slashed costs to stay profitable. Frequently referred to as "limited animation," the style made popular by UPA, it often gave up the use of twenty-four cels per second, which created smoother action, and adopted a standard as low as twelve frames per second, resulting in a more stuttered, rough-feeling look.

Limited animation was the norm for television, where characters often resembled cardboard cutouts floating across a screen, as they had in *Crusader Rabbit.* While the aesthetic might not have been as visually appealing as before, it enabled far greater output. Previously, at studios like Warner Bros., yearly output was usually around ten cartoons, all at six or seven minutes each, equating to about an hour's worth of material each year. Now, under economics that valued quantity over quality, animators working in television produced roughly three hours of material per *week.* The studios that would come to dominate television animation—Hanna-Barbera, DePatie-Freleng,

that resembled Disney characters. The TV commercial for "Puppets Cereal" urged kids to "Have fun with your puppet toys. Play with them . . . *sleep* with them."

Breakfast cereal manufacturers and other advertisers amassed startling influence over cartoons. In 1957, Walter Lantz, who had created Woody Woodpecker in the 1940s, decided to syndicate fifty-two of his old theatrical cartoons for television through a licensing deal with the Kellogg Company. Before the shorts could air, however, the cartoons had to be approved by the Leo Burnett ad agency, which represented Kellogg's cereals. Lantz later told the *Hollywood Reporter* that advertising agencies' censorship was more draconian than anything the Hays Office had ever enforced. Controversial material was cut: references to drinking, tobacco use, neurotic behavior (a mainstay of Woody Woodpecker cartoons), and depictions of African Americans, even if they were flattering. Said Lantz, "The agency reasoning was that if there was a question at all on a scene, why leave it in?" Lantz thought that the edited versions of the cartoons, after having so much material cut from them, were incoherent.

Censored versions of classic cartoons became what younger generations—those born after World War II—would ultimately come to know, never fully realizing what those cartoons had originally been. When shown on television, Disney cartoons were edited to remove anything even remotely controversial: a shot of Goofy with his mouth full of cold pills, a cat drinking liquor, people lighting fires, Pluto drowning, Donald Duck spanking a penguin, and Donald, again, trying to commit suicide. When ABC began syndicating classic Warner Bros. cartoons for *The Bugs Bunny Show*, the network likewise censored any provocative bits: collisions, explosions, falls, and even pie-in-the-face gags.

Over the years, animators who were familiar with the original versions of the classics watched in horror as their legacies were castrated. "When did we decide to allow our film heritage to be chopped up and hidden away from us for the 'public good' and 'political correctness?'" asked Mark Kausler, a former Disney animator. He then added, "I'm not surprised by this, only saddened. People ultimately don't gain rights when history is altered or censored, they lose them."

* * *

Traditional cartoon studios suffered financially as they struggled to compete within the new television paradigm. Many began looking for alternative sources of revenue. In 1954, Warner Bros. accepted money from the conservative Sloan Foundation—founded in 1934 to honor General Motors CEO Alfred P. Sloan—to make three short films glorifying shopping and consumerism, all directed by Friz Freleng. The first was *By Word of Mouse*, about a German mouse named Hans who visits America, where his cousin, Willie, lives in a shopping mall and can't stop talking about the glories of "mass consumption and mass production." The second, *Heir-Conditioned*, from 1955, featured Elmer Fudd trying to convince Sylvester the Cat to invest his inheritance rather than spend it. The third, *Yankee Dood It*, from 1956, was based on the classic fairy tale *The Elves and the Shoemaker* and cast Elmer Fudd as King of the Industrial Elves, explaining capitalist theory to his minions and showing them how to run a profitable factory.

What was most interesting about the Sloan Foundation–sponsored cartoons, besides their message, was how cheaply they were made—less than $30,000 each. Shortcuts meant choppier motion and fewer fine details. The visuals seemed borrowed from the faded industrial documentaries of World War II, all cheaply made, about the systematic movement of machines and weaponry. It was a look that was becoming more common among both new studios and traditional ones as they slashed costs to stay profitable. Frequently referred to as "limited animation," the style made popular by UPA, it often gave up the use of twenty-four cels per second, which created smoother action, and adopted a standard as low as twelve frames per second, resulting in a more stuttered, rough-feeling look.

Limited animation was the norm for television, where characters often resembled cardboard cutouts floating across a screen, as they had in *Crusader Rabbit*. While the aesthetic might not have been as visually appealing as before, it enabled far greater output. Previously, at studios like Warner Bros., yearly output was usually around ten cartoons, all at six or seven minutes each, equating to about an hour's worth of material each year. Now, under economics that valued quantity over quality, animators working in television produced roughly three hours of material per *week*. The studios that would come to dominate television animation—Hanna-Barbera, DePatie-Freleng,

as this programming was adapted to children, so was the marketing associated with it, like a virus to a new host. The show's masterminds amassed an additional fortune by selling the children's parents "kits," which were basically just the same wax paper and crayons that could be purchased at a grocery store for much less money.

The idea of using cartoons to generate ancillary income was long known—in the 1920s, *Felix the Cat* sparked a merchandising bonanza; in the sound era, studios were adept at using cartoons to promote songs from their music catalogues. But *Winky Dink and You* represented another level of salesmanship: it doubled as an actual commercial for a product, specifically promoting it. Advertisers must have eyed this strange new ecosystem in front of them—populated by television, kids, and advertisements—and spoken of it in the way that gold prospectors in 1849 once talked about California.

The powerful new forces shaping this advertising ecosystem were bright and shiny on the outside, but strange and dark on the inside. Advertisers' jobs were made easier by a loophole in the National Association of Broadcasters Television Code: while prime-time "adult" programming couldn't contain more than nine-and-a-half minutes of advertising per hour, "children's" programming had no such restraint, and could be filled with sixteen minutes of advertising per hour— children could be bombarded with advertising at almost double the rate of adults. Advertisers, ever shrewd, began asking what kind of products children would be most susceptible to on Saturday morning. Logically, they concluded it was breakfast cereal.

In 1954, General Mills introduced a breakfast cereal called Trix, a sweeter version of Kix, a healthier alternative that was historically marketed to adults. Made from 46 percent sugar, a recipe kids were sure to love, Trix was marketed with a cartoon rabbit and the slogan "Silly rabbit, Trix are for kids!" Over the next two decades, grocery-store cereal aisles became flooded with similar cartoon characters appealing to children. When children saw commercials for these products on Saturday morning, they could hardly tell the difference between the advertisements and the programming.

Over time, the connection between cartoons and specific com-mercial products became even more pronounced. By 1964, a car-toon called *Linus the Lionhearted* was created solely to promote a

sugary breakfast cereal from Post Cereals (it featured voices from Sheldon Leonard, Carl Reiner, Jonathan Winters, and Jerry Stiller). Industry-watchers described it as a "half-hour commercial," meaning a television show aimed at children using cartoon characters created specifically for those commercial products. It wasn't until 1969, after protests from watchdog groups, that the FCC forbade children's show characters from appearing in advertisements on the same program, and *Linus the Lionhearted* was canceled.

Like a disease spreading from a mainland out across an archipelago, corporate influence continued. Eventually, advertisers began conscripting classic cartoon characters into their ranks. In 1965, Bugs Bunny, a character who once defined rebellious cool, became the official spokesperson of presweetened Kool-Aid. (In 1970, after the FDA banned the use of sodium cyclamate, an artificial sweetener then used in Kool-Aid products, Bugs Bunny's image was removed from product packaging so consumers wouldn't confuse the new Kool-Aid formula with the old.) In 1966, Nabisco teamed with Disney to sell "Puppets Cereal," a sugary cereal packaged inside puppets

Cel from a Cap'n Crunch commercial after breakfast cereal manufacturers began heavily influencing the tone and character of cartoons.

Filmation, and Ruby-Spears—produced homogeneous work that was difficult to differentiate, especially when compared with the work of their predecessors at Disney, Fleischer, Warner Bros., UPA, and MGM, all studios that had distinct personalities. One critical animator said that the new studios' work was little more than "creative bookkeeping with moving arms and legs."

Of the old animation moguls, one of the few who eagerly rushed into television, besides Walt Disney, was Paul Terry. This surprised nobody who was familiar with Terry's relationship with money. In 1955, he sold his assets to CBS for $3.5 million without even bothering to tell his staff. When studio veterans showed up at work after the sale was complete, they learned that not only had the company been sold off, but they would not be receiving a share of the profit. His studio would still go on making cartoons, as mediocre as they had always been, but almost exclusively for television—including the forgettable Deputy Dawg, Sidney the Elephant, Astronut, and Sad Cat.

During this disruptive era in cartoon history, animators at the old studios feared for their jobs. In 1953, the Warner Bros. animators began hearing a rumor that they were being talked about in the executive dining room, which wasn't a good sign. Jack Warner had apparently admitted to colleagues that he didn't even know where his cartoon division was located. "The only thing I know," he said. "Is that we make Mickey Mouse." After somebody leaned over and informed him that no, they didn't make Mickey Mouse, Warner shut down the cartoon unit to make space for what he saw as the next great cinematic revolution: 3-D movies. A year later, after 3-D movies failed to pan out, the animation division was reopened, but was living on borrowed time.

Accountants at Hollywood's other major studios began sharpening their knives and poring over the books, looking for fat to trim. They discovered an interesting statistic: between 1941 and 1956, cartoon production costs had often increased by as much as 225 percent, while rentals had risen only 15 percent. In 1957, MGM chief accountant Arthur Loew discovered another interesting number: it cost between $30,000 and $60,000 to produce a short, but you could earn 90 percent of that simply by rereleasing an old one. Why make new cartoons when you could make almost as much by reissuing old

ones? Loew double-checked his numbers and made a call to William Hanna and Joe Barbera, who were in charge of the animation division, telling them, "Close the studio. Lay everybody off." By 1963, almost all the studios, including Disney, would stop making theatrical shorts.

In order to continue generating revenue, most of the studios, including Disney, began hiring out animators to work on television commercials. At Warner Bros., the cartoon unit was merged with the studio's commercial and industrial division. Thus, the ingenious minds of Friz Freleng and Chuck Jones were set to work dreaming up Charlie Tuna for StarKist; Sharpie the Parrot for Gillette razors; and campaigns for Skippy peanut butter, Right Guard deodorant, and Blatz beer. Tex Avery labored away on spots for Raid insect spray; Cricket lighters; and corn chip commercials featuring the Frito Bandito, which were eventually pulled after protests from Latino groups. Avery also worked on Kool-Aid's Bugs Bunny commercials, although he apparently had to convince the account executives—who were unaware that he had worked on the original, or that he had coined "What's up, doc?"—that he was qualified for the job.

With commercials, advertisers continued enforcing standards that avoided controversy, no matter how benign. Bill Scott recalled being forbidden to show "a kitchen knife breaking the smooth surface of a newly opened jar of peanut butter. We had to change the knife to a butter spreader because somebody at the network thought the kitchen knife entering the peanut butter implied violence." Experienced animators watched in disappointment as their beloved art form became spoiled, like ham in an unsealed can. Looking back over this general state of affairs, Bob Clampett would speak with regret, saying, "I really believe that it's the prostitution of a wonderful medium."

Other great animation talents moved back to New York, home of Madison Avenue, to open commercial studios. Shamus Culhane was one of them but didn't like the work very much, explaining, "The same Philistines who have generously larded our adult television shows with commercial spots for vaginal douches, pile cures, and earnest little men paddling kayaks in toilet bowls laid a heavy hand on the animation medium." According to Culhane, the advertising world was a sleezy one of kickbacks, bribes, and prostitution. The best advice he got about starting his commercial animation firm came from one of

his investors: "[B]uild this company to a million-dollar gross and sell it for two hundred thousand. Then go out and buy yourself a potato farm in Idaho and forget this whole goddamn business."

Walt Disney always made it a point never to preview his films with children, insisting that his films were not made for them. Most other classic animators agreed. When Chuck Jones was once asked if he ever thought of children as his basic audience, he replied, "Never . . . my films are not meant for children. They were made for me." Bill Scott, of UPA and Warner Bros., was flabbergasted by the same question. "How can anybody go along with the supposition that something can be good enough for children but *not* good enough for adults?" he asked. "The ghettoization of animation on television has been a dreary thing for me to watch. The great cartoon characters, the characters that made American animation, the personality-animated characters, were never designed for children. They were designed for big, general theater audiences. It wasn't kids that made Mickey Mouse a star; it wasn't kids that made Bugs Bunny a star or a host of other characters . . . I'm fond of saying I have never known a writer in animation whom I respected who ever wrote for children."

At some point during the 1960s, nobody is exactly sure when, a term was coined to describe the new state of animation: "kidvid." The label bothered old-timers like Jones, who described it as "one of the ugliest words in the English language. It means you're writing down to children. How are you going to build children up by writing down to them?" He thought the new tone of these cartoons might actually be hurting younger viewers—the repetitive sameness of so many Saturday morning programs, the suffocating homogeneity, couldn't be good. "[T]he same thing, the same actions, the same kind of stories," he complained. "It's like Chinese water torture . . . that continual drop-drop-drop. It's the sameness that kills you and hurts children." John Hubley, who refused to work on Saturday morning programs, agreed. "It's assembly-line stuff which can have no feeling, no personal attention. As a filmmaker and artist, I'm not interested." Observing how television had negatively affected his own career and the careers of so many of his colleagues, Jones could only say, "The sadness is that

many of the old-time animators are working only on these Saturday-morning shows. It's like a violinist playing a triangle . . ."

Not only were older animators bothered by the shoddy crafts-manship of Saturday morning cartoons, they were bothered by the messages. Many new cartoons stressed collective action over individual initiative. Storylines often portrayed characters trying to do something alone and failing, thus causing trouble for the group; only when a group acted together could it resolve a crisis. While this message was no doubt positive in many ways, it was often delivered in an insipid fashion. "Thus, Saturday mornings on ABC there is an hour-long pro-gram called 'Super Friends,'" writer Michael Arlen would drily note in the *New Yorker*, going on to describe the program as "a cartoon show that features Superman, Batman, Wonder Woman, and Aquaman, all together in a kind of bodystockinged, Nietzschean street gang—zooming and zipping about the world, solving all manner of global problems as an announcer periodically intones, 'Their mission is to fight injustice, to right that which is wrong, and to save all mankind!'"

The main problem, according to Arlen, was "with the shoddi-ness and insincerity of the entertainment." Children are smarter than adults often give them credit for being. Material doesn't need to be dumbed down for them; when it is, adults have done them a dis-service. Wrote Arlen, "Children respond avidly to stories and poetry and film and music and dance; to greatness and ordinariness—and to real voices. What they get most of the time is unfelt music, badly drawn cartoons, self-serving educational messages, synthetic adult 'personalities,' and mediocrity—not the middlingness of ordinary lives, which artists have often reworked into literature or film, but the traces and sounds of careless and distracted grownups who fol-low the easy road and try for the surefire laugh, and perhaps don't know any better."

Chuck Jones was bothered by cartoons' new emphasis on the group rather than the individual. "I really object to the idea in those Saturday morning shows that the only way we can solve problems is in groups. Our whole history has evolved from individuals, not from group behavior," he complained. Nor did he like cartoons' new turn toward superheroes, a premonition of another plague that would infect movies in the coming decades. He described "this super syndrome"

as "a far worse thing for children than the violence . . . After all, what was Hitler? . . . This person who goes out on his never-ending fight against evil, is he some kind of god? Where does he get the right, outside the law, to protect other people? It implies that he knows what is right and wrong, and God knows, that's the worst thing a child could suppose: that right and wrong are implicit."

During the troubled years, some artists resisted the new forces shaping their medium. They did this in small ways, like guerrilla fighters emerging from the jungle, squeezing off a few shots, and then retreating back into the bush.

In 1959, Jay Ward, one of the cocreators of *Crusader Rabbit,* was casting about for a new show. He teamed up with Bill Scott, who had worked for UPA and Warner Bros., to develop a series entitled *Frostbite Falls Review,* about animals that run a TV station. The men soon realized that the show they created wasn't very good, but that two of the lesser characters had a certain appeal: Rocky, a flying squirrel; and Bullwinkle, a French-Canadian moose. Between 1959 and 1964, a show based on those two characters aired under two different titles, *Rocky and His Friends* and *The Bullwinkle Show,* on ABC and NBC.

Because the networks were now so preoccupied with marketing to children, Ward and Scott knew they would have to cater to this demographic. This bothered them, so they devised sly forms of sabotage, hiding little subversive messages in their cartoons. In this way, the show became a Trojan horse. Ward and Scott always made sure there was a level of action where things "were always slam-bang, moving ahead very, very quickly," which was something "that a four-year-old could watch," Scott said. This tier was layered with another composed of standard jokes, "You know, people getting blown up and falling out of windows and doing crazy things." But it was the third layer that "really was the fun level to write—that was the satire, the parody, verbal jokes, puns."

The soldiers hiding in the Trojan horse, so to speak, came in the form of interludes, small segments woven into the show: "Fractured Fairy Tales" were send-ups of classic stories; "Peabody's Improbable History" featured a dog traveling with his boy via a "Way-Back

Machine"; and "Aesop and Son" added punny morals to old fables. The show's villains, Boris Badenov and Natasha Fatale—send-ups of Cold War hysteria—received the most interesting parts. Ward and Scott used their show to battle their corporate overlords, making fun of the hands that fed them. Sponsors objected and sometimes tried to cut the material, but the creators devised a work-around to deter them. Since production schedules were now so rushed, they worked close to the wire, hovering above their deadlines. Prints of the cartoon would appear at the studio just hours before the broadcast, giving sponsors little time to object to their content.

In one episode, Rocky and Bullwinkle tell kids to twist the knobs off their TV sets. "NBC was furious," Ward remembered. "Seems about 20,000 kids did pull the knobs off their sets." In another episode, "Box Top Robbery," Ward and Scott had Boris Badenov tell kids that counterfeiting box tops could topple capitalism—"I'm rolling in vital consumer goods," Badenov says while gloating over a warehouse of goods he has accumulated by manufacturing counterfeit box tops. Because General Mills sponsored the show, the call from suits at the cereal company hit the animators' phones like a bolt of lightning.

General Mills not only sponsored the show but owned it, even though Ward had creative control. It was a curious arrangement, demonstrating just how woven together cartoons, advertisers, and television had become. When General Mills learned that it could save $500,000 a year by outsourcing production to Mexico, it jumped at the chance, creating a trend common during the following decades. The arrangement often led to shoddy craftsmanship, as when Bullwinkle was accidentally drawn walking four feet above the ground. Such mistakes would have given Walt Disney an aneurysm, but Ward and Scott just rolled with them. Their audience didn't seem to care; it was watching mainly for the jokes and characters. In this way, the show was a predecessor of *The Simpsons* or *South Park* or *BoJack Horseman*, all series where the low production values manage to work as an asset—the same way a punk band's crummy gear lends it street cred, so long as that gear is played with heart.

Despite its cult appeal, *Rocky and Bullwinkle* suffered low Nielsen ratings, and the show was unceremoniously canceled in 1964. Even so, Ward and Scott had provided a useful field manual for budding

insurgents. The sly subversion in *Rocky and Bullwinkle* would inspire cartoons surfacing decades later, after the 1970s and '80s and what is generally considered a long, dark spell for the animation industry. Shows such as *The Simpsons* or *South Park*, among others (and including some features, like *Who Framed Roger Rabbit*), seemed to take many cues from Ward and Scott's example. (Since Rocky and Bullwinkle shared the same middle initial, J., *The Simpsons* creator Matt Groening paid homage to these influential characters by giving the same middle initial to Bart, Homer, and Abe.) Even though the animated short was dying in front of them, Ward and Scott proved that animation with the old heart would always survive, finding a way around the system. Reflecting back on this, Scott was proud to have "affected people, especially bright kids growing up. I'm fond of saying that we corrupted an entire generation."

Chapter 33

"Flesher"

Max Fleischer viewed the rise of television not with fear, but with fascination. Ever the tinkerer, an engineer at heart, he was intrigued by the potential of any new technology. He watched his first television set in fascination, bathed in its black-and-white glow, carefully adjusting the antenna when the picture got fuzzy. The number of cartoons being shown from the old days—now in syndication, revived from the dead—surprised him. It also got him thinking: whatever happened to all the old shorts he had made for Paramount?

By the 1950s, Fleischer was living back in New York. He had grown tired of Detroit, working on industrial and training films for the Jam Handy Organization. In 1953, he signed a contract with Bray Studios, the same studio he had worked for in 1916, which was still run by John Bray, who continued to admire Fleischer's technical abilities. Together, they established a division in Bray's company to explore new technologies that could be used in animation, including 3-D. But the prospect of television, and of discovering what had happened to his old cartoons, was what really interested Fleischer.

Fleischer's old studio—now known as Famous Studios—was beset by the same problems that affected all the animation studios since the rise of television. After moving from Florida back to New York, it continued making Superman and Popeye cartoons, as well as other series such as Little Lulu and Casper the Friendly Ghost, which became a regular series in 1950. To those who worked at the studio, Casper marked the beginning of a painful decline—the end of the gutsy old days. The storylines all seemed to follow a nearly identical pattern: Casper would try to make friends with people who reacted to him by screaming, "A g-g-ghost!" Then he would spend the rest of his time

trying to convince them that he was actually a good ghost. Animators working on the series found it painfully monotonous. "With the Casper series you never knew what picture you were working on," said in-betweener Lee Mishkin, "because they were all exactly the same."

Famous Studios was renamed Paramount Cartoon Studios in 1956 and was then beset by painful layoffs. Before long, the studio's output was entirely devoted to adapting, mainly for television, comic strip characters such as Beetle Bailey, Snuffy Smith, Popeye, and a version of Krazy Kat. Most of the work had to be subcontracted, a problem because the studio still hadn't converted to the metric system like the rest of the industry, wasting animators' time doing conversions. When the cartoons were finally released, it was obvious that unimaginative corporate men had been tinkering. "The bosses would go to screenings with a list of all the gags in a film on a clipboard," Mishkin remembered. "They'd put a check after each gag that got a laugh and use it in the next picture. If a gag got a laugh in three pictures in a row, it became a standard and they'd use it in every picture after that."

In 1955, Fleischer discovered the fate of the cartoons made at the studio while he had been in charge. That year, Paramount announced the sale of all its shorts, roughly 2,000 of them, including over 600 made by Fleischer Studios, for $4.5 million. Shortly thereafter, Max started seeing reruns of Popeye and Betty Boop pop up on his television screen. But these versions made his heart sink. Like so many old cartoons, they were edited for television in ways to suit younger audiences, with their natural rhythms interrupted to make way for commercial breaks. Some of the cartoons were barely recognizable from the originals, with the saltiest humor removed and storylines completely discombobulated. In extreme situations, editors had snipped short sequences from a variety of different titles and just strung them together, incoherently, to create entirely new storylines. (In this way, portions of *Ali Baba* became *Popeye Makes a Movie*.) These bastardized versions invaded airwaves like some sinister new form of pollution. Younger audiences would never know what these cartoons were, or had been. When Jack Mercer, who had voiced Popeye ever since 1934, was asked to help write and voice a televised version of the series for Hanna-Barbera, he was shocked to learn that Popeye

could no longer get into fights; the only acceptable violence was that which happened by accident.

For Fleischer, the most offensive edits were to the credits—the words "Produced by Max Fleischer" were often deleted, his legacy literally erased. Only the name of Adolph Zukor, head of Paramount, remained.

Fleischer grew reclusive and depressed. He spent his days in the cold glow of his TV set, growing angrier as his ulcers worsened. His family grew worried, especially his son Richard, who by now was a successful director in Hollywood. Max had been to California only once, and Richard began urging him and Essie to come visit in January 1956. He thought it would be good for their health, a way to escape the New York cold, and also a good way to celebrate their fiftieth wedding anniversary.

When Max and Essie agreed to make the trip, Richard began spreading the word around town. Since his arrival in Hollywood, he had made friends and connections, including a gossip columnist for *Variety*, who announced Max's trip in the paper. The next day, Richard received an unexpected phone call from Walt Disney. Remarkably, Disney and Max Fleischer had never formally met, despite years of poaching each other's talent. "I see your father's in town," Walt said. "I think we should meet."

Richard Fleischer had followed his father into show business because of all the fond memories he had of it during his childhood. When he was a boy, Max often took him to the movies; the first they ever saw together was *The Cabinet of Dr. Caligari*. Richard eventually attended Brown University and took premed courses but soon started thinking seriously about changing careers. When he sought his father's advice, Max said, "What I think you should do is find the toughest drama school you can find and go to it for a year. At the end of a year you'll either love the theater or you'll hate it." If Richard didn't at least try it, Max explained, "you'll be unhappy for the rest of your life, not knowing if the theater was your true calling. You'll always have a lingering doubt about whether medicine was really the right profession for you, and that's no way to live."

Richard attended the Yale School of Drama "and lived happily ever after," he later wrote in his memoir. In the early 1940s, he moved to Los Angeles, where the first words he ever heard spoken on a soundstage were "John Wayne hasn't shit yet." He later described the experience as "my introduction to the magic and glamor of Hollywood."

In 1952, Richard Fleischer met Walt Disney for the first time. Disney had reached out to Fleischer's agent and asked to meet with the rising young director. The news startled Richard when he heard it. He had grown up with a complicated view of Disney; his father had constantly called Disney a "son of a bitch," and the memory lingered. "*Me?*" Richard gasped. "You've got to be kidding."

Richard felt uncomfortable driving onto the lot of Disney's Burbank studio, slowly passing the guards who cheerfully waved him through. "This was enemy territory—Mickey Mouse Lane, Donald Duck Walk," he recalled. Once in Walt's office, he stopped cold. "There he was, standing behind his desk, smiling warmly: my father's nemesis."

Walt ushered him in and immediately got down to business as Richard settled into his chair. By this point, the studio was making more live-action movies, diversifying away from just cartoons. Pointing to a watercolor painting of a giant squid attacking a submarine, Disney explained that the studio's next project would be its biggest yet: an adaptation of Jules Verne's *Twenty Thousand Leagues Under the Sea*, featuring Kirk Douglas and James Mason. Disney wanted Fleischer to direct.

"But why me?" Richard asked.

"We saw your picture *The Happy Time*," Disney answered, referring to a movie starring Bobby Driscoll, a humdrum star from *Song of the South*. "Anybody who can make an actor out of Bobby Driscoll has got to be a great director."

Fleischer wanted the job badly but was hesitant. He asked if Disney knew who his father was.

"Yes, we know," Disney answered. "That doesn't make any difference to us."

Richard explained to Disney that he couldn't agree without speaking to his father first, for fear Max might find it disloyal.

"You're absolutely right," Disney answered. "You talk to your father tonight and call me tomorrow morning."

When Max heard the news, he was surprised Richard felt the need to ask. "You tell Walt that I said he's got great taste in directors."

Four years later, when Max visited California for his fiftieth wedding anniversary, Richard brokered the meeting between his father and Disney. In the cartoon world, Fleischer and Disney had always represented a special rivalry, defined by two men from different backgrounds, each with a different vision. Nonetheless, they shared far more than they didn't share, from their influences (Chaplin) to staff they had poached back and forth (Grim Natwick, among many). Still, the meeting was a hot topic of conversation among Disney's staff, many of whom had once worked for Fleischer.

Walt was a charming and flattering host. He gave Max a grand tour of the studio, the two men walking up and down the long hallways, poking their heads into all the various rooms. Later, they lunched in the cafeteria, where Disney had arranged to meet all of Fleischer's old employees, whom Max still called "his boys." The meal was punctuated by in-jokes and the exchange of old memories.

Somebody snapped a photograph of the lunch, later writing beneath it, "Inkwell Reunion, or What Cartoons Can Do to Cartoonists. Jan. 4 1956." In it, Fleischer and Disney both have a paunch around their middles, and their hair is graying. Max sits at the head of the table, the guest of honor, but the photo somehow makes him look distant and small. The camera wanted to focus on Disney, who fills more of the frame. Richard recalled that his dad, at that moment, "seemed diminished, and my heart broke for him." Walt was busy working on his amusement park, becoming an American icon, while Max was spending his days watching reruns of his own old cartoons, fretting about his name being erased from the credits. Looking at the two men together, reflecting on their old rivalry, Richard wrote of his father, "I had the feeling that Goliath had defeated David."

Even though Max Fleischer was at a gloomy low in his career, at age seventy-two, meeting Walt Disney seemed to inspire him. He returned to New York and threw himself into developing a new kind of film projector, one that used a small disc rimmed with pictures

instead of a reel. Once a design was ready, he enthusiastically began visiting investors who could help get the idea off the ground.

During one office visit, Fleischer chanced upon a young lawyer named Stanley Handman, fresh out of Harvard Law School. The two began to chat—Handman was a fan of Fleischer's work—and it wasn't long before the subject of Paramount came up. Fleischer vented and Handman listened. After all these years, the issue of the takeover was still burning a hole inside Max; many a casual conversation was hijacked by his seeming inability to avoid bringing it up. But Handman was a sympathetic ear, listening intently as Fleischer explained how he was still searching for a way to fight it, even though fifteen years had passed. He was frustrated, telling Handman there was nothing he could do legally without the documents Paramount had allegedly destroyed. As a lawyer, Handman agreed that Fleischer had no leverage.

Fleischer then mentioned how frustrating it was to see his name stripped from his old work. As soon as the words left his mouth, Handman sat bolt upright in his chair and shouted, "That's actionable!" The kind of evidence Max needed, he explained, was right there on the television screen. Max just needed to document it.

Fleischer rushed home and built a sort of screening bunker in his living room: a tower of televisions all tuned to different channels. He watched in the morning, as the sun came up, and late into the night, after the streetlights had gone yellow. His longtime secretary, Vera Coleman, helped browse the different channels for reruns of his old work; the two resembled security guards watching surveillance cameras. Every time they found a rerun, they recorded the details: time of showing, channel, distributor, producer's credit, any edits, and the names of all advertised products.

Weeks of this passed, then months, measured in a pile of notebooks to be used as evidence.

On April 2, 1956, Max reestablished Fleischer Studios, Inc., and Handman took action, charging that the old Fleischer cartoons were being televised "without proper credit and authority," that the credits had been "altered and mutilated," and that Fleischer's reputation had been damaged. They asked for $2,750,000. In a statement, Fleischer said, "I will not consent to being relegated to anonymity by allowing

others to reap the artistic prominence and financial reward of my lifetime of creative work in the motion picture field."

This would be a long lawsuit, stretched out over years, played out in rooms full of paperwork and lawyers. As time went on, Fleischer waited anxiously for news.

Three years later, in 1959, Handman appeared at Fleischer's apartment. He had sprinted over and was breathing hard, but also smiling. While reading the *Wall Street Journal* earlier that morning, he had spotted an article about a new copyright law—a thrilling event for an intellectual property lawyer. Previous copyright law stated that, if the original author of a work assigned his rights to a third party (which Paramount did when it sold the rights to Fleischer's cartoons), the copyright would run for twenty-eight years and could be renewed for an additional similar stretch of time. However, after that second term expired, the work became part of the public domain. Under the new law, if the author hadn't assigned renewal rights (which Fleischer hadn't) and was still alive (which Fleischer was), only he had the right to renew. What this meant, Handman explained, was that no third party could renew the about-to-expire *Betty Boop* copyright. Only Fleischer, as the living author, could do that.

On June 25, 1959, the copyright for *Betty Boop* went back to Fleischer. Good fortune finally seemed to be coming, and was augmented when Max received a phone call from an old friend with another exciting opportunity.

The phone call came from Hal Seeger, president of a company that did animation work for advertising agencies. Seeger asked if Fleischer was interested in reviving his old Out of the Inkwell shorts, starring Koko the Clown, for television. He had already procured financing for one hundred new episodes and wanted Max to help produce and direct. Seeger also wanted him to appear in them, just as he had done in the originals, which combined live action and animation.

Fleischer agreed, but worried he was too old. His hair was by now the color of a snowbank, his face saggy with wrinkles. Attempting to look younger, he tried to dye his hair brown; Essie took the first crack at the dye job and accidentally turned his hair green, a result

that required the services of a professional to fix. Besides giving him something to do, Fleischer hoped the new series would help his ongoing lawsuit by raising his public profile.

The Out of the Inkwell revival lasted several years, but struggled the entire time. Made for television, not the screen, the series had to play by a new set of rules. Its jingle proclaimed, "He's so gay and he's so jolly. He will make you laugh, by golly." It was obvious to anyone watching that Koko had lost his soul, as well as the gritty essence of his original appeal. The series drifted among different distribution companies, each one trying to resuscitate it. One observer noted that the redesigned Koko seemed drawn for a cereal box, an unflattering sign of the times they were now living in. It wasn't going well. In 1964, buried in the back pages of *Variety*, a short article finally announced the folding of Out of the Inkwell, Inc., five years after it started. The article had the feeling of an obituary.

That same year, Walt Disney was awarded a Presidential Medal of Freedom. His fellow honorees included the poet T. S. Eliot, the novelist John Steinbeck, the artist Willem de Kooning, the composer Aaron Copland, and the journalist Edward R. Murrow.

Fleischer soon received more bad news. After five years, he lost his case against Paramount. The studio's lawyers had persistently reminded the court of the problems created by Fleischer and his brother: their constant feuding, their decision to move to Florida, all their debt. "Morale suffered and any effective operation of the Studios was rendered impossible," read a statement from Paramount's attorneys. The studio had a point; with the statute of limitations having run its course, Paramount requested the case be thrown out, and it was.

For Fleischer, there was a silver lining to the ruling. The cloud of litigation forced many of the distribution companies Max had sued to restore his name to the old films. It was a small victory, at least, albeit somewhat undermined after some of the companies ended up misspelling his name as "Flesher."

Even in defeat, Max persisted, collecting evidence to reopen his case: he spent days in his apartment office, poring over legal books, pacing back and forth while dictating memos into a recorder. Now that he held the rights to Betty Boop, he fielded offers from

companies wanting to "do something" with her: maybe a television series or a Broadway musical? But none of these ideas ever amounted to anything. New audiences hadn't known Betty in her heyday, and besides, she was never meant for the kids that studios now hungered after; she was meant for adults.

In 1967, a management change occurred at Paramount Cartoon Studios. For well over a decade, the studio had struggled. Its output was primarily composed of series such as Swifty and Shorty, and Honey Halfwitch—cartoons that were almost immediately forgotten, not even remembered in a campy, so-bad-they-were-good way. Even though Max Fleischer had started the studio, he had been gone for more than twenty-five years. But one sensed he might share a spiritual connection with the studio's new leader, a twenty-nine-year-old wunderkind named Ralph Bakshi.

Bakshi grew up in Brownsville, the same section of Brooklyn where the Fleischers had once lived. A borderline juvenile delinquent, he escaped a grim future when he was transferred to a magnet high school for the arts, a path traveled by many earlier animators. Bakshi was a throwback to the old days, an iconoclastic and headstrong artist with a bawdy yet perceptive sense of humor. He had the thick hands of a street fighter, but those hands could draw. Those who admired his creative philosophy hoped he might bring new life not just to a dying studio, but to a struggling industry in the television age, in the way that Max Fleischer and Walt Disney had revived interest in cartoons for the sound age.

In order for Bakshi to do this, however, he would need to navigate a new kind of corporate landscape—he was showing up at the party late, just in time to see a cigarette butt floating in the final cocktail of the night. In 1966, just before he took over the studio's cartoon division, Paramount Pictures had come under the control of Gulf and Western, a multibillion-dollar conglomerate with holdings in industries as diverse as metal stamping, auto parts, financial services, apparel manufacturing, and home furnishings. Bakshi's new boss was Charles Bluhdorn, a Napoleonic tycoon stamped from the same mold as a Getty or a Rockefeller. After acquiring the giant movie studio,

Bluhdorn began touring its many different divisions, like a Roman emperor surveying newly conquered territory. When Bluhdorn was shown the cartoon studio, he asked, "What the hell is this?"

Bluhdorn's handlers said it was a cartoon studio and explained how it fit into the overall corporate structure.

"I never bought this. I make films. What is this?" he asked again.

"Of course, it comes with the whole package," the handlers replied.

To Bluhdorn, discovering that he owned a cartoon studio was a bit like the situation of someone who buys a mansion and learns that the previous owners left some condiments in the refrigerator. Bakshi would later describe how this situation unfolded: "Fade out. Fade in, three months later, they closed the place down." On December 1, 1967, Max Fleischer's old studio was shuttered forever.

After the studio closed, Bakshi struck out independently, teaming with a producer named Steve Krantz to make commercials for corporate clients like Coca-Cola. But this kind of work didn't suit Bakshi's sensibilities, so he changed direction by animating a series of comic books, *Fritz the Cat*, by the underground artist Robert Crumb. Crumb was a unique visionary, a connection back to that old, quirky America, when people still knew how to properly fold a newspaper and didn't lose their minds when they heard a dirty joke. Crumb's character, Fritz, was a superficial college student who wore the counterculture like a fashion accessory; he talked edgy, but his main interest was just in getting laid. He was electric and unpredictable, mocking both the status quo and the self-righteous young radicals on the other side. Studios had treated cartoons with contempt, so Bakshi used *Fritz the Cat* to return the contempt. Released as a feature film, the cartoon eviscerated polite conventions about society, race, and manners. Its depictions of sex, violence, and race relations were often graphic and uncomfortable. When asked whether the film's sex scenes were in good taste, Bakshi shot back, "Would you call a cat who chases a crow into a junk yard to fuck her in good taste?"

Fritz the Cat enjoyed the notoriety of being the first X-rated cartoon feature. Costing $850,000 to make, it blossomed into a $25 million hit. It was a sign that people still liked seeing boundaries pushed, but also that the people pushing those boundaries would always need

to find new ways of doing so. This is what the animators of yester-year had done, when movies were a young art and outsiders ran the industry. Winsor McCay might not have approved of Bakshi's material or attitude, but he no doubt would have approved of the comment Bakshi made after *Fritz the Cat* debuted in Los Angeles: "They forget it's animation. They treat it like a film. This means we can make *War and Peace* in animation. This is the real thing, to get people to take animation seriously."

Chapter 34

"Well, Kid,
This Is the End I Guess"

In "Ulysses," one of the greatest poems in Western literature, Tennyson describes his hero late in life. He doesn't have as much energy as he once did, but still has a little fire left in his belly. Looking back on his past adventures, Ulysses asks if there is room for one more:

> Death closes all; but something ere the end,
> Some work of noble note, may yet be done,
> Not unbecoming men that strove with Gods.

So Ulysses embarks on a last adventure "to sail beyond the sunset." Likewise, Walt Disney entered his twilight years still excited by new adventures. Reminders of death annoyed him—"he never goes to a funeral if he can help it," his daughter Diane wrote. When he did attend funerals, he spent the time nervously drumming his fingers. Time was getting on, and glances in the mirror reminded him of his age: his hair was now gray and he stooped, as a result of an old injury—a vertebra he cracked during a polo game thirty years earlier. As doctors eased his pain with infrared treatments, he sipped his scotch through a straw, to limit movement of his neck. A lifetime of cigarettes had also caused his hacking cough to grow worse.

Disney's final adventure started taking shape in the 1960s, his last decade. Despite Disneyland's popularity, it didn't get many visitors from the East Coast, so Disney's business advisors suggested he build another theme park, east of the Mississippi River.

In 1963, Disney sent a small group to scout land in Florida. This was done in secret, so they wouldn't startle speculative realtors into raising their prices. At corporate headquarters, everyone referred to their mission as "Project Future," or sometimes as "Project X." A spot near Orlando was eventually chosen, and Disney began purchasing land through front organizations. Any questions from curious Floridians were met with silence.

On November 15, 1965, Disney traveled to Orlando to announce Walt Disney World. Some five hundred reporters, tipped off that Disney was going to make a speech, crowded around to hear the announcement.

Disney wasn't interested in building just another amusement park. He had already revolutionized amusement parks, just as he had revolutionized animation. His real interest was in a small parcel of land adjacent to the amusement park, a wet, green square of swampland. Here he would build an experimental community where people would test out new ideas and philosophies about governing themselves. It was a City on a Hill, or a utopia, but Disney called it by neither of those names. He called it the Experimental Prototype Community of Tomorrow, or EPCOT.

EPCOT would reflect Disney's beliefs and aspirations, just as his movies and Disneyland did. It would be an optimistic place, built on what he called "traditional" values. There would be a strong preschool system, teen centers to prevent delinquency, and facilities for seniors to relax in during their retirement. There would also be playgrounds full of children's laugher, and churches full of people murmuring prayers.

Disney had strong opinions about his utopia's system of government and refused to relinquish absolute authority. His company would control all the planning and building; other issues would be determined by rotating groups of voters whose voting rights weren't permanent. With help from his lawyers, he began lobbying the Florida legislature to approve municipalities where all his new ideas could be tested. Disney envisioned that 20,000 residents would live in his city by 1980, and hopefully more in the years after. Robert Moses, the urban planner who tore up New York City to build concrete expressways, called Disney's plan "overwhelming." But he also admired it, calling EPCOT the "first accident free, noise free, pollution free city center in America."

For his movies, Disney always found inspiration in old fairy tales; when he needed inspiration for Disneyland, he toured amusement parks and historic villages. But EPCOT had a wider scope. Traveling aboard a Gulfstream jet, he visited Monsanto, the multinational agricultural technology company, to discuss a corporate sponsorship. Then he visited General Electric, RCA, and Westinghouse, asking if they wanted to help him realize his vision. The heads of these corporations often got woozy in the presence of Disney's celebrity; Don Burnham, CEO of Westinghouse, reacted as if Disney were the Pope, stumbling for words while his bottom lip quivered. In order to put everyone at ease, Disney began deliberately dressing down, the way he dressed in the old days, carelessly undoing a button or purposely slopping up his tie.

Other stops during Disney's research trips included shopping malls in Rochester and Philadelphia; a Neiman Marcus department store in Dallas; a trash-disposal project in Tampa; and the planned community of Reston, Virginia, just outside Washington, D.C., home to countless government bureaucrats. In places like these, he hoped to find a glorious future.

Disney kept three books close at hand during his research trips. The first was *Garden Cities of Tomorrow* by Sir Ebenezer Howard; it was originally published in 1902 and promoted rural, rather than urban, lifestyles. The second and third books were written by Victor Gruen, a designer of shopping malls who wanted to reorganize cities to be more ordered and rational. These were titled *The Heart of Our Cities: Urban Crisis, Diagnosis and Cure*, and *Out of a Fair, a City*. Walt read them whenever he had time, jotting down ideas on napkins or scraps of paper. He had spent his life helping people escape from reality into fantasy; now he wanted to turn a fantasy into reality. Bob Gurr, one of Disney's employees, remembered Walt pointing down at a little oval of land while they were flying over the EPCOT construction site one day. "When this EPCOT gets up and running," he said, "this little spot with a little bench is where Lilly and I are going to sit and watch."

Disney would never see EPCOT get built. In 1966, his cigarettes finally caught up with him. Doctors said he had lung cancer. He kept the situation quiet, but word crept out. When it did, Walt's friend

John Wayne, a lung cancer survivor, sent him a telegram: WELCOME TO THE CLUB.

Even though it had its ups and downs, Walt Disney's life was charmed. Once, in 1961, as wildfires roared through various parts of Los Angeles, inching toward his house, the flames suddenly stopped and moved away, as if the fire was told that Walt Disney lived there, and retreated out of respect.

Over time, Walt's legacy would become contested. Strange myths, none true, would fill the space around his legend: that he was the illegitimate son of a Spanish dancer; that he was a bigot, an alcoholic; and that he was, upon death, cryogenically frozen. People would interpret him in whatever ways supported their preexisting beliefs: that he was a champion of culture, or that he debased it; that he was an ambassador of American values, or a symbol of cultural imperialism. Conservatives would cherry-pick anecdotes to make a case that Disney was a preserver of the old ways. Liberals would use his memory as a cultural punching bag, a symbol of old-fashioned values needing to be torn down. Yet none of these interpretations seems particularly accurate. If you rub your eyes, Disney's movies can suddenly appear modern in their outlook; rub again, and suddenly they don't. Disney's films contradicted his era's conservatism as much as they reinforced it. He questioned authority, was skeptical of materialism, identified with outcasts rather than those in power, and believed strongly in internationalism—all values found in his work. Even *Pollyanna*, mawkish as it is, doesn't champion small-town virtues as much as it exposes small-town hypocrisy, questions privilege, and calls for tolerance.

Perhaps these latter values were the ones Disney wanted to promote at EPCOT. Since it was never built, we can never know. Because the executives at his company didn't want to run a city without his guidance, they folded EPCOT into the rest of the theme park and changed its spelling to lowercase, Epcot, a gesture with significant meaning. The suits taking over the enterprise would play it safe, something Walt never did.

Disney was thinking of his utopian city as he lay in the hospital on his deathbed. Saint Joseph's was located on Buena Vista Street, just

across from his studio. This was the studio financed by the bankers who hedged their bets against Disney's potential failure by requiring that the studio be easily converted, as a Plan B, into a hospital. But Disney hadn't failed, so St. Joseph's was built across the street. As the sunshine poured through the blinds, Disney looked up at the ceiling tiles and traced the plans for his utopian city with his fingers, designing heaven. He died on December 15, 1966, at 9:35 in the morning. When his family appeared at the hospital, they found Roy already there, standing at the foot of Walt's bed, looking over his body. He was quiet, tenderly massaging the feet of his younger brother. As Walt's daughter Diane joined the moment, she heard Roy mumble, "Well, kid, this is the end I guess."

When Walt Disney died, his career was still on an upward trajectory. Even though animation—the art form he revolutionized—was in the doldrums, he escaped the malaise to become a true American icon. The same can't be said for other animators working during animation's golden age. Most of them were now off struggling in the coal mines of television. They were the last of the ancients who had once thrown lightning bolts, now resigned to doodling toothpaste commercials. The past, not the future, would be the high point of their careers. Walt's death sent shock waves through the industry, a final curtain on a special era.

Disney's death came at a symbolic time—that same year, all three of the major television networks fully converted their Saturday morning programming to cartoons with a juvenile bent. It was also the year preceding Paramount's shutdown of the cartoon studio once owned by Disney's most prominent rival, Max Fleischer. There is no record of what Fleischer thought when his old studio was finally shuttered, or of his reaction to the death of his main competitor. In 1967, his family worried that he might be losing his mind. He spent his days in his home office, fretting, strategizing about how he could resume legal action to revive his legacy. He was becoming less coherent, stiff with age, making fewer and fewer trips out of his apartment.

Max's behavior had an effect on Essie, who still had a hot temper and would explode at him. She was tired of New York and their

lifestyle, of living in their cramped apartment and surviving on Social Security. She talked again of suicide, threatening to jump out their eleventh-floor window. Their daughter Ruth started receiving frantic phone calls; Essie would be on the other end of the line threatening to take her own life. Eventually, Ruth and Richard Fleischer began discussing an intervention.

Richard flew out from California and showed his parents brochures and pamphlets for the Motion Picture Country House in Woodland Hills, California, a retirement community for people who had worked in the film industry. Richard had contributed to it since 1945, as part of Hollywood's system of unions and guilds. The unions that Max Fleischer had fought so vehemently would now give him comfort in his old age. The grounds were immaculate, dotted with small cottages, a medical facility, and a first-run, state-of-the-art movie theater.

Looking at the brochures fanned out in front of him, Max Fleischer immediately balked, claiming that he had too much to do, and that he needed an office to continue researching his legal case.

Richard assured Max that his books and papers would be shipped out. He had arranged for Max's longtime secretary, Vera Coleman, to move to California as well, paying her a small salary so she could continue to take Max's dictation. With these assurances, Max had no excuses to stay.

Max and Essie moved to California and settled into a comfortable routine: sunshine, gardening, crossword puzzles. Every weekend, Richard and his wife took them out for lunch at a nearby Hamburger Hamlet. This routine lasted several years, until Richard began noticing changes in Max's behavior.

Max still continued to be as dapper as ever: he wore pressed shirts, ties, jackets, fedoras. Only now he would get dressed at three or four in the morning, his mind in a haze, and begin asking Essie if she was ready to go out, although he didn't know where to. She would lose her temper, as she always did, but would manage to get him undressed and back into bed. Max's mind continued to deteriorate, to a point where he could barely speak. Using the language of movie people, Richard described it as "a long fade-out."

In 1971, Max Fleischer was hospitalized in the medical ward of the Motion Picture Country House; he suffered from hardening of

the arteries around his brain. On September 11, 1972, after a worsening decline, he died. His long life, spanning a good portion of the American Century, had begun with sepia-toned images of Jewish Krakow in 1883, and ended in the lush Technicolor of Los Angeles in 1972. In the beginning, there were threadbare wool overcoats, worn by immigrants coming to America on boats; at the end, doctors with polyester butterfly collars carefully attended to him in his final days. Like so many Americans before him, Max was born into one world, but would die in another. Between the bookends was a beautiful story populated by colorful characters, the golden age of an industry and its art, the fruit of truly wild minds.

Max had been the pioneer of a truly great art form, and the other half of one of its great rivalries. On his deathbed, he was regularly surround by family, his son Richard and his daughter Ruth. One day, while browsing through a pile of magazines near Max's bed, Ruth came across an issue of *Life* featuring a cover story about the Disney empire. It went on and on about how Max's rival was an icon of American culture.

"Look, Pop," Ruth said, handing the issue over. "It's your old friend."

Max studied the cover, struggling to form words. He motioned with his hand for Ruth to move closer. She stepped forward, putting her ear to his lips. Then, after a moment, she quietly started laughing. Even though Max had almost entirely lost his ability to speak, his words barely audible, he hadn't lost his sense of humor.

"What did he say?" Richard asked.

"He said, 'Son of a bitch.'"

A Note on Sources
and Acknowledgments

This book is stitched together from many sources: interview transcripts, private documents, public records, memoirs, oral histories, autobiographies, biographies, films, archival materials, dissertations, photographs, newspaper and magazine articles, academic journals, and books. Many of the people profiled in this book died before I was born, indebting me to a handful of historians who recorded interviews with them during their twilight years. As all historians do, I benefited greatly from the work of many prior authors and researchers, notably Adam Abraham, Joe Adamson, Amid Amidi, Michael Barrier, Jerry Beck (who introduced me to a diner called Patys), John Canemaker, Donald Crafton, John Culhane, Maureen Furniss, Neal Gabler, Leonard Maltin, Ray Pointer, Steve Schneider, J. J. Sedelmaier, Tom Sito, and Charles Solomon. Thanks to Austin Considine for providing helpful advice with the proposal. Special thanks go to the staffs of the Library of Congress and the New York Public Library. Very special thanks go to the archivists and staff at New York University's Fales Library; the Margaret Herrick Library, Academy of Motion Picture Arts and Sciences; and the Film and Television Archive, University of California at Los Angeles. I'd particularly like to thank Sylvie BosRau and Todd and Debbie Levine for their gracious assistance with images.

In a handful of places, I extended the details of a scene slightly beyond spoken and written accounts of it, drawing reasonable conclusions from the available information. Verifiable facts were never ignored or changed. All dialogue, and anything else appearing between quotation marks, comes from a letter, an interview transcript, a memoir, or some other written document. These are cited in the endnotes. Any mistakes are my own.

It was a pleasure working with the team at Grove Atlantic. Thank you to Jamison Stoltz for recognizing how much fun a book like this could be and getting it off the ground. As an editor, George Gibson was a special treat to work with. He was thoughtful, careful, and a fascinating lunch conversationalist. Emily Burns offered much help and thoughtful perspective, while Fred Wiemer contributed helpful editorial assistance. Gretchen Mergenthaler provided beautiful design. Thanks to Michelle Brower at Aevitas Creative Management for finding this book a good home.

Of course my parents and siblings and in-laws deserve lots of thanks—I trust they all know who they are. But my wife Lauren gets the most credit. She listens to me go on about whatever topic I'm writing about, proving she must be an angel.

Selected Bibliography

Abraham, Adam. *When Magoo Flew: The Rise and Fall of Animation Studio UPA*. Middletown, CT: Wesleyan University Press, 2012.

Adamson, Joe. *Tex Avery: King of Cartoons*. New York: Da Capo, 1975.

Agee, James. *Agee on Film*. New York: Modern Library, 1969.

Allan, Robin. *Walt Disney and Europe: European Influences on the Animated Feature Films of Walt Disney*. Bloomington: Indiana University Press, 1999.

Barnouw, Erik. *Tube of Plenty: The Evolution of American Televison*. New York: Oxford University Press, 1990.

Barrier, Michael. *The Animated Man: A Life of Walt Disney*. Berkeley: University of California Press, 2007.

———. *Hollywood Cartoons: American Animation in Its Golden Age*. New York and Oxford: Oxford University Press, 1999.

Baughman, James. *The Republic of Mass Culture: Journalism, Filmmaking, and Broadcasting in America Since 1941*. Baltimore: Johns Hopkins University Press, 2006.

Beck, Jerry, and Will Friedwald. *Looney Tunes and Merrie Melodies: A Complete Guide to the Warner Bros. Cartoons*. New York: Henry Holt, 1989.

Bendazzi, Giannalberto. *Cartoons: One Hundred Years of Cinema Animation*. Bloomington: Indiana University Press, 1994.

Blanc, Mel. *That's Not All Folks! My Life in the Golden Age of Cartoons and Radio*. New York: Warner Books, 1988.

Bowers, Rick. *Superman Versus the Ku Klux Klan*. Washington, DC: National Geographic Books, 2012.

Bright, Randy. *Disneyland: The Inside Story*. New York: Harmony Books, 1979.

Brode, Douglas. *From Walt to Woodstock: How Disney Created the Counterculture*. Austin: University of Texas Press, 2004.

Brownlow, Kevin. *The Parade's Gone By*. New York: Knopf, 1968.

Cabarga, Leslie. *The Fleischer Story*. New York: Da Capo, 1988.

Canemaker, John. *Before the Animation Begins: The Art and Lives of Disney Inspirational Sketch Artists*. New York: Hyperion, 1996.

———. *Felix: The Twisted Tale of the World's Most Popular Cat*. New York: Pantheon, 1991.

———. *Walt Disney's Nine Old Men and the Art of Animation.* New York: Disney Editions, 2001.

———. *Walt Disney's Nine Old Men.* New York: Abbeville Press, 1987.

Capra, Frank. *The Name Above the Title: An Autobiography.* New York: Macmillan, 1971.

Carlson, Oliver. *Brisbane: A Candid Biography.* New York: Stackpole Sons, 1937.

Ceplair, Larry, and Steven Englund. *The Inquisition in Hollywood: Politics in the Film Community, 1930–1960.* Berkeley and Los Angeles: University of California Press, 1983.

Chafe, William. *The Unfinished Journey: America Since World War II.* New York: Oxford University Press, 1995.

Cohen, Karl F. *Forbidden Animation: Censored Cartoons and Blacklisted Animators in America.* Jefferson, NC: McFarland & Co., 1997.

Crafton, Donald. *Before Mickey: The Animated Film, 1898–1928.* Birch Lane Press, 1993.

Culhane, John. *Walt Disney's Fantasia.* New York: Harry N. Abrams, 1987.

Culhane, Shamus. *Talking Animals and Other People.* New York: St. Martin's Press, 1986.

Eliot, Marc. *Walt Disney: Hollywood's Dark Prince.* New York: Birch Lane Press, 1993.

Eyman, Scott. *The Speed of Sound: Hollywood and the Talkie Revolution, 1926–1930.* New York: Simon & Schuster, 1997.

Fariello, David. *Red Scare: Memories of the American Inquisition.* New York: W. W. Norton, 2008.

Fleischer, Max. *Noah's Shoes.* Detroit, MI: S. J. Bloch Publishing, 1944.

Fleischer, Richard. *Just Tell Me When to Cry: A Memoir.* New York: Carroll & Graf, 1993.

———. *Out of the Inkwell: Max Fleischer and the Animation Revolution.* Lexington: University Press of Kentucky, 2005.

France, Van Arsdale. *Window on Main Street: 35 Years of Creating Happiness at Disneyland Park.* Nashua, NH: Laughter Publications, 1991.

Furniss, Maureen, ed. *Chuck Jones: Conversations.* Jackson: University Press of Mississippi, 2005.

Gabler, Neal. *An Empire of Their Own: How the Jews Invented Hollywood.* New York: Anchor Books, 1988.

———. *Walt Disney: The Triumph of the American Imagination.* New York: Knopf, 2006.

Ghez, Didier. *They Drew As They Pleased: The Hidden Art of Disney's Musical Years (The 1940s—Part One).* San Francisco: Chronicle Books, 2016.

Green, Amy Boothe, and Howard E. Green. *Remembering Walt: Favorite Memories of Walt Disney.* New York: Hyperion Books, 1990.

Greene, Katherine, and Richard Greene. *Inside the Dream: The Personal Story of Walt Disney.* New York: Roundtable Press, 2001.

Hajdu, David. *The Ten-Cent Plague: The Great Comic-Book Scare and How It Changed America.* New York: Farrar, Straus & Giroux, 2008.

Hand, David Dodd. *Memoirs.* Cambria, CA: Lighthouse Litho, 1990.

Harris, Mark. *Five Came Back: A Story of Hollywood and the Second World War.* New York: Penguin, 2015.

Hays, Will H. *The Memoirs of Will H. Hays.* Garden City, NY: Doubleday, 1955.

Hiaasen, Carl. *Team Rodent: How Disney Devours the World.* New York: Library of Contemporary Thought, 1998.

Holt, Nathalia. *The Queens of Animation: The Untold Story of the Women Who Transformed the World of Disney and Made Cinematic History.* New York: Little Brown and Company, 2019.

Jones, Chuck. *Chuck Amuck: The Life and Times of an Animated Cartoonist.* New York: Farrar, Straus & Giroux, 1989.

Kanfer, Stefan. *Serious Business: The Art and Commerce of Animation in America from Betty Boop to Toy Story.* New York: Scribner, 1997.

Kaplan, Arie. *From Krakow to Krypton: Jews and Comic Books.* Philadelphia: Jewish Publication Society, 2008.

Kinney, Jack. *Walt Disney and Other Animated Characters: An Unauthorized Account of the Early Years at Disney's.* New York: Harmony Books, 1988.

Klein, Norman. *Seven Minutes: The Life and Death of the American Animated Cartoon.* New York: Verso, 1993.

Korkis, Jim, and John Cawley. *Cartoon Confidential.* Westlake Village, CA: Malibu Graphics Publishing Group, 1991.

Koszarski, Richard. *Hollywood on the Hudson: Film and Television in New York from Griffith to Sarnoff.* New Brunswick, NJ: Rutgers University Press, 2008.

Krause, Martin, and Linda Witkowski. *Walt Disney's Snow White and the Seven Dwarfs: An Art in Its Making.* New York: Hyperion Books, 1994.

Lawson, Tim, and Alisa Persons. *The Magic Behind the Voices: A Who's Who of Cartoon Voice Actors.* Jackson: University Press of Mississippi, 2005.

Lehman, Christopher P. *The Colored Cartoon: Black Representation in American Animated Short Film.* Amherst: University of Massachusetts Press, 2009.

Leland, John. *Hip: The History.* New York: Harper Perennial, 2004.

Lenburg, Jeff. *The Great Cartoon Directors.* New York: Da Capo, 1993.

Leslie, Esther, *Hollywood Flatlands: Animation, Critical Theory, and the Avant-Garde,* London: Verso, 2002.

Lewis, Tom. *Empire of the Air: The Men Who Made Radio.* New York: Harper-Collins, 1991.

Maltin, Leonard. *Of Mice and Magic: A History of American Animated Cartoons.* New York: Plume, 1987.

Mann, William J. *Tinseltown: Murder, Morphine, and Madness at the Dawn of Hollywood.* New York: Harper, 2014.

Marling, Karal Ann, ed. *Designing Disney's Theme Parks: The Architecture of Reassurance.* New York: Flammarion, 1997.

McCay, Winsor. *Illustrating and Cartooning: Animation.* Minneapolis: Federal Schools, Incorporated, 1923.

McGilligan, Patrick, and Paul Buhle. *Tender Comrades: A Backstory of the Hollywood Blacklist.* New York: St. Martin's Press, 1997.

Merritt, Russell, and J. B. Kaufman. *Walt in Wonderland: The Silent Films of Walt Disney.* Baltimore: Johns Hopkins University Press, 1993.

Miller, Diane Disney. *The Story of Walt Disney.* New York: Henry Holt, 1956.

Morgan, Judith, and Neil Morgan. *Dr. Seuss and Mr. Geisel: A Biography.* New York: Random House, 1995.

Mosley, Leonard. *Disney's World: A Biography.* New York: Stein & Day, 1985.

Nesteroff, Kliph. *The Comedians: Drunks, Thieves, Scoundrels, and the History of American Comedy.* New York: Grove Press, 2015.

Peary, Danny, and Gerald Peary. *The American Animated Cartoon: A Critical Anthology.* New York: Dutton, 1980.

Pease, Don. *Theodor Seuss Geisel.* Oxford: Oxford University Press, 2010.

Peet, Bill. *Bill Peet: An Autobiography.* Boston: Houghton Mifflin, 1989.

Pointer, Ray. *The Art and Inventions of Max Fleischer: American Animation Pioneer.* Jefferson, NC: McFarland & Co., 2017.

Reich, Cary. *The Life of Nelson Rockefeller: Worlds to Conquer, 1908–1958.* New York: Doubleday, 1996.

Ricca, Brad. *Superboys: The Amazing Adventures of Jerry Siegel and Joe Shuster—The Creators of Superman.* New York: St. Martin's Press, 2013.

Sagendorf, Bud. *Popeye: The First Fifty Years.* New York: Workman, 1979.

Sandler, Kevin S., ed. *Reading the Rabbit: Explorations in Warner Bros. Animation.* New Brunswick, NJ: Rutgers University Press, 1998.

Schatz, Thomas. *The Genius of the System: Hollywood Filmmaking in the Studio Era.* New York: Henry Holt, 1988.

Schickel, Richard. *The Disney Version: The Life, Times, Art, and Commerce of Walt Disney.* Chicago: Elephant Paperbacks, 1997.

Schiffrin, André. *Dr. Seuss & Co. Go to War,* New York: New Press, 2009.

Schneider, Steve. *That's All Folks! The Art of Warner Bros. Animation.* New York: Barnes & Noble Books, 1999.

Schwartz, Evan. *The Last Lone Inventor: A Tale of Genius, Deceit, and the Birth of Television.* New York: HarperCollins, 2002.

Shale, Richard. *Donald Duck Joins Up: The Walt Disney Studio During World War II.* Ann Arbor: University of Michigan Research Press, 1982.

Shull, Michael S., and David E. Wilt. *Doing Their Bit: Wartime American Animated Short Films, 1939–1945.* Jefferson, NC: McFarland & Co., 2004.

Silvester, Christopher, ed. *The Grove Book of Hollywood.* New York: Grove Press, 1998.

Sito, Tom. *Drawing the Line: The Untold Story of the Animation Unions from Bosko to Bart Simpson.* Lexington: University Press of Kentucky, 2006.

Sklar, Robert. *Movie-Made America: A Cultural History of American Movies.* New York: Vintage, 1994.

Smoodin, Eric. *Animating Culture: Hollywood Cartoons from the Sound Era.* New Brunswick, NJ: Rutgers University Press, 1993.

Solomon, Charles. *Enchanted Drawings: The History of Animation.* New York: Wings Books, 1994.

Stubbs, John. *Jonathan Swift: The Reluctant Rebel,* New York: W. W. Norton, 2017.

Suares, Jean-Claude. *Great Cats: The Who's Who of Famous Felines.* New York: Bantam, 1981.

Susanin, Timothy S. *Walt Before Mickey: Disney's Early Years, 1919–1928.* Jackson: University Press of Mississippi, 2011.

Thomas, Bob. *Building a Company: Roy O. Disney and the Creation of an Entertainment Empire.* New York: Hyperion, 1998.

———. *Walt Disney: An American Original.* New York: Simon & Schuster, 1976.

Thomas, Frank, and Ollie Johnston. *The Illusion of Life: Disney Animation.* New York: Hyperion Books, 1981.

Tisserand, Michael. *Krazy: George Herriman, a Life in Black and White.* New York: Harper, 2016.

Tye, Larry. *Superman: The High-Flying History of America's Most Enduring Superhero.* New York: Random House, 2012.

Tytle, Harry. *One of "Walt's Boys": An Insider's Account of Disney's Golden Years.* Royal Oak, MI: Airtight Seals Allied Production, 1997.

Udelson, Joseph H. *The Great Television Race: A History of the American Television Industry, 1925–1941.* Tuscaloosa: University of Alabama Press, 1982.

Vacher, Peter. *Swingin' on Central Avenue: African American Jazz in Los Angeles.* Lanham, MD: Rowman & Littlefield, 2015.

Watts, Steven. *The Magic Kingdom: Walt Disney and the American Way of Life.* Boston: Houghton Mifflin, 1997.

Weinstein, Simcha. *Up, Up, and Oy Vey! How Jewish History, Culture, and Values Shaped the Comic Book Superhero.* Fort Lee, NJ: Barricade Books, 2006.

Wilson, Robert, ed. *The Film Criticism of Otis Ferguson.* Philadelphia: Temple University Press, 1971.

Image Credits

Images credits for the insert section are as follows: Insert pages 1 through 3: Wikimedia Commons; Insert 4a: courtesy of Ray Pointer; Insert 4b: Wikimedia Commons; Insert 5a: courtesy of Ray Pointer; Insert 5b: courtesy of J.J. Sedelmaier; Insert 6a: courtesy of Ray Pointer; Insert 6b: Wikimedia Commons; Insert 7a: courtesy of Todd and Debbie Levine; Insert 7b: Wikimedia Commons; Insert 8a: courtesy of Ray Pointer; Insert 8b: Wikimedia Commons; Insert 9a: Elmer Holmes Bobst Library; Insert 9b: Wikimedia Commons; Insert 10a: Wikimedia Commons; Insert 10b: Library of Congress, Prints and Photographs Division; Insert 11a: Hubley Studio; Insert 11b: courtesy of Adam Abraham; Insert 12a: courtesy of Hubley Studio; Insert 12b: courtesy of Adam Abraham; Insert 13a: courtesy of Michael Barrier; Insert 13b: Orange County Archives; Insert page 14: courtesy of Adam Abraham; Insert 15a: courtesy of Adam Abraham; Insert 15b: courtesy of Hubley Studio; Insert 16a: courtesy of Adam Abraham; Insert 16b: courtesy of Ray Pointer.

Image credits for the images running throughout the text are as follows: pages 7, 12, 15, and 21: Wikimedia Commons; page 27: U.S. Patent and Trademark Office; page 30: courtesy of Ray Pointer; pages 32, 37, 40, and 48: Wikimedia Commons; page 52: courtesy of Ray Pointer; page 53: courtesy of Todd and Debbie Levine; pages 72 and 77: Wikimedia Commons; page 95: courtesy of *National Board of Review Magazine*; pages 102 and 105: courtesy of Todd and Debbie Levine; page 114: Wikimedia Commons; page 121: Library of Congress; page 132: courtesy of J.J. Sedelmaier; pages 140 and 147: courtesy of Todd and Debbie Levine; page 148: courtesy of Ray Pointer; pages 156 and 170: courtesy of Todd and Debbie Levine; page 182: Wikimedia Commons; page 188: courtesy of Jerry Beck; page 203: courtesy of Todd and Debbie Levine; page 209: Library of Congress; pages 218 and 245: Wikimedia Commons; page 247: Special Collection & Archives, University of California, San Diego; pages 253, 255, and 269: Wikimedia Commons; page 283: courtesy of Todd and Debbie Levine; page 294: courtesy of Jerry Beck; page 297: courtesy of the Chuck Jones Museum; page 299: courtesy of Jerry Beck; page 316: courtesy of Todd and Debbie Levine.

Notes

Prologue

xiii **West Hoboken, New Jersey:** This would later become known as Union City.

xiv **"Look, don't you know":** Otto Messmer interviewed by John Mariano and Mark Newgarden, "An Interview with Otto Messmer," May 7, 1980, transcript held in Canemaker Animation Collection, Fales Library and Special Collections, Elmer Holmes Bobst Library, New York University.

xv **"emote":** Otto Messmer interviewed by John Canemaker on March 5, 1975, and January 29, 1979, Canemaker Animation Collection, Fales Library and Special Collections, Elmer Holmes Bobst Library, New York University.

xv **Messmer biographical details:** John Canemaker, "Otto Messmer and Felix the Cat," *Millimeter Magazine*, September 1976, p. 32; Otto Messmer interviewed by David Weinstein, unpublished, Canemaker Animation Collection, Fales Library and Special Collections, Elmer Holmes Bobst Library, New York University.

Chapter 1

1 **Winsor's claim of being first:** Winsor McCay, "How I Originated Motion Picture Cartoons," *Cartoons and Movies Magazine*, April 1927, p. 11.

1 **Winsor McCay's early biographical details:** Winsor McCay files from John Canemaker Animation Collection, Fales Library and Special Collections, Elmer Holmes Bobst Library, New York University; John Canemaker, *Winsor McCay: His Life and Art* (New York: Abbeville Press, 1987), pp. 21–27.

2 **"Bob":** Jim Korkis, "Animation Anecdotes #217," *Cartoon Research*, June 19, 2015, www.cartoonresearch.com. (Hereafter, "Animation Anecdotes.")

2 **"A great many women":** Canemaker, *Winsor McCay*, p. 25.

3 **"heart was always":** and details of Kohl & Middleton's, Canemaker, *Winsor McCay*, pp. 35–36.

3 **Charles J. Christie:** Padraic O'Glasain, "Winsor McCay: Little Nemo's Daddy," unpublished manuscript, 1941, Canemaker Animation Collection, Fales Library and Special Collections, Elmer Holmes Bobst Library, New York University, Box 17. (Hereafter, Canemaker Animation Collection.)

3 **Details about McCay's personality:** Interview by John Canemaker with members of the Moniz family, September 13, 1984, Canemaker Animation Collection, Box 17.

4 **Letter from *New York Herald:*** Copy of letter dated Sepember 15, 1903, Canemaker Animation Collection, Box 17.

5 **"I just couldn't stop":** O'Glasain, "Winsor McCay"; Canemaker, *Winsor McCay,* p. 23.

5 **George McManus:** John A. Fitzsimmons, "My Days with Winsor McCay," unpublished manuscript, March 1974, Canemaker Animation Collection, Box 17, Folder 187.

6 **Winsor's tools:** Fitzsimmons, "My Days with Winsor McCay."

8 **Details of showing *Little Nemo:*** Canemaker, *Winsor McCay,* pp. 132–133.

8 **"Seventy or eighty years":** Quoted in Charles Solomon, *Enchanted Drawings: The History of Animation* (New York: Wings Books, 1994), p. 16.

8 **"It is as though":** Letter from Chuck Jones to John Canemaker, August 22, 1985, Canemaker Animation Collection.

8 **"Take, for instance":** Quoted in Solomon, *Enchanted Drawings,* p. 17.

Chapter 2

10 **Animation precursors:** Solomon, *Enchanted Drawings,* pp. 3–15; Donald Crafton, *Before Mickey: The Animated Film, 1898–1928* (Chicago: University of Chicago Press, 1993); Michael Barrier, *Hollywood Cartoons: American Animation in Its Golden Age* (Oxford: Oxford University Press, 1999); Giannalberto Bendazzi, *Cartoons: One Hundred Years of Cinema Animation* (Bloomington: Indiana University Press, 1994).

13 **Cohl correcting others:** Donald Crafton, "Émile Cohl and the Origins of the Animated Film" (Ph.D. dissertation, Yale University, 1977), p. 187.

14 **Cohl and Gaumont:** There are actually two different versions of how Cohl got his job at Gaumont. The other (less colorful) version has it that he had two friends working there, and they got him the job.

14 **Cohl and Blackton's film:** Crafton, *Before Mickey,* pp. 18–20.

14 **the Incoherents:** Crafton, *Before Mickey,* p. 78.

16 **Details of Cohl's early days:** Canemaker Animation Collection, Box 8, Folders 56–58, and Box 9, Folder 59, Émile Cohl; Crafton, "Émile

Cohl and the Origins of the Animated Film"; Crafton, *Before Mickey*;
Donald Crafton, *Émile Cohl, Caricature, and Film* (Princeton: Princeton
University Press, 1990).

16 **Cohl's time in America:** Crafton, *Before Mickey*, pp. 82–83.

18 **"It was lucrative":** Quoted in Crafton, *Before Mickey*, p. 111.

19 **Cohl's visitors:** Barrier, *Hollywood Cartoons*, pp. 10–11; Crafton, *Before Mickey*, p. 194.

Chapter 3

20 **"Winsor, you've done it":** O'Glasain, "Winsor McCay," p. 118.

20 **"Had I taken out patents":** O'Glasain, "Winsor McCay," p. 120.

20 **"Wishing to aid":** Fitzsimmons, "My Days with Winsor McCay."

20 **"I was paid":** Allan Harding, "They All Thought Him Crazy, but They Don't Think So Now," *American Magazine*, January 1925, p. 126.

21 **"I thought there was good":** Quoted in Leonard Maltin, *Of Mice and Magic: A History of American Animated Cartoons* (New York: Plume, 1987), p. 6.

22 **"If you have faith":** Harding, "They All Thought Him Crazy," p. 126.

23 **"citation of infringement":** Fitzsimmons, "My Days with Winsor McCay."

23 **"He felt he was":** Isadore Klein, "How I Came to Know the Fabulous Winsor McCay," *Cartoonist Profiles* 34 (June 1977): 51.

23 **"I didn't know":** John Bray interviewed by John Canemaker, March 25, 1974, Canemaker Animation Collection, Box 5, Folder 16.

23 **Bray's patents:** L. D. Underwood to Clair W. Fairbank, February 27, 1914, from file for Patent 1,107,193, issued August 11, 1914, Patent and Trademark Office, Record Group 241, National Archives, Washington, DC.

23 **"an interesting curiosity":** Quoted in Solomon, *Enchanted Drawings*, p. 25.

24 **John Bray background:** John Bray folders at Canemaker Animation Collection, Box 5, Folder 16, and Box 40, Folder 348.

24 **McCay's cut:** Letter from Burke & Burke to Winsor McCay on behalf of Bray Hurd Process Company, October 21, 1932, Canemaker Animation Collection.

24 **"McCay won a moral victory":** Klein, "How I Came to Know the Fabulous Winsor McCay," p. 51.

24 **Raoul Barré:** NYU Fales Library, Raoul Barré Folder, Box 27, Folder 345.

25 **Technical aspects of animation:** Crafton, *Before Mickey*, pp. 148–154; Barrier, *Hollywood Cartoons*, pp. 11–14.

Chapter 4

26 **"Max, you're a bright":** Richard Fleischer, *Out of the Inkwell: Max Fleischer and the Animation Revolution* (Lexington: University Press of Kentucky, 2005), p. 15.

27 **"To me, machinery":** Max Fleischer, unpublished biography, 1939, quoted in Fleischer, *Out of the Inkwell,* p. 13.

27 **Dave becoming intrigued by animation:** "Recollections of Dave Fleischer," transcript of interview of Dave Fleischer by Joe Adamson, 1969, p. 6, Canemaker Animation Collection.

28 **"Dave was fascinated":** Fleischer, *Out of the Inkwell,* pp. 16–17.

28 **"a five foot three":** Fleischer, *Out of the Inkwell,* p. 77.

28 **"This is for your crazy idea":** Family lore recounted in Fleischer, *Out of the Inkwell.*

28 **Max's experiences with distributors:** Fleischer, *Out of the Inkwell,* pp. 23–24.

29 **Dave's proposal:** Leslie Cabarga, *The Fleischer Story* (New York: Da Capo, 1988), p. 24.

29 **Filming Dave as clown:** Ray Pointer, *The Art and Inventions of Max Fleischer: American Animation Pioneer* (Jefferson, NC: McFarland & Co., 2017), pp. 31–32.

30 **Pathé and *Canterbury Tales*:** Pointer, *The Art and Inventions of Max Fleischer,* p. 33; Cabarga, *The Fleischer Story,* pp. 22–23.

31 **Ferry ride:** "Recollections of Dave Fleischer," transcript of interview of Dave Fleischer by Joe Adamson, p. 6.

32 **"Creepy":** Zukor had this nickname before 1912, when he was still working with Marcus Loew. *Motion Picture Herald,* February 6, 1937. Other Zukor biographical details: Neal Gabler, *An Empire of Their Own: How the Jews Invented Hollywood* (New York: Crown, 1988).

32 **Pitching Zukor:** Fleischer, *Out of the Inkwell,* p. 24.

Chapter 5

35 **"No one, however good":** "Remembrance of Hammerstein's Victoria," *New Yorker,* December 20, 1930, p. 42.

35 **"His act":** *New York Telegraph,* March 8, 1914.

35 **"can't come now":** Quoted in Canemaker, *Winsor McCay,* p. 145.

35 **"Hearst to Stop":** *New York Telegraph,* March 8, 1914.

35 **"Mr. McCay, you're a serious artist":** O'Glasain, "Winsor McCay," p. 158.

35 **Yearly salary of $260,000:** Equivalent to approximately $6.4 million in 2018.

35 **Brisbane:** Oliver Carlson, *Brisbane: A Candid Biography* (New York: Stackpole Sons, 1937), p. 182.

36 **Hearst and Swinnerton:** Michael Tisserand, *Krazy: George Herriman, a Life in Black and White* (New York, Harper, 2016), p. 74, referencing Louis Sobol with Jimmy Swinnerton, "The Voice of Broadway" (syndicated column).

36 **"Eight pages":** Quoted in Tisserand, *Krazy,* p. 74.

37 **Winsor's job switch:** O'Glasain, "Winsor McCay"; Canemaker, *Winsor McCay,* pp. 133–135.

38 **Hearst and war:** Carlson, *Brisbane,* p. 182.

38 **"was properly a spoil":** Carlson. *Brisbane.*

39 **"Imagine how effective":** *Detroit News,* July 22, 1916.

39 **"Blood-Stirring":** Quoted in Crafton, *Before Mickey,* pp. 116–117.

39 **Details of *Lusitania* production:** Fitzsimmons, "My Days with Winsor McCay," p. 27; Winsor McCay, *Illustrating and Cartooning: Animation* (Minneapolis: Federal Schools, Inc., 1923), p. 19.

Chapter 6

42 **"Dere ain't no":** *San Francisco Chronicle,* December 7, 1913.

42 **"left wings":** John Canemaker, *Felix: The Twisted Tale of the World's Most Famous Cat* (New York: Pantheon, 1991), p. 27.

43 **Barré's studio:** Isadore Klein describes this in *Cartoonist Profiles,* March 1975.

43 **Sullivan laid off:** Canemaker, *Felix,* p. 34.

44 **Royalties:** Crafton, *Before Mickey,* p. 303.

44 **Otto Messmer quotes:** Otto Messmer interviewed by John Canemaker, March 5, 1975, and January 29, 1979, Canemaker Animation Collection.

44 **"He taught me":** Quoted in Canemaker, *Felix,* p. 36.

44 **Chaplin and Felix:** Synch transcript with Al Eugster and Otto Messmer for documentary, interviewed by John Canemaker. Canemaker Animation Collection.

45 **"Why animate something":** Quoted in Canemaker, *Felix,* p. 39.

46 **Alice McCleary testimony:** Manhattan District Attorney Closed Case File, Unit #115312, 1917; New York Court of General Sessions transcript, September 13, 1917; Brief for the People, The People Vs. Patrick Sullivan; Witness testimony; copies in Canemaker Animation Collection, Box 18, Folders 208–208a.

46 **Marjorie Sullivan letter:** Canemaker Animation Collection, Box 18, Folders 208–208a.

46 **"A man of very"**: New York Court of General Sessions transcript, Sep-
 tember 13, 1917. Copy held in Canemaker Animation Collection.

46 **Alice McCleary and Gladys Bowen, rape case:** Manhattan District
 Attorney Closed Case File, Unit #115312, 1917; New York Court of
 General Sessions transcript, September 13, 1917; Brief for the People,
 The People Vs. Patrick Sullivan; Witness testimony; copies of all in the
 Canemaker Animation Collection, Box 18, Folders 208–208a.

46 **Envelope to Harry Kopp, lawyer:** Canemaker Animation Collection,
 Box 18.

47 **"making a lot"**: Quoted in Canemaker, *Felix*, p. 51.

48 **Felix's gestures:** Crafton, *Before Mickey*, p. 342.

49 **Bill Nolan:** Barrier, *Hollywood Cartoons*, p. 31.

50 **"Felix represented"**: From "Felix the Cat and the Twenties," Otto
 Messmer interviewed by John Culhane, circa 1974, unpublished manu-
 script of "The Art of the Comic Strip," for the University of Maryland
 Department of Art. Copy held in Canemaker Animation Collection,
 Box 19, Folder 210.

50 **Marcel Brion:** Quoted in Jean-Claude Suares, *Great Cats: The Who's Who
 of Famous Felines* (New York, Bantam, 1981), p. 38.

50 **Aldous Huxley:** Aldous Huxley, "Where Are the Movies Moving?" *Vanity
 Fair*, July 1925.

Chapter 7

51 **"How can I"**: Quoted in Crafton, *Before Mickey*, p. 158. Having already
 had children by this point, Fleischer probably wouldn't have been
 compelled to serve anyway.

53 **"A living example"**: *Motion Picture World*, July 24, 1920.

53 **"Mr. Fleischer's work"**: *New York Times*, October 12, 1919.

53 **"Why doesn't"**: *New York Times*, April 21, 1919.

54 **Cartoons on marquees:** Fleischer, *Out of the Inkwell*, p. 29.

54 **Details of transition to Goldwyn:** Pointer, *The Art and Inventions of Max
 Fleischer*, p. 41.

54 **$50,000 gambling:** Pointer, *The Art and Inventions of Max Fleischer*,
 p. 42.

55 **Margaret Winkler bio details:** Canemaker Animation Collection, Mar-
 garet Winkler Folder, Box 17, Folder 173.

55 **"How did you do it?"**: Referenced in Carol Hayes, "Cartoon Producer
 Recalls Early Days," *New York Times*, April 28, 1985.

56 **"I think the industry"**: *Exhibitor's Herald*, December 30, 1922.

56 **"but they got over it":** Hayes, "Cartoon Producer Recalls Early Days."

56 **New studio:** Pointer, *The Art and Inventions of Max Fleischer*, p. 42.

56 **Koko:** Pointer, *The Art and Inventions of Max Fleischer*, pp. 46–47.

57 **"When you see the stars":** Cabarga, *The Fleischer Story*, p. 30.

57 **"It amused me":** Cabarga, *The Fleischer Story*, p. 30.

58 **"either a man":** Quoted in *Fleischer's Animated News* #1, a studio newsletter, December 1934.

58 **"Now there are four":** Quoted in Stefan Kanfer, *Serious Business: The Art and Commerce of Animation in America from Betty Boop to Toy Story* (New York: Scribner, 1997), p. 57.

58 **"The picture made an attempt":** Fleischer, *Out of the Inkwell*, p. 36.

59 **"A dreamer":** Quoted in Maltin, *Of Mice and Magic*, p. 127.

59 **Paul Terry biographical details:** Transcript of Paul Terry interviewed by Harvey Deneroff, December 20, 1969, Canemaker Animation Collection, Box 24, Folders 234–242.

59 **Selznick:** Quoted in Maltin, *Of Mice and Magic*, p. 126.

60 **"unconscious satire":** Transcript of Dick Huemer interviewed by Joe Adamson, n.d., p. 29, Canemaker Animation Collection.

60 **Distributors and theater owners:** Maltin, *Of Mice and Magic*, p. 129.

60 **Babbitt's description of gags:** Art Babbitt interviewed by John Canemaker, June 1975, Canemaker Animation Collection; also discussed in Solomon, *Enchanted Drawings*, p. 94.

61 **"We take any idea":** Theodore Strauss, "Mr. Terry and the Animal Kingdom," *New York Times*, July 7, 1940.

61 **"We do shit here":** Shamus Culhane, *Talking Animals and Other People* (New York: St. Martin's 1986), p. 391.

Chapter 8

62 **Fellini:** Jim Korkis, "Animation Anecdotes #106," April 19, 2013.

62 **Sullivan's trip to England:** From "Felix the Cat and the Twenties," Otto Messmer interviewed by John Culhane, circa 1974, unpublished manuscript of "The Art of the Comic Strip," for the University of Maryland Department of Art. Copy held in Canemaker Animation Collection, Box 19 Folder 210.

62 **"publicity producing angles":** Unidentified trade journal quoted in Canemaker, *Felix*, p. 89.

63 **"It seems a dream":** From "Felix the Cat and the Twenties," Otto Messmer interviewed by John Culhane. Copy held in Canemaker Animation Collection, Box 19 Folder 210.

63 **Sullivan press trip in London:** Clippings from "Felix the Cat and the Twenties," Otto Messmer interviewed by John Culhane.

63 **Sullivan's interviews with the British press:** Newspaper clippings found in the Canemaker Animation Collection, Box 18, Folders 200–213; Box 26, Folder 248; Box 41, Folders 367–372.

64 **Stray cat:** Clippings from "Felix the Cat and the Twenties," Otto Messmer interviewed by John Culhane.

64 **"once and only once":** Canemaker, *Felix*, p. 59.

65 **Zukor's desk:** Canemaker, *Felix*, pp. 59–60.

65 **"the most consistent":** Culhane, *Talking Animals and Other People*, p. 57.

65 **Shamus Culhane:** Culhane, *Talking Animals and Other People*, p. 58.

66 **Al Eugster:** Transcript of Al Eugster interviewed by John Canemaker, May 13, 1976. Canemaker Animation Collection.

Chapter 9

67 **Julius:** During Julius's first appearances, in the *Alice* comedies, he still wasn't officially called "Julius." The official naming would happen later.

68 **Walt and Winkler:** Michael Barrier, *The Animated Man: A Life of Walt Disney* (Berkeley: University of California Press, 2007), pp. 40–41, 49.

69 **Walt's memories of Marceline:** Roy Disney interviewed by Richard Hubler, Richard Hubler Collection, Special Collections, Mugar Library, Boston University. Quoted in Neal Gabler, *Walt Disney: The Triumph of the American Imagination* (New York: Knopf, 2006), p. 10.

69 **Aunt Maggie:** Gabler, *Walt Disney*, pp. 14–15, citing Walt Disney, "Autobiography," unpublished manuscript, 1939, 2nd installment, Walt Disney Archives.

69 **Doc Sherwood:** Phil Santora, "A Kid from Chicago," *New York Daily News*, September 30, 1964.

69 **"the highlight":** Amy Boothe Green and Howard E. Green, *Remembering Walt: Favorite Memories of Walt Disney* (New York: Hyperion, 1990), p. 5.

69 **"giving whiskey":** Quoting Don Taylor interview about Marceline, cited in Gabler, *Walt Disney*, p. 16.

69 **Other Disney views of Walt's childhood:** Roy Disney interview by Richard Hubler, June 18, 1968, Richard Hubler Collection, Special Collections, Mugar Library, Boston University; Ruth Disney Beecher interviewed by David Smith, December 1976, Ruth Beecher Folder, Disney Family Correspondence, A2379, Walt Disney Archives, cited in Gabler, *Walt Disney*, pp. 22, 32.

70 **"seldom more":** Margaret Hamilton, "Walt Disney: Back to School," *Kansas City Star*, February 8, 1942.

70 **"Your summer vacation":** *The McKinley Voice*, October 1917, Disney Drawings Folder, Walt Disney Archives, cited in Gabler, *Walt Disney*, p. 33.

70 **"This nonsense":** Walt Disney, speech at Big Brothers ceremony, March 14, 1957, Walt Disney Archives, cited in Gabler, *Walt Disney*, p. 41.

71 **Chaplin:** Richard Hubler, "Walt Disney," unpublished biography, 1968, p. 120, Richard Hubler Collection, cited in Gabler, *Walt Disney*, p. 27.

71 **"liked the applause":** Walt quoted in Gabler, *Walt Disney*, p. 27.

71 **"it seemed easier":** Quoted in Hubler, "Walt Disney," p. 93.

71 **Comic-strip plates:** Walt Disney interview by Martin.

71 **"He had the drive":** Nadine Missakian, Notes, Nadine Missakian, Correspondence Folder, Kansas City Box, A2364, Walt Disney Archives, cited in Gabler, *Walt Disney*, p. 68.

71 **Census:** Federal Census, January 7, 1920, Jackson County, Mo., ed. 166, sheet 5, line 37, cited in Gabler, *Walt Disney*, p. 46.

72 **"cartoons for the":** Walt quoted in Gabler, *Walt Disney*, p. 49.

72 **Old camera:** Brian Burnes, Robert W. Butler, and Dan Viets, *Walt Disney's Missouri: The Roots of Creative Genius,* ed. Donna Martin (Kansas City, MO: Kansas City Star Books, 2002), p. 79.

72 **"puttering away":** Roy Disney quoted in *Walt Disney: An Intimate History of the Man and His Magic* (CD-ROM) (Pantheon Productions, 1998).

73 **Laugh-O-Grams:** Don Eddy, "The Amazing Secret of Walt Disney," *American Magazine*, August 1955, p. 113.

73 **"I got to be a little":** Diane Disney Miller, *The Story of Walt Disney* (New York: Henry Holt, 1956), p. 64.

73 **"It was more fun":** Gabler, *Walt Disney*, p. 67, citing Bob Thomas interviewing Walt Pfeiffer, April 26, 1973, Walt Disney Archives.

73 **Beans:** Richard Schickel, *The Disney Version: The Life, Times, Art, and Commerce of Walt Disney* (Chicago: Elephant Paperbacks, 1997, originally published by Simon & Schuster, 1968), p. 81.

74 **"Our ideas were great":** Quoted in "The Mouse That Won a Nation," *Kansas City Times*, November 11, 1978.

74 **"I took Walt Disney":** William Rast to Donn Tatum, September 18, 1979, William Rast Folder, Disney Family: Genealogy, Etc., A2382, Walt Disney Archives, cited in Gabler, *Walt Disney*, p. 74.

75 *Alice* **trade reviews:** Quoted in Gabler, *Walt Disney*, p. 95.

75 **Deposit on studio:** David Smith, "Disney Before Burbank: The Kingswell and Hyperion Studios," *Funnyworld*, no. 20 (Summer 1979): 34–35.

75 **"more like Felix"; "You'd better watch that stuff":** Animator Frank Thomas to John Canemaker, October 15, 1989, Canemaker Animation Collection, Box 14, Folders 157–158.

75 **"I was ambitious":** Walt Disney, "Growing Pains," *American Cinematographer*, March 1941.

76 **"My home, family":** Quoted in Crafton, *Before Mickey*, p. 319.

76 **"too many cats":** Barrier, *The Animated Man*, p. 51.

76 **Laemmle:** Bob Thomas, *Walt Disney: An American Original* (New York: Simon & Schuster, 1976).

76 **"I want the characters":** Quoted in Russell Merritt and J. B. Kaufman, *Walt in Wonderland: The Silent Films of Walt Disney* (Baltimore: Johns Hopkins University Press, 1993), p. 81.

76 **an advance of $2,250:** Barrier, *The Animated Man*, p. 65.

76 **"I am the LUCKY":** *Universal Weekly*, May 28, 1927.

77 **"clearly drawn":** *Motion Picture News*, August 19, 1927.

77 **"contender":** *Film Daily*, June 7, 1927.

77 **Walt's salary:** Timothy S. Susanin, *Walt Before Mickey: Disney's Early Years, 1919–1928* (Jackson: University Press of Mississippi).

78 **Hiring away staff:** Ub Iwerks interview, circa 1956, Walt Disney Archives, cited in Gabler, *Walt Disney*, p. 106.

78 **Walt's cables and meeting with Quimby:** Cited in Gabler, *Walt Disney*, pp. 106–107.

79 **"He was like":** Eddy, "The Amazing Secret of Walt Disney," p. 113.

79 **"All he could say":** Eddy, "The Amazing Secret of Walt Disney," p. 113.

Chapter 10

80 **"It's too dangerous":** Nancy Roe Pimm, *The Jerrie Mock Story: The First Woman to Fly Solo Around the World* (Athens: Ohio University Press, 2016).

80 **Ruth Elder:** Canemaker, *Felix*, pp. 118–119.

80 **"Felix was goin'":** Transcript of Otto Messmer interviewed by John Canemaker, March 5, 1975, Canemaker Animation Collection.

81 **Night at Roth's:** Detailed in Klein, "How I Came to Know the Fabulous Winsor McCay," pp. 49–51.

82 **"Since I originated":** Canemaker, *Winsor McCay*, p. 191.

82 **Cuba:** Karl Cohen, *Forbidden Animation: Censored Cartoons and Blacklisted Animators in America* (Jefferson, NC: McFarland & Co., 1997), p. 12.

83 **"The laughter almost blew":** Quoted in Jim Korkis, "Harlequin: X-Rated Cartoon!" *Mindrot*, Spring 1977, p. 6. The quote comes from

Ward Kimball, a Disney animator who wasn't actually there, but remembered hearing countless stories about the evening.

83 **"Bad luck!":** Klein, "How I Came to Know the Fabulous Winsor McCay."

Chapter 11

85 **Max at the Rialto:** Fleischer, *Out of the Inkwell,* pp. 41–42.
86 **Edison's problems with the Kinetophone:** Richard Koszarski, *Hollywood on the Hudson: Film and Television in New York from Griffith to Sarnoff* (New Brunswick, NJ: Rutgers University Press, 2008), p. 144.
86 **De Forest's financial problems:** Tom Lewis, *Empire of the Air: The Men Who Made Radio* (New York: HarperCollins, 1991), pp. 82–85.
87 *My Old Kentucky Home:* Fleischer, *Out of the Inkwell,* p. 43.
87 **Fears of sound:** Norman Klein, *Seven Minutes* (New York: Verso, 1993), p. 3.
87 **"the dangers of radio":** Kliph Nesteroff, *The Comedians: Drunks, Thieves, Scoundrels, and the History of American Comedy* (New York: Grove Press, 2015), p. 24.
88 **Harry Warner:** Koszarski, *Hollywood on the Hudson,* p. 149.
88 **"Warner Vitaphone Peril":** Schickel, *The Disney Version,* p. 119.
88 **Warner Bros. stock and rise:** Alva Johnston, "Profile," *New Yorker,* December 22, 1928; Kevin Brownlow, *The Parade's Gone By* (New York: Knopf, 1968), p. 658.
88 **Transition to sound:** There are countless books on this subject. Particularly useful ones are Scott Eyman, *The Speed of Sound: Hollywood and the Talkie Revolution, 1926–1930* (New York: Simon & Schuster, 1997); Thomas Schatz, *The Genius of the System: Hollywood Filmmaking in the Studio Era* (New York: Henry Holt, 1988); Robert Sklar, *Movie-Made America: A Cultural History of American Movies* (New York: Vintage, 1994).
88 **Wilfred Jackson:** Interviewed by Richard Hubler, quoted in Gabler, *Walt Disney,* p. 117.

Chapter 12

90 **Lillian recalls Mickey creation:** Eddy, "The Amazing Secret of Walt Disney," p. 113. Also accounts in Gabler, *Walt Disney,* p. 112; and Barrier, *The Animated Man,* pp. 56–57.
90 **Walt Mouse stories:** Isabella Taves, "I Live with a Genius," *McCall's,* February 1953, p. 104; *Saturday Evening Post,* October 31, 1953, p. 92; *Los Angeles Times,* November 15, 1931, sec. 2, p. 2; *New York Journal-*

American, January 29, 1938; Gerald Nachman, "Walt Disney: Portrait of the Artist," *New York Post,* October 10, 1965.

90 **"highly exaggerated":** Quoted in Gabler, *Walt Disney,* p. 113.

91 **"to push out 700 feet":** Quoted in Schickel, *The Disney Version,* p. 117.

91 **"You realize now":** Robert W. Welkos, "The Genie Has a Gripe with Disney," *Los Angeles Times,* November 25, 1993.

91 **Account of making *Plane Crazy:*** Disney, "Growing Pains," p. 106.

92 **Walt and distributors:** Gabler, *Walt Disney,* p. 116.

92 **MY GOSH:** Quoted in Crafton, *Before Mickey,* p. 211.

92 **First recording session:** Miller, *The Story of Walt Disney,* pp. 100–101.

93 **"Not the first":** *Variety,* November 21, 1928.

94 **Theater owners and *Skeleton Dance:*** Barrier, *The Animated Man,* p. 68.

94 **Mayer and MGM:** Frances Marion, *Off with Their Heads! A Serio-Comic Tale of Hollywood,* excerpted in *The Grove Book of Hollywood,* ed. Christopher Silvester (New York: Grove Press, 1998), pp. 116–118.

95 **Frank Capra:** Frank Capra, *The Name Above the Title: An Autobiography* (New York: Macmillan, 1971), p. 104.

96 **"The Most Popular":** *Film Daily,* December 1, 1930.

96 **"narcotized":** Dr. A. A. Brill, "Dr. Brill Analyzes Walt Disney's Masterpiece," *Photoplay* 45 (April 1934).

96 **"perfect expression":** John Culhane, "A Mouse for All Seasons," *Saturday Review of Literature,* November 11, 1978.

96 **"We just make a Mickey":** John T. McManus, "Speaking of Movies," *PM,* August 1943.

Chapter 13

97 **"It became the rage":** David Dodd Hand, *Memoirs* (Cambria, CA: Lighthouse Litho, 1990), p. 66.

97 **"You don't change":** Quoted in Barrier, *Hollywood Cartoons,* p. 34.

98 **"Disney put us":** Quoted in Canemaker, *Felix,* p. 7.

98 **"eating, breathing":** Quoted in Canemaker, *Felix,* p. 129.

99 **"used Marjorie":** Canemaker, *Felix,* p. 134.

99 **Other details of Sullivan's last days and Marjorie's death:** John Culhane, "The Art of the Comic Strip," unpublished manuscript, held in the Fales Collection at NYU; Tom Sito, *Drawing the Line: The Untold Story of the Animation Unions from Bosko to Bart Simpson* (Lexington: University Press of Kentucky, 2006), p. 38.

99 **Philo T. Farnsworth:** Evan Schwartz, *The Last Lone Inventor: A Tale of Genius, Deceit, and the Birth of Television* (New York: HarperCollins, 2002); Malcolm Gladwell, "The Televisionary," *New Yorker,* May 27, 2002.

100 **"the way an inventor":** Gladwell, "The Televisionary."

100 **Early television history:** Erik Barnouw, *Tube of Plenty: The Evolution of American Television* (New York: Oxford University Press, 1990); Joseph Udelson, *The Great Television Race: A History of the American Television Industry, 1925–1941* (Tuscaloosa: University of Alabama Press, 1982).

101 **McCay on television:** O'Glasain, "Winsor McCay"; Conrad Smith, "The Early History of Animation: Saturday Morning TV Discovers 1915," *Journal of the University Film Association* 29, no. 3 (Summer 1977): 23.

101 **Dick Huemer:** Richard Huemer interviewed by Joe Adamson, "Recollections of Richard Huemer," 1969, copy of transcript held in Canemaker Animation Collection, Richard Huemer Folder.

104 **Grim Natwick biographical details:** Grim Natwick interview by John Canemaker, 1974, transcript in Canemaker Animation Collection, Box 28, Folder 260.

104 **"She was wearing":** Grim Natwick interviewed by John Canemaker, May 19, 1974, transcript in Canemaker Animation Collection.

105 **Grim Natwick designing Betty Boop:** Grim Natwick interviewed by John Canemaker, 1974, transcript in Canemaker Animation Collection, Box 13, Folder 136.

Chapter 14

107 **Betty Boop trial details:** "Cinema: Boop in Court," *Time,* February 19, 1934; "Helen Kane in Court; Testifies in Her $250,000 Suit over Betty Boop Films," *New York Times,* April 18, 1934; "Claims 'Betty Boop': Artist Denies Theft in Answering $250,000 Suit—Verdict Reserved," *New York Times,* April 20, 1934; "Helen Kane Asks $250,000, Sues over 'Betty Boop' Films, Saying They Imitate Her," *New York Times,* May 3, 1932.

110 **Natwick on Betty Boop:** Grim Natwick interviewed by John Canemaker, 1974, transcript in Canemaker Animation Collection.

110 **Walt interviewing Natwick:** Culhane, *Talking Animals and Other People,* p. 128.

110 **"Without personality":** Walt Disney to John Culhane, August 26, 1951, quoted in John Canemaker, *Walt Disney's Nine Old Men and the Art of Animation* (New York: Disney Editions, 2001), p. 7.

110 **"perfection of the movies":** Gilbert Seldes, "Disney and Others," *New Republic,* June 8, 1932.

114 **"Yes indeed!":** "Cinema: Boop in Court," *Time,* February 19, 1934.

Chapter 15

117 **"wrong by wrong":** Quoted in Cohen, *Forbidden Animation*, p. 16.

118 **"about to observe":** Alva Johnston, "Czar and Elder," a profile of Will Hays, *New Yorker*, June 10, 1933.

118 **Delmonico's:** William J. Mann, *Tinseltown: Murder, Morphine, and Madness at the Dawn of Hollywood* (New York: Harper, 2014), p. 101.

118 **"They *were* the audience":** Quoted in Gabler, *An Empire of Their Own*, p. 5.

119 **"Moses wielding":** Mann, *Tinseltown*, p. 100.

119 **"A product of the gutters!":** *Kokomo* (IN) *Daily Tribune*, September 15, 1921.

119 **The sex thrill:** Various newspaper reports: *Mansfield* (OH) *News*, January 18, 1921; *Kingston* (NY) *Daily Freeman*, January 19, 1921; *Uniontown* (PA) *Daily News Standard*, January 19, 1921.

119 **"the devil and 500 non-Christian Jews":** *Variety*, December 31, 1920.

119 **"code of rules":** *Variety*, February 25, 1921. The paper published Lasky's complete list.

120 **"Caesar of the Cinema":** *Los Angeles Times*, July 21, 1922.

120 **30,000 people:** *Los Angeles Times*, July 30, 1922.

121 **"For the life of me":** *Los Angeles Times*, July 28, 1922.

121 **Moguls hiring Hays:** Johnston, "Czar and Elder."

121 **Will Hays's teeth, biographical details:** Johnston, "Czar and Elder"; Mann, *Tinseltown*, p. 262.

122 **Hays's strategy:** Stephen Vaughn, "The Devil's Advocate: Will H. Hays and the Campaign to Make Movies Respectable," *Indiana Magazine of History* 101, no. 2.

122 **"Anvil Chorus":** Will H. Hays, *The Memoirs of Will H. Hays* (Garden City, NY: Doubleday, 1955).

122 **"a woman making":** Quoted in Mann, *Tinseltown*.

123 **Shirley Temple:** David Denby, "Sex and Sexier," *New Yorker*, May 2, 2016, p. 66.

124 *Three Little Pigs*: Barrier, *The Animated Man*, pp. 94–98; Gabler, *Walt Disney*, p. 185.

125 **"it wasn't how a character looked":** Quoted in Kanfer, *Serious Business*, p. 82.

125 **"historians of the future":** Will Hays, *Annual Report to the Motion Picture Producers and Distributors of America* (New York, 1934).

125 *Three Little Pigs* **and anti-Semitism:** J. B. Kaufman, "Three Little Pigs—Big Little Picture," *American Cinematographer*, November 1988, pp. 43–44;

Gabler, *Walt Disney*, p. 454. Here, Gabler offers a nuanced argument addressing, and disputing, later claims that Walt himself was anti-Semitic.

126 **"turned the attention of young artists":** Disney, "Growing Pains," p. 139.

126 **"the main thing":** Quoted in Gabler, *Walt Disney*, p. 184.

Chapter 16

127 **"Now look, you guys":** Cabarga, *The Fleischer Story*, p. 100, from an interview with Essie Fleischer.

128 **"I did not welcome the trend":** Culhane, *Talking Animals and Other People*, p. 62.

128 **"very gay and colorful things":** Quoted in Gabler, *Walt Disney*, p. 157.

129 **"Let me give you the situation":** Culhane, *Talking Animals and Other People*, p. 110.

129 **Milt Schaffer:** Milt Schaffer, interview with Gray, March 21, 1977, quoted in Barrier, *Hollywood Cartoons*, p. 120.

130 **"institutional greens":** Culhane, *Talking Animals and Other People*, p. 113.

130 **volleyball courts:** Culhane, *Talking Animals and Other People*, p. 145.

130 **"mythical sun":** Grim Natwick quoted in "Animation," from *Cartoonist Profiles*, June 1979, p. 74.

130 **Culhane's first day at Disney:** Culhane, *Talking Animals and Other People*, p. 111.

130 **"Women do not do any":** Nathalia Holt, *The Queens of Animation: The Untold Story of the Women Who Transformed the World of Disney and Made Cinematic History* (New York: Little, Brown and Company, 2019), p. 17.

131 **"got the call":** Culhane, *Talking Animals and Other People*, p. 114.

131 **"stiffen you up":** John Canemaker, "Animation History and Shamus Culhane," *Filmmakers Newsletter*, June 1974.

131 **"Anyone who goes to art school":** John Canemaker, "Vlad Tytla: Animation's Michelangelo," from *The American Animated Cartoon: A Critical Anthology*, ed. Gerald Peary and Danny Peary (New York: Dutton, 1980), p. 84. (Hereafter, *The American Animated Cartoon*.)

131 **Details of Art Babbitt's coming to Disney:** Canemaker Animation Collection, Art Babbitt Folder, Box 5, Folders 3–7; Art Babbitt interviewed by Michael Barrier, June 2, 1971, in Hollywood, California, transcript in Canemaker Animation Collection.

133 **Inception of the art classes:** Culhane, *Talking Animals and Other People*, p. 116; Solomon, *Enchanted Drawings*, p. 52; John Canemaker, "Art

Babbitt: The Animator as Firebrand," *Millimeter*, September 1975, p. 12; Gabler, *Walt Disney*, p. 681.

133 **Cost of art school:** Gabler, *Walt Disney*, p. 176.

133 **Arshile Gorky:** Culhane, *Talking Animals and Other People*, p. 132.

133 **"Having problems?":** Chuck Jones, *Chuck Amuck: The Life and Times of an Animated Cartoonist* (New York: Farrar, Straus & Giroux, 1989).

134 **"Does your drawing":** Frank Thomas and Ollie Johnston. *The Illusion of Life: Disney Animation* (New York: Hyperion, 1998), p. 67.

134 **"Laymen":** Culhane, *Talking Animals and Other People*, p. 188.

135 **Slow-motion photographic studies:** Peter Martin interviewing Diane Disney Miller for *The Story of Walt Disney*, p. 121; Janet Martin, "Librarian to Walt Disney," *Wilson Library Bulletin*, December 1939, pp. 292–293; Thomas and Johnston, *The Illusion of Life*, pp. 321, 474; Gabler, *Walt Disney*, p. 176.

135 **Zoo:** Schickel, *The Disney Version*, p. 181.

135 **Jean Charlot and Frank Lloyd Wright:** Culhane, *Talking Animals and Other People*, pp. 157–158.

135 **Rico LeBrun:** Gabler, *Walt Disney*, p. 320.

136 **"looked like skull practice":** Culhane, *Talking Animals and Other People*, pp. 141–142; other descriptions of Morkovin's classes: Schickel, *The Disney Version*, p. 182; Gabler, *Walt Disney*, p. 231, referencing Boris Morkovin, Technique and Psychology of the Animated Cartoon, Studio Course, November 14, 1935–February 5, 1936, Beginners' Class, 1935–1936, Walt Disney Archives; Dr. Boris Morkovin, "Psychology of a Gag," n.d., p. 2, Walt Disney Archives.

136 ***The Golden Touch:*** Jack Kinney, *Walt Disney and Other Animated Characters: An Unauthorized Account of the Early Years at Disney's* (New York: Harmony Books, 1988); Jim Korkis, "Walt Disney's 'The Golden Touch' (1935)," March 20, 2013, from *Cartoon Research* (www.cartoonresearch.com); **Barrier,** *Hollywood Cartoons*, pp. 129–131.

136 **"best gag mind":** Huemer interviews. Fales Special Collection, NYU; Richard Huemer, *Recollections of Richard Huemer*, 1969, Special Collections, Young Research Library, UCLA.

137 **"Rubens":** Culhane, *Talking Animals and Other People,* p. 128.

Chapter 17

139 **Max Fleischer's encounter with Gortatowsky:** Detailed in Cabarga, *The Fleischer Story*, p. 82.

139 **"Popeye is much more":** Quoted in Cabarga, *The Fleischer Story*, p. 87.

139 Sagendorf: Quoted in Cabarga, *The Fleischer Story,* p. 87.

140 Concerned mothers: "Mellowed with Age," from "Topics of the Times," *New York Times,* October 17, 1938.

141 Abraham Lincoln Brigade: Sito, *Drawing the Line,* p. 79.

142 Spaghetti and Guinness: Korkis, "Animation Anecdotes #151," February 28, 2014.

142 Mercer biographical details: Michael Sporn interview by Jack Mercer 1977, interview posted to soundcloud: https://soundcloud.com/cartoon-research/jack-mercer-interview-by; also see Pointer, *The Art and Inventions of Max Fleischer,* p. 135.

142 "From his newspapers": "Mellowed with Age," *New York Times,* October 17, 1938.

143 Spinach sales up by a third: Kanfer, *Serious Business,* p. 96.

143 Spinach nutritional value: The story of spinach's nutritional value has indeed become a "supermyth." Many have reported that misperceptions of spinach's high nutritional content came about because a German chemist, Erich von Wolff, misplaced a decimal point in 1870. This then became a widely published myth: see Samuel Arbesman, *The Half-Life of Facts* (New York: Current, 2013). The misperception most likely came from poor methodology on the part of nutritional scientists. See https://fivethirtyeight.com/features/who-will-debunk-the-debunkers/ as well as http://super-myths.blogspot.com/2010/12/spinach-iron-decimal-point-error-myth.html.

143 Spinach sparking controversy among nutritionists: Helen Dallas, "The Spinach Dispute in Crisis," *New York Times,* May 24, 1936.

144 Popeye and Pepsi: Profile of Walter S. Mack Jr., *New Yorker,* July 1, 1950, p. 40.

144 "Oatmeal is good food": "'Well Blow Me Down,' Popeye Forsakes Spinach for Oatmeal," *Des Moines Register,* April 10, 1990.

144 Popeye and Quaker Oatmeal: "'Well Blow Me Down'"; Jim Korkis, "Animation Anecdotes #256," April 1, 2016.

145 Marijuana connoisseurs: Obscure corners of pothead culture have explored the Popeye-marijuana connection endlessly, debating the finer points as if in a dorm room on a Saturday night. For an example, see Dana Larsen's article "Popeye the Pothead" in *Cannabis Culture,* published on February 2, 2005, online at http://www.cannabisculture.com/content/2005/02/02/3568.

147 Ulcer: Max's ulcer is mentioned by Richard Fleischer in *Out of the Inkwell,* p. 84.

149 "We have an eye": *Miami News,* December 25, 1936.

Chapter 18

150 **Man on train:** Miller, *The Story of Walt Disney*, p. 145.

150 **"He started to tell":** Richard Huemer interviewed by Joe Adamson, "Recollections of Richard Huemer," for "An Oral History of the Motion Picture in America," University of California, 1969, pp. 119–120, Canemaker Animation Collection.

151 **"spellbinder":** Joe Grant interviewed by Neal Gabler, quoted in Gabler, *Walt Disney*, p. 218.

151 **London crowds:** *Los Angeles Times*, June 13, 1935.

151 **Rothschild:** Bob Thomas, *Building a Company: Roy O. Disney and the Creation of an Entertainment Empire* (New York: Hyperion, 1998), pp. 100–101.

152 **Mussolini bragged:** Hubler, "Walt Disney."

152 **Profit value to theaters of shorts:** "The Big Bad Wolf," *Fortune*, November 1934, p. 148.

152 **Louis B. Mayer and Hal Horne:** Quoted in Kanfer, *Serious Business*, p. 104.

153 **"You can't top pigs":** This comment was made regarding more shorts of the Three Pigs, but nonetheless shows Walt's feelings for original material. Jim Korkis, "The Three Sleepy Pigs: The Three Little Pigs Go to Mexico," from "Animation Anecdotes," August 27, 2016.

153 **Other Snow White suggestions:** Gabler, *Walt Disney*, pp. 215–216.

154 **"we will destroy it":** Douglas W. Churchill, "Now Mickey Mouse Enters Art's Temple," *New York Times Magazine*, June 3, 1934, pp. 12–13.

154 **"What we are trying":** Gabler, *Walt Disney*, citing: Personality meeting, December 29, 1936, Snow White—Story Meetings, December 16–31, 1936 Folder, *Snow White and the Seven Dwarfs*, Story Meetings, Box I, A1731, Walt Disney Archives.

154 **"Janet Gaynor type":** Martin Krause and Linda Witkowski, *Walt Disney's Snow White and the Seven Dwarfs: An Art in Its Making* (New York: Hyperion, 1994), p. 20.

154 **Deanna Durbin:** Durbin was allegedly at the tryouts. Gabler, *Walt Disney*, p. 253.

155 **"I'm sorry":** Jim Korkis, "Animation Anecdotes #120," July 26, 2013.

155 **Queen types:** Barrier, *Hollywood Cartoons*, p. 128.

155 **Live models:** Canemaker, *Walt Disney's Nine Old Men*, p. 245; Gabler, *Walt Disney*, p. 262.

156 **"A mixture of Lady Macbeth":** Krause and Witkowski, *Walt Disney's Snow White*, p. 20.

156 **False teeth:** Krause and Witkowski. *Walt Disney's Snow White*, p. 36.

156 **"more Lionel Barrymore":** Barrier, *Hollywood Cartoons*, p. 232, citing the *Snow White* sweatbox notes, sequence 13, August 20, 1937, Walt Disney Archives.

157 **Dwarf names:** Barrier, *Hollywood Cartoons*, p. 201; Gabler, *Walt Disney*, p. 220.

157 **Shakespeare and Dopey:** Kanfer, *Serious Business*, p. 103.

158 **"He is not an imbecile":** November 3, 1936, meeting notes for the Walt Disney Archives, cited in Barrier, *Hollywood Cartoons*, p. 213.

158 **Dopey:** Story conferences on dwarf personalities, primarily from December 1936, cited in Gabler, *Walt Disney*; and Barrier, *Hollywood Cartoons*.

158 **Dopey's mannerisms:** Krause and Witkowski, *Walt Disney's Snow White*, p. 36.

158 **"You have to go":** Barrier, *Hollywood Cartoons*, p. 214.

158 **"Roy didn't even":** Disney, "Growing Pains," p. 140.

158 **THE SUPER COLOSSAL:** Telegram from Walt to Margaret and Hal Roach, September 28, 1937, Ro Folder, Walt Disney Correspondence, 1936–1937, M-R, A1513, Walt Disney Archives, cited in Gabler, *Walt Disney*, p. 265.

159 **"a bunch of SOB's":** Roy Disney interviewed by Richard Hubler, June 18, 1968, RHC, Box 14, Folder 52, cited in Gabler, *Walt Disney*, p. 266.

159 **"If an animator":** Culhane, *Talking Animals and Other People*, p. 218.

159 **Rosenberg's tour:** Schickel, *The Disney Version*, pp. 214–215.

159 **Multiplane camera:** Thomas and Johnston, *The Illusion of Life*, p. 307.

160 **"I don't like the Cab Calloway":** *Snow White* story meetings, October 1934–1937, Box I, A1731, Walt Disney Archives, cited in Gabler, *Walt Disney*, p. 254.

160 **Foley:** Kirtley Basketter, "The Amazing Inside Story of How They Made Snow White," *Photoplay Magazine*, April 1938.

160 **"Good-bye":** Quoted in Schickel, *The Disney Version*, p. 215.

161 **"Black Forest":** Ken O'Connor interviewed by Martin Krause, February 24, 1994, cited in Krause and Witkowski, *Walt Disney's Snow White*, p. 20.

161 **Hurter biographical details:** Hurter folder, Box 30, Folder 272, Canemaker Animation Collection; Didier Ghez, *They Drew as They Pleased: The Hidden Art of Disney's Musical Year (The 1940s–Part One)* (San Francisco: Chronicle Books, 2016).

162 **"Albert knows":** Robin Allan, *Walt Disney and Europe* (Bloomington: Indiana University Press, 1999), p. 46.

162 **AM CONVINCED:** Gabler, *Walt Disney*, p. 271, citing copy of telegram held in Snow White (First Nite Congratulations, etc.) Folder, Walt Disney Correspondence, 1938–1939, Q-T, A1519, Walt Disney Archives.

162 **Details of the *Snow White* premiere:** Barrier, *The Animated Man*, pp. 131–133; Gabler, *Walt Disney*, pp. 271–273.

163 **Sergei Eisenstein:** Esther Leslie, *Hollywood Flatlands: Animation, Critical Theory, and the Avant-Garde* (London: Verso, 2002), p. 112.

163 **English young folk":** Associated Press, February 16, 1938, cited in Cohen, *Forbidden Animation*, p. 30.

163 **Dr. Spock:** Spock was telling a story told to him by Nelson Rockefeller. "Dr. Spock Changes Course, Takes on Caped Crusader," *Caller-Times* (Corpus Christi, Texas), June 19, 1966, p. 74.

163 **the highest-grossing:** *New York Times*, May 2, 1939, p. 29.

163 **Forty-nine countries:** *New York Times*, February 5, 1939, sec. 9, p. 4.

163 **Depression:** Editorial, "Topics of the Times," *New York Times*, May 2, 1938, p. 16.

163 **"They deserve":** Ed Sullivan, "Hollywood," *New York Daily News*, August 10, 1938.

164 **"Even the old witch":** Culhane, *Talking Animals and Other People*, p. 180.

164 **"sexual intercourse":** Canemaker, *Walt Disney's Nine Old Men*, p. 154.

164 **"Ben Sharpsteen":** Kinney, *Walt Disney and Other Animated Characters*, p. 37.

164 **Norconian party:** Dick Huemer interviewed by Joe Adamson, "Reflections of Richard Huemer," p. 190; Dick Huemer, "Thumbnail Sketches," *Funnyworld*, Fall 1979, p. 42; Leonard Mosley, *Disney's World: A Biography* (New York: Stein & Day, 1985), p. 167; Todd James Pierce, "Walt's Field Day—1938," *Disney History Institute* publication, September 16, 2013, http://www.disneyhistoryinstitute.com/2013/09/walts-field-day-1938 .html; Gabler, *Walt Disney*, p. 284.

165 **"It's no more a cartoon":** "Cinema: Mouse & Man," *Time*, December 27, 1937.

Chapter 19

166 **"Disney is doing art":** Bernie Fleischer interviewed by Ray Pointer, in Pointer, *The Art and Inventions of Max Fleischer*, p. 171.

166 **"There seems to be grave":** A. M. Botsford to Russell Holman, January 19, 1938; **"I just don't think . . .":** Bogart Rogers to A. M. Botsford, February 15, 1938, both cited in Pointer, *The Art and Inventions of Max Fleischer*, p. 171.

167 **"Fleischer has been urging":** Paramount internal memo, March 1, 1938, cited in Pointer, *The Art and Inventions of Max Fleischer*, p. 172.

167 **Jonathan Swift:** See John Stubbs, *Jonathan Swift: The Reluctant Rebel* (New York: W. W. Norton, 2017).

167 **"the smallness of human beings":** From Max Fleischer's unpublished biography, 1939, cited in Pointer, *The Art and Inventions of Max Fleischer*, p. 180.

168 **Robin and Rainger:** Cabarga, *The Fleischer Story*, p. 149; Pointer, *The Art and Inventions of Max Fleischer*, p. 197.

169 **Dan Glass:** His story is recounted in Harvey Deneroff, "'We Can't Get Much Spinach'! The Organization and Implementation of the Fleischer Animation Strike," *Film History* 1, no. 1 (1987): 1–14; also Sito, *Drawing the Line*, pp. 84–85; Pointer, *The Art and Inventions of Max Fleischer*.

171 **"Who hasn't had his name":** The veracity of this quote has been challenged by some but confirmed by many others, including Dave Tendlar, Shamus Culhane, and Grim Natwick. For more, see Sito, *Drawing the Line*, p. 81; and Solomon, *Enchanted Drawings*, p. 22.

172 **Hall passes at Disney:** Sito, *Drawing the Line*, p. 16.

172 **"She looked at her watch":** Irv Levine interviewed by Michael Barrier, January 23, 1979, cited in Barrier, *Hollywood Cartoons*, p. 187.

172 **Meeting in secret:** Culhane, *Talking Animals and Other People*, p. 86.

173 **Max started carrying a gun:** This and other recollections of the strike are found in Dave Fleischer, "Recollections," Canemaker Animation Collection.

173 **Actions against strikers:** Culhane, *Talking Animals and Other People*, p. 201. Culhane, reprinting a letter from an old colleague, Nick Tafuri, speculates that the methods of fighting probably trickled down from Paramount and the Commercial Artists and Designers Union.

175 *How to Break a Strike*: Deneroff, "'We Can't Get Much Spinach'!" pp. 1–14; Sito, *Drawing the Line*, p. 87.

Chapter 20

177 **"Disney can make the chicken salad":** Michael Maltese and Tex Avery interviewed in Joe Adamson, *Tex Avery: King of Cartoons* (New York: Da Capo, 1975), p. 126.

178 **Schlesinger's contracts with Harman, Ising, and Warner Bros.:** Barrier, *Hollywood Cartoons*, p. 157.

179 **Schlesinger hiring new animators.:** Barrier, *Hollywood Cartoons*, pp. 323–324.

180 **"all these guys"**: Bob Clampett interviewed by Michael Barrier, 1975, quoted in Barrier, *Hollywood Cartoons*, p. 324.

180 **Schlesinger kept aloof:** Jim Korkis, "Animation Anecdotes #143," January 3, 2014.

180 **"I don't want any poor"**: Chuck Jones interviewed by Michael Barrier and Bill Spicer, 1969, from *Funnyworld* 13 (1971), reprinted in Maureen Furniss, ed., *Chuck Jones: Conversations* (Jackson: University Press of Mississippi, 2005), p. 24; Steve Schneider, *That's All Folks! The Art of Warner Bros. Animation* (New York: Barnes & Noble Books, 1999), p. 38.

180 **"I've always felt"**: Tom Shales, "Chuck Jones and the Daffy World of Cartoons," *Washington Post*, November 26, 1989, pp. G1 and G5.

180 **"I will say this for Leon"**: Clampett quoted in Schneider, *That's All Folks!* p. 38.

181 **"Animators were so scarce"**: Demorest interviewed by Michael Barrier, quoted in Barrier, *Hollywood Cartoons*, p, 324.

181 **"Studios had faces"**: Quoted in Gabler, *An Empire of Their Own*, p. 187.

181 **"like a shantytown"**: Phil Monroe quoted in Solomon, *Enchanted Drawings*, p. 104.

181 **Russell Jones:** Jones, *Chuck Amuck*, p. 82.

182 **"Pew!"**: Jim Korkis, "Animation Anecdotes #174," August 8, 2014.

183 **"From now on"**: Tom Baron in conversation with Gray, June 21, 1978, quoted in Barrier, *Hollywood Cartoons*, p. 325.

183 **"The Buddy cartoons"; "even less personality"**: Maltin, *Of Mice and Magic*, p. 228.

183 **The pig's stutter to add "character"**: Friz Freleng interviewed by Joe Adamson, in Adamson, *Tex Avery*.

184 **"a little fat kid"**: Freleng is quoted telling this story in numerous places, and the exact quote is often different. He is quoted this way in Kanfer, *Serious Business*, p. 90.

184 **In the sound booth:** Tex Avery commented on noticing how much audiotape Dougherty used during an interview with Joe Adamson on August 17, 1974, at Chapman College, cited in Barrier, *Hollywood Cartoons*, p. 331.

184 **"[Dougherty] would begin"**: Quoted in Schneider, *That's All Folks!* p. 142.

185 **"with its lilting"**: Mel Blanc, *That's Not All Folks! My Life in the Golden Age of Cartoons and Radio* (New York: Warner Books, 1988), p. 5.

185 **Blank changed to Blanc:** Blanc, *That's Not All Folks!* p. 10.

185 **Blanc bio details:** Canemaker Animation Collection, Mel Blanc Folder, Box 5, Folder 12.

185 **Enrico Caruso:** Blanc, *That's Not All Folks!* p. 93.

185 **"While I wanted to work for Walt Disney":** Blanc also discusses here how Warner Bros. hired many voice actors, Blanc, *That's Not All Folks!* p. 61.

186 **"I just imagined myself":** From an interview with Carl Stalling by Barrier, Gray, and Spicer, quoted in Barrier, *Hollywood Cartoons,* p. 339.

186 **Fred "Tex" Avery:** Canemaker Animation Collection, Box 5, Folder 2.

187 **"We need a drunken bull":** Blanc, *That's Not All Folks!* p. 63.

187 **Blanc's encounter with Schlesinger about doing Porky's voice:** Blanc, *That's Not All Folks!* p. 66.

189 **"Daffy gallantly and publicly":** Jones, *Chuck Amuck,* p. 240.

189 **"All he wants to do is survive":** Chuck Jones interviewed by Greg Ford and Richard Thompson, originally printed in *Film Comment,* January-February 1975, reprinted in Furniss, *Chuck Jones: Conversations,* p. 128.

189 **"A social amenity":** Jones, *Chuck Amuck,* p. 240.

190 **"Jeethus Christh":** Jones, *Chuck Amuck,* pp. 89–90.

Chapter 21

191 **$3 million:** Barrier, *Hollywood Cartoons,* p. 262.

192 **Disney met with his engineers:** *Discussion of New Burbank Disney Studio by Frank Crowhurst,* interview by Gerrit Roelof, April 16, 1940, p. 15, Walt Disney Archives, cited in Gabler, *Walt Disney,* p. 321.

192 **Atmospherics and aesthetics at Burbank studio:** Sam Robins, "Disney Again Tries Trailblazing," *New York Times Magazine,* November 3, 1940; Barrier, *The Animated Man.*

192 **Diane and Sharon screaming:** Meeting notes, December 11, 1939, *Bambi* story meetings, 1939, *Bambi* production materials—story meeting notes, A3267, Walt Disney Archives, cited in Gabler, *Walt Disney,* p. 322.

193 **Penthouse Club and Carl Johnson:** Todd James Pierce, "The Penthouse Club at the Disney Studio," *Disney History Institute,* March 18, 2014, http://www.disneyhistoryinstitute.com/2014/03/the-penthouse-club -at-disney-studio.html.

193 **"could pick up a phone":** Robert Carlson, interviewed by Gray, January 29, 1977, cited in Barrier, *Hollywood Cartoons,* p. 263.

193 **"[Y]ou can't help feeling":** Paul Hollister, "Genius at Work: Walt Disney," *Atlantic Monthly,* December 1940.

193 **"What else is it good for?":** J. P. McEvoy, "Walt Disney Goes to War," *This Week,* July 5, 1942; Schickel, *The Disney Version,* pp. 235–236.

194 **"They need loose clothing":** Cabarga, *The Fleischer Story,* p. 144.

194 **"Miami's dream of a motion picture":** "Film Dream Nears Reality," *Miami Herald,* February 3, 1938.

195 **"an ideal community":** Donna Dial, "Cartoons in Paradise: How the Fleischer Brothers Moved to Miami and Lost Their Studio," *Florida Historical Quarterly* 78, no. 3 (Winter 2000): 309–330.

195 **"blocky little factories":** Mark Langer, "Working at the Fleischer Studio: An Annotated Interview with Myron Waldman," *Velvet Light Trap* 24 (Fall 1989).

196 **"They scoured the town":** Culhane, *Talking Animals and Other People,* p. 204.

196 **Shamus Culhane neuritis:** Culhane, *Talking Animals and Other People,* pp. 194, 197–198.

197 **Tibet:** Culhane, *Talking Animals and Other People,* p. 202.

197 **"Florida in those days":** Culhane, *Talking Animals and Other People,* p. 210.

197 **"You're being poisoned":** Culhane, *Talking Animals and Other People,* p. 214.

197 **Culhane's art classes in Miami:** Culhane, *Talking Animals and Other People,* p. 215.

198 **Ku Klux Klan:** Cabarga, *The Fleischer Story,* 152–154;

198 **"The strikers":** Shamus Culhane interviewed by John Canemaker, February 13, 1973, tape transcript, Canemaker Animation Collection, Shamus Culhane Folder.

199 **Dave's gambling and relations with his secretary:** Dave discusses this in his interview with Joe Adamson, "Recollections of Dave Fleischer," in an addendum starting on p. 120; also see Cabarga, *The Fleischer Story,* p. 194; Fleischer, *Out of the Inkwell,* pp. 107–108.

199 **Essie and attempted suicide:** From an interview of Joe Fleischer by Leslie Cabarga in Cabarga, *The Fleischer Story,* p. 194; also see Fleischer, *Out of the Inkwell,* pp. 79–80, discussing his mother's bouts.

Chapter 22

200 *Gulliver's Travels* **production:** Pointer, *The Art and Inventions of Max Fleischer,* p. 183.

200 **"because animation is essentially":** Italics mine. Culhane, *Talking Animals and Other People,* p. 159.

201 **"Florida is a great place":** Cabarga, *The Fleischer Story,* p. 155.

201 **Culhane observations about *Gulliver* premiere:** Culhane, *Talking Animals and Other People*, p. 211.

202 **Estimates of *Gulliver's Travels* profits:** Pointer, *The Art and Inventions of Max Fleischer*, p. 197; Barrier, *Hollywood Cartoons*, p. 296.

202 **"all in the Old Testament":** Quoted in Culhane, *Talking Animals and Other People*, p. 214.

202 **"We can do better than that":** Frank Tashlin interviewed by Michael Barrier, May 29, 1971, transcript at www.michaelbarrier.com.

203 **"a skinny, brash":** Steve Hulett, "The Making of *Pinocchio*—Walt Disney Style," *San Francisco Chronicle*, December 24, 1978.

204 ***Pinocchio* premiere:** Jim Korkis, "Animation Anecdotes #270," July 8, 2016; also see Paul Anderson, "Pinocchio Premiere—Exploitation and the Center Theater," *Disney History Institute*, May 14, 2010, http://www. disneyhistoryinstitute.com/2010/05/pinocchio-premiere-exploitation-and.html.

204 ***Pinocchio's* critical reception:** Otis Ferguson, from the March 11, 1940, *New Republic*, in Robert Wilson, ed., *The Film Criticism of Otis Ferguson* (Philadelphia: Temple University Press, 1971), p. 289; *New York Times*, February 8, 1940.

204 ***Pinocchio* background:** Canemaker Animation Collection, Pinocchio Folder, Box 10, Folder 81, and Box 23, Folder 232.

Chapter 23

206 **Meeting Stokowski at Chasen's:** John Culhane, *Walt Disney's "Fantasia"* (New York: Harry N. Abrams, 1987), p. 15; Abram Chasins, *Leopold Stokowski: A Profile* (New York: Hawthorn Books, 1979), pp. 168–169.

206 **"Of course you know":** "Three Disney Channel Stars Remember Walt," *Disney Channel Magazine*, February 1984, cited in Gabler, *Walt Disney*, p. 296.

207 **"Yen Sid":** Steven Watts, *The Magic Kingdom: Walt Disney and the American Way of Life* (Boston: Houghton Mifflin, 1997), p. 96.

207 **"I would like to have"; "This is different":** These quotes came from story meetings Walt had much later, in the fall of 1938, cited in Gabler, *Walt Disney*, p. 309.

207 **"sheer fantasy":** Walt Disney, "Mickey Mouse Presents," in *We Make the Movies*, ed. Nancy Naumburg (New York: W. W. Norton, 1937), p 270.

207 **"I have never been":** Walt Disney to Stokowski, November 18, 1937, St Folder, Walt Disney Correspondence, 1938–39, Q-T, A1519, Walt Disney Archives, cited in Gabler, *Walt Disney*, p. 299.

207 **Exploiting Greta Garbo divorce:** Gabler, *Walt Disney*, p. 299.

208 **"it makes everybody alert":** Culhane, *Walt Disney's "Fantasia,"* p. 16.

209 **"poseur":** Culhane, *Talking Animals and Other People*, p. 197.

210 **"Quite good":** Culhane, *Talking Animals and Other People*, p. 197.

210 **Alternative titles:** Gabler, *Walt Disney*, p. 316.

211 **the word "abstract":** Jules Engel (another fine artist brought in to work on *Fantasia*) interviewed by Lawrence Wechsler and Milton Zolotow, Los Angeles Art Community Group Portrait, UCLA, 1985, p. 21, available through open library.

211 **Art Babbitt and Paul Cézanne:** Art Babbitt interviewed by Michael Barrier, 1971, available at www.michaelbarrier.com, also quoted in Barrier, *Hollywood Cartoons*, p. 85.

211 **"This is more or less picturing":** Story meeting on "Toccata and Fugue," February 28, 1939, Story Meetings—1939, *Fantasia*, A1782, Walt Disney Archives, cited in Gabler, *Walt Disney*, p. 316; Barrier, *The Animated Man*, pp. 161–162.

212 **"no artists":** Quoted in Jules Engel interview by Lawrence Wechsler and Milton Zolotow, Los Angeles Art Community Group Portrait, UCLA, 1985, p. 21.

212 **Walt discussing Bach:** Story meetings on November 8 and 17, 1938, cited in Gabler, *Walt Disney*, p. 301.

212 **"Go back down":** Roy Disney interviewed by Richard Hubler, November 17, 1967, p. 15, Walt Disney Archives, cited in Gabler, *Walt Disney*, p. 301.

213 **Thomas Mann:** Culhane, *Walt Disney's "Fantasia,"* p. 22.

213 **"humor . . . rather than":** Quoted from *Clair de Lune* meeting notes from *Fantasia*, cited in Barrier, *Hollywood Cartoons*, p. 252.

213 **"change the history":** Ollie Johnston interviewed by Neal Gabler, cited in Gabler, *Walt Disney*, p. 306.

213 **Walt and Stokowski's exchange about Stravinsky:** Details found in Dick Huemer interview by Joe Adamson, pp. 99–100.

214 **"Sounds good backwards, too!":** Culhane, *Walt Disney's "Fantasia,"* p. 117.

214 **"dog eat dog":** Culhane, *Walt Disney's "Fantasia,"* p. 108.

214 **"Should we stick":** September 13, 1938, meeting notes, cited in Barrier, *Hollywood Cartoons*, p. 253.

214 **"this music to the consciousness":** Quoted in Culhane, *Walt Disney's "Fantasia,"* p. 110.

214 **"We shouldn't worry":** September 13, 1938, meeting notes, cited in Barrier, *Hollywood Cartoons*, p. 253.

214 **"Who cares what they think?":** Transcript of Dick Huemer interview by Joe Adamson, pp. 99–100.

214 *Fantasia* **background:** Canemaker Animation Collection, Box 10, Folder 73; Box 27, Folder 261; Box 28, Folders 262–263.

215 **"I defy anybody";** *Pastorale* **quarrel:** From *Fantasia* meeting notes, cited in Gabler, *Walt Disney,* p. 318; other notes on *Fantasia* in Barrier, *The Animated Man.*

215 **Hays Office and centaurettes:** Solomon, *Enchanted Drawings,* p. 69.

215 **"I think this thing will make Beethoven":** *Fantasia* meeting notes (*Pastorale*), August 8, 1939, cited in Barrier, *Hollywood Cartoons,* p. 254.

215 **Vladimir "Bill" Tytla biographical details:** Canemaker Animation Collection, Bill Tytla Folders, Box 15, Folders 160–161; Box 21, Folders 227–228; Box 23, Folder 229.

217 **"to portray the triumphant return":** These are Dick Huemer's words about what Walt wanted to achieve. Huemer interviewed by Joe Adamson, UCLA, p. 148.

217 **"You're going to give them":** *Fantasia* meeting notes from September 14, 1938, cited in Barrier, *Hollywood Cartoons,* p. 246.

217 *Fantasia* **Foley artists:** Burt Folkart, "J. MacDonald; Innovator in Sound Effects," *Los Angeles Times,* February 6, 1991.

217 **Fantasound details:** Culhane, *Walt Disney's "Fantasia,"* pp. 16–19.

219 **Fantasound, William Garity:** "Fantasound," *New Yorker,* November 16, 1940, p. 15.

219 **"I never liked this stuff":** Virgil Thomson, *New York Herald Tribune,* November 14, 1940.

220 **"Motion picture history was made":** Bosley Crowther, *New York Times,* November 14, 1940.

220 **"distracted from":** Olin Downes, "Disney's Experiment: Second Thoughts on 'Fantasia' and Its Visualization of Music," *New York Times,* November 17, 1940.

220 **"That's not my music":** "Stoki," *New Yorker,* October 8, 1990, p. 37.

220 **"slow money maker":** Gabler, *Walt Disney,* p. 340.

221 **Dorothy Thompson:** "On the Record," *New York Herald Tribune,* November 25, 1940.

221 **"couldn't have been sweeter":** Walt to Mike May, November 19, 1940, C. A. (Mike) May Folder, Walt Disney Correspondence, 1945–1946, L-P, A1535, WDA, cited in Gabler, *Walt Disney,* p. 343.

Chapter 24

222 **Walt's speech on February 11, 1941:** Sito, *Drawing the Line,* pp. 118–120; Barrier, *The Animated Man,* pp. 165–167.

223 **"We were disappointed in him":** Anonymous quote from Schickel, *The Disney Version.*

223 **Disney staff complaints about credit:** Bill Peet, *Bill Peet: An Autobiography* (Boston: Houghton Mifflin, 1989), pp. 108–109; Dave Hand interviewed by Michael Barrier, in Didier Ghez, *Walt's People* (Bloomington, IN: Xlibris, 2005); **"He's a genius at":** Anonymous, in Richard Hubler, "Walt Disney," unpublished manuscript, quoted in Gabler, *Walt Disney,* p. 355.

223 **"This speech recruited":** Anthony Bower, "Snow White and the 1,200 Dwarfs," *The Nation,* May 10, 1941.

224 **"My attitude was":** Canemaker, "Art Babbitt: The Animator as Firebrand," p. 10.

224 **"squeeze Disney's balls":** Quoted in Marc Eliot, *Walt Disney: Hollywood's Dark Prince* (New York: Birch Lane Press, 1993), p. 136.

224 **Lessing biographical details:** Culhane, *Talking Animals and Other People;* Barrier, *The Animated Man;* Gabler, *Walt Disney.* Lessing also wrote an unpublished manuscript, "My Adventures During the Madero-Villa Mexican Revolution," in 1963.

225 **Austerity plan and labor issues:** Gabler, *Walt Disney,* pp. 357–362; Barrier, *The Animated Man,* pp. 158–161.

225 **"What do we do now?":** From an interview with Steve Bosustow, quoted in Barrier, *The Animated Man,* p. 169.

225 **Details of the strike:** Sito, *Drawing the Line;* picket signs, untitled clipping, 8-MWEZ, New York Public Library for the Performing Arts; Schickel, *The Disney Version;* Gabler, *Walt Disney,* pp. 366–368; Barrier, *The Animated Man,* pp. 169–171.

225 **Jack Kinney's memories of strike:** Kinney, *Walt Disney and Other Animated Characters,* pp. 137–138.

226 **Maurice Noble's broom closet:** Cohen, *Forbidden Animation,* pp. 162–163.

226 **Bioff and Sorrell:** Gabler, *Walt Disney,* p. 369.

226 **"I'll guarantee":** "Disney Strike Washup Near," *Daily Variety,* July 1, 1941; "AF of L Quits Disney Strikers," *Daily Variety,* July 9, 1941; Sito, *Drawing the Line,* Chap. 5, "The Great Disney Studio Strike."

226 **"Walt wasn't really a villain":** Culhane, *Talking Animals and Other People,* p. 225.

226 **Walt correspondence with Pegler:** Reprinted and quoted in Barrier, *The Animated Man,* pp. 173–174.

226 **"Gradually":** Quoted in Barrier, *The Animated Man,* p. 171.

227 **Rockefeller's Office of the Coordinator of Inter-American Affairs:** Cary Reich, *The Life of Nelson Rockefeller: Worlds to Conquer, 1908–1958* (New York: Doubleday, 1996), pp. 166–173, 181–185.

228 **"Mainly we were wined":** Frank Thomas quoted in Canemaker, *Walt Disney's Nine Old Men,* p. 185.

228 **Walt's trip to South America:** *Walt and El Grupo,* film, directed by Theodore Thomas; *South of the Border with Disney: Walt Disney and the Good Neighbor Program, 1941–1948* (New York: Disney Editions, 2009).

Chapter 25

230 *Look* **magazine:** *Look,* February 27, 1940.

230 **Nazis' hatred of Superman:** Rick Bowers, *Superman Versus the Ku Klux Klan* (Washington, DC: National Geographic Books, 2012).

231 **Highballing Superman:** Dave Fleischer gave the $100,000 figure in interviews, including his 1968 interview with Joe Adamson, although the figure appeared to actually have been less than that. The history of Fleischer Studios' initial involvement with *Superman* is murky, and additional details are given in Pointer, *The Art and Inventions of Max Fleischer.*

231 **"Okay, go ahead":** Fleischer, *Out of the Inkwell,* p. 105. Richard Fleischer doesn't clarify whether this quote was spoken or sent via cable. It is possible he was paraphrasing.

233 **Superman's Jewish origins:** Simcha Weinstein, *Up, Up, and Oy Vey! How Jewish History, Culture, and Values Shaped the Comic Book Superhero* (Fort Lee, NJ: Barricade Books, 2006); Arie Kaplan, *From Krakow to Krypton: Jews and Comic Books* (Philadelphia: Jewish Publication Society, 2008).

233 **Details of Superman's origins:** Bowers, *Superman Versus the Ku Klux Klan;* Larry Tye, *Superman: The High-Flying History of America's Most Enduring Superhero* (New York: Random House, 2012); Brad Ricca, *Superboys: The Amazing Adventures of Jerry Siegel and Joe Shuster—The Creators of Superman* (New York: St. Martin's Press, 2013).

234 **Fleischer catchphrases for Superman:** Cabarga, *The Fleischer Story,* p. 177; Pointer, *The Art and Inventions of Max Fleischer;* Maltin, *Of Mice and Magic.*

234 **Superman as a boyfriend:** Tye, *Superman.*

235 **Max's encounter with Dick Murray:** Fleischer, *Out of the Inkwell,* p. 114.

235 **Previously produced cartoons as collateral:** Barrier, *Hollywood Cartoons,* p. 292.

236 **"We can take care of that":** Fleischer, *Out of the Inkwell,* p. 115.

236 **Stock-share agreement; "resignations in blank":** Barrier, *Hollywood Cartoons,* pp. 304–305.

236 **Meeting with Balaban:** Max Fleischer's notes, cited by Richard Fleischer in *Out of the Inkwell,* p. 121.

237 **Max had sent Paramount a telegram:** Lou Fleischer told this to Leslie Cabarga during an interview, cited in Cabarga, *The Fleischer Story*, p. 192.

237 **Details of Dave's leaving for California:** Dave Fleischer interviewed by Joe Adamson, 1969; Pointer, *The Art and Inventions of Max Fleischer*, pp. 237–238.

237 **Seymour Kneitel:** Fleischer, *Out of the Inkwell*, p. 122.

238 **Burning records:** Pointer, *The Art and Inventions of Max Fleischer*, p. 241.

238 **"The only way you'll see":** Fleischer, *Out of the Inkwell*, p. 73.

238 **Dave's recollection of the Florida years:** Dave Fleischer interviewed by Joe Adamson, 1969. An Oral History of the Motion Picture in America, Regents of the University of California.

239 **Max's boat ride:** Cabarga, *The Fleischer Story*, p. 197.

239 **Film historians:** "But Max and Dave were severed from the company in what was possibly, even probably, an illegal maneuver . . ." Maltin, *Of Mice and Magic*, p. 124.

239 **Television in the 1930s:** Koszarski, *Hollywood on the Hudson*, p. 440.

240 **Walt's television rights:** Schickel, *The Disney Version*, p. 213.

240 **Dave Fleischer's later career:** Dave Fleischer interviewed by Joe Adamson, "Recollections of Dave Fleischer," pp. 44–50, 84–85.

240 **Betting calculator:** Pointer, *The Art and Inventions of Max Fleischer*, p. 204.

240 **Details of the never-wind clock:** Fleischer, *Out of the Inkwell*, p. 99.

241 **Jam Handy:** Fleischer, *Out of the Inkwell*, p. 125; Pointer, *The Art and Inventions of Max Fleischer*, pp. 261–267.

241 **Max building case against Paramount:** Fleischer, *Out of the Inkwell*, pp. 127–130.

241 **Mental breakdown:** Pointer, *The Art and Inventions of Max Fleischer*, p. 263.

241 **"Adding 567 thousand":** Max Fleischer, *Noah's Shoes* (Detroit: S. J. Bloch Publishing, 1944), p. 14.

242 **"My assistants":** Fleischer, *Noah's Shoes*, p. 113.

242 **ENTOZOA:** Fleischer, *Noah's Shoes*, p. 126.

Chapter 26

243 **Details of the FMPU:** Solomon, *Enchanted Drawings*, p. 114; Mark Harris, *Five Came Back: A Story of Hollywood and the Second World War* (New York: Penguin, 2015).

243 **Memories of Fort Roach:** Culhane, *Talking Animals and Other People*, pp. 270–271.

244 **"Hiya there, Rudy!":** Quoted in Culhane, *Talking Animals and Other People,* p. 271.

246 **"through idiosyncrasies":** Judith Morgan and Neil Morgan, *Dr. Seuss and Mr. Geisel* (New York: Random House, 1995), p. xix.

246 **Theodor Geisel:** Excellent resources on Geisel's wartime work: Morgan and Morgan, *Dr. Seuss and Mr. Geisel*; André Schiffrin, *Dr. Seuss & Co. Go to War* (New York: New Press, 2009); and Don Pease, *Theodor Seuss Geisel* (Oxford: Oxford University Press, 2010).

246 **"I've left a window":** Quoted in Morgan and Morgan, *Dr. Seuss and Mr. Geisel,* p. 97.

246 *New York Times Book Review:* October 13, 1940.

246 **"I had no great":** Quoted in Morgan and Morgan, *Dr. Seuss and Mr. Geisel,* p. 98.

247 **"razor-keen":** "Malice in Wonderland," *Newsweek,* February 9, 1942, cited in Morgan and Morgan, *Dr. Seuss and Mr. Geisel,* p. 104.

248 **Geisel and Nye:** Morgan and Morgan, *Dr. Seuss and Mr. Geisel,* p. 102.

248 **Sidearm:** Morgan and Morgan, *Dr. Seuss and Mr. Geisel,* p. 112.

249 **Reagan:** Harris, *Five Came Back,* p. 378.

249 *Scrap the Japs:* Quoted in Kanfer, *Serious Business,* p. 134.

249 **Office of War Information:** Michael S. Shull and David E. Wilt, *Doing Their Bit: Wartime American Animated Short Films, 1939–1945* (Jefferson, NC: McFarland & Co., 2004).

250 *Rebel Without a Cause:* Pease, *Theodor Seuss Geisel,* p. 69.

250 **Geisel's honorary doctorate:** Morgan and Morgan, *Dr. Seuss and Mr. Geisel,* p. 152.

Chapter 27

251 **"Hardaway needed a story":** Quoted in Schneider, *That's All Folks!* p. 172.

251 **"A tough little":** Blanc, *That's Not All Folks!* p. 87.

252 **"Bugs' Bunny":** There are several different versions of this story. Mel Blanc claims he suggested naming the rabbit after Hardaway to Leon Schlesinger. Chuck Jones interviewed by Joe Adamson, with "Witty Birds and Well-Drawn Cats: An Interview with Chuck Jones," 1971, published in Furniss, *Chuck Jones: Conversations,* p. 61.

252 **"We made every":** Quoted in Jeff Lenburg, *The Great Cartoon Directors* (New York: Da Capo, 1993), p. 106.

252 **"So I thought . . .":** Quoted in Schneider, *That's All Folks!* p. 180.

252 **Bugs Bunny's Brooklyn accent:** Blanc, *That's Not All Folks!* p. 87.

252 **"They make my throat tighten":** Quoted in Schneider, *That's All Folks!* p. 57.

253 **"What's up, doc?":** Avery interviewed by Joe Adamson, in Adamson, *Tex Avery*, p. 164.

253 **"what you might call":** Chuck Jones interviewed by Michael Barrier and Bill Spicer, "An Interview with Chuck Jones," 1969, from *Funnyworld* 13 (1971): 4–19, reprinted in Furniss, *Chuck Jones: Conversations*, p. 31.

253 **"[H]e never bent":** Chuck Jones and Ray Bradbury interviewed by Mary Harrington Hall, "The Fantasy Makers: A Conversation with Ray Bradbury and Chuck Jones," *Psychology Today*, April 1968, reprinted in Furniss, *Chuck Jones: Conversations*, pp. 8–9.

254 **Bugs Bunny's popularity:** Schneider, *That's All Folks!* pp. 68–72.

254 **"Just as America":** Quoted in Schneider, *That's All Folks!* p. 181.

254 **Bill Scott:** Chuck Jones interviewed by the Academy of Achievement, "Chuck Jones: Animation Pioneer," 1993, reprinted in Furniss, *Chuck Jones: Conversations*, p. 166.

254 **"We always started Bugs":** Quoted in Lenburg, *The Great Cartoon Directors*, p. 54.

254 **"He was never mischievous":** Quotes from separate interviews. Chuck Jones interviewed in *Business Screen* magazine, August-September 1982, quoted in Lenburg, *The Great Cartoon Directors*, p. 56.

255 **"You'll dream about":** Chuck Jones interviewed by Stephen Thompson, *The Onion* 33, no. 13 (1998), reprinted in Furniss, *Chuck Jones: Conversations*, p. 199.

255 **"Bugs is what I would like":** Jones, *Chuck Amuck*, p. 38.

256 **"We showed":** Tashlin quoted in Culhane, *Talking Animals and Other People*, p. 235.

256 **"Many of us wished":** Kinney, *Walt Disney and Other Animated Characters*, p. 130.

256 **Leo Salkin:** Quoted in Solomon, *Enchanted Drawings*, p. 107.

256 **"admiring the kind of":** Barrier, *Hollywood Cartoons*, p. 402, quoting his 1973 Dick Huemer interview.

257 **"I would encourage":** Quoted in Schneider, *That's All Folks!* p. 74.

257 **"Why don't you ever use":** Bob Clampett interviewed by Michael Barrier, cited in Barrier, *Hollywood Cartoons*, p. 439; **"and I didn't":** Clampett taped interview.

257 **Virgil Ross:** Jim Korkis, "Animation Anecdotes #190," citing interview by John Province, 1990.

257 **Club Alabam:** Peter Vacher, *Swingin' on Central Avenue: African American Jazz in Los Angeles* (Lanham, MD: Rowman & Littlefield, 2015).

257 **Bob Clampett:** Canemaker Animation Collection, Box 8, Folder 55.

258 **"vulgar parody":** Shull and Wilt, *Doing Their Bit*, p. 116.

259 *Coal Black* **and the NAACP:** Christopher P. Lehman, *The Colored Cartoon: Black Representation in American Animated Short Film* (Amherst: University of Massachusetts Press, 2009).

259 **Commentary on** *Coal Black*: Klein, *Seven Minutes*, p. 196; John Leland, *Hip: The History* (New York: Harper Perennial, 2004), pp. 196–198; Barrier, *Hollywood Cartoons*, pp. 436–438.

259 **"It takes":** Maltin, *Of Mice and Magic*, p. 251.

260 **Tom Bradley and** *Coal Black*: Jim Korkis, "Jim Korkis on Bob Clampett's 'Coal Black and de Sebben Dwarfs' (1943)," "Animation Anecdotes," May 20, 2017.

Chapter 28

261 **Disney studio seized:** Barrier, *The Animated Man*, p. 182; Gabler, *Walt Disney*, pp. 398–399.

262 **$25 per insignia:** Solomon, *Enchanted Drawings*, p. 119.

262 **Normandy invasion:** It is often (probably) misreported that "Mickey Mouse" was Allied headquarters' code name for the invasion, but it appears this was only a password for a smaller part of the operation. Mary Braggiotti, *New York Post* article, June 30, 1944; Michael Barrier also does more sleuthing here: http://www.michaelbarrier.com/Home%20Page/WhatsNewArchivesMay10.htm#mickeymouseanddday.

262 **Larson and** *Bambi*: Gabler, *Walt Disney*, p. 320.

262 **Landsburgh:** Jim Korkis, "Animation Anecdotes #265."

262 **Frank Churchill:** Gabler, *Walt Disney*, p. 397.

263 **Gallup:** David Ogilvy (associate director, Audience Research Institute) to Roy, August 22, 1942, *Bambi*—Exploitation and Publicity, Walt Disney Correspondence, Inter-Office, 1938–1944, A, A1625, Disney Archives, cited in Gabler, *Walt Disney*, p. 397.

263 **"ape the trumped up":** Manny Farber, "Saccharine Symphony—Bambi," in Peary and Peary, *The American Animated Cartoon*, p. 90.

263 **"depresses me":** James Agee, *Agee on Film* (New York: Grosset & Dunlap, 1969).

263 **Felix Salten's metaphors about anti-Semitism:** Holt, *The Queens of Animation*, p. 26.

263 **Alternative** *Bambi* **scene:** Jim Korkis, "Animation Anecdotes #255."

263 *Bambi* **initial box office:** Barrier, *The Animated Man*, p. 118.

263 **"***Bambi* **was a sweet little story":** Quoted in Solomon, *Enchanted Drawings*, p. 129.

265 **IRS reports:** Eric Smoodin, *Animating Culture: Hollywood Cartoons from the Sound Era* (New Brunswick, NJ: Rutgers University Press, 1993), p. 173.

266 **"Disney is fearful":** Inter-Office Communications, Kuhn to Morgenthau, March 6, 1942, Morgenthau Diary, #505, FDR Library.

266 **"in the background":** Gabler, *Walt Disney*, p. 390, citing a memo, Roy Disney, February 16, 1942, Reader's Digest Folder, Annex, Walt Disney Archives.

267 **Seversky biography:** *New York Post Daily Magazine*, July 7, 1943; Gabler, *Walt Disney*, p. 391; Barrier, *The Animated Man*, p. 185.

269 **Florencio Molina Campos:** Details of his concerns found in Smoodin, *Animating Culture*, pp. 141–145.

271 **"depresses me":** James Agee, "On Film," *The Nation*, February 10, 1945, p. 141.

271 **"a mixture of atrocious taste":** Wolcott Gibbs, *New Yorker*, February 10, 1945.

271 **Barbara Deming on *The Three Caballeros*:** Barbara Deming, "The Artlessness of Walt Disney," *Partisan Review* 12, no. 2 (Spring 1945): 226–231.

Chapter 29

273 **Paul Julian:** Paul Julian interviewed by Michael Barrier, in Barrier, *Hollywood Cartoons*, p. 517.

273 **UPA "founding fathers":** Details in Maltin, *Of Mice and Magic*, p. 323; Barrier, *Hollywood Cartoons*; Adam Abraham, *When Magoo Flew: The Rise and Fall of Animation Studio UPA* (Middletown, CT: Wesleyan University Press, 2012). Canemaker Animation Collection, John and Faith Hubley Folders, Box 12, Folder 111; Box 40, Folder 347; Gene Deitch Folder, Box 9, Folder 65.

273 **"We were doing a lot of crazy":** John D. Ford, "An Interview with John and Faith Hubley," in Peary and Peary, *The American Animated Cartoon*, p. 184.

273 **Additional history of UPA:** Abraham, *When Magoo Flew*.

273 **"at UPA any kind of slam-bang":** Bill Scott interviews by Michael Barrier, June 15, 1978, quoted in Barrier, *Hollywood Cartoons*, p. 522.

274 **Kepes's influence:** Barrier, *Hollywood Cartoons*, pp. 515–516.

274 **"It was very modern":** Ford, "An Interview with John and Faith Hubley," p. 190.

275 **"Our camera is closer":** Schwartz quoted in Barrier, *Hollywood Cartoons*.

276 **UPA studio location:** Barrier, *Hollywood Cartoons*, p. 519.

276 **Anti-Semitism and anti-Hollywoodism of HUAC:** Gabler, *An Empire of Their Own*, pp. 355–358.

277 **Fleury testimony:** Eugene's testimony: (82) H 1375-4, pp. 2061–2071. Bernyce: (82) H 1348-6-B, pp. 1775–1785. Also, Cohen, *Forbidden Animation*, pp. 171–172.

277 **Raskin:** Quoted in David Fariello, *Red Scare: Memories of the American Inquisition* (New York: W. W. Norton, 2008), p. 305.

278 **Sam Wood and MPA:** Gabler, *An Empire of Their Own*, pp. 363–364.

278 **Walt's politics:** Voting in Gabler, *Walt Disney*, p. 448.

278 *Song of the South:* Walt's outreach to the NAACP is explained in further detail in Gabler, *Walt Disney*, pp. 433–435.

279 **Tyrolean jacket:** Frank Nugent, "This Disney Whirl," *New York Times*, January 29, 1939, sec. 9, p. 5.

280 **Walt's testimony:** Walter E. Disney, testimony, in House Committee on Un-American Activities, Hearings Regarding the Communist Infiltration of the Motion Picture Industry, 80th Cong., 1st. sess., October 24, 1947, pp. 280–286.

280 **UPA's commercial clients:** Abraham, *When Magoo Flew*, p. 72; **UPA's new headquarters:** Abraham, *When Magoo Flew*, p. 85.

281 **"If I happened to be":** Quoted in Agraham, *When Magoo Flew*, p. 75.

282 **"Our strength and our vision":** Quoted in Abraham, *When Magoo Flew*, p. 77.

283 **Mr. Magoo:** Additional details on Hubley's collaboration with Kaufman can be found in Abraham, *When Magoo Flew*, pp. 76–80.

284 **"All the cartoons":** Morgan and Morgan, *Dr. Seuss and Mr. Geisel*, p. 129.

284 **Gilbert Seldes:** Quoted in Maltin, *Of Mice and Magic*, p. 323.

284 **"[Mr. Magoo] is a creation":** David Fisher, "Two Premieres: Disney and UPA," in Peary and Peary, *The American Animated Cartoon*, pp. 178–179, 182.

285 **Gene Deitch:** Canemaker Animation Collection, Gene Deitch Folder, Box 9, Folder 65.

286 **Paul Julian:** Quoted in Abraham, *When Magoo Flew*, p. 130.

286 **"In those bad old days":** Bill Scott quoted in Solomon, *Enchanted Drawings*, pp. 221–222. UPA's troubles with HUAC are also addressed in Abraham, *When Magoo Flew*, pp. 128–131.

286 **"Hubley just sort of disappeared":** Bill Hurtz interviewed by Michael Barrier, quoted in Barrier, *Hollywood Cartoons*, p. 536.

287 **Shamus Culhane's advertising work:** Culhane, *Talking Animals and Other People*; and Shamus Culhane's *New York Times* obituary, February 4, 1996.

287 Eastman's hearing: Identified as (83) H 1428-2-A, pp. 319–326, re-printed in Cohen, *Forbidden Animation*, pp. 179–180.

Chapter 30

289 "If I'd been born in Butte": Michael Barrier and Bill Spicer, "An Interview with Chuck Jones," from *Funnyworld* 13 (1971): 4–19, reprinted in Furniss, *Chuck Jones: Conversations*, p. 29.

289 Charles A. Jones biographic material: Jones, *Chuck Amuck*, p. 49.

290 "We were forbidden": Chuck Jones interviewed by Mary Harrington Hall, "The Fantasy Makers: A Conversation with Ray Bradbury and Chuck Jones," from *Psychology Today*, April 1968, reprinted in Furniss, *Chuck Jones: Conversations*, pp. 18–19.

290 "Suppose you were": Jones, *Chuck Amuck*, p. 50.

290 "They didn't pay you": Michael Barrier and Bill Spicer, "An Interview with Chuck Jones," from *Funnyworld* 13 (1971), reprinted in Furniss, *Chuck Jones: Conversations*, p. 46.

290 "how difficult": Chuck Jones interviewed by Ron Barbagallo, 1999, reprinted in Furniss, *Chuck Jones: Conversations*, p. 205.

290 Chuck Jones biographic material: Canemaker Animation Collection, Box 12, Folder 116; Box 27, Folder 284; Box 30, Folder 277; Box 31, Folders 278–283.

290 "did not think of themselves": Barrier and Spicer, "An Interview with Chuck Jones," p. 46.

291 "with derision": Jones, *Chuck Amuck*, pp. 42–43.

291 "Chuck always read the encyclopedia": Quoted in Kanfer, *Serious Business*, p. 163.

292 "We would do a satire": Jones, *Chuck Amuck*, p. 226.

292 "beep, beep": Blanc, *That's Not All Folks!* Barrier, *Hollywood Cartoons*, pp. 494–495.

293 "[T]he Coyote never wins": Jim Korkis, "Animation Anecdotes #253."

293 "The Coyote is victimized": Quoted in Lenburg, *The Great Cartoon Directors*, p. 60.

293 "he was insulted": Quoted in Barrier, *Hollywood Cartoons*, p. 499.

293 "Everyone I've ever respected": Chuck Jones interviewed by Greg Ford and Richard Thompson, "Chuck Jones," from *Film Comment*, January/February 1975.

294 Coyote and Road Runner "rules": Jones, *Chuck Amuck*, p. 225.

296 "It is just fun for me": Chuck was asked this by Jim Korkis, who recounted it in "Animation Anecdotes #269," July 1, 2016.

296 **Chuck Jones's creative "rules":** Jones, *Chuck Amuck*, p. 101.

297 **"Chuck, they can kill you":** Jones, *Chuck Amuck*, p. 25.

298 **"He looked like Mr. Magoo":** Chuck Jones interviewed by Joe Adamson, "Witty Birds and Well-Drawn Cats," 1971, reprinted in Furniss, *Chuck Jones: Conversations*, p. 80.

298 **"He was just":** Adamson, "Witty Birds and Well-Drawn Cats," p. 80.

298 **"[Selzer] said":** Adamson, "Witty Birds and Well-Drawn Cats," p. 80.

298 **"No one is going to laugh":** Quoted in Sito, *Drawing the Line*, p. 42.

298 **"But in those days"; "I've never been able to discover that":** Ford and Thompson, "Chuck Jones."

300 **Chuck Jones's recollections of Tedd Pierce:** Jones, *Chuck Amuck*, p. 119.

300 **"Not only was [Pepé] completely":** Adamson, "Witty Birds and Well-Drawn Cats," p. 51.

300 **"I was a wimp":** Jones, *Chuck Amuck*, p. 264.

300 **"Pepé was quite the opposite of that":** Adamson, "Witty Birds and Well-Drawn Cats," p. 51.

300 **"Pepé is so intoxicated":** Blanc, *That's Not All Folks!* p. 113.

Chapter 31

301 **"The thing I resent most":** Arthur Miller, "Dali and Disney Plan Something Definitely New," *Los Angeles Times*, April 7, 1946.

301 **Walt, Salvador Dalí, and Orson Welles:** Gabler, *Walt Disney*, pp. 414–415.

301 **"There is not room":** Edward Rothstein, "70 Years On, Magic Concocted in Exile," *New York Times*, January 23, 2014.

302 **"adjusting his art":** *New York Times*, April 28, 1946; **sentimentality and kitsch:** James Agee used the word "tacky," *Agee on Film*.

302 **Nor did these films enjoy as much of Walt's attention:** Based on a series of interviews of Disney animators by Michael Barrier, summarized in Barrier, *The Animated Man*, p. 220.

302 **ARI:** Leo Salkin, "Disney's 'Pigs Is Pigs,' Notes from a Journal, 1949–1953," in *Storytelling in Animation: The Art of the Animated Image*, ed. John Canemaker (Los Angeles: AFI, 1988).

302 **"We're through with caviar":** "Father Goose," *Time*, December 27, 1954.

303 **Jimmy Macdonald:** Solomon, *Enchanted Drawings*, p. 201; Gabler, *Walt Disney*, p. 426.

303 **Walt's miniatures hobby:** Barrier, *The Animated Man*, p. 211; Gabler, *Walt Disney*, p. 481.

303 **An existentialist dilemma:** William Chafe, *The Unfinished Journey: America Since World War II* (New York: Oxford University Press, 1995), p. 99.

304　**Ken Anderson:** Barrier, *The Animated Man*, p. 231; Gabler, *Walt Disney*, p. 481.

304　**"I become so absorbed":** Walt's correspondence, quoted in Gabler, *Walt Disney*, p. 482.

304　**Disneylandia:** Karal Ann Marling, "Imagineering the Disney Theme Parks," in *Designing Disney's Theme Parks: The Architecture of Reassurance*, ed. Karal Ann Marling (New York: Flammarion, 1997), pp. 50–51; Barrier, *The Animated Man*, p. 232–233.

304　**"The quintessential product":** Jackson Lears, "The Mouse That Roared," *New Republic*, June 15, 1998, p. 27.

304　**"dirty, phoney":** Quoted in Schickel, *The Disney Version*, p. 310.

305　**"I'm going to build an amusement park":** Quoted in Solomon, *Enchanted Drawings*, p. 191. Walt told this to Rudy Ising. The date is unknown, but Ising remembered him talking about amusement parks as far back as the 1920s.

305　**Jack Cutting:** Gabler, *Walt Disney*, p. 485.

305　**Scouting other parks:** Barrier, *The Animated Man*, p. 212.

305　**Park planning:** Green and Green, *Remembering Walt*, p. 152.

305　**"This is scene one":** Quoted in Marling, "Imagineering the Disney Theme Parks," p. 60.

305　**Architects:** Barrier, *The Animated Man*, pp. 235–239; Gabler, *Walt Disney*, p. 494.

306　**"How can anyone":** Quoted in Noah Isenberg, *We'll Always Have Casablanca* (New York: W. W. Norton, 2017), p. 108.

306　**"Get More Out of Life":** Quoted in Kanfer, *Serious Business*, p. 157.

306　**"Moviegoing has become a fixed":** From a study done by the Twentieth Century Fund in 1948. Quoted in James Baughman, *The Republic of Mass Culture: Journalism, Filmmaking, and Broadcasting in America Since 1941* (Baltimore: Johns Hopkins University Press, 2006), p. 77.

306　**"Television is the coming thing":** Quoted in Gabler, *Walt Disney*, p. 503; **it might kill off the B-movie:** Thomas Pryor, "Disney Will Spend Millions on Films," *New York Times*, June 20, 1952.

307　**Walt's television series:** Harry Tytle, *One of "Walt's Boys": An Insider's Account of Disney's Golden Years* (Royal Oak, MI: Airtight Seals Allied Production, 1997), p. 114.

307　**ABC and Hoblitzelle deal:** Gabler, *Walt Disney*, pp. 508–510.

308　**"suspend operations":** Jack Gould, *New York Times*, October 29, 1954, p. 34.

308　**"most flagrant example":** Lears, "The Mouse That Roared," p. 33.

308　**"He walked":** Ward Kimball, "The Wonderful World of Walt Disney," in *You Must Remember This*, ed. Walter Wagner (New York: Putnam, 1975), p. 272.

309 **"so that a trip":** Gabler, *Walt Disney*, p. 499.

309 **"This costs more":** Quoted in Schickel, *The Disney Version*, p. 323.

309 **"You know, tyrants":** Ken Anderson quoting Walt in Gabler, *Walt Disney*, p. 533.

309 **"We don't hire for jobs here":** Kevin Wallace, "The Engineering of Ease," *New Yorker*, September 7, 1963, p. 114.

309 **"No bright nail polish":** Quoted in Schickel, *The Disney Version*, p. 318.

309 **"Walt doesn't like fat guys":** Quoted in Van Arsdale France, *Window on Main Street: 35 Years of Creating Happiness at Disneyland Park* (Nashua, NH: Laughter Publications, 1991), p. 50.

309 **Power lines:** Schickel, *The Disney Version*, p. 326.

310 **"The park means a lot":** Quoted in Barrier, *The Animated Man*, p. 251.

310 **Anniversary party:** Richard and Katherine Greene, *The Man Behind the Magic: The Story of Walt Disney* (New York: Viking, 1998).

311 **"Walt's dream is a nightmare":** Quoted in Randy Bright, *Disneyland: The Inside Story* (New York: Harry N. Abrams, 1987), p. 107; **"Mr. Disney has tastefully":** *New York Times*, July 22, 1955, p. 22.

311 **Disneyland attendance:** "Wonderful World: What Walt Disney Made," *New Yorker*, December 11, 2006, p. 67.

311 **Disney stock:** Michael Gordon, "Disney's Land," *Wall Street Journal*, February 4, 1958.

311 **"why should I run for mayor":** Quoted in Schickel, *The Disney Version*, p. 364.

Chapter 32

313 **Television viewing statistics:** Thomas W. Bohn and Richard L. Stromgren, *Light and Shadows: A History of Motion Pictures* (Mountain View, CA: Mayfield Publishing Co., 1987); Joel Finler, *The Hollywood Story* (New York: Crown, 1988); David A. Cook, *A History of Narrative Film* (New York: W. W. Norton, 1996).

314 **"a device that":** Quoted in Nesteroff, *The Comedians*, p. 95.

315 **Breakfast cereal:** One market survey, done in 1968 but confirming a long-lasting trend, revealed that 16 million children started their weekends by watching television.

315 **Breakfast cereals:** See Barnouw, *Tube of Plenty*, p. 348; Kanfer, *Serious Business*, p. 197; "Crispy Critters," *Cartoon Research*, posted by Jerry Beck on March 5, 2013.

317 **"The agency reasoning":** Lantz quoted in Cohen, *Forbidden Animation*,

p. 124; Lantz also discussed the censorship in the January 4, 1958, issue of *TV Guide*.

317 **Censorship of Disney cartoons:** Karl Cohen compiles examples in Cohen, *Forbidden Animation*, p. 125.

317 **"When did we decide":** Kausler quoted in Cohen, *Forbidden Animation*, p. 126. The quote was in a letter to Cohen in May 1996.

318 **The Sloane Foundation:** Klein, *Seven Minutes*, pp. 208–209; Cohen, *Forbidden Animation*, p. 194.

318 **Quantity over quality:** Chuck Jones discussed the new economics of cartoons in Furniss, *Chuck Jones: Conversations*, p. 43.

319 **"creative bookkeeping":** Quoted in Solomon, *Enchanted Drawings*, p. 243.

319 **Paul Terry sale to CBS:** Solomon, *Enchanted Drawings*, pp. 180–181.

319 **225 percent:** Klein, *Seven Minutes*.

320 **"Close the studio":** Quoted in Kanfer, *Serious Business*, p. 173; and Klein, *Seven Minutes*.

320 **1963:** Barrier, *Hollywood Cartoons*, p. 565.

320 **Warner Bros. and commercial cartoons:** Barrier, *Hollywood Cartoons*, p. 562; accounts of Chuck Jones's commercial work are also found in Jim Korkis's "Animation Anecdotes #139."

320 **Frito Bandito:** Lenburg, *The Great Cartoon Directors*, p. 148.

320 **Kool-Aid:** Jim Korkis, "Animation Anecdotes #116," June 28, 2013; **"Puppets Cereal":** Jerry Beck, "Disney's Forgotten 'Puppets Cereal' Commercial," March 13, 2013, cartoonresearch.com.

320 **"a kitchen knife":** Bill Scott quoted in Solomon, *Enchanted Drawings*, p. 246.

320 **"I really believe":** Bob Clampett quoted in Jim Korkis's "Animation Anecdotes #221," July 17, 2015.

320 **"The same Philistines":** Culhane, *Talking Animals and Other People*, p. 18.

320 **Culhane on working with ad agencies:** Culhane, *Talking Animals and Other People*, p. 354; **on business advice:** Culhane, *Talking Animals and Other People*, p. 338.

321 **Walt Disney's refusal to preview films with children:** Gabler, *Walt Disney*, p. 424.

321 **"Never . . . my films":** Jones quoted in Furniss, *Chuck Jones: Conversations*, p. 36.

321 **Chuck Jones and Bill Scott and cartoons and kids:** Jones and Scott interviewed by Charles Solomon on KUSC-FM, April 16, 1985, transcript, "Live from Trumps," reprinted in Furniss, *Chuck Jones: Conversations*, pp. 132–133.

321 **"one of the ugliest":** Jones quoted in Furniss, *Chuck Jones: Conversations,* p. 164.

321 **"[T]he same thing":** Jones quoted in Furniss, *Chuck Jones: Conversations,* p. 38; **"the sadness":** Quoted in Furniss, *Chuck Jones: Conversations,* p. 42.

321 **"It's assembly-line stuff":** Hubley quoted in Solomon, *Enchanted Drawings,* p. 229.

322 **"Thus, Saturday mornings":** Michael J. Arlen, "The Air," *New Yorker,* November 4, 1974, p. 138.

322 **"I really object":** Quoted in Jim Korkis, "Animation Anecdotes #165."

323 **"this super syndrome":** Jones quoted in Furniss, *Chuck Jones: Conversations,* p. 38.

323 *Frostbite Falls Review:* John Cawley and Jim Korkis, *The Encyclopedia of Cartoon Superstars* (Las Vegas, Pioneer Books, 1990), pp. 166–167.

323 **"were always slam-bang":** Quoted in Solomon, *Enchanted Drawings,* p. 233.

323 **Work-arounds:** Solomon, *Enchanted Drawings,* p. 233.

324 **"NBC was furious":** Quoted in Kanfer, *Serious Business,* p. 185.

325 **"affected people":** Quoted in Kanfer, *Serious Business,* p. 185.

Chapter 33

327 **Lee Mishkin:** Quoted in Solomon, *Enchanted Drawings,* p. 178.

327 **Metric system:** Culhane, *Talking Animals and Other People,* p. 401.

327 **"The bosses":** Solomon, *Enchanted Drawings,* p. 178.

327 **Jack Mercer adapting Popeye for television:** This happened in 1978, but the point still holds for cartoons in the 1950s, which were edited along the same lines. Cohen, *Forbidden Animation,* p. 133.

329 **"and lived happily":** Fleischer, *Out of the Inkwell,* pp. 74–75.

329 **"John Wayne":** Richard Fleischer, *Just Tell Me When to Cry: A Memoir* (New York: Carroll & Graf, 1993), p. 9.

329 **"Me?":** Fleischer, *Out of the Inkwell,* p. 136.

330 **Richard Fleischer's recollection of Max and Walt's meeting:** Fleischer, *Out of the Inkwell,* pp. 137–139; Fleischer, *Just Tell Me When to Cry,* pp. 121–122.

331 **Details of Max's work with Handman:** Fleischer, *Out of the Inkwell,* pp. 144–146.

333 **1964 Presidential Medal of Freedom:** *New York Times,* July 4, 1964.

333 **Summary judgment:** Pointer, *The Art and Inventions of Max Fleischer,* p. 265; Fleischer, *Out of the Inkwell,* p. 154.

334 **Bluhdorn:** Michael Korda, "The Last Business Eccentric," *New Yorker,* December 16, 1996.

335 **"Would you call":** Quoted in Kanfer, *Serious Business*, p. 204.

336 **"They forget":** Michael Barrier, "The Filming of *Fritz the Cat*," *Funnyworld*, no. 14 (Spring 1972).

Chapter 34

337 **"he never goes":** Miller, *The Story of Walt Disney*, p. 114.

337 **Ailments:** Gabler, *Walt Disney*, p. 622.

337 **Details on planning Disney World:** Barrier, *The Animated Man*; Gabler, *Walt Disney*.

338 **Announcing Disney World:** *New York Times*, November 16, 1965; C. E. Wright, "East Coast Disneyland to Rise Near Orlando," *New York Times*, November 21, 1965.

338 **Robert Moses:** Robert Moses, "EPCOT: Walt Disney's Legacy," *Newsday*, April 29, 1967, p. 14.

339 **Corporate sponsors/putting CEOs at ease:** Green and Green, *Remembering Walt*, pp. 90–91.

339 **City planning books:** Marling, "Imagineering the Disney Theme Parks," pp. 146–147; Green and Green, *Remembering Walt*, p. 175.

339 **Bob Gurr:** Quoted in Katherine Greene and Richard Greene, *Inside the Dream: The Personal Story of Walt Disney* (New York: Roundtable Press, 2001), p. 169.

340 **"WELCOME TO THE CLUB":** Ron Miller quoted in Green and Green, *Remembering Walt*, p. 194.

340 **Wildfires:** Gabler, *Walt Disney*, p. 567.

341 **Tracing the EPCOT plans with his fingers:** Gabler, *Walt Disney*, p. 630.

341 **"Well, kid, this":** Quoted in Greene and Greene, *Inside the Dream*, pp. 179–180.

341 **The three networks converting to cartoons:** Solomon, *Enchanted Drawings*, p. 241.

342 **Essie's threats of suicide:** Fleischer, *Out of the Inkwell*, p. 165.

342 **"a long fade-out":** Fleischer, *Out of the Inkwell*, p. 167.

343 *Life* **magazine featuring Walt Disney World:** Fleischer, *Just Tell Me When to Cry*, p. 122.

Index

Note: All cartoon titles, cartoon characters, and films are shown in *italics*.